COMPUTER TYPE

A DESIGNER'S GUIDE TO COMPUTER-GENERATED TYPE

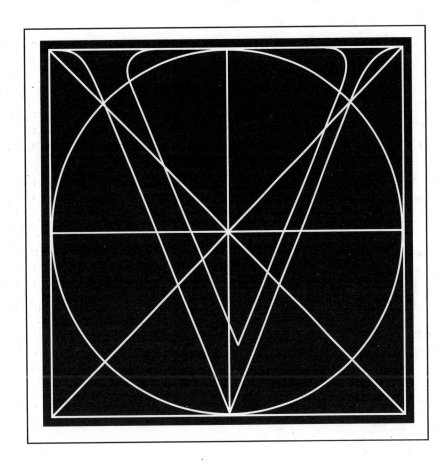

MICHAEL ROGONDINO

Chronicle Books • San Francisco

Production and technical assistance: Pat Rogondino
Illustrations: Pat Rogondino
Service Bureau: York Graphic Services, Inc.

ATM, Adobe Type Manager, Font Foundry are trademarks of Adobe Systems Incorporated. Adobe, Display PostScript, the PostScript Logo, PostScript are trademarks of Adobe Systems Incorporated registered in the U.S. Apple, ImageWriter, LaserWriter, and Macintosh are registered trademarks of Apple Computer, Inc. LaserJet and PaintJet are registered trademarks of Hewlett-Packard Company. IBM is a registered trademark of International Business Machines Corp. NeXT is a registered trademark of NeXT Inc. Clarendon, Helvetica, Janson, Melior, Memphis, Optima, Palatino, Sabon, Times, Trump Mediaeval, and Univers are trademarks of Linotype AG and/or its subsidiaries. ITC American Typewriter, ITC Avant Garde Gothic, ITC Bookman, ITC Cheltenham, ITC Clearface, ITC Galliard, ITC Garamond, ITC Kabel, ITC Korinna, ITC Lubalin Graph, ITC New Baskerville, ITC Serif Gothic, ITC Souvenir, ITC Stone, ITC Tiffany, and ITC Zapf Chancery are registered trademarks of International Typeface Corporation. Futura is a registered trademark of Fundicion Tipografica Neufville S.A. Lucida is a registered trademark of Bigelow & Holmes. Americana, Kaufman and Park Avenue are registered trademark of Kingsley/ATF Type Corporation. Eurostile is a trademark of Nebiolo. Freestyle Script, Italia, Revue, and University Roman are licensed from Letraset. Microsoft is a registered trademark of Microsoft Corporation. PageMaker is a registered trademark of Aldus Corporation. QuarkXPress is a registered trademark of Quark, Inc. Ventura Publisher is a registered trademark of Xerox Ventura Software. Other brand or product names are trademarks or registered trademarks of their respective holders.

Printed in the United States of America

Library of Congress Cataloging in Publication Data

Rogondino, Michael.
 Computer type: a designer's guide to computer-generated type
 Michael Rogondino
 p. cm.
 ISBN 0-87701-802-2
 1. Desktop publishing--Style manuals. 2.Type and type-founding--Data processing.
 3. Printing, Practical--Layout--Data processing.
 I. Title.
 Z286.D47R63 1991
 686.22'2544--dc20 90-1401
 CIP

Distributed in Canada by Raincoast Books
112 East Third Avenue
Vancouver, B.C. V5T 1C8

10 9 8 7 6 5 4 3 2 1

Chronicle Books
275 Fifth Street
San Francisco, California 94103

Contents

Introduction

Computer Type was written and designed for anyone interested in using computer-generated type. The development of the PostScript page description language and the laser printer changed computer type. Now anyone using a computer and a PostScript printer can create a document that resembles one prepared by a typographer. More than twenty-five companies produce computer typefaces, and more than one thousand fonts are available, with more being created every week. This multitude of type fonts has given designers a wealth of resources. On the other hand, the variety has made it more difficult for students of design and novice designers to make decisions about typefaces.

Computer Type shows examples of forty-eight of the most useful computer type families—traditionally called typefaces. Each font is shown with the complete upper- and lowercase alphabet. In addition, many fonts are shown in sizes ranging from 6 point to 72 point. This large selection of point sizes allows you to compare the design and shape of the letters of the various fonts. Doing so will add to your understanding of the rich and varied world of typography. Sample paragraphs show what several lines of the font, set in a variety of sizes and leadings, will look like. Studying these paragraphs will allow you to compare the *color* or overall tone of a block of text. Whether you are writing a résumé, a business report, a full-length novel, or designing overhead projections, letterheads, ads, or a monthly newsletter, by giving you a large variety of printed samples to compare and choose from, *Computer Type* will help you find the right font for the most effective finished document.

One section of *Computer Type* includes a brief history of typography that gives an overview of the styles and parts of a font or typeface. It also contains a handy reference guide to marking copy and copyfitting. These traditional skills are still essential to everyone who works with type. Another section contains information for users who are new to computer type and a guide to hidden computer type characters.

To show you what you can expect from computer typesetting, *Computer Type* was produced entirely on a personal computer. The typefaces, kerning, and word spacing were done in PageMaker 4.0. All the type in this book was output to film at high resolution (2,540 dots per inch) on a Linotronic 300, and the book was printed on a 60-pound white stock.

How to use this book

Computer Type is a comprehensive type specimen book for students, writers, artists, and designers—novice and professional. It was designed specifically to help you view the various type fonts in a variety of weights and sizes. If you're not familiar with a specific font, it is best to review more than a single line of that type style to make sure it has the characteristics the job needs. The fonts in this book have been chosen for their style and because they can easily be incorporated into a large variety of formats. The decorative faces are useful in designing letterheads, logos, advertisements, and signs.

Designers today have thousands of typefaces to choose from and more are created every day. Just as biologists organize plants into families as an aid for identification, typographers classify typefaces in families. The *Origins of Type* section covers the different parts that make up a character, and includes samples of the various type classifications. This information will help you identify typefaces you see in other publications and want to use in your own.

Computer keyboards and typefaces provide more than the standard alphabet, punctuation, and numbers. The type fonts shown in this book also include an extended character set with fractions, legal marks, accented characters, ligatures, typographic symbols, and ornaments. These hidden characters can dramatically improve the appearance of your documents by giving them a professional typographic quality. The hidden characters charts make it easy to find and use these special characters to make your documents more professional.

The book was designed to lie flat on a desk for tracing or viewing. You can easily do page layouts, trace characters, or make xerox copies directly from the book. The material on proofreading and copyfitting was written with the beginner in mind. A glossary is included for anyone unfamiliar with the terminology of typography or computer type.

Michael Rogondino is a freelance graphic designer and graduate of the Chicago Art Institute. He teaches typography and book design for the University of California, Santa Cruz. He uses a computer to design and produce several different kinds of books.

Origins of Type

To fully appreciate typography today, you should have some knowledge of the history of typography and what our ancestors went through to develop modern letterforms. The alphabet we use today is made up of twenty-six symbols, each of which more or less represents a sound of speech. Many of the symbols that we use today are the same as those used thousands of years ago.

Pictographs

Writing started with pictographs, rough-drawn pictures representing objects. Early cave dwellers used pictographs to communicate. Pictures drawn on the walls of their caves depicted people, religious signs, animals, and tools. It was common to draw everyday objects that would record an event or relay a message to the community. Drawings of a bison or deer could be a record of a successful hunt. Examples of pictographs can be found throughout the world.

Ideographs

As communities grew in size and as humans improved their communication skills, mere recordkeeping wasn't sufficient, and the symbols began to reflect abstract thoughts. Soon our ancestors learned that, by combining different pictographs, they could express abstract thoughts. Combining the pictograph of a man with that of an animal could have the meaning *to hunt*. At that time the symbol no longer represented an object; it represented an idea or a thought. These symbols are called ideographs. Most early cultures used ideographs and pictographs as their means of communication and recordkeeping. There are disadvantages to this system of communication, though, because the symbols became very complex and eventually ran into the tens of thousands.

A good example of a modern-day ideograph is the sign of the man or woman on the doors of some restrooms. These drawings are not seen solely as meaning *male* and *female*, but also recognized as meaning *restroom*. Another ideograph you will readily recognize is the skull and crossbones. It is used as a warning for poison. The skull and crossbones are not seen in a literal sense but as a symbol of death or danger.

An example of a Hittite pictograph.

Modern ideograph meaning *women's restroom*.

This ideograph is used as a symbol of danger, death, or poison.

35,000 B.C.	Pictographs
33,000 B.C.	Hieroglyphics (Egyptians)
1600 B.C.	Phoenicians develop an alphabet with 22 characters
1400 B.C.	Chinese dictionary with 40,000 characters
1000 B.C.	Greek alphabet with vowels
500 B.C.	Roman alphabet has 23 characters
789	Charlemagne appoints Alcuin of York to revise church's books— lowercase letters developed
1456	Johann Gutenberg invents movable type, prints Bible
1501	Aldus Manutius designs first italic type
1734	William Caslon Caslon
1757	John Baskerville Baskerville
1788	Giambattista Bodoni Bodoni

Cuneiform is the oldest known form of writing.

The Phoenician alphabet, 1500 B.C.

Cuneiform

Mesopotamian cuneiform, the oldest known form of writing, was used throughout the Near East. Its wedge-shaped indentations were easy to carve into soft clay tablets or on stone. Around 2500 B.C., cuneiform had about two or three thousand sound symbols. By Babylonian and Assyrian times, it was pared down to about six or seven hundred signs. One hundred and fifty of these represented syllables: sounds like *me* or *mu*, *we* or *wa*. These syllables could be combined with others to make up thousands of words. Cuneiform could not be truly called an alphabet because its symbols represented syllables or entire words, while alphabets are made up of single characters representing sounds that cannot be simplified or reduced further.

Phoenicians

The early Egyptians did not make the complete break with cuneiform that would have given them a true phonetic alphabet that was easy to learn and would allow the expression of ideas. The Phoenicians are usually credited with this invention around 2000 B.C. Fragments of clay tablets found in the Sinai Peninsula, dating from approximately 1800 B.C., suggest that the semitic inhabitants, the Ugarits, of the area between Egypt and Palestine had adapted Egyptian cuneiform into their language. By streamlining cuneiform, almost like shorthand, to about thirty characters, the characters were simplified until they became single consonants. The Ugarits' written language didn't need vowels to be understood. Their Sinaitic script, the oldest known example of the use of an alphabet, evolved into the Phoenician alphabet.

The Phoenicians were busy merchants and sea traders who needed to keep records and correspond with far-off people. They had to be able to jot down their records quickly and unobtrusively. The first documents in Phoenician script must have been business letters and records, but because they were written on clay and paper few examples survive. The Phoenicians must have found clay tablets difficult to transport and store. Papyrus was easier to work with. It required different writing tools from the wedge-shaped tools used on clay tablets, thus character formation took on a far more fluid and painting-like quality. Curved lines were difficult to produce on clay tablets,

but pens allowed the Phoenicians to draw circles, slanted lines, crosses, etc. This is a clear example of how the tools of a craft have a very significant effect on its form.

Scholars today agree that the Phoenicians' greatest achievement was to put cuneiform sound symbols into an alphabetical sequence from A to Z. They are credited with developing the phonetic system that is the root of later Greek writing, from which most Western written language evolved.

The Greeks

The Greeks adopted the Phoenicians' alphabet around 1000 B.C. Their language was rich in vowels, so they added five vowels to the alphabet and formalized the letterforms. The advantages of the new system of writing were enormous. Intellectual education lost its professional and monopolistic character. People could learn to read and write and, within a year, illiteracy almost disappeared. Instead of just keeping business ledgers, the Greeks used the alphabet as a means of preserving knowledge, writing poems and stories, creating a rich cultural life and strong national consciousness. In 405 B.C. the revised Greek alphabet was officially adopted by Athens.

The Romans

The Romans adopted and modified the Greek alphabet, taking thirteen Greek letters, modifying eight letters, and adding two more, *F* and *Q*. The twenty-three letters of the alphabet could be used to write any Latin word. The Romans also dropped the Greek names for letters—alpha, beta, gamma, etc.—for the simple ABCs we use today.

As Romans started using pens instead of a stylus for their writing, the stiff angles of many letters such as *B, C, R,* and *S* changed to more graceful curves and took on a flowing look. Writing with a broad pen held at a constant angle causes a difference in line weight—thick and thin strokes. These written letters were difficult to carve cleanly into stone, so stonecutters found that chiseling a stroke at a right angle to the end of each line gave their letters a more finished look. Scribes started using this finishing stroke on written manuscripts. This stroke is called a *serif*. The shape and angle of the serif gives a typeface its distinctive characteristics. (If a typeface lacks this finishing stroke, it is a *sans serif* typeface.) Surviving today are manuscripts in the Latin alphabet dating back to the first century A.D.

A ΑΒΓΔΕΖΗΘΙΚΛΜΝΞΟΠΡΣΤ

B ABCDEFGHIKLMNOPQRS

A. The Greeks adopted the Phoenician alphabet around 1000 B.C. B. The Romans adopted the Greek alphabet and added two more letters, around 400 B.C.

	
1822	William Church invents a keyboard-operated typesetting machine
1886	Ottmar Mergenthaler perfects the Linotype linecasting machine
1887	Tolbert Lanston invents the Monotype typesetting machine
1932	Stanley Morison Times Roman appears in London
1946	Herman Freund creates the Fotosetter, a typesetting machine using photographic typemasters
1985	John Warnock and Charles Geschke develop the PostScript page description language
1985	Apple introduces the PostScript-equipped Laserwriter and desktop publishing becomes a reality
1988	Adobe Systems develops Display PostScript
1990	Time magazine is completely produced using computers

Quadrata Rustic

Unical Half-unical Roman Cursive

Our modern letterforms derive from
these Roman letters.

Carolingian miniscules

Greek punctuation, 500 B.C.

This diagram shows examples of specific
drawings that were instrumental to the
development of our present letterforms.

Roman handwriting developed along five different forms. It is from these different styles of letter formation that the upper- and lowercase alphabet we use today evolved.

- **Quadrata**—Letters drawn to imitate the square capital letters carved by Roman stonecutters on arches, columns, and walls. These letters were graceful and elegant with thick and thin strokes and fine serifs or finishing strokes.
- **Roman rustic capitals**—Scribes began to eliminate many of the small finishing strokes used in quadrata. Instead of a separate pen stroke, they made serifs with the turn of a pen. Some letters were joined together without lifting the pen.
- **Unical**—Began appearing in the sixth century. Characters were much rounder, more uniform in height, and less formal than previous styles. Unicals were still capital letters, even though some characters were written larger than others.
- **Half-unicals**—Were the beginning of our lowercase letters. This style had a more exaggerated height difference between characters, and looser more informal style than unicals.
- **Roman cursives**—A flowery writing style related to modern writing.

Lowercase letters

Charles the Great (Charlemagne) encouraged the scribes of his day to completely revise the church's books. Led by the English cleric Alcuin, the monks at the Abbey of St. Martin at Tours developed the beautiful flowing and efficient letterforms known as Carolingian miniscules (little letters), based on the unical and half-unical style of the classical Roman manuscripts. Letters that rose above or descended below the body of type broke up the monotony of the line. Because this style was easy to write and read, it became popular with scribes throughout Europe and led to the increased use of lowercase letters.

Punctuation

In early Greek and Roman writing, words either all ran together or were separated with dots or slashes. At times this made it difficult to understand the message. Punctuation became specific in the fifteenth century with the advent of the printing press. Punctuation is necessary for understanding the meaning of your words, and it can also add feeling or emphasis to a message!

	Sinai 1500 B.C.	Canaan 1000 B.C.	Phoenicia Greece 750 B.C.		Today
Oxhead	⛢	K	✕	⋏	A
Fence	⊟	⊟	⊟	⊟	H
Water	ᨓ	⟨	ᴟ	ᴎ	M
Human Head	⟨ᴎ	◁	◁	⟩	R
Bow	⌣	W	W	⧢	S

Printed Type

Movable Type/Foundry Type

Johann Gutenberg is generally credited with inventing printing in the mid 1400s. His formula for a blend of tin, lead, and antimony was used to make movable type. The benefit of movable type was that each letter could be used over and over. The letterforms remained consistent. With movable type, printed matter could be produced in large quantities. Movable type was so workable that it changed little throughout the centuries.

Movable type (or foundry type) starts with the design of each letterform in the alphabet. A punch-cutter uses the design as a guideline to cut the letters into a block of metal. As the metal is carved away from the character with chisels and files, a raised letter is left behind on a solid block, or punch. The punch is tempered to ensure hardness and then struck into a bar of softer metal, creating a matrix. The matrix is then aligned and put into a mold. Hot metal is poured into the matrix and trimmed to a standard height to create a solid line of type. Thin strips of lead are inserted between letters, words, and lines to add space. (The term *leading,* which refers to the thin strips of lead inserted between lines, is still used today for measurement.)

Foundry type was stored in drawers, called a case. The top drawer, or upper case, contained capital letters, while the bottom drawers, or lower case, contained the small letters. This is where we get the terms *uppercase* and *lowercase.*

Linotype

Setting type by hand is a slow, tedious process. In 1886 Ottmar Mergenthaler invented the Linotype machine, the first great step towards automation. No longer did the typesetter have to sort and return each character to type cases; the Linotype machine produced a single line of type whose length was specified by a keyboard operator.

The Linotype works on a system of belts, cams, and gravity. The matrix for fonts in one size and style are stored at the top of the machine in a container called a magazine. Each time the operator presses a key, a single brass matrix drops into a vertical channel. When the entire line is typed, the matrix moves to the casting section, where the line of type is cast in hot lead. The keyboard operator types the next line while the first is being cast. When the casting process is finished, cast lines of type, called slugs, are ejected from the mold and the matrix returns to its slot in the machine, ready to be used again. The slugs are then assembled by a compositor and proofed.

The first Linotype machine set lines of type up to thirty picas long. It was widely used for newspapers, books, and general typesetting until photocomposition was introduced in the 1960s.

Punch, matrix

Hot metal type

Linotype brass matrix, slug

Linotype machine

Monotype machine

Monotype

In 1887 Tolbert Lanston invented a machine that molded type and assembled it in justified lines. This was the Monotype machine. It could set type at an average rate of 150 characters per minute. The Monotype operator types at a keyboard, creating a perforated paper tape. The coded tape drives a separate piece of equipment called a typecaster. Compressed air driven through holes punched in the paper tape determine which character or space is cast by the typecaster. Hot metal is forced into molds, cooled, and placed in a metal tray called a galley. There it is assembled by the compositor. Corrections can be made by individual letter rather than by resetting the whole line, much like foundry type. Letterpress printing can use type in the cast metal form much like rubber stamping. The cast type is a mirror image of the printed results. The line castings of Linotype and Monotype were ideal for letterpress printing, but the raised type has to be converted into a printed proof for use in lithographic printing. The lithographic printing plate is made photographically from a film negative or positive. This takes additional time and can result in a loss of type quality.

Phototypesetting

Experiments in phototypesetting began in 1880, but it wasn't until printing technology advanced that phototypesetting became practical. Offset lithography is the most commonly used printing method today.

The 1960s saw the introduction of phototypesetting, sometimes called cold type. Computer equipment greatly improved the composing time for display and text, offered greater variety of type sizes, and required less storage space for fonts. Phototypesetters produce type directly on paper or on film, making it ideal for lithography.

The typical phototypesetting system has five parts:

- **Keyboards and monitor**—Keyboards enter copy into the computer. Changes in copy or line breaks, font specifications, and spacing can all be made from your keyboard. Text is viewed on a monitor.
- **Computer**—The computer relays information between the keyboard, monitor, photo-unit, processor, and storage unit.
- **Photo-unit**—The photo-unit takes the information from the computer and, using a master for different fonts, generates type. It photographically produces type (photo type) onto paper or film. The equipment is fast, quieter, and more dependable than hot metal machinery. In the 1980s, digital typesetters were developed. Digital typesetters store fonts as data instead of using a photographic master. They can also draw rules, graphics, and halftone dots. The digital images cannot wear out, and the equipment has very few moving parts. A laser printer is an example of a simple digital photosetter.
- **Processor**—The photosensitive paper or film is developed in a chemical solution.
- **Storage Unit**—Text is stored temporarily in the computer and then to disks or magnetic tape for a permanent record. Digital fonts are also stored on disk or tape. If changes are needed in text or fonts, it is a simple matter to put the information back into the computer.

For additional information on phototypesetting see the section of the book called *Computer Type*.

Type Classifications

Since the first typeface was introduced in 1450, we have seen hundreds of new type designs. Because of the enormous numbers of typefaces available, putting type into families, or classifications, helps the designer find and identify typefaces with common design elements, such as serif style, thick/thin contrast, etc. Studying and comparing differences in the type from one family to another will help you understand the elements of design that make up typefaces. There are many approaches to classifying typefaces. The following classification system is one of the more general.

Oldstyle

Oldstyle typefaces are based on early Dutch, Venetian, and English typographic designs. They are easily recognized for their readability. Because of their legibility, the oldstyle typefaces are most widely used for lengthy publishing projects. Their letterforms are open and wide with well-rounded characters. Oldstyle designs were developed as a manuscript hand during the Renaissance and derive their shapes from the forms created from the broad pens used by early scribes, who held their pens at a natural writing slant. This system of writing was adopted for typographic designs by fifteenth century printers. The pointed serifs (the finishing stroke at the end of the main stroke) produce a pleasing contrast between the heavy and light strokes of the individual characters. Two examples are Galliard and Sabon.

Transitional

Transitional type represents a shift from oldstyle to modern. The English printer and typographer John Baskerville was very influential in the inception of transitional typestyles. His work with calendered papers (fine grained, smooth high-quality paper) and improved printing methods made it possible to reproduce the fine character strokes and subtler character shapes indicative of transitional typefaces. These typefaces are much lighter and the designs more refined than oldstyle faces. They show more contrast between the thick and thin strokes of individual characters, which are usually wider than oldstyle characters. Notice the long, rounded, curved serifs characteristic of this style. They help to identify transitional styles, such as Baskerville and Caledonia.

Slab serif Hairline serif Bracketed serif

Serifs (finishing stroke at the end of the main stroke) are one of the distinctive characteristics that determines a typeface's style.

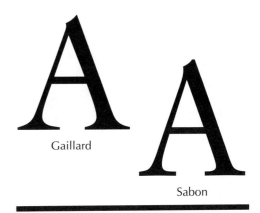

Gaillard

Sabon

Samples of Oldstyle

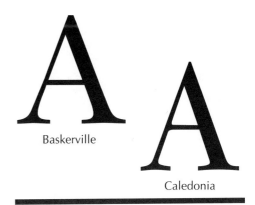

Baskerville

Caledonia

Examples of Transitional

Bodoni

New Century Schoolbook

Examples of Modern

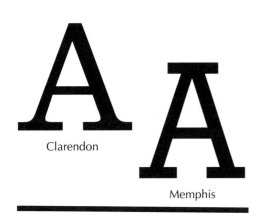

Clarendon

Memphis

Examples of Egyptian

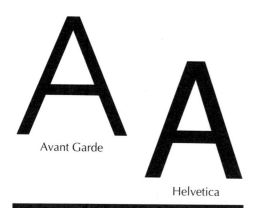

Avant Garde

Helvetica

Sans Serif examples

Modern

The work of Giambattista Bodoni and Firmin Didot in the late eighteenth and early nineteenth centuries gave us modern typographic designs, which are more geometric than other styles. The letters display extreme contrasts between thick and thin strokes, and serifs have been reduced to hairlines. Modern typestyles do not have bracketed serifs (brackets are the connection between a serif and a stroke) characteristic of earlier styles. Modern typestyles can be identified by their abrupt transition from one weight to another, as well as the strong contrast in weight from thick to thin strokes and unbracketed serifs. Bodoni and Century Schoolbook are good examples of modern typestyles.

Egyptian

English typefounder Vincent Figgin first introduced the Antique typestyle, one of the Egyptian typestyles, in the nineteenth century during a time when England was experiencing a mania for ancient Egyptian artifacts. Egyptian typefaces have heavy square or rectangular serifs, usually unbracketed, called slab serifs. Other characteristics of this style include little contrast between thick and thin strokes and minimal stress placed on the curved strokes. In many slab-serif typefaces, all strokes are of the same weight. Other typefounders adapted the name Egyptian for their slab-serif designs. Two examples are Clarendon and Memphis.

Sans Serif

In 1816 the English typefounder William Caslon IV published a type specimen book in which the first sans serif typestyles appeared. *Sans* is the French word meaning without, so a *sans serif* typestyle is one without serifs. Even though the designs originated in the nineteenth century, much sans serif type was produced in the twentieth century. The characters in these type designs have no serifs and an evenly weighted appearance. There is a lack of contrast between individual characters and, because of this lack of contrast, sans serif typestyles are considered less legible than the oldstyle and modern typefaces. Even so, many contemporary designers use sans serif typefaces in their designs. Avant Garde and Helvetica continue to be popular sans serif faces.

Computer Type

The announcement of Adobe's PostScript and Apple's LaserWriter in 1985 paved the way for professional desktop publishing. PostScript is the powerful page description language that permits precise control over text scaling, positioning, graphics, and special effects. The LaserWriter included a set of built-in fonts that, when printed at 300 dots per inch (dpi), looked almost as good as typeset text. Before long type companies began digitizing their type libraries, putting them into a format that could be used on computers. Using PostScript, several imagesetters could run out copy at 2500 dpi to produce typeset-quality pages.

Only a small sampling of the hundreds of PostScript fonts available could be used in this book. The selection here offers designers a wide range of typefaces suitable for any project. Remember, the best fonts at the lowest prices are worthless if they don't work with your system and printer. Thus compatibility is the primary consideration, not only with your software but also with your service bureau's. PostScript is the de facto standard for digitized type. Most service bureaus offer typefaces from the Adobe Type Library.

Font Packages

A PostScript font package comes with a disk that contains a screen font, a printer font, and a font metric file. The concept that seems most confusing to novice computer users is the difference between screen fonts and printer fonts. Simply put: The *screen font* is what a computer uses to draw the image of type that appears on the monitor. The *printer font* sends the laser printer or imagesetter the information necessary to print type. Both the screen font and the printer font must be installed in the computer in order for the font to print correctly. The *font metric file* (AFM) is a separate file that contains information needed by PCs or PC clones—the information about the width of each character and information about any kerning pairs that the manufacturer has included. The manual that comes with the font package contains the information necessary to install fonts.

If you want to use any of the typefaces shown in this book and don't own the printer font, check with your local service bureau. Many will supply you with a copy of their screen fonts, without charge if you bring your own disk. This will allow you to work on your computer and print on their equipment.

Screen Fonts

Screen fonts, also called bit-mapped fonts, provide the image for the computer's display. *Bit* means binary digit, the ones and zeros that make up computer instructions. The character display on a monitor is made up of square dots or pixels. Each pixel, or picture element, holds one bit of information. On a monochrome monitor, if a bit is 1,

```
%%Feature: NormalizedTransfer
 settransfer erasepage cleartomark
/#copies 1 def
 (Pat; document: Untitled)
 statusdict /jobname 3 -1 roll put
 statusdict /waittimeout 300 put
3300 2550 false false false BEGJOB
300 SETRES
25000 S_WORKING
save /SUsv exch def
%%EndSetup
%%Page: 1 1
BEGPAGE
SURSTR
false S_LOADFONT
(Helvetica) FTRECODE
SUSAVE
/|_____Helvetica 240 100 mul
false SET
844 830 0.0000 0.0000
(A) 1 0 67 OUT
ENDPAGE
ENDJOB
```

Portion of the PostScript code required to print the letter *A* in 24-point Helvetica.

Bit-mapped fonts are made up of pixels, which is why they appear jagged.

Outline fonts can be scaled to any size.

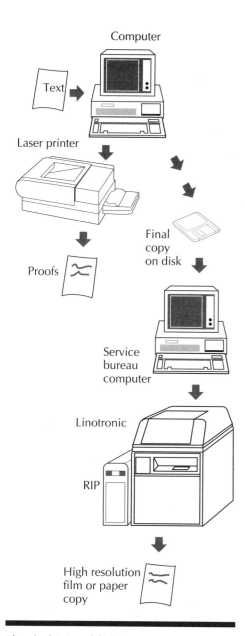

The desktop publishing process

or on, the pixel is black; if a bit is 0, or off, the pixel is white. Macintosh screen fonts also contain the font metrics; this information is contained in a separate font metric file for the PC.

Computers differ in the way they handle screen fonts to display type on the screen. One of the major problems in desktop publishing has been that most screen fonts look very jagged. At larger sizes pixels produce a stair-step effect when drawing diagonal lines and curves on screen. Several companies have addressed this problem. The NeXT computer uses Display PostScript to draw smooth characters on the screen at any size, using the same outline fonts that it uses for printing. Adobe Systems has released *Adobe Type Manager (ATM),* which generates smooth onscreen characters, using screen fonts and outline fonts. It is compatible with graphics and desktop publishing software. Graphic Programming Interface (GPI) offers clean font imaging onscreen for *Presentation Manager* running under *OS/2.* LaserMaster Corporation's DPSI display controller produces smooth onscreen type with Xerox *Ventura Publisher* and Aldus *PageMaker.* Even if you don't use one of these programs, the way your screen font looks doesn't affect your printed document. PostScript printer fonts produce smooth results at all sizes.

Type 1 Fonts

Type 1 fonts are PostScript outline printer fonts that are made up of a series of Bézier curves. A Bézier curve is a class of curves connected by four points. The letter's outline is defined by a mathematical description—or equation. Using this equation, the outline of the shape can be scaled to virtually any size and still maintain its relative proportions. Type 1 fonts are encrypted and contain hints. Encrypted fonts are more efficiently coded than nonencrypted ones; they print faster and take up less disk space.

Hints are proprietary scaling algorithms that enhance the appearance of printed characters at the low resolution of 300 dpi. In most typefaces, the strokes that make up the three legs of the letter *M* should all be the same width. But at a resolution of 300 dpi, the edge of one of the legs may fall between two dots. Because a laser printer cannot print a portion of a dot, the edge of the leg, or stem, will be placed on the nearest whole dot, resulting in a character with uneven stroke widths. The problem is especially noticeable in fonts scaled to 9 points or smaller. Adobe's hints make minute adjustments to even out stroke widths and solve other problems, making the type look good at 300 dpi, even in the smaller type sizes. Bitstream's Type B fonts contain their own hints. Other companies argue that hints are not necessary because serious users will print final copy on high-resolution imagesetters. Type 1 fonts are produced by Adobe and Adobe-licensees such as Agfa Compugraphic, Autographic, Autologic, Linotype, Morisawa, and Varityper.

Until recently, any downloadable font not licensed by Adobe was a second-class citizen, unable to print on a PostScript printer. Bitstream and RIPS broke Adobe's font-encryption code and now most of its high-end library of fonts are PostScript compatible. RIPS manufactures PostScript clone printer interpreters for use in PostScript compatible printers. Adobe has responded to all this pressure by publishing the Adobe Type 1 Specifications. They are releasing *Font Foundry,* a type utility that allows non-PostScript printers like the HP LaserJet to print Type 1 fonts. All these changes mean

more choices for desktop publishers, but they also mean that PostScript fonts will be the publishing standard for some time to come.

Type 3 Fonts

Type 3 fonts are PostScript fonts that aren't encrypted and don't contain hints. Type 3 fonts can be downloaded to a PostScript laser printer or imagesetter. (Type 2 fonts disappeared when the technology didn't work as expected.)

When printing smaller size type, 12 point or less, at 300 dpi, fonts without hints produce characters that look uneven and rough and often have a heavy appearance. When printed at 1270 dpi or 2540 dpi on an imagesetter, there is no difference between hinted and nonhinted fonts. Some designers and type manufacturers contend that hinting degrades the quality of traditional type design because there should be subtle differences in weight in some cases. Adobe maintains that current hinted faces adhere to the original typefaces as closely as possible within a digital format. Many manufacturers offer top-quality Type 3 fonts.

Printing Final Output

Laser printers or imagesetters interpret PostScript page descriptions to create bit-mapped representations of the page for printing. The number of dots per inch determines how good your printed document looks. The greater the number of dots, the better the resolution of your printed page. At 300 dpi, laser printers give fairly low resolution, but for some jobs this resolution is perfectly acceptable. Service bureaus have sprung up in most metropolitan areas to service the growing desktop publishing industry. They range from full-service to do-it-yourself outlets. In some, you can rent time on computers to try out different software, print out a project on a 300 dpi laser printer for a modest fee, or take computer classes.

Service bureaus also offer gray-scale and color scanners, color separation systems, optical character recognition (OCR) scanners, and modems and fax machines. You could complete every prepress publishing step, going from typewritten manuscript and color photos to final film for a four-color printing press, all under one roof. The service bureau will also supply a high-end imagesetter, such as a Linotronic 300 or Compugraphic, which can produce copy at 1270 dpi or 2540 dpi, equal in quality to traditional typeset copy. The difference between 300 and 1270 dpi may not sound like a lot, but at 300 dpi the laser printer prints 90,000 dots per square inch. At 1270 dpi an imagesetter prints 1.6 million dots per square inch—*18* times the laser printer's resolution. At 2540 dpi, an imagesetter prints 6.45 million dots per square inch—more than *70* times the resolution of a laser printer.

The best way to make sure that your final output is just what you want is to talk to the people at your service bureau. They will tell you if they have the fonts you want or if your fonts are compatible with their equipment. After all, effective communication is what type is all about!

resolution **resolution**
72 dots per inch

resolution **resolution**
300 dots per inch

resolution resolution
1270 dots per inch

resolution resolution
2540 dots per inch

10-point Palatino shown actual size and enlarged 300 percent with different resolutions.

Measurement

36/36 Sabon Bold

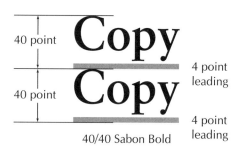

40/40 Sabon Bold

In the United States typography is based on a system of measurement known as the American point system. The sizing and terminology we use today originated with metal type. Though metal type is obsolete (only a few specialists still work with hot lead), the vocabulary is still applied to all forms of computer typesetting.

Points and Picas

The point is the basic unit of typographic measurement. One point equals 1/72 or 0.0138 of an inch. Points can be converted into picas, just as inches are converted into feet. There are 72 points in an inch (actually, in 0.9961 inch). There are 12 points in a pica and 6 picas in an inch (0.99961 inch). The illustration below shows the relationship of points to picas.

Points and picas are the most useful measurements for designers. They measure everything inside a page: type size, leading, column width, art sizes, and so on. Type is always measured in points, while picas or points can be used to measure line length. Points indicate the physical height of the metal type body rather than the size of the letter. Points are also used for specifying the thickness of rules. Picas are often divided into halves and quarters to describe type measurements, but it is unusual to use smaller fractions. The abbreviations for these terms is pi for pica and pt for point.

Computer page makeup programs such as Ventura and PageMaker make it easy to specify type in 1/2 point sizes, such as 7 1/2 pt.

With 12 points equaling a pica, the 12-scale on the Haberule can double as a pica scale.

The following table converts points and picas into inches.

Points	Picas	Inches
1 pt	0.01	384 in.
6 pts	0.5 pi	0.08304 in.
12 pts	1 pi	0.16608 in.
72 pts	6 pi	0.9961 in.

Inches

Inches are always used to measure the trim size of a page. For example, 8 1/2" × 11" or 7 1/4" × 9 1/4". The margins of a page are also usually measured in inches. Most computer page makeup programs allow you to change the system of measurement in the Preference box. You should start your design in inches when you set up the page size, margins, and gutter, and then switch Preferences to picas for the rest of your design specifications.

There are 12 points to a pica and almost 6 picas to an inch.

X-Height

X-height is a measurement of the height of the body of a lowercase letter. The x-height of a typeface determines the visual impact of the type size. Type size is determined by measuring the type from the top of the tallest ascender (portion of the lowercase letter that extends above the height of the lowercase *x*) to the base of the lowest descender (portion of the lowercase letter that falls below the body of the letter). Designers must consider the x-height of a face when choosing a font. Typefaces with a large x-height can be used in smaller point sizes without sacrificing legibility.

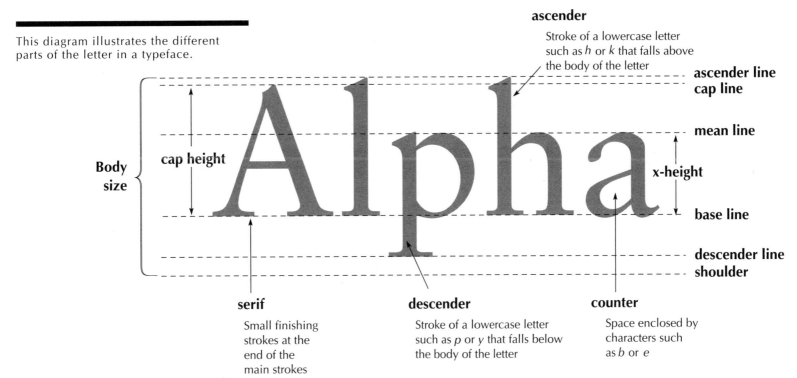

This diagram illustrates the different parts of the letter in a typeface.

ascender
Stroke of a lowercase letter such as *h* or *k* that falls above the body of the letter

ascender line
cap line
mean line
x-height
base line
descender line
shoulder

Body size
cap height

serif
Small finishing strokes at the end of the main strokes

descender
Stroke of a lowercase letter such as *p* or *y* that falls below the body of the letter

counter
Space enclosed by characters such as *b* or *e*

bpm bpm bpm

Garamond Palatino Helvetica

These three typefaces have the same point size, but different x-heights.

This form of measurement can leave typography novices baffled when they see two faces with the same type size that appear to be of very different physical size. If you measure the three fonts in the figure above, you will see that they all measure the same height from the top of their ascenders to the base of their descenders. However, the physical design of the typefaces is such that one looks much smaller than the others. The difference is in their x-height.

Letterspacing

Letterspacing is the space between individual characters. We normally perceive words as whole entities rather than as a collection of individual letters. The ideal letterspacing allows for individual character recognition; too much spacing or too little would affect legibility. Letterspacing varies according to the point size used. Adjusting the letterspacing also affects the number of characters that will fit on a line. In computer page makeup programs, uniform letterspacing is also called tracking. High-end page makeup programs allow you to adjust the tracking manually or automatically. Some programs also letterspace or track in points and fractions of points.

LETTERSPACING

Letterspacing is the addition or subtraction of space between letters to improve the visual balance between those letters.

Kerning

Kerning refers to the deletion of space between characters in order to improve the visual balance between pairs of letters. The term originated in the seventeenth century when type was created for wood or metal blocks. At that time, characters were created individually. The space surrounding each character was determined by the material, called sidebaring, around it. This material extended from either edge of the character to the the edge of the metal or wood block. Additional space could be added to separate characters by inserting thin brass or lead strips between each block. When the characters had to fit closer together, the metal blocks were filed down. This was called kerning.

Software manufacturers include kerning tables with their page makeup programs for numerous type pairs such as *Av*, *LT*, *Wa*, and *Yo*. The programs automatically kern these type pairs. However, you may want to manually kern pairs in display type or large font sizes. Your software should allow you to do this.

Te Te Wa Wa

Kerning is deleting space between characters to improve the visual balance between pairs of letters. *Wa* is a common kerning pair.

Word spacing

Word spacing refers to the amount of space between words. Words require sufficient space between them for legibility. When a line can be scanned smoothly without individual words jumping out, distracting you, the text is considered legible. Nor should a line of text be set so tight that individual words cannot be distinguished. Word spacing can be controlled with letterspacing, hyphenation, and line length.

Leading/Line Spacing

Line spacing refers to the amount of space inserted between lines of type. This is commonly called *leading* after the practice of adding thin strips of lead between lines of metal type. Leading (or line spacing) is measured in points and occasionally in half points. The notation 12/14 Times Roman means that 12-point Times Roman type should be set on 14-point leading. Always measure leading from baseline to baseline. The baseline is an imaginary horizontal line on which all the letters in a given line of type rest.

Typeface, type size, and line length all affect the amount of leading needed. Typefaces with a large x-height and a long line length tend to require more leading than typefaces with a small x-height and a shorter line length. Large display typefaces may actually look better with less leading between lines.

Minus leading means setting the type so that ascenders and descenders touch. Many of the type samples in this book have been set in paragraphs with several different leadings to show how different leadings can affect the legibility and overall tone of a block of type.

Haberule

A Haberule is a type gauge used to measure line spacing. Anyone who works with type on a regular basis knows that a Haberule is the one measuring tool that is indispensable. Since point sizes are so small (72 points to 1 inch), the Haberule groups points into units of different point sizes. It shows gradations in units from 6 to 15 points. The 12-point scale makes a convenient pica scale. Laying the Haberule gauge along a type area will quickly tell you how many lines of a given leading will fit into that depth. For example, if your type is set 9/11, using the 11-point gauge (always include the leading when measuring line depth) will show that 23 lines of type will fit into an area 21 picas deep. Double all Haberule scales for larger point sizes. If you are using 14-point leading, you can use the 7-point scale and count every second measurement.

Type Arrangement

There are five ways of arranging type on a page: justified type, flush left/ragged right, flush right/ragged left, centered, and asymmetric.

Justified

Type is justified when all lines are the same length *and* when all lines align on both the left and right margins. Justified copy generally requires less space than unjustified copy. It is most often found in books, newspapers, and magazines. Justified type has a

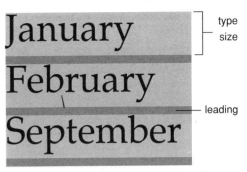

Desktop publishing programs can handle leading in different ways. This sample is from Aldus PageMaker.

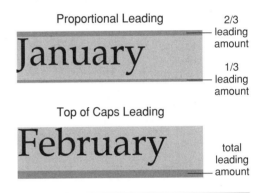

Leading is the space between lines of type. It is measured in points.

Haberule

This line of type is justified. Space is added between words to even out the lines of type.

This line of type is flush left, ragged right. It reduces hyphenation.

This line of type is flush right, ragged left. It can be effective in some situations.

Centered type can create visual interest in short blocks of text.

Asymmetric type
is laid out by the
designer. This is used
for poetry.

Examples of various type arrangements

tidy, squared off appearance, but requires variable word spacing and hyphenation to make the words fit in even lines. You can set up specific parameters for minimum and maximum word spacing and hyphenation in your page makeup program to ensure proper spacing.

Flush left/ragged right

Flush left/ragged right is unjustified (unaligned) type with all lines set flush to the left margin. It is the easiest copy to read. Its major advantage is that word spacing is even and hyphenation reduced. Even word spacing contributes to a uniform overall texture.

Flush right/ragged left

Flush right/ragged left is another unjustified type arrangement with lines on the right margin set flush. It is more difficult to read than text set in other ways but is very effective in special situations, such as short blocks of advertising copy, table text, or art and photo captions.

Centered copy

Centered copy is when all lines of type are set in the center of a line. It is difficult to read in lengthy passages. Centered lines of text should vary enough in length to create some visual interest but should not be used for long blocks of copy.

Asymmetric

Asymmetric type is laid out with no predictable line length or placement. This format is used for poetry and special situations. There are no guidelines for using this technique. It is up to the designer to come up with a visually pleasing design.

Copyfitting

Copyfitting is the process used to calculate the amount of space the text will occupy when it is typeset with a given font and a specific line width, leading, and point size. Knowing the amount of space text will occupy allows you to decide how to adjust the length of the text, the type specifications, or the space allowed.

Desktop publishing technology may make copyfitting obsolete someday. However, basic copyfitting skills are still necessary, especially when a long manuscript must fit into limited space. Before you can begin to design a project and select type, you must know how much typewritten material you are working with and how much space is available.

Start with a clean copy of the manuscript with all copy-edited changes and corrections made. Since adding and deleting copy will change your estimate, make sure there won't be unpleasant surprises in final pages. It is easier and much cheaper to make changes before sending pages to an imagesetter or to the printer.

Character counting

The first step in copyfitting is to count the number of typewritten characters, including punctuation and spaces, in your manuscript. This is called *character count*. All copyfitting methods use character count as a basis for projecting the length of a manuscript when typeset. Several word processing and page makeup programs do this automatically. Check your manual for this information. If your software doesn't do this—don't panic. You won't have to count each character individually! Simply measure the average line length in the typewritten manuscript in inches, count the number of characters in a one-inch segment, and multiply by the line length. This gives you the average number of characters in one line. Multiply this number by the number of lines in the manuscript to get the total character count.

$$\mathbf{A} \times \mathbf{B_1} \times \mathbf{B_2} = \mathbf{C}$$

| characters per inch | average line length | total manuscript lines | total manuscript characters |

For example, if line length is 6 inches and a one-inch segment has 10 characters, then each line has 60 characters. If the typewritten page is 30 lines long, each page has a total character count of 1800 characters. This count includes space between words and punctuation. If the manuscript has 8 pages with an average of 30 lines per page, then the total number of manuscript lines is 240. The complete manuscript has an approximate total character count of 14,400. As you can see a calculator is an indispensable aid for the copyfitter!

1	Count all of the characters in your typewritten manuscript, including all of the word spaces and punctuation.
2	Select the typeface and point size that you want to use.
3	Set the complete lowercase alhabet and measure it in points. Divide 342 by this number. This gives you the character per pica.
4	Multiply your line length by the character per pica number. This gives you the number of typeset characters per line.
5	Divide the total number of manuscript characters by the character per line. This gives you the total number of typeset lines.
6	Select the leading to determine page depth. Add leading or decrease line length to lengthen page. If page is too long, decrease leading or increase line length.

Copyfitting

Once you've determined the total number of characters in the typewritten manuscript, you need to know how much space they will occupy when typeset. This process requires three steps.

1.) Each typeface has a *character per pica* value. This will vary according to the typeface and point size. To determine a particular typeface's character per pica measurement, set the font's complete lowercase alphabet (from *a* to *z*) and measure the line length in points. Divide 342 by the length of your lowercase alphabet when set. The number you get is the character per pica for that typeface.

$$1. \quad 342 \div \underset{\substack{\text{lowercase} \\ \text{alphabet's line} \\ \text{length in points}}}{D} = \underset{\substack{\text{characters} \\ \text{per pica}}}{A_2}$$

For example, if 10-point Helvetica's lowercase alphabet is 130 points long when set, then $342 \div 130 = 2.63$. So this font has a character per pica measurement of 2.63.

2.) Next, you will need to determine the total characters per line for the typeface you have chosen. To do this, multiply the character per pica figure you just got by the average line length.

$$2. \quad \underset{\substack{\text{characters} \\ \text{per pica}}}{A_2} \times \underset{\substack{\text{average} \\ \text{line length}}}{B_1} = \underset{\substack{\text{characters} \\ \text{per line}}}{C_2}$$

If you decide to use a line length of 20 picas, at 20 picas × 2.63 you end up with 52.6 characters per line.

3.) Finally, you will need to figure the total lines needed for typeset copy. To do this, divide the total character count by the number of characters per line.

$$3. \quad \underset{\substack{\text{total} \\ \text{manuscript} \\ \text{characters}}}{C} \div \underset{\substack{\text{total} \\ \text{characters} \\ \text{per line}}}{C_2} = \underset{\substack{\text{total} \\ \text{number of} \\ \text{typeset lines}}}{T}$$

If your manuscript copy has 18,000 characters, divide it by 52.6, the number of characters per line: $18,000 \div 52.6 = 342.2$. The result tells you that your copy will set 343 20-pica lines of 10-point Helvetica type.

Column depth

To calculate column depth, add the amount of leading you want to use to the point size of your typeface. If you want to add 2 points of leading to 10-point Helvetica, you will arrive at a total of 12 points or 1 pica. Multiply this figure by the number of typeset

lines to get the total column depth for your typeset copy. Dealing in points can be cumbersome, so convert the points into picas (12 points = 1 pica) for clarity.

$$\mathbf{P_1} + \mathbf{P_2} \times \mathbf{T} = \mathbf{L}$$

typeface point size	leading	total typeset lines	total column depth

Calculating type size

Calculating type size is a useful skill when you have a manuscript that must fit into a given size. To figure out what type size to use in such circumstances, you will need to know what the character per pica size is. To do this, multiply the column depth in picas by the line length, also in picas. Then divide the total number of manuscript characters by this figure.

$$\mathbf{C} \div (\mathbf{L} \times \mathbf{B_1}) = \mathbf{A_2}$$

total manuscript characters	total column depth in picas	average line length in picas	characters per pica

For example, you want to use a 10-point typeface with 2 points leading, the line length is 23 picas, the column depth is 32 lines long (32 picas), and the manuscript has 1725 characters: $1725 \div (32 \times 23) = 2.34$ characters per pica. If 10-point Palatino has a character count per pica of 2.55 and 10-point Bookman has a character count per pica of 2.37, you might decide to set the type in Bookman.

Calculating manuscript characters

Occasionally you know the type specifications and need to write copy to fit a specific space. In this case you are looking for the total number of manuscript characters needed to fill the allotted space. The following formula will give you the answer.

$$\mathbf{A_2} \times \mathbf{B_1} \times \mathbf{L} = \mathbf{C}$$

characters per pica	average line length in picas	total column depth in picas	total manuscript characters

Proofreader's Marks

The reason for marking copy is to make design and editorial ideas clear to the typesetter. The marked manuscript is nothing more than an instruction sheet informing the typesetter precisely what should be done to the copy. You should be extremely legible and precise when writing these instructions.

Using a spell checker with a word processor does not guarantee an error-free manuscript. A spell checker only looks for words that are misspelled. It can't catch correctly spelled words that are inappropriately used or dropped words. The best way to minimize errors is to make sure copy is proofread by someone other than the typesetter. The designer, the proofreader, and the typesetter need to communicate which changes need to be made to the copy. Proofreader's marks, shown in the chart below, provide the basis for this communication.

Proofreader's Marks

Mark	Meaning	Example	Mark	Meaning	Example
/	lowercase	an idea who's Time has come	#	insert space	an idea who's timehas come
≡	capital	an idea who's time has come	e/	insert character	an ida who's time has come
U&lc	upper and lowercase	an idea who's time has come	⌒	close up	an idea w ho's time has come
——	italic	an idea who's time has come	℈	delete	an idea who's time hashas
bf	boldface	an idea who's time has come	eq #	equalize spacing	an idea who's time has come
bf ital	boldface italic	an idea who's time has come	☐	indent 1 em	☐ an idea who's time has come
℈	delete	an idea who's time has has come	☐☐	indent 2 ems	☐☐ an idea who's time has has
⋀	insert comma	Now an idea who's time has	¶	begin a paragraph	¶ An idea who's time has
stet	let it stand	an idea who's Time has come	tr	transpose letters	an idae who's time has come
wf	wrong font	an idea who's time has come	tr	transpose words	an idea who's has time come
‖	straighten line	an idea who's time has come	⊙	period	an idea who's time has come⊙
⊏	move left	an idea who's time has come	:/	colon	an idea who's time has come
⊐	move right	an idea who's time has come	⌄	apostrophe	an idea whos time has come
⊓	raise	an idea who's time has come	!/	exclamation	an idea who's time has come
⊔	lower	an idea who's time has come	/-/	hyphen	an idea who's time has come
ld>	add leading	an idea who's time has come	$\frac{1}{m}$	em dash	an idea who's time has come

Hidden Characters

The standard computer keyboard has forty-six keys. These keys are used to select commonly used letters or numbers. However, there are a number of special characters—such as legal symbols, typographer's punctuation marks, accent marks for foreign languages, etc.—built into most fonts. These special characters give typeset copy a professional look. You can't see these characters on the keyboard because they are hidden, but you can access them using different key combinations or commands.

Character sets vary among manufactures, so check before you buy a font to make sure it has the characters you want. These charts list the key combinations you need to call up special characters. One chart shows key combinations for the Macintosh and the other combinations for the Windows, Ventura, and IBM PC environments.

Macintosh

Á	Option-shift-y	ä	Option-u, a	¤	Option-shift-2	fl	Option-shift-6
À	Option-`, shift-a	ã	Option-n, a	¥	Option-y	Ø	Option-shift-o
Â	Option-shift-r	å	Option-a	£	Option-3	ø	Option-o
Ã	Option-n, shift-a	ç	Option-c	¢	Option-4	≤	Option-,
Ä	Option-u, shift-a	é	Option-e, e	∞	Option-5	≥	Option-.
Å	Option-shift-a	è	Option-`, e	§	Option-6	Δ	Option-j
Ç	Option-shift-c	ê	Option-i, e	¶	Option-7	Ω	Option-z
É	Option-e, shift-e	ë	Option-u, e	•	Option-8	Σ	Option-w
È	Option-shift-i	í	Option-e, i	ª	Option-9	Π	Option-shift-p
Ê	Option-shift-t	ì	Option-`, i	º	Option-0	π	Option-p
Ë	Option-shift-u	ï	Option-u, i	ß	Option-s	µ	Option-m
Í	Option-shift-s	ñ	Option-n, n	®	Option-r	∂	Option-d
Ì	Option-shift-g	ó	Option-e, o	©	Option-g	ı	Option-shift-b
Î	Option-shift-d	ò	Option-`, o	™	Option-2	^	Option-shift-n
Ï	Option-shift-f	ô	Option-i, o	◊	Option-shift-v	¯	Option-shift-,
Ñ	Option-n, shift-n	õ	Option-n, o	´	Option-e, spacebar	˘	Option-shift-.
Ó	Option-shift-h	ú	Option-e, u	¨	Option-u, spacebar	·	Option-h
Ò	Option-shift-l	ù	Option-`, u	≠	Option-=	"	Option-[
Ô	Option-shift-j	û	Option-i, u	≈	Option-x	"	Option-shift-[
Ö	Option-u, shift-o	ü	Option-u, u	√	Option-v	'	Option-]
Õ	Option-n, shift-o	ÿ	Option-u, y	ƒ	Option-f	'	Option-shift-]
Ú	Option-shift-;	Æ	Option-shift-'	¬	Option-l	°	Option-k
Ù	Option-shift-x	æ	Option-'	±	Option-shift-=	·	Option-shift-9
Û	Option-shift-z	Œ	Option-shift-q	∫	Option-b	✿	Option-shift-k
Ü	Option-u, shift-u	œ	Option-q	÷	Option-/		
Ÿ	Option-shift-'	†	Option-t	‰	Option-shift-e		
á	Option-e, a	‡	Option-shift-7	⁄	Option-shift-1		
à	Option-`, a	°	Option-shift-8	fi	Option-shift-5		

Hidden Characters

Windows

À	Alt-0-192	ü	Alt-0-252
Á	Alt-0-193	ÿ	Alt-0-255
Â	Alt-0-194	÷	Alt-0-247
Å	Alt-0-197	°	Alt-0-186
Ÿ	Alt-0-198	¤	Alt-0-164
Ç	Alt-0-199	¥	Alt-0-165
È	Alt-0-200	£	Alt-0-163
É	Alt-0-201	¢	Alt-0-162
Ê	Alt-0-202	§	Alt-0-167
Ë	Alt-0-203	©	Alt-0-169
Ñ	Alt-0-209	®	Alt-0-174
Ù	Alt-0-217	´	Alt-0-180
à	Alt-0-224	¶	Alt-0-182
ã	Alt-0-226	ß	Alt-0-223
å	Alt-0-229		
ç	Alt-0-231		
é	Alt-0-233		
è	Alt-0-232		
ê	Alt-0-234		
ë	Alt-0-235		
í	Alt-0-237		
ï	Alt-0-239		
ñ	Alt-0-241		
ó	Alt-0-243		
ô	Alt-0-244		
õ	Alt-0-245		
ù	Alt-0-249		
ú	Alt-0-250		
û	Alt-0-251		

IBM PC Commands

Ç	Alt-0-128
Ú	Alt-0-129
é	Alt-0-130
ä	Alt-0-132
à	Alt-0-133
å	Alt-0-134
Ç	Alt-0-135
ê	Alt-0-136
ë	Alt-0-137
è	Alt-0-138
ï	Alt-0-139
ì	Alt-0-141
Ä	Alt-0-142
Å	Alt-0-143
É	Alt-0-144
æ	Alt-0-145
Æ	Alt-0-146
ô	Alt-0-147
ò	Alt-0-149
^n	Alt-0-150
ù	Alt-0-151
ÿ	Alt-0-152
Ö	Alt-0-153
Ü	Alt-0-154
¢	Alt-0-155
£	Alt-0-156
¥	Alt-0-157
≥	Alt-0-253
¨	Alt-0-254

Ventura Commands

À	Alt-182	"	Shift-control-[
Á	Alt-199	-	Control-[
Â	Alt-200	—	Control-]
Å	Alt-143	…	Alt-193
à	Alt-133	†	Alt-187
á	Alt-160	‡	Alt-186
å	Alt-134	¶	Alt-188
Ç	Alt-128	§	Alt-185
ç	Alt-135	£	Alt-156
è	Alt-130	¥	Alt-157
ê	Alt-136	ƒ	Alt-159
ë	Alt-137		
È	Alt-201		
É	Alt-202		
Ë	Alt-203		
ñ	Alt-164		
Ñ	Alt-165		
ù	Alt-151		
Ù	Alt-213		
æ	Alt-145		
Æ	Alt-146		
œ	Alt-180		
Œ	Alt-181		
®	Shift-control-r		
©	Shift-control-c		
™	Shift-control-2		
•	Alt-195		
°	Alt-198		
"	Shift-control-]		

Glossary

Alignment Placement of type on a line or lines so that the base of each letter rests on the same line (i.e., base aligning). Also arranging type so that the ends of all lines are even (flush left, flush right).

Alterations Changes made to the original copy after it has been typeset.

Arabic numerals Numerals that originated in Arabia; numbers 1 through 9 and 0.

Ascender The stroke of a letter such as *d* or *h* that extends above the body of the letter.

ASCII (American Standard Code for Information Interchange) A numbering system used by computers to denote character and control commands.

Baseline Imaginary horizontal line on which all letters in a given line of type rest.

Bit-mapped Grid of dots (or pixels) that makes up characters or graphics on a computer screen.

Bleed Artwork, color areas, and photographs that extend beyond the edge of the page.

Body type (also called **body copy**) Type used for the main text or reading matter. Usually set in less than 14-point type.

Boldface Heavy form of a typeface used for emphasis.

Built-in font Set of characters permanently in a printer's memory.

Bulk Thickness of printing paper, measured in pages per inch (ppi).

C. & s.c. See entry for Caps and small caps.

Calligraphy Flowering handwriting or the art of producing such handwriting.

Cap height Height of a face's capital letter. This height is shorter than the ascenders in some faces.

Capitals Capital letters of the alphabet, also known as caps or uppercase.

Caps and small caps Alphabet of capital letters that are the same size as the x-height or body of the lowercase letters of a given typeface.

Casting off Another term for copyfitting.

Centered type Line of type placed in the middle of the line measure, set with equal space on either side.

Cold type Term used to describe typesetting by means other than casting hot metal, which is sometimes referred to as hot type. It is generally thought of as typewriter or strike-on composition rather than phototypesetting. Do not use as a synonym for phototypesetting.

Compositor Person who sets or composes type.

Condensed type Narrow version of a typeface.

Copyfitting Calculating how much space the manuscript will occupy after it has been typeset in a given typeface and line length.

Counter (or **counterform**) The space surrounded by closed letters such as *a* or *b*.

Cursives Typefaces with rounded angles that look like handwriting although the letters do not touch. Similar to unical letters.

Data Term used to describe information used as input or output coming from a computer.

Descender The stroke of the lowercase letter that falls below the body of the character, as in, *j, g, p,* and *y.*

Digital computer Computer that uses arithmetic and logical processes on data, resulting in representative and processed information consisting of concise, well-defined, or discrete data. Opposite of an analog computer.

Dingbats Ornamental typographical elements used for decorative touches, such as stars and arrows.

Display type Type used for emphasis, 18 point or larger.

DPI (dots per inch) The resolution of a computer screen or an output device, such as a laser printer or imagesetter.

Downloadable font Font that can be temporarily stored in a printer's memory and then removed when the job is done.

Drop cap Large decorative capital letter placed at the beginning of a paragraph that drops into the surrounding text. Used for emphasis.

Dummy Preview of the final piece to be printed.

Elite Typewriter type that equals 12 characters per inch. This is the smallest of the typewriter type sizes.

Em Square (four equal sides) of the body of any size type: 12 points wide for 12-point type, and so on.

En One-half the width of an em.

Extended type Widened version of a given typeface.

Face Top part of the metal type, the part that prints the image. Also the style or distinguishing feature of the typeface.

Family Group of related typefonts, type sizes, and styles, all in one particular typeface. A typical family includes roman, bold, italic, and bold italic fonts.

Folio Number on a page. Also a reference to a piece of paper folded once.

Font Entire assortment of a typeface in one size, style, and face including upper- and lowercase letters, numerals, punctuation marks.

Galley proof Copy of the typeset material, usually not fully assembled, allowing the client to preview the job before it is finished.

GIGO Garbage in, garbage out. Programming slang meaning that bad input produces bad output.

Grotesque Constant or uniform letters or type without serifs. Also sans serif.

Haberule Ruler for measuring type.

Hairline rule Thinnest rule that can be printed.

Hardware Computer equipment, excluding manuals and programs.

Head Top of the page of a book.

Heading Type that is most emphasized—not the body copy. Usually set bold in 18-point type or greater.

Head margin White space at the top of a text type page.

Imagesetter High-end printers that output computer-generated type and images at up to 2400 dpi.

Imposition Positioning of pages in a press form so that they fall in correct order when the printed press-sheet is folded and trimmed.

Initial cap Large, often decorative capital letter placed at the beginning of a chapter, paragraph, or section.

Input In computer typesetting, information entered into a computer.

Italic Slanted or tilted letterforms.

Justification Spacing type in a given measure so that lines of type are uniform in length.

Kerning Adjusting spaces between letters.

Leading Inserting space between lines of type.

Light face Lightest or thinnest letterforms of a typeface.

Lowercase Small forms of letters, such as *a, b, c*; opposite of capitals.

Margin Space left around the type area of a page—top, bottom, and sides.

Measure Width of a column of typeset copy.

Monospaced type All characters of a typeface having the same width, such as in a typewriter face.

Oblique Roman characters slanted to the right.

Outline font Computerized font made up of Bézier curves, which can be scaled to any size. Since these fonts are scalable, only one set of outlines needs to be created for a given typeface.

Output In computer typesetting, type printed by a printer.

Pagination Sequence of consecutive numbers assigned to pages.

Pica Typographic unit of measure: one pica equals 12 points (approximately 1/72 inch). Also, on a Pica typewriter, 10 characters fit into one inch.

Pixel Square dot, the smallest unit displayed on a computer screen. Select pixels are turned on or off to create characters or graphics on the monitor.

Point Typographic unit of measure; 12 points equal 1 pica and 1 point equals 1/72 inch.

PostScript Page description language developed by Adobe Systems to describe text and graphics. PostScript is built into numerous laser printers and imagesetters.

Printer fonts Set of scalable outlines for a given character set used by laser printers and imagesetters to output type.

Proportionally spaced type Type in which character widths vary according to the actual width of the character. An *i* is narrower than an *m,* for example.

Proofs Printed material that is checked against the final manuscript.

Ragged Uneven lines of copy; unjustified type.

Recto Right-hand page of a document. Recto pages always carry uneven page numbers or folios.

Reverse type White characters on a dark background.

RIP (Raster Image Processor) Device that converts computer instructions into bit maps that are output by a printer or imagesetter.

Roman Upright letters; the opposite of tilted or italic letters.

Rule Continuous vertical or horizontal line.

Sans serif Type without serifs at the ends of strokes.

Script type Type that has the appearance of handwriting.

Serifs Fine cross-strokes in the letterforms of some typefaces.

Software Another name for computer programs.

Solid Lines of type that have been set with no leading between them.

Space Area left open around type.

Swash letters Italic capital letterforms with long tails and flourishes.

Text Words set in a book or on a page.

Text type Type used for the body of the text, usually 14-point type or smaller.

Tracking Overall letterspacing in a block of text.

Trim size Size of a book or page after it has been printed and cut to size.

Type family Entire range of typeface designs, including all the variations of one basic style of alphabet; usually includes roman, italic, and bold.

Typography Art of arranging type.

Uppercase Capital letters.

Verso Left-hand page of a document. Verso pages always carry even page numbers or folios.

Weight Variations in the width of a typeface's strokes. These can include light, regular, demibold or semibold, and bold and ultrabold.

Word space Space between words.

X-height Height of the body of the lowercase letters, not counting the ascenders or descenders.

X-line Line that marks the top of the main body of lowercase letters.

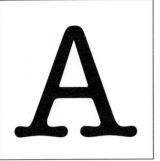

ITC American Typewriter Medium 72 point

ABCDEFGHIJK
LMNOPQRSTUV
WXYZabcdefghi
jklmnopqrstuvw
xyz1234567890
?!&&$%#@*"":;.,

ITC American Typewriter Medium 10 point

ABCDEFGHIJKLMNOPQRSTUVWXYZ abcdefghij
klmnopqrstuvwxyz 1234567890 ?!/&$%#@*""":;.,

ITC American Typewriter Medium 12 point

ABCDEFGHIJKLMNOPQRSTUVWXYZ abcdefghij
klmnopqrstuvwxyz 1234567890 ?!/&$%#@*""":;.,

ITC American Typewriter Medium 13 point

ABCDEFGHIJKLMNOPQRSTUVWXYZ abcdefghij
klmnopqrstuvwxyz 1234567890 ?!/&$%#@*""":;.,

ITC American Typewriter Medium 14 point

ABCDEFGHIJKLMNOPQRSTUVWXYZ abcdefghij
klmnopqrstuvwxyz 1234567890 ?!/&$%#@*""":;.,

ITC American Typewriter Medium 16 point

ABCDEFGHIJKLMNOPQRSTUVWXYZ abcdefghij
klmnopqrstuvwxyz 1234567890 ?!/&$%#@*""":;.,

ITC American Typewriter Medium 18 point

ABCDEFGHIJKLMNOPQRSTUVWXYZ abcdefghij
klmnopqrstuvwxyz 1234567890 ?!/&$%#@*""":;.,

ITC American Typewriter Medium 20 point

ABCDEFGHIJKLMNOPQRSTUVWXYZ abcdefghij
klmnopqrstuvwxyz 1234567890 ?!/&$%#@*""":;.,

ITC American Typewriter Medium 22 point

ABCDEFGHIJKLMNOPQRSTUVWXYZ abcdefghij
klmnopqrstuvwxyz1234567890 ?!/&$%#@*""":;.,

6/8 ITC American Typewriter Medium

It was the best of times, it was the worst of times, it was the age of wisdom, it was the age of foolishness, it was the epoch of belief, it was the epoch of incredulity, it was the season of light, it was the season of darkness, it was the spring of hope, it was the winter of despair, we had everything before us, we had nothing before us, we were all going direct to Heaven, we were all going direct the other way-in short, the period was so far like the present period,

8/10 ITC American Typewriter Medium

It was the best of times, it was the worst of times, it was the age of wisdom, it was the age of foolishness, it was the epoch of belief, it was the epoch of incredulity, it was the season of light, it was the season of darkness, it was the spring of hope, it was the winter of despair, we had everything before us, we had nothing before us, we were all going

9/10 ITC American Typewriter Medium

It was the best of times, it was the worst of times, it was the age of wisdom, it was the age of foolishness, it was the epoch of belief, it was the epoch of incredulity, it was the season of light, it was the season of darkness, it was the spring of hope, it was the winter of despair, we had everything before us, we

9/11 ITC American Typewriter Medium

It was the best of times, it was the worst of times, it was the age of wisdom, it was the age of foolishness, it was the epoch of belief, it was the epoch of incredulity, it was the season of light, it was the season of darkness, it was the spring of hope, it was the winter of despair, we had everything before us, we

10/11 ITC American Typewriter Medium

It was the best of times, it was the worst of times, it was the age of wisdom, it was the age of foolishness, it was the epoch of belief, it was the epoch of incredulity, it was the season of light, it was the season of darkness, it was the spring of hope, it was the winter of despair, we had everything before us, we

10/12 ITC American Typewriter Medium

It was the best of times, it was the worst of times, it was the age of wisdom, it was the age of foolishness, it was the epoch of belief, it was the epoch of incredulity, it was the season of light, it was the season of darkness, it was the spring of hope, it was the winter of despair, we had everything before us, we

11/13 ITC American Typewriter Medium

It was the best of times, it was the worst of times, it was the age of wisdom, it was the age of foolishness, it was the epoch of belief, it was the epoch of incredulity, it was the season of light, it was the season of darkness, it was the spring of hope,

11/14 ITC American Typewriter Medium

It was the best of times, it was the worst of times, it was the age of wisdom, it was the age of foolishness, it was the epoch of belief, it was the epoch of incredulity, it was the season of light, it was the season of darkness, it was the spring of hope,

12/13 ITC American Typewriter Medium

It was the best of times, it was the worst of times, it was the age of wisdom, it was the age of foolishness, it was the epoch of belief, it was the epoch of incredulity, it was the season of light, it was the season of darkness, it was the

12/14 ITC American Typewriter Medium

It was the best of times, it was the worst of times, it was the age of wisdom, it was the age of foolishness, it was the epoch of belief, it was the epoch of incredulity, it was the season of light, it was the season of darkness, it was the

13/15 ITC American Typewriter Medium

It was the best of times, it was the worst of times, it was the age of wisdom, it was the age of foolishness, it was the epoch of belief, it was the epoch of incredulity, it was the season of light, it was the season of dark-

14/15 ITC American Typewriter Medium

It was the best of times, it was the worst of times, it was the age of wisdom, it was the age of foolishness, it was the epoch of belief, it was the epoch of incredulity, it was the season of light, it was the season

14/15 ITC American Typewriter Medium

It was the best of times, it was the worst of times, it was the age of wisdom, it was the age of foolishness, it was the epoch of belief, it was the epoch of incredulity, it was the season of light, it was the season

ITC American Typewriter Bold 72 point

ABCDEFGHIJK
LMNOPQRSTU
VWXYZ abcdef
ghijklmnopqrst
uvwxyz 123456
7890?!&$%@:;.,

ITC American Typewriter Bold 10 point

**ABCDEFGHIJKLMNOPQRSTUVWXYZ abcdefghij
klmnopqrstuvwxyz 1234567890 ?!/&$%#@*""":;.,**

ITC American Typewriter Bold 12 point

**ABCDEFGHIJKLMNOPQRSTUVWXYZ abcdefghij
klmnopqrstuvwxyz 1234567890 ?!/&$%#@*""":;.,**

ITC American Typewriter Bold 13 point

**ABCDEFGHIJKLMNOPQRSTUVWXYZ abcdefghij
klmnopqrstuvwxyz 1234567890 ?!/&$%#@*""":;.,**

ITC American Typewriter Bold 14 point

**ABCDEFGHIJKLMNOPQRSTUVWXYZ abcdefghij
klmnopqrstuvwxyz 1234567890 ?!/&$%#@*""":;.,**

ITC American Typewriter Bold 16 point

**ABCDEFGHIJKLMNOPQRSTUVWXYZ abcdefghij
klmnopqrstuvwxyz 1234567890 ?!/&$%#@*""":;.,**

ITC American Typewriter Bold 18 point

**ABCDEFGHIJKLMNOPQRSTUVWXYZ abcdefghij
klmnopqrstuvwxyz 1234567890 ?!/&$%#@*""":;.,**

ITC American Typewriter Bold 20 point

**ABCDEFGHIJKLMNOPQRSTUVWXYZ abcdefghij
klmnopqrstuvwxyz 1234567890 ?!/&$%#@*""":;.,**

ITC American Typewriter Bold 22 point

**ABCDEFGHIJKLMNOPQRSTUVWXYZ abcdefghij
klmnopqrstuvwxyz 1234567890?!/&$%#@*""":;.,**

6/8 ITC American Typewriter Bold

It was the best of times, it was the worst of times, it was the age of wisdom, it was the age of foolishness, it was the epoch of belief, it was the epoch of incredulity, it was the season of light, it was the season of darkness, it was the spring of hope, it was the winter of despair, we had everything before us, we had nothing before us, we were all going direct to Heaven, we were all going direct the other way-in short, the period was so far like the

8/10 ITC American Typewriter Bold

It was the best of times, it was the worst of times, it was the age of wisdom, it was the age of foolishness, it was the epoch of belief, it was the epoch of incredulity, it was the season of light, it was the season of darkness, it was the spring of hope, it was the winter of despair, we had everything before us, we had nothing before us, we were all

9/10 ITC American Typewriter Bold

It was the best of times, it was the worst of times, it was the age of wisdom, it was the age of foolishness, it was the epoch of belief, it was the epoch of incredulity, it was the season of light, it was the season of darkness, it was the spring of hope, it was the winter of despair, we had everything before us, we

9/11 ITC American Typewriter Bold

It was the best of times, it was the worst of times, it was the age of wisdom, it was the age of foolishness, it was the epoch of belief, it was the epoch of incredulity, it was the season of light, it was the season of darkness, it was the spring of hope, it was the winter of despair, we had everything before us, we

10/11 ITC American Typewriter Bold

It was the best of times, it was the worst of times, it was the age of wisdom, it was the age of foolishness, it was the epoch of belief, it was the epoch of incredulity, it was the season of light, it was the season of darkness, it was the spring of hope, it was

10/12 ITC American Typewriter Bold

It was the best of times, it was the worst of times, it was the age of wisdom, it was the age of foolishness, it was the epoch of belief, it was the epoch of incredulity, it was the season of light, it was the season of darkness, it was the spring of hope, it was

11/13 ITC American Typewriter Bold

It was the best of times, it was the worst of times, it was the age of wisdom, it was the age of foolishness, it was the epoch of belief, it was the epoch of incredulity, it was the season of light, it was the season of darkness, it was the spring of hope, it was

11/14 ITC American Typewriter Bold

It was the best of times, it was the worst of times, it was the age of wisdom, it was the age of foolishness, it was the epoch of belief, it was the epoch of incredulity, it was the season of light, it was the season of darkness, it was the spring of hope, it was

12/13 ITC American Typewriter Bold

It was the best of times, it was the worst of times, it was the age of wisdom, it was the age of foolishness, it was the epoch of belief, it was the epoch of incredulity, it was the season of light, it was the season of darkness, it was the

12/14 ITC American Typewriter Bold

It was the best of times, it was the worst of times, it was the age of wisdom, it was the age of foolishness, it was the epoch of belief, it was the epoch of incredulity, it was the season of light, it was the season of darkness, it was the

13/15 ITC American Typewriter Bold

It was the best of times, it was the worst of times, it was the age of wisdom, it was the age of foolishness, it was the epoch of belief, it was the epoch of incredulity, it was the season of light, it was the season of dark

14/15 ITC American Typewriter Bold

It was the best of times, it was the worst of times, it was the age of wisdom, it was the age of foolishness, it was the epoch of belief, it was the epoch of incredulity, it was the season of light, it was the

14/16 ITC American Typewriter Bold

It was the best of times, it was the worst of times, it was the age of wisdom, it was the age of foolishness, it was the epoch of belief, it was the epoch of incredulity, it was the season of light, it was the

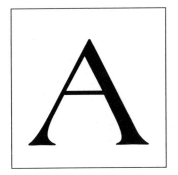

Americana 72 Point

ABCDEFGHIJKL
MNOPQRSTUV
WXYZabcdefghi
jklmnopqrstuvw
xyz 1234567890
?!/&$%#@*""":;.,

Americana 11 point

ABCDEFGHIJKLMNOPQRSTUVWXYZ abcdefghij
klmnopqrstuvwxyz 1234567890 ?!/&$%#@*""":;.,

Americana 12 point

ABCDEFGHIJKLMNOPQRSTUVWXYZ abcdefghij
klmnopqrstuvwxyz 1234567890 ?!/&$%#@*""":;.,

Americana 13 point

ABCDEFGHIJKLMNOPQRSTUVWXYZ abcdefghij
klmnopqrstuvwxyz 1234567890 ?!/&$%#@*""":;.,

Americana 14 point

ABCDEFGHIJKLMNOPQRSTUVWXYZ abcdefghij
klmnopqrstuvwxyz 1234567890 ?!/&$%#@*""":;.,

Americana 16 point

ABCDEFGHIJKLMNOPQRSTUVWXYZ abcdefghij
klmnopqrstuvwxyz 1234567890 ?!/&$%#@*""":;.,

Americana 18 point

ABCDEFGHIJKLMNOPQRSTUVWXYZ abcdefghij
klmnopqrstuvwxyz 1234567890 ?!/&$%#@*""":;.,

Americana 20 point

ABCDEFGHIJKLMNOPQRSTUVWXYZ abcdefghij
klmnopqrstuvwxyz 1234567890 ?!/&$%#@*""":;.,

Americana 22 point

ABCDEFGHIJKLMNOPQRSTUVWXYZ abcdefghij
klmnopqrstuvwxyz 1234567890 ?!/&$%#@*""":;.,

6/8 Americana

It was the best of times, it was the worst of times, it was the age of wisdom, it was the age of foolishness, it was the epoch of belief, it was the epoch of incredulity, it was the season of light, it was the season of darkness, it was the spring of hope, it was the winter of despair, we had everything before us, we had nothing before us, we were all going direct to Heaven, we were all going direct the other way-in short, the period was so far like the present period, that some

8/10 Americana

It was the best of times, it was the worst of times, it was the age of wisdom, it was the age of foolishness, it was the epoch of belief, it was the epoch of incredulity, it was the season of light, it was the season of darkness, it was the spring of hope, it was the winter of despair, we had everything before us, we had nothing before us, we

9/10 Americana

It was the best of times, it was the worst of times, it was the age of wisdom, it was the age of foolishness, it was the epoch of belief, it was the epoch of incredulity, it was the season of light, it was the season of darkness, it was the spring of hope, it was the winter of despair, we had everything before us, we

9/11 Americana

It was the best of times, it was the worst of times, it was the age of wisdom, it was the age of foolishness, it was the epoch of belief, it was the epoch of incredulity, it was the season of light, it was the season of darkness, it was the spring of hope, it was the winter of despair, we had everything before us, we

10/11 Americana

It was the best of times, it was the worst of times, it was the age of wisdom, it was the age of foolishness, it was the epoch of belief, it was the epoch of incredulity, it was the season of light, it was the season of darkness, it was the spring of hope, it was

10/12 Americana

It was the best of times, it was the worst of times, it was the age of wisdom, it was the age of foolishness, it was the epoch of belief, it was the epoch of incredulity, it was the season of light, it was the season of darkness, it was the spring of hope, it was

11/13 Americana

It was the best of times, it was the worst of times, it was the age of wisdom, it was the age of foolishness, it was the epoch of belief, it was the epoch of incredulity, it was the season of light, it was the season of darkness, it was the spring of hope, it was the winter of despair

11/14 Americana

It was the best of times, it was the worst of times, it was the age of wisdom, it was the age of foolishness, it was the epoch of belief, it was the epoch of incredulity, it was the season of light, it was the season of darkness, it was the spring of hope, it was the winter of despair

12/13 Americana

It was the best of times, it was the worst of times, it was the age of wisdom, it was the age of foolishness, it was the epoch of belief, it was the epoch of incredulity, it was the season of light, it was the season of darkness, it was the

12/14 Americana

It was the best of times, it was the worst of times, it was the age of wisdom, it was the age of foolishness, it was the epoch of belief, it was the epoch of incredulity, it was the season of light, it was the season of darkness, it was the

13/15 Americana

It was the best of times, it was the worst of times, it was the age of wisdom, it was the age of foolishness, it was the epoch of belief, it was the epoch of incredulity, it was the season of light, it was the season of darkness, it was the

14/15 Americana

It was the best of times, it was the worst of times, it was the age of wisdom, it was the age of foolishness, it was the epoch of belief, it was the epoch of incredulity, it was the season of light, it was the season

14/16 Americana

It was the best of times, it was the worst of times, it was the age of wisdom, it was the age of foolishness, it was the epoch of belief, it was the epoch of incredulity, it was the season of light, it was the season

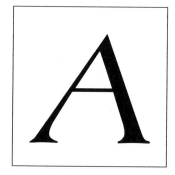

Americana Italic 72 point

ABCDEFGHIJKL
MNOPQRSTUV
WXYZabcdefghij
klmnopqrstuvw
xyz1234567890
?!&$%#@*""·,·,

Americana Italic 11 point

*ABCDEFGHIJKLMNOPQRSTUVWXYZ abcdefghij
klmnopqrstuvwxyz 1234567890 ?!/&$%#@*"":;.,*

Americana Italic 12 point

*ABCDEFGHIJKLMNOPQRSTUVWXYZ abcdefghij
klmnopqrstuvwxyz 1234567890 ?!/&$%#@*"":;.,*

Americana Italic 13 points

*ABCDEFGHIJKLMNOPQRSTUVWXYZ abcdefghij
klmnopqrstuvwxyz 1234567890 ?!/&$%#@*"":;.,*

Americana Italic 14 point

*ABCDEFGHIJKLMNOPQRSTUVWXYZ abcdefghij
klmnopqrstuvwxyz 1234567890 ?!/&$%#@*"":;.,*

Americana Italic 16 point

*ABCDEFGHIJKLMNOPQRSTUVWXYZ abcdefghij
klmnopqrstuvwxyz 1234567890 ?!/&$%#@*"":;.,*

Americana Italic 18 point

*ABCDEFGHIJKLMNOPQRSTUVWXYZ abcdefghij
klmnopqrstuvwxyz 1234567890 ?!/&$%#@*"":;.,*

Americana Italic 20 point

*ABCDEFGHIJKLMNOPQRSTUVWXYZ abcdefghij
klmnopqrstuvwxyz 1234567890 ?!/&$%#@*"":;.,*

Americana Italic 22 point

*ABCDEFGHIJKLMNOPQRSTUVWXYZ abcdefghij
klmnopqrstuvwxyz 1234567890 ?!/&$%#@*"":;.,*

6/8 Americana Italic

It was the best of times, it was the worst of times, it was the age of wisdom, it was the age of foolishness, it was the epoch of belief, it was the epoch of incredulity, it was the season of light, it was the season of darkness, it was the spring of hope, it was the winter of despair, we had everything before us, we had nothing before us, we were all going direct to Heaven, we were all going direct the other way-in short, the period was so far like the present period,

8/10 Americana Italic

It was the best of times, it was the worst of times, it was the age of wisdom, it was the age of foolishness, it was the epoch of belief, it was the epoch of incredulity, it was the season of light, it was the season of darkness, it was the spring of hope, it was the winter of despair, we had everything before us, we had nothing before us, we were all going

9/10 Americana Italic

It was the best of times, it was the worst of times, it was the age of wisdom, it was the age of foolishness, it was the epoch of belief, it was the epoch of incredulity, it was the season of light, it was the season of darkness, it was the spring of hope, it was the winter of despair, we had everything before us, we had nothing before us,

9/11 Americana Italic

It was the best of times, it was the worst of times, it was the age of wisdom, it was the age of foolishness, it was the epoch of belief, it was the epoch of incredulity, it was the season of light, it was the season of darkness, it was the spring of hope, it was the winter of despair, we had everything before us, we had nothing before us,

10/11 Americana Italic

It was the best of time, it was the worst of times, it was the age of wisdom, it was the age of foolishness, it was the epoch of belief, it was the epoch of incredulity, it was the season of light, it was the season of darkness, it was the spring of hope, it was

10/12 Americana Italic

It was the best of times, it was the worst of times, it was the age of wisdom, it was the age of foolishness, it was the epoch of belief, it was the epoch of incredulity, it was the season of light, it was the season of darkness, it was the spring of hope, it was

11/13 Americana Italic

It was the best of times, it was the worst of times, it was the age of wisdom, it was the age of foolishness, it was the epoch of belief, it was the epoch of incredulity, it was the season of light, it was the season of darkness, it was the spring of hope, it was the winter of despair

11/14 Americana Italic

It was the best of times, it was the worst of times, it was the age of wisdom, it was the age of foolishness, it was the epoch of belief, it was the epoch of incredulity, it was the season of light, it was the season of darkness, it was the spring of hope, it was the winter of despair

12/13 Americana Italic

It was the best of times, it was the worst of times, it was the age of wisdom, it was the age of foolishness, it was the epoch of belief, it was the epoch of incredulity, it was the season of light, it was the season of darkness, it was the spring of

12/14 Americana Italic

It was the best of times, it was the worst of times, it was the age of wisdom, it was the age of foolishness, it was the epoch of belief, it was the epoch of incredulity, it was the season of light, it was the season of darkness, it was the spring of

13/15 Americana Italic

It was the best of times, it was the worst of times, it was the age of wisdom, it was the age of foolishness, it was the epoch of belief, it was the epoch of incredulity, it was the season of light, it was the season of dark-

14/15 Americana Italic

It was the best of times, it was the worst of times, it was the age of wisdom, it was the age of foolishness, it was the epoch of belief, it was the epoch of incredulity, it was the season of light, it was the season

14/16 Americana Italic

It was the best of times, it was the worst of times, it was the age of wisdom, it was the age of foolishness, it was the epoch of belief, it was the epoch of incredulity, it was the season of light, it was the season

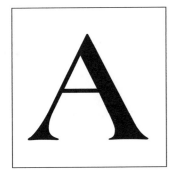

Americana Bold 72 point

ABCDEFGHIJK
LMNOPQRSTUV
WXYZabcdefghi
jklmnopqrstuvw
xyz1234567890
?!/&$%#@*"":;.,

Americana Bold 24 point

ABCDEFGHIJKLMNOPQRSTUVWXYZ abcd
efghijklmnopqrstuvwxyz 1234567890 !?%&

Americana Bold 30 point

ABCDEFGHIJKLMNOPQRSTUVWXYZ
abcdefghijklmnopqrstuvwxyz 12345

Americana Bold 36 point

ABCDEFGHIJKLMNOPQRSTUV
abcdefghijklmnopqrst 123456

Americana Bold 48 point

ABCDEFGHIJKLMNOPQ
abcdefghijklmnopq 123

Americana Bold 60 point

ABCDEFGHIJKLMN
abcdefghijklmn 123

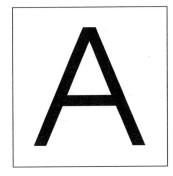

ITC Avant Garde Gothic Book 72 Point

ABCDEFGHIJKLM
NOPQRSTUVWX
YZ abcdefghijklm
nopqrstuvwxyz
1234567890
?!/&$%#@*""":;.,

ITC Avant Garde Gothic Book 10 point

ABCDEFGHIJKLMNOPQRSTUVWXYZ abcdefghij
klmnopqrstuvwxyz 1234567890 ?!/&$%#@*"":;.,

ITC Avant Garde Gothic Book 12 point

ABCDEFGHIJKLMNOPQRSTUVWXYZ abcdefghij
klmnopqrstuvwxyz 1234567890 ?!/&$%#@*"":;.,

ITC Avant Garde Gothic Book 13 point

ABCDEFGHIJKLMNOPQRSTUVWXYZ abcdefghij
klmnopqrstuvwxyz 1234567890 ?!/&$%#@*"":;.,

ITC Avant Garde Gothic Book 14 point

ABCDEFGHIJKLMNOPQRSTUVWXYZ abcdefghij
klmnopqrstuvwxyz 1234567890 ?!/&$%#@*"":;.,

ITC Avant Garde Gothic Book 16 point

ABCDEFGHIJKLMNOPQRSTUVWXYZ abcdefghij
klmnopqrstuvwxyz 1234567890 ?!/&$%#@*"":;.,

ITC Avant Garde Gothic Book 18 point

ABCDEFGHIJKLMNOPQRSTUVWXYZ abcdefghij
klmnopqrstuvwxyz 1234567890 ?!/&$%#@*"":;.,

ITC Avant Garde Gothic Book 20 point

ABCDEFGHIJKLMNOPQRSTUVWXYZ abcdefghij
klmnopqrstuvwxyz 1234567890 ?!/&$%#@*"":;.,

ITC Avant Garde Gothic Book 22 point

ABCDEFGHIJKLMNOPQRSTUVWXYZ abcdefghij
klmnopqrstuvwxyz 1234567890 ?!/&$%#@*"":;.,

ITC Avant Garde Gothic Book 24 point

ABCDEFGHIJKLMNOPQRSTUVWXYZ
abcdefghijklmnopqrstuvwxyz 1234567890 !?%&*

ITC Avant Garde Gothic Book 30 point

ABCDEFGHIJKLMNOPQRSTUVWXYZ
abcdefghijklmnopqrstuvwxyz 12345678

ITC Avant Garde Gothic Book 36 point

ABCDEFGHIJKLMNOPQRSTUVWX
abcdefghijklmnopqrstuvwxyz 12

ITC Avant Garde Gothic Book 48 point

ABCDEFGHIJKLMNOPQR
abcdefghijklmnopqrst 12

ITC Avant Garde Gothic Book 60 point

ABCDEFGHIJKLMNO
abcdefghijklmnop 12

6/8 ITC Avant Garde Gothic Book

It was the best of times, it was the worst of times, it was the age of wisdom, it was the age of foolishness, it was the epoch of belief, it was the epoch of incredulity, it was the season of light, it was the season of darkness, it was the spring of hope, it was the winter of despair, we had everything before us, we had nothing before us, we were all going direct to Heaven, we were all going direct the other way—in short, the period was so far like the present period, that some of its noisiest authorities insisted on

8/10 ITC Avant Garde Gothic Book

It was the best of times, it was the worst of times, it was the age of wisdom, it was the age of foolishness, it was the epoch of belief, it was the epoch of incredulity, it was the season of light, it was the season of darkness, it was the spring of hope, it was the winter of despair, we had everything before us, we had nothing before us, we were all going direct to Heaven, we were

9/10 ITC Avant Garde Gothic Book

It was the best of times, it was the worst of times, it was the age of wisdom, it was the age of foolishness, it was the epoch of belief, it was the epoch of incredulity, it was the season of light, it was the season of darkness, it was the spring of hope, it was the winter of despair, we had everything before us, we had nothing before us,

9/11 ITC Avant Garde Gothic Book

It was the best of times, it was the worst of times, it was the age of wisdom, it was the age of foolishness, it was the epoch of belief, it was the epoch of incredulity, it was the season of light, it was the season of darkness, it was the spring of hope, it was the winter of despair, we had everything before us, we had nothing before us,

10/11 ITC Avant Garde Gothic Book

It was the best of times, it was the worst of times, it was the age of wisdom, it was the age of foolishness, it was the epoch of belief, it was the epoch of incredulity, it was the season of light, it was the season of darkness, it was the spring of hope, it was the winter of despair, we had everything before us, we had nothing before us, we

10/12 ITC Avant Garde Gothic Book

It was the best of times, it was the worst of times, it was the age of wisdom, it was the age of foolishness, it was the epoch of belief, it was the epoch of incredulity, it was the season of light, it was the season of darkness, it was the spring of hope, it was the winter of despair, we had everything before us, we had

11/13 ITC Avant Garde Gothic Book

It was the best of times, it was the worst of times, it was the age of wisdom, it was the age of foolishness, it was the epoch of belief, it was the epoch of incredulity, it was the season of light, it was the season of darkness, it was the spring of hope, it was the winter of despair, we

11/14 ITC Avant Garde Gothic Book

It was the best of times, it was the worst of times, it was the age of wisdom, it was the age of foolishness, it was the epoch of belief, it was the epoch of incredulity, it was the season of light, it was the season of darkness, it was the spring of hope, it was the winter of despair, we

12/13 ITC Avant Garde Gothic Book

It was the best of times, it was the worst of times, it was the age of wisdom, it was the age of foolishness, it was the epoch of belief, it was the epoch of incredulity, it was the season of light, it was the season of darkness, it was the spring of hope, it

12/14 ITC Avant Garde Gothic Book

It was the best of times, it was the worst of times, it was the age of wisdom, it was the age of foolishness, it was the epoch of belief, it was the epoch of incredulity, it was the season of light, it was the season of darkness, it was the spring of hope, it

13/15 ITC Avant Garde Gothic Book

It was the best of times, it was the worst of times, it was the age of wisdom, it was the age of foolishness, it was the epoch of belief, it was the epoch of incredulity, it was the season of light, it was the season of darkness, it was the

14/15 ITC Avant Garde Gothic Book

It was the best of times, it was the worst of times, it was the age of wisdom, it was the age of foolishness, it was the epoch of belief, it was the epoch of incredulity, it was the season of light, it was the season of darkness,

14/16 ITC Avant Garde Gothic Book

It was the best of times, it was the worst of times, it was the age of wisdom, it was the age of foolishness, it was the epoch of belief, it was the epoch of incredulity, it was the season of light, it was the season of darkness,

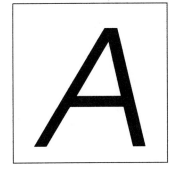

ITC Avant Garde Gothic Book Oblique 72 point

ABCDEFGHIJKLM
NOPQRSTUVWX
YZ abcdefghijkl
mnopqrstuvwx
yz1234567890
?!&$$%#@""";;,,*

ITC Avant Garde Gothic Book Oblique 10 point

*ABCDEFGHIJKLMNOPQRSTUVWXYZ abcdefghij
klmnopqrstuvwxyz 1234567890 ?!/&$%#@*""";;.,*

ITC Avant Garde Gothic Book Oblique 12 point

*ABCDEFGHIJKLMNOPQRSTUVWXYZ abcdefghij
klmnopqrstuvwxyz 1234567890 ?!/&$%#@*""";;.,*

ITC Avant Garde Gothic Book Oblique 13 point

*ABCDEFGHIJKLMNOPQRSTUVWXYZ abcdefghij
klmnopqrstuvwxyz 1234567890 ?!/&$%#@*""";;.,*

ITC Avant Garde Gothic Book Oblique 14 point

*ABCDEFGHIJKLMNOPQRSTUVWXYZ abcdefghij
klmnopqrstuvwxyz 1234567890 ?!/&$%#@*""";;.,*

ITC Avant Garde Gothic Book Oblique 16 point

*ABCDEFGHIJKLMNOPQRSTUVWXYZ abcdefghij
klmnopqrstuvwxyz 1234567890 ?!/&$%#@*""";;.,*

ITC Avant Garde Gothic Book Oblique 18 point

*ABCDEFGHIJKLMNOPQRSTUVWXYZ abcdefghij
klmnopqrstuvwxyz 1234567890 ?!/&$%#@*""";;.,*

ITC Avant Garde Gothic Book Oblique 20 point

*ABCDEFGHIJKLMNOPQRSTUVWXYZ abcdefghij
klmnopqrstuvwxyz 1234567890 ?!/&$%#@*""";;.,*

ITC Avant Garde Gothic Book Oblique 22 point

*ABCDEFGHIJKLMNOPQRSTUVWXYZ abcdefghij
klmnopqrstuvwxyz 1234567890 ?!/&$%#@*""";;.,*

ITC Avant Garde Gothic Book Oblique 24 point

ABCDEFGHIJKLMNOPQRSTUVWXYZ
*abcdefghijklmnopqrstuvwxyz 1234567890 !?%&**

ITC Avant Garde Gothic Book Oblique 30 point

ABCDEFGHIJKLMNOPQRSTUVWXYZ
abcdefghijklmnopqrstuvwxy 123456789

ITC Avant Garde Gothic Book Oblique 36 point

ABCDEFGHIJKLMNOPQRSTUVWX
abcdefghijklmnopqrstuvwxyz 12

ITC Avant Garde Gothic Book Oblique 48 point

ABCDEFGHIJKLMNOPQRST
abcdefghijklmnopqrst 123

ITC Avant Garde Gothic Book Oblique 60 point

ABCDEFGHIJKLMNOP
abcdefghijklmnop 12

6/8 ITC Avant Garde Gothic Book Oblique

It was the best of times, it was the worst of times, it was the age of wisdom, it was the age of foolishness, it was the epoch of belief, it was the epoch of incredulity, it was the season of light, it was the season of darkness, it was the spring of hope, it was the winter of despair, we had everything before us, we had nothing before us, we were all going direct to Heaven, we were all going direct the other way-in short, the period was so far like the present period, that some of its noisiest authorities insisted on

8/10 ITC Avant Garde Gothic Book Oblique

It was the best of times, it was the worst of times, it was the age of wisdom, it was the age of foolishness, it was the epoch of belief, it was the epoch of incredulity, it was the season of light, it was the season of darkness, it was the spring of hope, it was the winter of despair, we had everything before us, we had nothing before us, we were all going direct to Heaven, we were

9/10 ITC Avant Garde Gothic Book Oblique

It was the best of times, it was the worst of times, it was the age of wisdom, it was the age of foolishness, it was the epoch of belief, it was the epoch of incredulity, it was the season of light, it was the season of darkness, it was the spring of hope, it was the winter of despair, we had everything before us, we had nothing before us,

9/11 ITC Avant Garde Gothic Book Oblique

It was the best of times, it was the worst of times, it was the age of wisdom, it was the age of foolishness, it was the epoch of belief, it was the epoch of incredulity, it was the season of light, it was the season of darkness, it was the spring of hope, it was the winter of despair, we had everything before us, we had nothing before us,

10/11 ITC Avant Garde Gothic Book Oblique

It was the best of times, it was the worst of times, it was the age of wisdom, it was the age of foolishness, it was the epoch of belief, it was the epoch of incredulity, it was the season of light, it was the season of darkness, it was the spring of hope, it was the winter of despair, we had everything before us, we had

10/12 ITC Avant Garde Gothic Book Oblique

It was the best of times, it was the worst of times, it was the age of wisdom, it was the age of foolishness, it was the epoch of belief, it was the epoch of incredulity, it was the season of light, it was the season of darkness, it was the spring of hope, it was the winter of despair, we had everything before us, we had

11/13 ITC Avant Garde Gothic Book Oblique

It was the best of times, it was the worst of times, it was the age of wisdom, it was the age of foolishness, it was the epoch of belief, it was the epoch of incredulity, it was the season of light, it was the season of darkness, it was the spring of hope, it was the winter of despair,

11/14 ITC Avant Garde Gothic Book Oblique

It was the best of times, it was the worst of times, it was the age of wisdom, it was the age of foolishness, it was the epoch of belief, it was the epoch of incredulity, it was the season of light, it was the season of darkness, it was the spring of hope, it was the winter of despair,

12/13 ITC Avant Garde Gothic Book Oblique

It was the best of times, it was the worst of times, it was the age of wisdom, it was the age of foolishness, it was the epoch of belief, it was the epoch of incredulity, it was the season of light, it was the season of darkness, it was the spring of hope, it

12/14 ITC Avant Garde Gothic Book Oblique

It was the best of times, it was the worst of times, it was the age of wisdom, it was the age of foolishness, it was the epoch of belief, it was the epoch of incredulity, it was the season of light, it was the season of darkness, it was the spring of hope, it

13/15 ITC Avant Garde Gothic Book Oblique

It was the best of times, it was the worst of times, it was the age of wisdom, it was the age of foolishness, it was the epoch of belief, it was the epoch of incredulity, it was the season of light, it was the season of darkness, it was the

14/15 ITC Avant Garde Gothic Book Oblique

It was the best of times, it was the worst of times, it was the age of wisdom, it was the age of foolishness, it was the epoch of belief, it was the epoch of incredulity, it was the season of light, it was the season of

14/16 ITC Avant Garde Gothic Book Oblique

It was the best of times, it was the worst of times, it was the age of wisdom, it was the age of foolishness, it was the epoch of belief, it was the epoch of incredulity, it was the season of light, it was the season of

ITC Avant Garde Gothic Demi 72 point

ABCDEFGHIJKL
MNOPQRSTUVW
XYZ abcdefghij
klmnopqrstuvw
xyz1234567890
?!/&$%#@*""".;.,

ITC Avant Garde Gothic Demi 10 point

ABCDEFGHIJKLMNOPQRSTUVWXYZ abcdefghij
klmnopqrstuvwxyz 1234567890 ?!/&$%#@*""":;.,

ITC Avant Garde Gothic Demi 12 point

ABCDEFGHIJKLMNOPQRSTUVWXYZ abcdefghij
klmnopqrstuvwxyz 1234567890 ?!/&$%#@*""":;.,

ITC Avant Garde Gothic Demi 13 point

ABCDEFGHIJKLMNOPQRSTUVWXYZ abcdefghij
klmnopqrstuvwxyz 1234567890 ?!/&$%#@*""":;.,

ITC Avant Garde Gothic Demi 14 point

ABCDEFGHIJKLMNOPQRSTUVWXYZ abcdefghij
klmnopqrstuvwxyz 1234567890 ?!/&$%#@*""":;.,

ITC Avant Garde Gothic Demi 16 point

ABCDEFGHIJKLMNOPQRSTUVWXYZ abcdefghij
klmnopqrstuvwxyz 1234567890 ?!/&$%#@*""":;.,

ITC Avant Garde Gothic Demi 18 point

ABCDEFGHIJKLMNOPQRSTUVWXYZ abcdefghij
klmnopqrstuvwxyz 1234567890 ?!/&$%#@*""":;.,

ITC Avant Garde Gothic Demi 20 point

ABCDEFGHIJKLMNOPQRSTUVWXYZ abcdefghij
klmnopqrstuvwxyz 1234567890 ?!/&$%#@*""":;.,

ITC Avant Garde Gothic Demi 22 point

ABCDEFGHIJKLMNOPQRSTUVWXYZ abcdefghij
klmnopqrstuvwxyz 1234567890 ?!/&$%#@*""":;.,

ITC Avant Garde Gothic Demi 24 point

ABCDEFGHIJKLMNOPQRSTUVWXYZ
abcdefghijklmnopqrstuvwxyz 1234567890 !?%&

ITC Avant Garde Gothic Demi 30 point

ABCDEFGHIJKLMNOPQRSTUVWXYZ
abcdefghijklmnopqrstuvwxyz 123456

ITC Avant Garde Gothic Demi 36 point

ABCDEFGHIJKLMNOPQRSTUVWX
abcdefghijklmnopqrstuvwx 123

ITC Avant Garde Gothic Demi 48 point

ABCDEFGHIJKLMNOPQR
abcdefghijklmnopqrs 12

ITC Avant Garde Gothic Demi 60 point

ABCDEFGHIJKLMNO
abcdefghijklmnop 12

6/8 ITC Avant Garde Gothic Demi

It was the best of times, it was the worst of times, it was the age of wisdom, it was the age of foolishness, it was the epoch of belief, it was the epoch of incredulity, it was the season of light, it was the season of darkness, it was the spring of hope, it was the winter of despair, we had everything before us, we had nothing before us, we were all going direct to Heaven, we were all going direct the other way-in short, the period was so far like the present period, that some of its noisiest authorities insisted on

8/10 ITC Avant Garde Gothic Demi

It was the best of times, it was the worst of times, it was the age of wisdom, it was the age of foolishness, it was the epoch of belief, it was the epoch of incredulity, it was the season of light, it was the season of darkness, it was the spring of hope, it was the winter of despair, we had everything before us, we had nothing before us, we were all going direct to Heaven, we were

9/10 ITC Avant Garde Gothic Demi

It was the best of times, it was the worst of times, it was the age of wisdom, it was the age of foolishness, it was the epoch of belief, it was the epoch of incredulity, it was the season of light, it was the season of darkness, it was the spring of hope, it was the winter of despair, we had everything before us, we had nothing before us,

9/11 ITC Avant Garde Gothic Demi

It was the best of times, it was the worst of times, it was the age of wisdom, it was the age of foolishness, it was the epoch of belief, it was the epoch of incredulity, it was the season of light, it was the season of darkness, it was the spring of hope, it was the winter of despair, we had everything before us, we had nothing before us,

10/11 ITC Avant Garde Gothic Demi

It was the best of times, it was the worst of times, it was the age of wisdom, it was the age of foolishness, it was the epoch of belief, it was the epoch of incredulity, it was the season of light, it was the season of darkness, it was the spring of hope, it was the winter of despair, we had everything before us, we had we

10/12 ITC Avant Garde Gothic Demi

It was the best of times, it was the worst of times, it was the age of wisdom, it was the age of foolishness, it was the epoch of belief, it was the epoch of incredulity, it was the season of light, it was the season of darkness, it was the spring of hope, it was the winter of despair, we had everything before us, we had we

11/13 ITC Avant Garde Gothic Demi

It was the best of times, it was the worst of times, it was the age of wisdom, it was the age of foolishness, it was the epoch of belief, it was the epoch of incredulity, it was the season of light, it was the season of darkness, it was the spring of hope, it was the winter of despair, we

11/14 ITC Avant Garde Gothic Demi

It was the best of times, it was the worst of times, it was the age of wisdom, it was the age of foolishness, it was the epoch of belief, it was the epoch of incredulity, it was the season of light, it was the season of darkness, it was the spring of hope, it was the winter of despair, we

12/13 ITC Avant Garde Gothic Demi

It was the best of times, it was the worst of times, it was the age of wisdom, it was the age of foolishness, it was the epoch of belief, it was the epoch of incredulity, it was the season of light, it was the season of darkness, it was the spring of hope, it was the winter of despair,

12/14 ITC Avant Garde Gothic Demi

It was the best of times, it was the worst of times, it was the age of wisdom, it was the age of foolishness, it was the epoch of belief, it was the epoch of incredulity, it was the season of light, it was the season of darkness, it was the spring of hope, it was the winter of despair,

13/15 ITC Avant Garde Gothic Demi

It was the best of times, it was the worst of times, it was the age of wisdom, it was the age of foolishness, it was the epoch of belief, it was the epoch of incredulity, it was the season of light, it was the season of darkness, it was the spring of

14/15 ITC Avant Garde Gothic Demi

It was the best of times, it was the worst of times, it was the age of wisdom, it was the age of foolishness, it was the epoch of belief, it was the epoch of incredulity, it was the season of light, it was the season of

14/16 ITC Avant Garde Gothic Demi

It was the best of times, it was the worst of times, it was the age of wisdom, it was the age of foolishness, it was the epoch of belief, it was the epoch of incredulity, it was the season of light, it was the season of

ITC Avant Garde Gothic Demi Oblique 72 point

ABCDEFGHIJKL MNOPQRSTUVW XYZabcdefghij klmnopqrstuvw xyz1234567890 ?!/&$$%#@*""'';,','

ITC Avant Garde Gothic Demi Oblique 10 point

ABCDEFGHIJKLMNOPQRSTUVWXYZ abcdefghij
klmnopqrstuvwxyz 1234567890 ?!/&$%#@""":;.,*

ITC Avant Garde Gothic Demi Oblique 12 point

ABCDEFGHIJKLMNOPQRSTUVWXYZ abcdefghij
klmnopqrstuvwxyz 1234567890 ?!/&$%#@""":;.,*

ITC Avant Garde Gothic Demi Oblique 13 point

ABCDEFGHIJKLMNOPQRSTUVWXYZ abcdefghij
klmnopqrstuvwxyz 1234567890 ?!/&$%#@""":;.,*

ITC Avant Garde Gothic Demi Oblique 14 point

ABCDEFGHIJKLMNOPQRSTUVWXYZ abcdefghij
klmnopqrstuvwxyz 1234567890 ?!/&$%#@""":;.,*

ITC Avant Garde Gothic Demi Oblique 16 point

ABCDEFGHIJKLMNOPQRSTUVWXYZ abcdefghij
klmnopqrstuvwxyz 1234567890 ?!/&$%#@""":;.,*

ITC Avant Garde Gothic Demi Oblique 18 point

ABCDEFGHIJKLMNOPQRSTUVWXYZ abcdefghij
klmnopqrstuvwxyz 1234567890 ?!/&$%#@""":;.,*

ITC Avant Garde Gothic Demi Oblique 20 point

ABCDEFGHIJKLMNOPQRSTUVWXYZ abcdefghij
klmnopqrstuvwxyz 1234567890 ?!/&$%#@""":;.,*

ITC Avant Garde Gothic Demi Oblique 22 point

ABCDEFGHIJKLMNOPQRSTUVWXYZ abcdefghij
klmnopqrstuvwxyz 1234567890 ?!/&$%#@""":;.,*

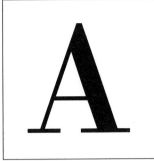

Bodoni 72 Point

ABCDEFGHIJKL
MNOPQRSTUV
WXYZ abcdefghij
klmnopqrstuvw
xyz 1234567890
?!/&$%#@*""·,

Bodoni 11 point

ABCDEFGHIJKLMNOPQRSTUVWXYZ abcdefghij
klmnopqrstuvwxyz 1234567890 ?!/&$%#@*""":;.,

Bodoni 12 point

ABCDEFGHIJKLMNOPQRSTUVWXYZ abcdefghij
klmnopqrstuvwxyz 1234567890 ?!/&$%#@*""":;.,

Bodoni 13 point

ABCDEFGHIJKLMNOPQRSTUVWXYZ abcdefghij
klmnopqrstuvwxyz 1234567890 ?!/&$%#@*""":;.,

Bodoni 14 point

ABCDEFGHIJKLMNOPQRSTUVWXYZ abcdefghij
klmnopqrstuvwxyz 1234567890 ?!/&$%#@*""":;.,

Bodoni 16 point

ABCDEFGHIJKLMNOPQRSTUVWXYZ abcdefghij
klmnopqrstuvwxyz 1234567890 ?!/&$%#@*""":;.,

Bodoni 18 point

ABCDEFGHIJKLMNOPQRSTUVWXYZ abcdefghij
klmnopqrstuvwxyz 1234567890 ?!/&$%#@*""":;.,

Bodoni 20 point

ABCDEFGHIJKLMNOPQRSTUVWXYZ abcdefghij
klmnopqrstuvwxyz 1234567890 ?!/&$%#@*""":;.,

Bodoni 22 point

ABCDEFGHIJKLMNOPQRSTUVWXYZ abcdefghij
klmnopqrstuvwxyz 1234567890 ?!/&$%#@*""":;.,

Bodoni 24 point

ABCDEFGHIJKLMNOPQRSTUVWXYZ
abcdefghijklmnopqrstuvwxyz 1234567890 !?%&*

Bodoni 30 point

ABCDEFGHIJKLMNOPQRSTUVWXYZ
abcdefghijklmnopqrstuvwxyz 1234567890

Bodoni 36 point

ABCDEFGHIJKLMNOPQRSTUVW
abcdefghijklmnopqrstuvwxyz 12345

Bodoni 48 point

ABCDEFGHIJKLMNOPQ
abcdefghijklmnopqrstuv 12

Bodoni 60 point

ABCDEFGHIJKLMN
abcdefghijklmnopq 12

6/8 Bodoni

It was the best of times, it was the worst of times, it was the age of wisdom, it was the age of foolishness, it was the epoch of belief, it was the epoch of incredulity, it was the season of light, it was the season of darkness, it was the spring of hope, it was the winter of despair, we had everything before us, we had nothing before us, we were all going direct to Heaven, we were all going direct the other way-in short, the period was so far like the present period, that some of its noisiest authorities insisted on its being received, for good or for evil, in the superlative degree

8/10 Bodoni

It was the best of times, it was the worst of times, it was the age of wisdom, it was the age of foolishness, it was the epoch of belief, it was the epoch of incredulity, it was the season of light, it was the season of darkness, it was the spring of hope, it was the winter of despair, we had everything before us, we had nothing before us, we were all going direct to Heaven, we were all going direct the other way-in short, the period was so

9/10 Bodoni

It was the best of times, it was the worst of times, it was the age of wisdom, it was the age of foolishness, it was the epoch of belief, it was the epoch of incredulity, it was the season of light, it was the season of darkness, it was the spring of hope, it was the winter of despair, we had everything before us, we had nothing before us, we were all going direct to Heaven, we were all

9/11 Bodoni

It was the best of times, it was the worst of times, it was the age of wisdom, it was the age of foolishness, it was the epoch of belief, it was the epoch of incredulity, it was the season of light, it was the season of darkness, it was the spring of hope, it was the winter of despair, we had everything before us, we had nothing before us, we were all going direct to Heaven, we were all

10/11 Bodoni

It was the best of times, it was the worst of times, it was the age of wisdom, it was the age of foolishness, it was the epoch of belief, it was the epoch of incredulity, it was the season of light, it was the season of darkness, it was the spring of hope, it was the winter of despair, we had everything before us, we had we had nothing before us, we

10/12 Bodoni

It was the best of times, it was the worst of times, it was the age of wisdom, it was the age of foolishness, it was the epoch of belief, it was the epoch of incredulity, it was the season of light, it was the season of darkness, it was the spring of hope, it was the winter of despair, we had everything before us, we had we had nothing before us, we

11/13 Bodoni

It was the best of times, it was the worst of times, it was the age of wisdom, it was the age of foolishness, it was the epoch of belief, it was the epoch of incredulity, it was the season of light, it was the season of darkness, it was the spring of hope, it was the winter of despair, we had everything before us, we had nothing before us,

11/14 Bodoni

It was the best of times, it was the worst of times, it was the age of wisdom, it was the age of foolishness, it was the epoch of belief, it was the epoch of incredulity, it was the season of light, it was the season of darkness, it was the spring of hope, it was the winter of despair, we had everything before us, we had nothing before us,

12/13 Bodoni

It was the best of times, it was the worst of times, it was the age of wisdom, it was the age of foolishness, it was the epoch of belief, it was the epoch of incredulity, it was the season of light, it was the season of darkness, it was the spring of hope, it was the winter of despair, we had everything before us, we

12/14 Bodoni

It was the best of times, it was the worst of times, it was the age of wisdom, it was the age of foolishness, it was the epoch of belief, it was the epoch of incredulity, it was the season of light, it was the season of darkness, it was the spring of hope, it was the winterof despair, we had everything before us,we

13/15 Bodoni

It was the best of times, it was the worst of times, it was the age of wisdom, it was the age of foolishness, it was the epoch of belief, it was the epoch of incredulity, it was the season of light, it was the season of darkness, it was the spring of hope, it was the winter of despair, we had

14/15 Bodoni

It was the best of times, it was the worst of times, it was the age of wisdom, it was the age of foolishness, it was the epoch of belief, it was the epoch of incredulity, it was the season of light, it was the season of darkness, it was the spring of hope, it

14/16 Bodoni

It was the best of times, it was the worst of times, it was the age of wisdom, it was the age of foolishness, it was the epoch of belief, it was the epoch of incredulity, it was the season of light, it was the season of darkness, it was the spring of hope, it

Bodoni Italic 72 point

ABCDEFGHIJKL

MNOPQRSTUV

WXYZ abcdefghij

klmnopqrstuvw

xyz1234567890

?!&$%#@""`:.;.,*

Bodoni Italic 11 point

ABCDEFGHIJKLMNOPQRSTUVWXYZ abcdefghij klmnopqrstuvwxyz 1234567890 ?!/&$%#@""":;.,*

Bodoni Italic 12 point

ABCDEFGHIJKLMNOPQRSTUVWXYZ abcdefghij klmnopqrstuvwxyz 1234567890 ?!/&$%#@""":;.,*

Bodoni Italic 13 point

ABCDEFGHIJKLMNOPQRSTUVWXYZ abcdefghij klmnopqrstuvwxyz 1234567890 ?!/&$%#@""":;.,*

Bodoni Italic 14 point

ABCDEFGHIJKLMNOPQRSTUVWXYZ abcdefghij klmnopqrstuvwxyz 1234567890 ?!/&$%#@""":;.,*

Bodoni Italic 16 point

ABCDEFGHIJKLMNOPQRSTUVWXYZ abcdefghij klmnopqrstuvwxyz 1234567890 ?!/&$%#@""":;.,*

Bodoni Italic 18 point

ABCDEFGHIJKLMNOPQRSTUVWXYZ abcdefghij klmnopqrstuvwxyz 1234567890 ?!/&$%#@""":;.,*

Bodoni Italic 20 point

ABCDEFGHIJKLMNOPQRSTUVWXYZ abcdefghij klmnopqrstuvwxyz 1234567890 ?!/&$%#@""":;.,*

Bodoni Italic 22 point

ABCDEFGHIJKLMNOPQRSTUVWXYZ abcdefghij klmnopqrstuvwxyz 1234567890 ?!/&$%#@""":;.,*

Bodoni Italic 24 point

ABCDEFGHIJKLMNOPQRSTUVWXYZ
abcdefghijklmnopqrstuvwxyz 1234567890 !?%&*

Bodoni Italic 30 point

ABCDEFGHIJKLMNOPQRSTUVWXYZ
abcdefghijklmnopqrstuvwxyz 1234567890

Bodoni Italic 36 point

ABCDEFGHIJKLMNOPQRSTUVW
abcdefghijklmnopqrstuvwxyz 12345

Bodoni Italic 48 point

ABCDEFGHIJKLMNOPQ
abcdefghijklmnopqrstu 12

Bodoni Italic 60 point

ABCDEFGHIJKLMNO
abcdefghijklmnopqrst 12

6/8 Bodoni Italic

It was the best of times, it was the worst of times, it was the age of wisdom, it was the age of foolishness, it was the epoch of belief, it was the epoch of incredulity, it was the season of light, it was the season of darkness, it was the spring of hope, it was the winter of despair, we had everything before us, we had nothing before us, we were all going direct to Heaven, we were all going direct the other way-in short, the period was so far like the present period, that some of its noisiest authorities insisted on its being received, for good or for evil, in the superlative

8/10 Bodoni Italic

It was the best of times, it was the worst of times, it was the age of wisdom, it was the age of foolishness, it was the epoch of belief, it was the epoch of incredulity, it was the season of light, it was the season of darkness, it was the spring of hope, it was the winter of despair, we had everything before us, we had nothing before us, we were all going direct to Heaven, we were all going direct the other way-in short, the period

9/10 Bodoni Italic

It was the best of times, it was the worst of times, it was the age of wisdom, it was the age of foolishness, it was the epoch of belief, it was the epoch of incredulity, it was the season of light, it was the season of darkness, it was the spring of hope, it was the winter of despair, we had everything before us, we had nothing before us, we were all going direct to Heaven, we were

9/11 Bodoni Italic

It was the best of times, it was the worst of times, it was the age of wisdom, it was the age of foolishness, it was the epoch of belief, it was the epoch of incredulity, it was the season of light, it was the season of darkness, it was the spring of hope, it was the winter of despair, we had everything before us, we had nothing before us, we were all going direct to Heaven, we were

10/11 Bodoni Italic

It was the best of times, it was the worst of times, it was the age of wisdom, it was the age of foolishness, it was the epoch of belief, it was the epoch of incredulity, it was the season of light, it was the season of darkness, it was the spring of hope, it was the winter of despair, we had everything before us, we had we had nothing before us, we

10/12 Bodoni Italic

It was the best of times, it was the worst of times, it was the age of wisdom, it was the age of foolishness, it was the epoch of belief, it was the epoch of incredulity, it was the season of light, it was the season of darkness, it was the spring of hope, it was the winter of despair, we had everything before us, we had we had nothing before us, we

11/13 Bodoni Italic

It was the best of times, it was the worst of times, it was the age of wisdom, it was the age of foolishness, it was the epoch of belief, it was the epoch of incredulity, it was the season of light, it was the season of darkness, it was the spring of hope, it was the winter of despair, we had everything before us, we had nothing before

11/14 Bodoni Italic

It was the best of times, it was the worst of times, it was the age of wisdom, it was the age of foolishness, it was the epoch of belief, it was the epoch of incredulity, it was the season of light, it was the season of darkness, it was the spring of hope, it was the winter of despair, we had everything before us, we had nothing before

12/13 Bodoni Italic

It was the best of times, it was the worst of times, it was the age of wisdom, it was the age of foolishness, it was the epoch of belief, it was the epoch of incredulity, it was the season of light, it was the season of darkness, it was the spring of hope, it was the winter of despair, we had everything before us, we

12/14 Bodoni Italic

It was the best of times, it was the worst of times, it was the age of wisdom, it was the age of foolishness, it was the epoch of belief, it was the epoch of incredulity, it was the season of light, it was the season of darkness, it was the spring of hope, it was the winter of despair, we had everything before us, we

13/15 Bodoni Italic

It was the best of times, it was the worst of times, it was the age of wisdom, it was the age of foolishness, it was the epoch of belief, it was the epoch of incredulity, it was the season of light, it was the season of darkness, it was the spring of hope, it was the winter of despair, we had

14/15 Bodoni Italic

It was the best of times, it was the worst of times, it was the age of wisdom, it was the age of foolishness, it was the epoch of belief, it was the epoch of incredulity, it was the season of light, it was the season of darkness, it was the spring of hope, it was the winter

14/16 Bodoni Italic

It was the best of times, it was the worst of times, it was the age of wisdom, it was the age of foolishness, it was the epoch of belief, it was the epoch of incredulity, it was the season of light, it was the season of darkness, it was the spring of hope, it was the winter

Bodoni Bold 72 point

ABCDEFGHIJKL
MNOPQRSTUV
WXYZ abcdefghij
klmnopqrstuvw
xyz1234567890
?!/&$%#@*"",.;.,

Bodoni Bold 11 point

ABCDEFGHIJKLMNOPQRSTUVWXYZ abcdefghij
klmnopqrstuvwxyz 1234567890 ?!/&$%#@*""":;.,

Bodoni Bold 12 point

ABCDEFGHIJKLMNOPQRSTUVWXYZ abcdefghij
klmnopqrstuvwxyz 1234567890 ?!/&$%#@*""":;.,

Bodoni Bold 13 point

ABCDEFGHIJKLMNOPQRSTUVWXYZ abcdefghij
klmnopqrstuvwxyz 1234567890 ?!/&$%#@*""":;.,

Bodoni Bold 14 point

ABCDEFGHIJKLMNOPQRSTUVWXYZ abcdefghij
klmnopqrstuvwxyz 1234567890 ?!/&$%#@*""":;.,

Bodoni Bold 16 point

ABCDEFGHIJKLMNOPQRSTUVWXYZ abcdefghij
klmnopqrstuvwxyz 1234567890 ?!/&$%#@*""":;.,

Bodoni Bold 18 point

ABCDEFGHIJKLMNOPQRSTUVWXYZ abcdefghij
klmnopqrstuvwxyz 1234567890 ?!/&$%#@*""":;.,

Bodoni Bold 20 point

ABCDEFGHIJKLMNOPQRSTUVWXYZ abcdefghij
klmnopqrstuvwxyz 1234567890 ?!/&$%#@*""":;.,

Bodoni Bold 22 point

ABCDEFGHIJKLMNOPQRSTUVWXYZ abcdefghij
klmnopqrstuvwxyz 1234567890 ?!/&$%#@*""":;.,

Bodoni Bold 24 point

ABCDEFGHIJKLMNOPQRSTUVWXYZ
abcdefghijklmnopqrstuvwxyz 1234567890 !?%&

Bodoni Bold 30 point

ABCDEFGHIJKLMNOPQRSTUVWXYZ
abcdefghijklmnopqrstuvwxyz 12345678

Bodoni Bold 36 point

ABCDEFGHIJKLMNOPQRSTUV
abcdefghijklmnopqrstuvwxy 1234

Bodoni Bold 48 point

ABCDEFGHIJKLMNOPQ
abcdefghijklmnopqrstu 12

Bodoni Bold 60 point

ABCDEFGHIJKLMN
abcdefghijklmnopqr

6/8 Bodoni Bold

It was the best of times, it was the worst of times, it was the age of wisdom, it was the age of foolishness, it was the epoch of belief, it was the epoch of incredulity, it was the season of light, it was the season of darkness, it was the spring of hope, it was the winter of despair, we had everything before us, we had nothing before us, we were all going direct to Heaven, we were all going direct the other way-in short, the period was so far like the present period, that some of its noisiest authorities insisted on its being received, for good or for evil,

8/10 Bodoni Bold

It was the best of times, it was the worst of times, it was the age of wisdom, it was the age of foolishness, it was the epoch of belief, it was the epoch of incredulity, it was the season of light, it was the season of darkness, it was the spring of hope, it was the winter of despair, we had everything before us, we had nothing before us, we were all going direct to Heaven, we were all going direct the other way-in

9/10 Bodoni Bold

It was the best of times, it was the worst of times, it was the age of wisdom, it was the age of foolishness, it was the epoch of belief, it was the epoch of incredulity, it was the season of light, it was the season of darkness, it was the spring of hope, it was the winter of despair, we had everything before us, we had nothing before us, we were all going direct to Heaven,

9/11 Bodoni Bold

It was the best of times, it was the worst of times, it was the age of wisdom, it was the age of foolishness, it was the epoch of belief, it was the epoch of incredulity, it was the season of light, it was the season of darkness, it was the spring of hope, it was the winter of despair, we had everything before us, we had nothing before us, we were all going direct toHeaven,

10/11 Bodoni Bold

It was the best of times, it was the worst of times, it was the age of wisdom, it was the age of foolishness, it was the epoch of belief, it was the epoch of incredulity, it was the season of light, it was the season of darkness, it was the spring of hope, it was the winter of despair, we had everything before us, we had nothing before us,

10/12 Bodoni Bold

It was the best of times, it was the worst of times, it was the age of wisdom, it was the age of foolishness, it was the epoch of belief, it was the epoch of incredulity, it was the season of light, it was the season of darkness, it was the spring of hope, it was the winter of despair, we had everything before us, we had nothing before us,

11/13 Bodoni Bold

It was the best of times, it was the worst of times, it was the age of wisdom, it was the age of foolishness, it was the epoch of belief, it was the epoch of incredulity, it was the season of light, it was the season of darkness, it was the spring of hope, it was the winter of despair, we had everything before

11/14 Bodoni Bold

It was the best of times, it was the worst of times, it was the age of wisdom, it was the age of foolishness, it was the epoch of belief, it was the epoch of incredulity, it was the season of light, it was the season of darkness, it was the spring of hope, it was the winter of despair, we had everything before

12/13 Bodoni Bold

It was the best of times, it was the worst of times, it was the age of wisdom, it was the age of foolishness, it was the epoch of belief, it was the epoch of incredulity, it was the season of light, it was the season of darkness, it was the spring of hope, it was the winter of despair,

12/14 Bodoni Bold

It was the best of times, it was the worst of times, it was the age of wisdom, it was the age of foolishness, it was the epoch of belief, it was the epoch of incredulity, it was the season of light, it was the season of darkness, it was the spring of hope, it was the winter of despair,

13/15 Bodoni Bold

It was the best of times, it was the worst of times, it was the age of wisdom, it was the age of foolishness, it was the epoch of belief, it was the epoch of incredulity, it was the season of light, it was the season of darkness, it was the spring of hope, it was the winter of despair,

14/15 Bodoni Bold

It was the best of times, it was the worst of times, it was the age of wisdom, it was the age of foolishness, it was the epoch of belief, it was the epoch of incredulity, it was the season of light, it was the season of darkness, it was the spring

14/16 Bodoni Bold

It was the best of times, it was the worst of times, it was the age of wisdom, it was the age of foolishness, it was the epoch of belief, it was the epoch of incredulity, it was the season of light, it was the season of darkness, it was the spring

Bodoni Bold Italic 72 point

ABCDEFGHIJKL

MNOPQRSTUVW

XYZ abcdefghij

klmnopqrstuvw

xyz1234567890

?!/&$%#@""";:.*

Bodoni Bold Italic 11 point

ABCDEFGHIJKLMNOPQRSTUVWXYZ abcdefghij
klmnopqrstuvwxyz 1234567890 ?!/&$%#@""":;.,*

Bodoni Bold Italic 12 point

ABCDEFGHIJKLMNOPQRSTUVWXYZ abcdefghij
klmnopqrstuvwxyz 1234567890 ?!/&$%#@""":;.,*

Bodoni Bold Italic 13 point

ABCDEFGHIJKLMNOPQRSTUVWXYZ abcdefghij
klmnopqrstuvwxyz 1234567890 ?!/&$%#@""":;.,*

Bodoni Bold Italic 14 point

ABCDEFGHIJKLMNOPQRSTUVWXYZ abcdefghij
klmnopqrstuvwxyz 1234567890 ?!/&$%#@""":;.,*

Bodoni Bold Italic 16 point

ABCDEFGHIJKLMNOPQRSTUVWXYZ abcdefghij
klmnopqrstuvwxyz 1234567890 ?!/&$%#@""":;.,*

Bodoni Bold Italic 18 point

ABCDEFGHIJKLMNOPQRSTUVWXYZ abcdefghij
klmnopqrstuvwxyz 1234567890 ?!/&$%#@""":;.,*

Bodoni Bold Italic 20 point

ABCDEFGHIJKLMNOPQRSTUVWXYZ abcdefghij
klmnopqrstuvwxyz 1234567890 ?!/&$%#@""":;.,*

Bodoni Bold Italic 22 point

ABCDEFGHIJKLMNOPQRSTUVWXYZ abcdefghij
klmnopqrstuvwxyz 1234567890 ?!/&$%#@""":;.,*

Bodoni Bold Italic 24 point

ABCDEFGHIJKLMNOPQRSTUVWXYZ
abcdefghijklmnopqrstuvwxyz *1234567890 !?%&*

Bodoni Bold Italic 30 point

ABCDEFGHIJKLMNOPQRSTUVWXYZ
abcdefghijklmnopqrstuvwxyz *12345678*

Bodoni Bold Italic 36 point

ABCDEFGHIJKLMNOPQRSTUVW
abcdefghijklmnopqrstuvwxy *12345*

Bodoni Bold Italic 48 point

ABCDEFGHIJKLMNOPQ
abcdefghijklmnopqrstu *12*

Bodoni Bold Italic 60 point

ABCDEFGHIJKLMN
abcdefghijklmnop *12*

6/8 Bodoni Bold Italic

It was the best of times, it was the worst of times, it was the age of wisdom, it was the age of foolishness, it was the epoch of belief, it was the epoch of incredulity, it was the season of light, it was the season of darkness, it was the spring of hope, it was the winter of despair, we had everything before us, we had nothing before us, we were all going direct to Heaven, we were all going direct the other way-in short, the period was so far like the present period, that some of its noisiest authorities insisted on its being received, for good or for evil,

8/10 Bodoni Bold Italic

It was the best of times, it was the worst of times, it was the age of wisdom, it was the age of foolishness, it was the epoch of belief, it was the epoch of incredulity, it was the season of light, it was the season of darkness, it was the spring of hope, it was the winter of despair, we had everything before us, we had nothing before us, we were all going direct to Heaven, we were all going direct the other way-in

9/10 Bodoni Bold Italic

It was the best of times, it was the worst of times, it was the age of wisdom, it was the age of foolishness, it was the epoch of belief, it was the epoch of incredulity, it was the season of light, it was the season of darkness, it was the spring of hope, it was the winter of despair, we had everything before us, we had nothing before us, we were all going direct to Heaven,

9/11 Bodoni Bold Italic

It was the best of times, it was the worst of times, it was the age of wisdom, it was the age of foolishness, it was the epoch of belief, it was the epoch of incredulity, it was the season of light, it was the season of darkness, it was the spring of hope, it was the winter of despair, we had everything before us, we had nothing before us, we were all going direct to Heaven,

10/11 Bodoni Bold Italic

It was the best of times, it was the worst of times, it was the age of wisdom, it was the age of foolishness, it was the epoch of belief, it was the epoch of incredulity, it was the season of light, it was the season of darkness, it was the spring of hope, it was the winter of despair, we had everything before us, we had we had nothing

10/12 Bodoni Bold Italic

It was the best of times, it was the worst of times, it was the age of wisdom, it was the age of foolishness, it was the epoch of belief, it was the epoch of incredulity, it was the season of light, it was the season of darkness, it was the spring of hope, it was the winter of despair, we had everything before us, we had we had nothing

11/13 Bodoni Bold

It was the best of times, it was the worst of times, it was the age of wisdom, it was the age of foolishness, it was the epoch of belief, it was the epoch of incredulity, it was the season of light, it was the season of darkness, it was the spring of hope, it was the winter of despair, we had everything before

11/14 Bodoni Bold Italic

It was the best of times, it was the worst of times, it was the age of wisdom, it was the age of foolishness, it was the epoch of belief, it was the epoch of incredulity, it was the season of light, it was the season of darkness, it was the spring of hope, it was the winter of despair, we had everything before

12/13 Bodoni Bold Italic

It was the best of times, it was the worst of times, it was the age of wisdom, it was the age of foolishness, it was the epoch of belief, it was the epoch of incredulity, it was the season of light, it was the season of darkness, it was the spring of hope, it was the winter of despair,

12/14 Bodoni Bold Italic

It was the best of times, it was the worst of times, it was the age of wisdom, it was the age of foolishness, it was the epoch of belief, it was the epoch of incredulity, it was the season of light, it was the season of darkness, it was the spring of hope, it was the winter of despair, we

13/15 Bodoni Bold Italic

It was the best of times, it was the worst of times, it was the age of wisdom, it was the age of foolishness, it was the epoch of belief, it was the epoch of incredulity, it was the season of light, it was the season of darkness, it was the spring of hope, it was the winter of despair,

14/15 Bodoni Bold Italic

It was the best of times, it was the worst of times, it was the age of wisdom, it was the age of foolishness, it was the epoch of belief, it was the epoch of incredulity, it was the season of light, it was the season of darkness, it was the spring

14/16 Bodoni Bold Italic

It was the best of times, it was the worst of times, it was the age of wisdom, it was the age of foolishness, it was the epoch of belief, it was the epoch of incredulity, it was the season of light, it was the season of darkness, it was the spring

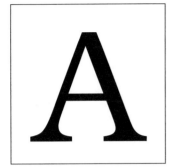

ITC Bookman Light 72 point

ABCDEFGHIJK
LMNOPQRSTU
VWXYZabcdefg
hijklmnopqrstu
vwxyz1234567
890?!/&$%*""·,

ITC Bookman Light 10 point

ABCDEFGHIJKLMNOPQRSTUVWXYZ abcdefghij
klmnopqrstuvwxyz 1234567890 ?!/&$%#@*"":;.,

ITC Bookman Light 12 point

ABCDEFGHIJKLMNOPQRSTUVWXYZ abcdefghij
klmnopqrstuvwxyz 1234567890 ?!/&$%#@*"":;.,

ITC Bookman Light 13 point

ABCDEFGHIJKLMNOPQRSTUVWXYZ abcdefghij
klmnopqrstuvwxyz 1234567890 ?!/&$%#@*"":;.,

ITC Bookman Light 14 point

ABCDEFGHIJKLMNOPQRSTUVWXYZ abcdefghij
klmnopqrstuvwxyz 1234567890 ?!/&$%#@*"":;.,

ITC Bookman Light 16 point

ABCDEFGHIJKLMNOPQRSTUVWXYZ abcdefghij
klmnopqrstuvwxyz 1234567890 ?!/&$%#@*"":;.,

ITC Bookman Light 18 point

ABCDEFGHIJKLMNOPQRSTUVWXYZ abcdefghij
klmnopqrstuvwxyz 1234567890 ?!/&$%#@*"":;.,

ITC Bookman Light 20 point

ABCDEFGHIJKLMNOPQRSTUVWXYZ abcdefghij
klmnopqrstuvwxyz 1234567890 ?!/&$%#@*"":;.,

ITC Bookman Light 22 point

ABCDEFGHIJKLMNOPQRSTUVWXYZ abcdefghij
klmnopqrstuvwxyz 1234567890 ?!/&$%#@*"":;.,

ITC Bookman Light 24 point

ABCDEFGHIJKLMNOPQRSTUVWXYZ
abcdefghijklmnopqrstuvwxyz 1234567890 !?%&*

ITC Bookman Light 30 point

ABCDEFGHIJKLMNOPQRSTUVWXYZ
abcdefghijklmnopqrstuvwxyz12345678

ITC Bookman Light 36 point

ABCDEFGHIJKLMNOPQRSTUV
abcdefghijklmnopqrstuvwx 1234

ITC Bookman Light 48 point

ABCDEFGHIJKLMNOPQ
abcdefghijklmnopqr 123

ITC Bookman Light 60 point

ABCDEFGHIJKLMN
abcdefghijklmn 123

6/8 ITC Bookman Light

It was the best of times, it was the worst of times, it was the age of wisdom, it was the age of foolishness, it was the epoch of belief, it was the epoch of incredulity, it was the season of light, it was the season of darkness, it was the spring of hope, it was the winter of despair, we had everything before us, we had nothing before us, we were all going direct to Heaven, we were all going direct the other way-in short, the period was so far like the present period, that some of its noisiest

8/10 ITC Bookman Light

It was the best of times, it was the worst of times, it was the age of wisdom, it was the age of foolishness, it was the epoch of belief, it was the epoch of incredulity, it was the season of light, it was the season of darkness, it was the spring of hope, it was the winter of despair, we had everything before all going direct the other way-in short, the period was so far like the

9/10 ITC Bookman Light

It was the best of times, it was the worst of times, it was the age of wisdom, it was the age of foolishness, it was the epoch of belief, it was the epoch of incredulity, it was the season of light, it was the season of darkness, it was the spring of hope, it was the winter of despair, we had everything before us, we had nothing before us,

9/11 ITC Bookman Light

It was the best of times, it was the worst of times, it was the age of wisdom, it was the age of foolishness, it was the epoch of belief, it was the epoch of incredulity, it was the season of light, it was the season of darkness, it was the spring of hope, it was the winter of despair, we had everything before us, we had nothing before us,

10/11 ITC Bookman Light

It was the best of times, it was the worst of times, it was the age of wisdom, it was the age of foolishness, it was the epoch of belief, it was the epoch of incredulity, it was the season of light, it was the season of darkness, it was the spring of hope, it was the winter of despair, we had everything before

10/12 ITC Bookman Light

It was the best of times, it was the worst of times, it was the age of wisdom, it was the age of foolishness, it was the epoch of belief, it was the epoch of incredulity, it was the season of light, it was the season of darkness, it was the spring of hope, it was the winter of despair, we had everything before

11/13 ITC Bookman Light

It was the best of times, it was the worst of times, it was the age of wisdom, it was the age of foolishness, it was the epoch of belief, it was the epoch of incredulity, it was the season of light, it was the season of darkness, it was the spring of hope, it was the winter of despair,

11/14 ITC Bookman Light

It was the best of times, it was the worst of times, it was the age of wisdom, it was the age of foolishness, it was the epoch of belief, it was the epoch of incredulity, it was the season of light, it was the season of darkness, it was the spring of hope, it was the winter of despair,

12/13 ITC Bookman Light

It was the best of times, it was the worst of times, it was the age of wisdom, it was the age of foolishness, it was the epoch of belief, it was the epoch of incredulity, it was the season of light, it was the season of darkness, it was the spring of

12/14 ITC Bookman Light

It was the best of times, it was the worst of times, it was the age of wisdom, it was the age of foolishness, it was the epoch of belief, it was the epoch of incredulity, it was the season of light, it was the season of darkness, it was the spring of

13/15 ITC Bookman Light

It was the best of times, it was the worst of times, it was the age of wisdom, it was the age of foolishness, it was the epoch of belief, it was the epoch of incredulity, it was the season of light, it was the season of darkness, it was the

14/15 ITC Bookman Light

It was the best of times, it was the worst of times, it was the age of wisdom, it was the age of foolishness, it was the epoch of belief, it was the epoch of incredulity, it was the season of light, it was the season

14/16 ITC Bookman Light

It was the best of times, it was the worst of times, it was the age of wisdom, it was the age of foolishness, it was the epoch of belief, it was the epoch of incredulity, it was the season of light, it was the season

ITC Bookman Light Italic 72 point

*ABCDEFGHIJK
LMNOPQRSTU
VWXYZ abcdef
ghijklmnopqrst
uvwxyz1234567
890?!&$%@ "":;*

ITC Bookman Light Italic 10 point

ABCDEFGHIJKLMNOPQRSTUVWXYZ abcdefghij klmnopqrstuvwxyz 1234567890 ?!/&$%#@""::.,*

ITC Bookman Light Italic 12 point

ABCDEFGHIJKLMNOPQRSTUVWXYZ abcdefghij klmnopqrstuvwxyz 1234567890 ?!/&$%#@""::.,*

ITC Bookman Light Italic 13 point

ABCDEFGHIJKLMNOPQRSTUVWXYZ abcdefghij klmnopqrstuvwxyz 1234567890 ?!/&$%#@""::.,*

ITC Bookman Light Italic 14 point

ABCDEFGHIJKLMNOPQRSTUVWXYZ abcdefghij klmnopqrstuvwxyz 1234567890 ?!/&$%#@""::.,*

ITC Bookman Light Italic 16 point

ABCDEFGHIJKLMNOPQRSTUVWXYZ abcdefghij klmnopqrstuvwxyz 1234567890 ?!/&$%#@""::.,*

ITC Bookman Light Italic 18 point

ABCDEFGHIJKLMNOPQRSTUVWXYZ abcdefghij klmnopqrstuvwxyz 1234567890 ?!/&$%#@""::.,*

ITC Bookman Light Italic 20 point

ABCDEFGHIJKLMNOPQRSTUVWXYZ abcdefghij klmnopqrstuvwxyz 1234567890 ?!/&$%#@""::.,*

ITC Bookman Light Italic 22 point

ABCDEFGHIJKLMNOPQRSTUVWXYZ abcdefghij klmnopqrstuvwxyz 1234567890 ?!/&$%#@""::.,*

6/8 ITC Bookman Light Italic

It was the best of times, it was the worst of times, it was the age of wisdom, it was the age of foolishness, it was the epoch of belief, it was the epoch of incredulity, it was the season of light, it was the season of darkness, it was the spring of hope, it was the winter of despair, we had everything before us, we had nothing before us, we were all going direct to Heaven, we were all going direct the other way-in short, the period was so far like the present period, that some of its noisiest authorities

8/10 ITC Bookman Light Italic

It was the best of times, it was the worst of times, it was the age of wisdom, it was the age of foolishness, it was the epoch of belief, it was the epoch of incredulity, it was the season of light, it was the season of darkness, it was the spring of hope, it was the winter of despair, we had everything before us, we had nothing before us, we were all going direct to Heaven, we were

9/10 ITC Bookman Light Italic

It was the best of times, it was the worst of times, it was the age of wisdom, it was the age of foolishness, it was the epoch of belief, it was the epoch of incredulity, it was the season of light, it was the season of darkness, it was the spring of hope, it was the winter of despair, we had everything before us, we had nothing before us, we

9/11 ITC Bookman Light Italic

It was the best of times, it was the worst of times, it was the age of wisdom, it was the age of foolishness, it was the epoch of belief, it was the epoch of incredulity, it was the season of light, it was the season of darkness, it was the spring of hope, it was the winter of despair, we had everything before us, we had nothing before us, we

10/11 ITC Bookman Light Italic

It was the best of times, it was the worst of times, it was the age of wisdom, it was the age of foolishness, it was the epoch of belief, it was the epoch of incredulity, it was the season of light, it was the season of darkness, it was the spring of hope, it was the winter of despair, we had everything before us, we

10/12 ITC Bookman Light Italic

It was the best of times, it was the worst of times, it was the age of wisdom, it was the age of foolishness, it was the epoch of belief, it was the epoch of incredulity, it was the season of light, it was the season of darkness, it was the spring of hope, it was the winter of despair, we had everything before us, we

11/13 ITC Bookman Light Italic

It was the best of times, it was the worst of times, it was the age of wisdom, it was the age of foolishness, it was the epoch of belief, it was the epoch of incredulity, it was the season of light, it was the season of darkness, it was the spring of hope, it was the winter of despair,

11/14 ITC Bookman Light Italic

It was the best of times, it was the worst of times, it was the age of wisdom, it was the age of foolishness, it was the epoch of belief, it was the epoch of incredulity, it was the season of light, it was the season of darkness, it was the spring of hope, it was the winter of despair,

12/13 ITC Bookman Light Italic

It was the best of times, it was the worst of times, it was the age of wisdom, it was the age of foolishness, it was the epoch of belief, it was the epoch of incredulity, it was the season of light, it was the season of darkness, it was the spring of

12/14 ITC Bookman Light Italic

It was the best of times, it was the worst of times, it was the age of wisdom, it was the age of foolishness, it was the epoch of belief, it was the epoch of incredulity, it was the season of light, it was the season of darkness, it was the spring of

13/15 ITC Bookman Light Italic

It was the best of times, it was the worst of times, it was the age of wisdom, it was the age of foolishness, it was the epoch of belief, it was the epoch of incredulity, it was the season of light, it was the season of darkness, it was the

14/15 ITC Bookman Light Italic

It was the best of times, it was the worst of times, it was the age of wisdom, it was the age of foolishness, it was the epoch of belief, it was the epoch of incredulity, it was the season of light, it was the season of

14/16 ITC Bookman Light Italic

It was the best of times, it was the worst of times, it was the age of wisdom, it was the age of foolishness, it was the epoch of belief, it was the epoch of incredulity, it was the season of light, it was the season of

ITC Bookman Demi 72 point

ABCDEFGHIJK
LMNOPQRSTU
VWXYZ abcdef
ghijklmnopqrs
tuvwxyz123456
7890?!&$%"":

ITC Bookman Demi 10 point

**ABCDEFGHIJKLMNOPQRST UV WXYZ abcdefghij
klmnopqrstuvwxyz 1234567890 ?!/&$%#@*""":;.,**

ITC Bookman Demi 12 point

**ABCDEFGHIJKLMNOPQRSTUVWXYZ abcdefghij
klmnopqrstuvwxyz 1234567890 ?!/&$%#@*""":;.,**

ITC Bookman Demi 13 point

**ABCDEFGHIJKLMNOPQRSTUVWXYZ abcdefghij
klmnopqrstuvwxyz 1234567890 ?!/&$%#@*""":;.,**

ITC Bookman Demi 14 point

**ABCDEFGHIJKLMNOPQRSTUVWXYZ abcdefghij
klmnopqrstuvwxyz 1234567890 ?!/&$%#@*""":;.,**

ITC Bookman Demi 16 point

**ABCDEFGHIJKLMNOPQRSTUVWXYZ abcdefghij
klmnopqrstuvwxyz 1234567890 ?!/&$%#@*""":;.,**

ITC Bookman Demi 18 point

**ABCDEFGHIJKLMNOPQRSTUVWXYZ abcdefghij
klmnopqrstuvwxyz 1234567890 ?!/&$%#@*""":;.,**

ITC Bookman Demi 20 point

**ABCDEFGHIJKLMNOPQRSTUVWXYZ abcdefghij
klmnopqrstuvwxyz 1234567890 ?!/&$%#@*""":;.,**

ITC Bookman Demi 22 point

**ABCDEFGHIJKLMNOPQRSTUVWXYZ abcdefghij
klmnopqrstuvwxyz 1234567890 ?!/&$%#@*""":;.,**

ITC Bookman Demi 24 point

ABCDEFGHIJKLMNOPQRSTUVWXYZ
abcdefghijklmnopqrstuvwxyz1234567890

ITC Bookman Demi 30 point

ABCDEFGHIJKLMNOPQRSTUVWXY
abcdefghijklmnopqrstuvwxyz 12345

ITC Bookman Demi 36 point

ABCDEFGHIJKLMNOPQRSTU
abcdefghijklmnopqrstuvw 123

ITC Bookman Demi 48 point

ABCDEFGHIJKLMNOP
abcdefghijklmnop 123

ITC Bookman Demi 60 point

ABCDEFGHIJKLM
abcdefghijklm 123

ITC Bookman Demi Italic 72 point

ABCDEFGHIJK
LMNOPQRSTU
VWXYZabcdefg
hijklmnopqrst
uvwxyz 123456
7890?!/&$$%:.,

ITC Bookman Demi Italic 10 point

ABCDEFGHIJKLMNOPQRSTUVWXYZ abcdefghij klmnopqrstuvwxyz 1234567890 ?!/&$%#@*""":;.,

ITC Bookman Demi Italic 12 point

ABCDEFGHIJKLMNOPQRSTUVWXYZ abcdefghij klmnopqrstuvwxyz 1234567890 ?!/&$%#@*""":;.,

ITC Bookman Demi Italic 13 point

ABCDEFGHIJKLMNOPQRSTUVWXYZ abcdefghij klmnopqrstuvwxyz 1234567890 ?!/&$%#@*""":;.,

ITC Bookman Demi Italic 14 point

ABCDEFGHIJKLMNOPQRSTUVWXYZ abcdefghij klmnopqrstuvwxyz 1234567890 ?!/&$%#@*""":;.,

ITC Bookman Demi Italic 16 point

ABCDEFGHIJKLMNOPQRSTUVWXYZ abcdefghij klmnopqrstuvwxyz 1234567890 ?!/&$%#@*""":;.,

ITC Bookman Demi Italic 18 point

ABCDEFGHIJKLMNOPQRSTUVWXYZ abcdefghij klmnopqrstuvwxyz 1234567890 ?!/&$%#@*""":;.,

ITC Bookman Demi Italic 20 point

ABCDEFGHIJKLMNOPQRSTUVWXYZ abcdefghij klmnopqrstuvwxyz 1234567890 ?!/&$%#@*""":;.,

ITC Bookman Dem Italic 22 point

ABCDEFGHIJKLMNOPQRSTUVWXYZ abcdefghij klmnopqrstuvwxyz 1234567890 ?!/&$%#@*""":;.,

ITC Bookman Demi Italic 24 point

*ABCDEFGHIJKLMNOPQRSTUVWXYZ abcd
efghijklmnopqrstuvwxyz1234567890 !?%&*

ITC Bookman Demi Italic 30 point

*ABCDEFGHIJKLMNOPQRSTUVWXYZ
abcdefghijklmnopqrstuvwxyz12345*

ITC Bookman Demi Italic 36 point

*ABCDEFGHIJKLMNOPQRSTU
abcdefghijklmnopqrstuvw123*

ITC Bookman Demi Italic 48 point

*ABCDEFGHIJKLMNOP
abcdefghijklmnop 123*

ITC Bookman Demi Italic 60 point

*ABCDEFGHIJKLM
abcdefghijklm123*

Brush Script 72 point

ABCDEFGHIJK
LMNOPQRSTU
VWXYZ abcdefghi
jklmnopqrstuvwxyz
1234567890
?!/&$%*" ".,;,,

Brush Script 10 point

ABCDEFGHIJKLMNOP2RSTUVWXYZ abcdefghij
klmnopqrstuvwxyz 1234567890 ?!/&$%*""::..

Brush Script 12 point

ABCDEFGHIJKLMNOP2RSTUVWXYZ abcdefghij
klmnopqrstuvwxyz 1234567890 ?!/&$%*""::..

Brush Script 13 point

ABCDEFGHIJKLMNOP2RSTUVWXYZ abcdefghij
klmnopqrstuvwxyz 1234567890 ?!/&$%*""::..

Brush Script 14 point

ABCDEFGHIJKLMNOP2RSTUVWXYZ abcdefghij
klmnopqrstuvwxyz 1234567890 ?!/&$%*""::..

Brush Script 16 point

ABCDEFGHIJKLMNOP2RSTUVWXYZ abcdefghij
klmnopqrstuvwxyz 1234567890 ?!/&$%*""::..

Brush Scriot 18 point

ABCDEFGHIJKLMNOP2RSTUVWXYZ abcdefghij
klmnopqrstuvwxyz 1234567890 ?!/&$%*""::..

Brush Script 20 point

ABCDEFGHIJKLMNOP2RSTUVWXYZ abcdefghij
klmnopqrstuvwxyz 1234567890 ?!/&$%*""::..

Brush Script 22 point

ABCDEFGHIJKLMNOP2RSTUVWXYZ abcdefghij
klmnopqrstuvwxyz 1234567890 ?!/&$%*""::..

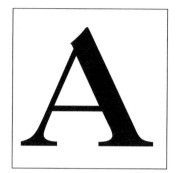

Caslon 3 Roman 72 point

ABCDEFGHIJK
LMNOPQRSTU
VWXYZ abcdefg
hijklmnopqrstuv
wxyz1234567890
?!/&$%#@*""";.;,

Caslon 3 Roman 10 point

ABCDEFGHIJKLMNOPQRSTUVWXYZ abcdefghij
klmnopqrstuvwxyz 1234567890 ?!/&$%#@*""";.,

Caslon 3 Roman 12 point

ABCDEFGHIJKLMNOPQRSTUVWXYZ abcdefghij
klmnopqrstuvwxyz 1234567890 ?!/&$%#@*""";.,

Caslon 3 Roman 13 point

ABCDEFGHIJKLMNOPQRSTUVWXYZ abcdefghij
klmnopqrstuvwxyz 1234567890 ?!/&$%#@*""";.,

Caslon 3 Roman 14 point

ABCDEFGHIJKLMNOPQRSTUVWXYZ abcdefghij
klmnopqrstuvwxyz 1234567890 ?!/&$%#@*""";.,

Caslon 3 Roman 16 point

ABCDEFGHIJKLMNOPQRSTUVWXYZ abcdefghij
klmnopqrstuvwxyz 1234567890 ?!/&$%#@*""";.,

Caslon 3 Roman 18 point

ABCDEFGHIJKLMNOPQRSTUVWXYZ abcdefghij
klmnopqrstuvwxyz 1234567890 ?!/&$%#@*""";.,

Caslon 3 Roman 20 point

ABCDEFGHIJKLMNOPQRSTUVWXYZ abcdefghij
klmnopqrstuvwxyz 1234567890 ?!/&$%#@*""";.,

Caslon 3 Roman 22 point

ABCDEFGHIJKLMNOPQRSTUVWXYZ abcdefgh
ijklmnopqrstuvwxyz 1234567890 ?!/&$%#@*""";.,

Caslon 3 Roman 24 point

ABCDEFGHIJKLMNOPQRSTUVWXYZ
abcdefghijklmnopqrstuvwxyz 1234567890 !?%&

Caslon 3 Roman 30 point

ABCDEFGHIJKLMNOPQRSTUVW
abcdefghijklmnopqrstuvwxyz 1234567

Caslon 3 Roman 36 point

ABCDEFGHIJKLMNOPQRST
abcdefghijklmnopqrstuvwxyz 123

Caslon 3 Roman 48 point

ABCDEFGHIJKLMNO
abcdefghijklmnopqrst 12

Caslon 3 Roman 60 point

ABCDEFGHIJKL
abcdefghijklmnop 12

6/8 Caslon 3 Roman

It was the best of times, it was the worst of times, it was the age of wisdom, it was the age of foolishness, it was the epoch of belief, it was the epoch of incredulity, it was the season of light, it was the season of darkness, it was the spring of hope, it was the winter of despair, we had everything before us, we had nothing before us, we were all going direct to Heaven, we were all going direct the other way-in short, the period was so far like the present period, that some of its noisiest authorities insisted on its being

8/10 Caslon 3 Roman

It was the best of times, it was the worst of times, it was the age of wisdom, it was the age of foolishness, it was the epoch of belief, it was the epoch of incredulity, it was the season of light, it was the season of darkness, it was the spring of hope, it was the winter of despair, we had everything before us, we had nothing before us, we were all going direct to Heaven, we were all going direct

9/10 Caslon 3 Roman

It was the best of times, it was the worst of times, it was the age of wisdom, it was the age of foolishness, it was the epoch of belief, it was the epoch of incredulity, it was the season of light, it was the season of darkness, it was the spring of hope, it was the winter of despair, we had everything before us, we had nothing before us, we were all going

9/11 Caslon 3 Roman

It was the best of times, it was the worst of times, it was the age of wisdom, it was the age of foolishness, it was the epoch of belief, it was the epoch of incredulity, it was the season of light, it was the season of darkness, it was the spring of hope, it was the winter of despair, we had everything before us, we had nothing before us, we were all going

10/11 Caslon 3 Roman

It was the best of times, it was the worst of times, it was the age of wisdom, it was the age of foolishness, it was the epoch of belief, it was the epoch of incredulity, it was the season of light, it was the season of darkness, it was the spring of hope, it was the winter of despair, we had everything before us, we had

10/12 Caslon 3 Roman

It was the best of times, it was the worst of times, it was the age of wisdom, it was the age of foolishness, it was the epoch of belief, it was the epoch of incredulity, it was the season of light, it was the season of darkness, it was the spring of hope, it was the winter of despair, we had everything before us, we had

11/13 Caslon 3 Roman

It was the best of times, it was the worst of times, it was the age of wisdom, it was the age of foolishness, it was the epoch of belief, it was the epoch of incredulity, it was the season of light, it was the season of darkness, it was the spring of hope, it was the winter of despair, we had everything before us, we

11/14 Caslon 3 Roman

It was the best of times, it was the worst of times, it was the age of wisdom, it was the age of foolishness, it was the epoch of belief, it was the epoch of incredulity, it was the season of light, it was the season of darkness, it was the spring of hope, it was the winter of despair, we had everything before us, we

12/13 Caslon 3 Roman

It was the best of times, it was the worst of times, it was the age of wisdom, it was the age of foolishness, it was the epoch of belief, it was the epoch of incredulity, it was the season of light, it was the season of darkness, it was the spring of hope, it was the winter

12/14 Caslon 3 Roman

It was the best of timess, it was the worst of times, it was the age of wisdom, it was the age of foolishness, it was the epoch of belief, it was the epoch of incredulity, it was the season of light, it was the season of darkness, it was the spring of hope, it was the winter

13/15 Caslon 3 Roman

It was the best of times, it was the worst of times, it was the age of wisdom, it was the age of foolishness, it was the epoch of belief, it was the epoch of incredulity, it was the season of light, it was the season of darkness, it was the spring of

14/15 Caslon 3 Roman

It was the best of times, it was the worst of times, it was the age of wisdom, it was the age of foolishness, it was the epoch of belief, it was the epoch of incredulity, it was the season of light, it was the season of darkness, it

14/16 Caslon 3 Roman

It was the best of times, it was the worst of times, it was the age of wisdom, it was the age of foolishness, it was the epoch of belief, it was the epoch of incredulity, it was the season of light, it was the season of darkness, it

Caslon 3 Italic 72 point

ABCDEFGHIJK
LMNOPQRSTU
VWXYZ abcdefg
hijklmnopqrstuv
wxyz 1234567890
?!&$%#@*""";.;,

Caslon 3 Italic 10 point

ABCDEFGHIJKLMNOPQRSTUVWXYZ abcdefghij
klmnopqrstuvwxyz 1234567890 ?!/&$%#@""";.,*

Caslon 3 Italic 12 point

ABCDEFGHIJKLMNOPQRSTUVWXYZ abcdefghij
klmnopqrstuvwxyz 1234567890 ?!/&$%#@""";.,*

Caslon 3 Italic 13 point

ABCDEFGHIJKLMNOPQRSTUVWXYZ abcdefghij
klmnopqrstuvwxyz 1234567890 ?!/&$%#@""";.,*

Caslon 3 Italic 14 point

ABCDEFGHIJKLMNOPQRSTUVWXYZ abcdefghij
klmnopqrstuvwxyz 1234567890 ?!/&$%#@""";.,*

Caslon 3 Italic 16 point

ABCDEFGHIJKLMNOPQRSTUVWXYZ abcdefghij
klmnopqrstuvwxyz 1234567890 ?!/&$%#@""";.,*

Caslon 3 Italic 18 point

ABCDEFGHIJKLMNOPQRSTUVWXYZ abcdefghij
klmnopqrstuvwxyz 1234567890 ?!/&$%#@""";.,*

Caslon 3 Italic 20 point

ABCDEFGHIJKLMNOPQRSTUVWXYZ abcdefghij
klmnopqrstuvwxyz 1234567890 ?!/&$%#@""";.,*

Caslon 3 Italic 22 point

ABCDEFGHIJKLMNOPQRSTUVWXYZ abcdefghij
klmnopqrstuvwxyz 1234567890 ?!/&$%#@""";.,*

Caslon 3 Italic 24 point

ABCDEFGHIJKLMNOPQRSTUVWXYZ
*abcdefghijklmnopqrstuvwxyz 1234567890 !?%&**

Caslon 3 Italic 30 point

ABCDEFGHIJKLMNOPQRSTUVWXYZ
abcdefghijklmnopqrstuvwxyz 1234567890

Caslon 3 Italic 36 point

ABCDEFGHIJKLMNOPQRSTUV
abcdefghijklmnopqrstuvwxyz 12345

Caslon 3 Italic 48 point

ABCDEFGHIJKLMNOPQ
abcdefghijklmnopqrstu 12345

Caslon 3 Italic 60 point

ABCDEFGHIJKLM
abcdefghijklmnopq 12

6/8 Caslon 3 Italic

It was the best of times, it was the worst of times, it was the age of wisdom, it was the age of foolishness, it was the epoch of belief, it was the epoch of incredulity, it was the season of light, it was the season of darkness, it was the spring of hope, it was the winter of despair, we had everything before us, we had nothing before us, we were all going direct to Heaven, we were all going direct the other way-in short, the period was so far like the present period, that some of its noisiest authorities insisted on its being received, for good or for evil, in the superlative

8/10 Caslon 3 Italic

It was the best of times, it was the worst of times, it was the age of wisdom, it was the age of foolishness, it was the epoch of belief, it was the epoch of incredulity, it was the season of light, it was the season of darkness, it was the spring of hope, it was the winter of despair, we had everything before us, we had nothing before us, we were all going direct to Heaven, we were all going direct the other way-in short, the period

9/10 Caslon 3 Italic

It was the best of times, it was the worst of times, it was the age of wisdom, it was the age of foolishness, it was the epoch of belief, it was the epoch of incredulity, it was the season of light, it was the season of darkness, it was the spring of hope, it was the winter of despair, we had everything before us, we had nothing before us, we were all going direct to Heaven, we were all

9/11 Caslon 3 Italic

It was the best of times, it was the worst of times, it was the age of wisdom, it was the age of foolishness, it was the epoch of belief, it was the epoch of incredulity, it was the season of light, it was the season of darkness, it was the spring of hope, it was the winter of despair, we had everything before us, we had nothing before us, we were all going direct to Heaven, we were all

10/11 Caslon 3 Italic

It was the best of times, it was the worst of times, it was the age of wisdom, it was the age of foolishness, it was the epoch of belief, it was the epoch of incredulity, it was the season of light, it was the season of darkness, it was the spring of hope, it was the winter of despair, we had everything before us, we had nothing before us, we were all

10/12 Caslon 3 Italic

It was the best of times, it was the worst of times, it was the age of wisdom, it was the age of foolishness, it was the epoch of belief, it was the epoch of incredulity, it was the season of light, it was the season of darkness, it was the spring of hope, it was the winter of despair, we had everything before us, we had nothing before us, we were all

11/13 Caslon 3 Italic

It was the best of times, it was the worst of times, it was the age of wisdom, it was the age of foolishness, it was the epoch of belief, it was the epoch of incredulity, it was the season of light, it was the season of darkness, it was the spring of hope, it was the winter of despair, we had everything before us, we had

11/14 Caslon 3 Italic

It was the best of times, it was the worst of times, it was the age of wisdom, it was the age of foolishness, it was the epoch of belief, it was the epoch of incredulity, it was the season of light, it was the season of darkness, it was the spring of hope, it was the winter of despair, we had everything before us, we had

12/13 Caslon 3 Italic

It was the best of times, it was the worst of times, it was the age of wisdom, it was the age of foolishness, it was the epoch of belief, it was the epoch of incredulity, it was the season of light, it was the season of darkness, it was the spring of hope, it was the winter of despair, we had everything before us, we

12/14 Caslon 3 Italic

It was the best of times, it was the worst of times, it was the age of wisdom, it was the age of foolishness, it was the epoch of belief, it was the epoch of incredulity, it was the season of light, it was the season of darkness, it was the spring of hope, it was the winter of despair, we had everything before us, we

13/15 Caslon 3 Italic

It was the best of times, it was the worst of times, it was the age of wisdom, it was the age of foolishness, it was the epoch of belief, it was the epoch of incredulity, it was the season of light, it was the season of darkness, it was the spring of hope, it was the winter

14/15 Caslon 3 Italic

It was the best of times, it was the worst of times, it was the age of wisdom, it was the age of foolishness, it was the epoch of belief, it was the epoch of incredulity, it was the season of light, it was the season of darkness, it was the spring of hope, it was the winter

14/16 Caslon 3 Italic

It was the best of times, it was the worst of times, it was the age of wisdom, it was the age of foolishness, it was the epoch of belief, it was the epoch of incredulity, it was the season of light, it was the season of darkness, it was the spring of hope, it was the winter

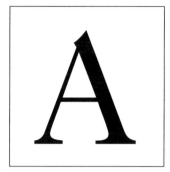

Caslon 540 Roman 72 point

ABCDEFGHIJK
LMNOPQRSTU
VWXYZ abcdefg
hijklmnopqrstuv
wxyz1234567890
?!/&$%#@*""..;.,

Caslon 540 Roman 10 point

ABCDEFGHIJKLMNOPQRSTUVWXYZ abcdefghij
klmnopqrstuvwxyz 1234567890 ?!/&$%#@*""":;.,

Caslon 540 Roman 12 point

ABCDEFGHIJKLMNOPQRSTUVWXYZ abcdefghij
klmnopqrstuvwxyz 1234567890 ?!/&$%#@*""":;.,

Caslon 540 Roman 13 point

ABCDEFGHIJKLMNOPQRSTUVWXYZ abcdefghij
klmnopqrstuvwxyz 1234567890 ?!/&$%#@*""":;.,

Caslon 540 Roman 14 point

ABCDEFGHIJKLMNOPQRSTUVWXYZ abcdefghij
klmnopqrstuvwxyz 1234567890 ?!/&$%#@*""":;.,

Caslon 540 Roman 16 point

ABCDEFGHIJKLMNOPQRSTUVWXYZ abcdefghij
klmnopqrstuvwxyz 1234567890 ?!/&$%#@*""":;.,

Caslon 540 Roman 18 point

ABCDEFGHIJKLMNOPQRSTUVWXYZ abcdefghij
klmnopqrstuvwxyz 1234567890 ?!/&$%#@*""":;.,

Caslon 540 Roman 20 point

ABCDEFGHIJKLMNOPQRSTUVWXYZ abcdefghij
klmnopqrstuvwxyz 1234567890 ?!/&$%#@*""":;.,

Caslon 540 Roman 22 point

ABCDEFGHIJKLMNOPQRSTUVWXYZ abcdefghij
klmnopqrstuvwxyz 1234567890 ?!/&$%#@*""":;.,

Caslon 540 Roman 24 point

ABCDEFGHIJKLMNOPQRSTUVWXYZ
abcdefghijklmnopqrstuvwxyz 1234567890 !?%&*

Caslon 540 Roman 30 point

ABCDEFGHIJKLMNOPQRSTUVWXYZ
abcdefghijklmnopqrstuvwxyz 1234567890

Caslon 540 Roman 36 point

ABCDEFGHIJKLMNOPQRSTUV
abcdefghijklmnopqrstuvwxyz 12345

Caslon 540 Roman 48 point

ABCDEFGHIJKLMNOP
abcdefghijklmnopqrstu 123

Caslon 540 Roman 60 point

ABCDEFGHIJKLM
abcdefghijklmnop 123

6/8 Caslon 540 Roman

It was the best of times , it was the worst of times, it was the age of wisdom, it was the age of foolishness, it was the epoch of belief, it was the epoch of incredulity, it was the season of light, it was the season of darkness, it was the spring of hope, it was the winter of despair, we had everything before us, we had nothing before us, we were all going direct to Heaven, we were all going direct the other way-in short, the period was so far like the present period, that some of its noisiest authorities insisted on its being received, for good or for evil, in the superlative

8/10 Caslon 540 Roman

It was the best of times , it was the worst of times, it was the age of wisdom, it was the age of foolishness, it was the epoch of belief, it was the epoch of incredulity, it was the season of light, it was the season of darkness, it was the spring of hope, it was the winter of despair, we had everything before us, we had nothing before us, we were all going direct to Heaven, we were all going direct the other way-in short, the period was so far

9/10 Caslon 540 Roman

It was the best of times , it was the worst of times, it was the age of wisdom, it was the age of foolishness, it was the epoch of belief, it was the epoch of incredulity, it was the season of light, it was the season of darkness, it was the spring of hope, it was the winter of despair, we had everything before us, we had nothing before us, we were all going direct to Heaven, we were all going

9/11 Caslon 540 Roman

It was the best of times , it was the worst of times, it was the age of wisdom, it was the age of foolishness, it was the epoch of belief, it was the epoch of incredulity, it was the season of light, it was the season of darkness, it was the spring of hope, it was the winter of despair, we had everything before us, we had nothing before us, we were all going direct to Heaven, we were all going

10/11 Caslon 540 Roman

It was the best of times , it was the worst of times, it was the age of wisdom, it was the age of foolishness, it was the epoch of belief, it was the epoch of incredulity, it was the season of light, it was the season of darkness, it was the spring of hope, it was the winter of despair, we had everything before us, we had nothing before us, we were all

10/12 Caslon 540 Roman

It was the best of times , it was the worst of times, it was the age of wisdom, it was the age of foolishness, it was the epoch of belief, it was the epoch of incredulity, it was the season of light, it was the season of darkness, it was the spring of hope, it was the winter of despair, we had everything before us, we had nothing before us, we were all

11/13 Caslon 540 Roman

It was the best of times , it was the worst of times, it was the age of wisdom, it was the age of foolishness, it was the epoch of belief, it was the epoch of incredulity, it was the season of light, it was the season of darkness, it was the spring of hope, it was the winter of despair, we had everything before us, we had

11/14 Caslon 540 Roman

It was the best of times, it was the worst of times, it was the age of wisdom, it was the age of foolishness, it was the epoch of belief, it was the epoch of incredulity, it was the season of light, it was the season of darkness, it was the spring of hope, it was the winter of despair, we had everything before us, we had

12/13 Caslon 540 Roman

It was the best of times, it was the worst of times, it was the age of wisdom, it was the age of foolishness, it was the epoch of belief, it was the epoch of incredulity, it was the season of light, it was the season of darkness, it was the spring of hope, it was the winter of despair, we had everything before us, we

12/14 Caslon 540 Roman

It was the best of times, it was the worst of times, it was the age of wisdom, it was the age of foolishness, it was the epoch of belief, it was the epoch of incredulity, it was the season of light, it was the season of darkness, it was the spring of hope, it was the winter of despair, we had everything before us, we

13/15 Caslon 540 Roman

It was the best of times, it was the worst of times, it was the age of wisdom, it was the age of foolishness, it was the epoch of belief, it was the epoch of incredulity, it was the season of light, it was the season of darkness, it was the spring of hope, it was

14/15 Caslon 540 Roman

It was the best of times, it was the worst of times, it was the age of wisdom, it was the age of foolishness, it was the epoch of belief, it was the epoch of incredulity, it was the season of light, it was the season of darkness, it was the spring of

14/16 Caslon 540 Roman

It was the best of times, it was the worst of times, it was the age of wisdom, it was the age of foolishness, it was the epoch of belief, it was the epoch of incredulity, it was the season of light, it was the season of darkness, it was the spring of

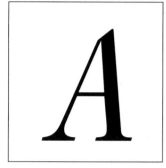

Caslon 540 Italic 72 point

ABCDEFGHIJK
LMNOPQRSTU
VWXYZ abcdefgh
ijklmnopqrstuvw
xyz 1234567890
?!&$%#@*""..;.,

Caslon 540 Italic 10 point

ABCDEFGHIJKLMNOPQRSTUVWXYZ abcdefghij
klmnopqrstuvwxyz 1234567890 ?!/&$%#@""":;.,*

Caslon 540 Italic 12 point

ABCDEFGHIJKLMNOPQRSTUVWXYZ abcdefghij
klmnopqrstuvwxyz 1234567890 ?!/&$%#@""":;.,*

Caslon 540 Italic 13 point

ABCDEFGHIJKLMNOPQRSTUVWXYZ abcdefghij
klmnopqrstuvwxyz 1234567890 ?!/&$%#@""":;.,*

Caslon 540 Italic 14 point

ABCDEFGHIJKLMNOPQRSTUVWXYZ abcdefghij
klmnopqrstuvwxyz 1234567890 ?!/&$%#@""":;.,*

Caslon 540 Italic 16 point

ABCDEFGHIJKLMNOPQRSTUVWXYZ abcdefghij
klmnopqrstuvwxyz 1234567890 ?!/&$%#@""":;.,*

Caslon 540 Italic 18 point

ABCDEFGHIJKLMNOPQRSTUVWXYZ abcdefghij
klmnopqrstuvwxyz 1234567890 ?!/&$%#@""":;.,*

Caslon 540 Italic 20 point

ABCDEFGHIJKLMNOPQRSTUVWXYZ abcdefghij
klmnopqrstuvwxyz 1234567890 ?!/&$%#@""":;.,*

Caslon 540 Italic 22 point

ABCDEFGHIJKLMNOPQRSTUVWXYZ abcdefghij
klmnopqrstuvwxyz 1234567890 ?!/&$%#@""":;.,*

Caslon 540 Italic 24 point

ABCDEFGHIJKLMNOPQRSTUVWXYZ
abcdefghijklmnopqrstuvwxyz 1234567890 !?%&*

Caslon 540 Italic 30 point

ABCDEFGHIJKLMNOPQRSTUVWXYZ
abcdefghijklmnopqrstuvwxyz 1234567890

Caslon 540 Italic 36 point

ABCDEFGHIJKLMNOPQRSTUVWX
abcdefghijklmnopqrstuvwxyz 12345678

Caslon 540 Italic 48 point

ABCDEFGHIJKLMNOPQR
abcdefghijklmnopqrstu 12345

Caslon 540 Italic 60 point

ABCDEFGHIJKLMN
abcdefghijklmnopqr 123

6/8 Caslon 540 Italic

It was the best of times , it was the worst of times, it was the age of wisdom, it was the age of foolishness, it was the epoch of belief, it was the epoch of incredulity, it was the season of light, it was the season of darkness, it was the spring of hope, it was the winter of despair, we had everything before us, we had nothing before us, we were all going direct to Heaven, we were all going direct the other way-in short, the period was so far like the present period, that some of its noisiest authorities insisted on its being received, for good or for evil, in the superlative degree of comparison only.

8/10 Caslon 540 Italic

It was the best of times , it was the worst of times, it was the age of wisdom, it was the age of foolishness, it was the epoch of belief, it was the epoch of incredulity, it was the season of light, it was the season of darkness, it was the spring of hope, it was the winter of despair, we had everything before us, we had nothing before us, we were all going direct to Heaven, we were all going direct the other way-in short, the period was so far like the present period, that some of its

9/10 Caslon 540 Italic

It was the best of times , it was the worst of times, it was the age of wisdom, it was the age of foolishness, it was the epoch of belief, it was the epoch of incredulity, it was the season of light, it was the season of darkness, it was the spring of hope, it was the winter of despair, we had everything before us, we had nothing before us, we were all going direct to Heaven, we were all going direct the other way-in short, the period was so

9/11 Caslon 540 Italic

It was the best of times , it was the worst of times, it was the age of wisdom, it was the age of foolishness, it was the epoch of belief, it was the epoch of incredulity, it was the season of light, it was the season of darkness, it was the spring of hope, it was the winter of despair, we had everything before us, we had nothing before us, we were all going direct to Heaven, we were all going direct the other way-in short, the period was so

10/11 Caslon 540 Italic

It was the best of times , it was the worst of times, it was the age of wisdom, it was the age of foolishness, it was the epoch of belief, it was the epoch of incredulity, it was the season of light, it was the season of darkness, it was the spring of hope, it was the winter of despair, we had everything before us, we had nothing before us, we were all going direct to Heaven, we were all going

10/12 Caslon 540 Italic

It was the best of times , it was the worst of times, it was the age of wisdom, it was the age of foolishness, it was the epoch of belief, it was the epoch of incredulity, it was the season of light, it was the season of darkness, it was the spring of hope, it was the winter of despair, we had everything before us, we had nothing before us, we were all going direct to Heaven, we were all going

11/13 Caslon 540 Italic

It was the best of times , it was the worst of times, it was the age of wisdom, it was the age of foolishness, it was the epoch of belief, it was the epoch of incredulity, it was the season of light, it was the season of darkness, it was the spring of hope, it was the winter of despair, we had everything before us, we had nothing before us, we were all going direct

11/14 Caslon 540 Italic

It was the best of times, it was the worst of times, it was the age of wisdom, it was the age of foolishness, it was the epoch of belief, it was the epoch of incredulity, it was the season of light, it was the season of darkness, it was the spring of hope, it was the winter of despair, we had everything before us, we had nothing before us, we were all going direct

12/13 Caslon 540 Italic

It was the best of times, it was the worst of times, it was the age of wisdom, it was the age of foolishness, it was the epoch of belief, it was the epoch of incredulity, it was the season of light, it was the season of darkness, it was the spring of hope, it was the winter of despair, we had everything before us, we had nothing before

12/14 Caslon 540 Italic

It was the best of times, it was the worst of times, it was the age of wisdom, it was the age of foolishness, it was the epoch of belief, it was the epoch of incredulity, it was the season of light, it was the season of darkness, it was the spring of hope, it was the winter of despair, we had everything before us, we had nothing before

13/15 Caslon 540 Italic

It was the best of times, it was the worst of times, it was the age of wisdom, it was the age of foolishness, it was the epoch of belief, it was the epoch of incredulity, it was the season of light, it was the season of darkness, it was the spring of hope, it was the winter of despair, we had everything before us, we

14/15 Caslon 540 Italic

It was the best of times, it was the worst of times, it was the age of wisdom, it was the age of foolishness, it was the epoch of belief, it was the epoch of incredulity, it was the season of light, it was the season of darkness, it was the spring of hope, it was the winter of despair, we had everything before us, we

14/16 Caslon 540 Italic

It was the best of times, it was the worst of times, it was the age of wisdom, it was the age of foolishness, it was the epoch of belief, it was the epoch of incredulity, it was the season of light, it was the season of darkness, it was the spring of hope, it was the winter of despair, we had everything before us, we

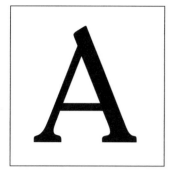

ITC Cheltenham Book 72 point

ABCDEFGHIJKL
MNOPQRSTUVW
XYZ abcdefghijkl
mnopqrstuvwxyz
1234567890
?!/&$%#@*""..
·,·,

ITC Cheltenham Book 24 point

ABCDEFGHIJKLMNOPQRSTUVWXYZ
abcdefghijklmnopqrstuvwxyz 1234567890 !?%&*

ITC Cheltenham Book 30 point

ABCDEFGHIJKLMNOPQRSTUVWXYZ
abcdefghijklmnopqrstuvwxyz 1234567

ITC Cheltenham Book 36 point

ABCDEFGHIJKLMNOPQRSTUVWXY
abcdefghijklmnopqrstuvwxyz 123456

ITC Cheltenham Book 48 point

ABCDEFGHIJKLMNOPQRST
abcdefghijklmnopqrstuv 123

ITC Cheltenham Book 60 point

ABCDEFGHIJKLMNOP
abcdefghijklmnop 1234

6/8 ITC Cheltenham Book

It was the best of times, it was the worst of times, it was the age of wisdom, it was the age of foolishness, it was the epoch of belief, it was the epoch of incredulity, it was the season of light, it was the season of darkness, it was the spring of hope, it was the winter of despair, we had everything before us, we had nothing before us, we were all going direct to Heaven, we were all going direct the other way-in short, the period was so far like the present period, that some of its noisiest authorities insisted on its being received,

8/10 ITC Cheltenham Book

It was the best of times, it was the worst of times, it was the age of wisdom, it was the age of foolishness, it was the epoch of belief, it was the epoch of incredulity, it was the season of light, it was the season of darkness, it was the spring of hope, it was the winter of despair, we had everything before us, we had nothing before us, we were all going direct to Heaven, we were all going direct

9/10 ITC Cheltenham Book

It was the best of times , it was the worst of times, it was the age of wisdom, it was the age of foolishness, it was the epoch of belief, it was the epoch of incredulity, it was the season of light, it was the season of darkness, it was the spring of hope, it was the winter of despair, we had everything before us, we had nothing before us, we were all going

9/11 ITC Cheltenham Book

It was the best of times, it was the worst of times, it was the age of wisdom, it was the age of foolishness, it was the epoch of belief, it was the epoch of incredulity, it was the season of light, it was the season of darkness, it was the spring of hope, it was the winter of despair, we had everything before us, we had nothing before us, we were all going

10/11 ITC Cheltenham Book

It was the best of times, it was the worst of times, it was the age of wisdom, it was the age of foolishness, it was the epoch of belief, it was the epoch of incredulity, it was the season of light, it was the season of darkness, it was the spring of hope, it was the winter of despair, we had everything before us, we had nothing before us,

10/12 ITC Cheltenham Book

It was the best of times, it was the worst of times, it was the age of wisdom, it was the age of foolishness, it was the epoch of belief, it was the epoch of incredulity, it was the season of light, it was the season of darkness, it was the spring of hope, it was the winter of despair, we had everything before us, we had nothing before us,

11/13 ITC Cheltenham Book

It was the best of times, it was the worst of times, it was the age of wisdom, it was the age of foolishness, it was the epoch of belief, it was the epoch of incredulity, it was the season of light, it was the season of darkness, it was the spring of hope, it was the winter of despair, we had everything before us, we

11/14 ITC Cheltenham Book

It was the best of times, it was the worst of times, it was the age of wisdom, it was the age of foolishness, it was the epoch of belief, it was the epoch of incredulity, it was the season of light, it was the season of darkness, it was the spring of hope, it was the winter of despair, we had everything before us, we

12/13 ITC Cheltenham Book

It was the best of times, it was the worst of times, it was the age of wisdom, it was the age of foolishness, it was the epoch of belief, it was the epoch of incredulity, it was the season of light, it was the season of darkness, it was the spring of hope, it was the winter

12/14 ITC Cheltenham Book

It was the best of times, it was the worst of times, it was the age of wisdom, it was the age of foolishness, it was the epoch of belief, it was the epoch of incredulity, it was the season of light, it was the season of darkness, it was the spring of hope, it was the winter

13/15 ITC Cheltenham Book

It was the best of times, it was the worst of times, it was the age of wisdom, it was the age of foolishness, it was the epoch of belief, it was the epoch of incredulity, it was the season of light, it was the season of darkness, it was the spring of

14/15 ITC Cheltenham Book

It was the best of times, it was the worst of times, it was the age of wisdom, it was the age of foolishness, it was the epoch of belief, it was the epoch of incredulity, it was the season of light, it was the season of darkness, it

14/16 ITC Cheltenham Book

It was the best of times, it was the worst of times, it was the age of wisdom, it was the age of foolishness, it was the epoch of belief, it was the epoch of incredulity, it was the season of light, it was the season of darkness, it

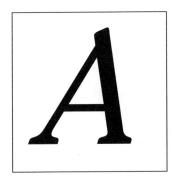

ITC Cheltenham Book Italic 72 point

ABCDEFGHIJKL

MNOPQRSTUVW

XYZ abcdefghijkl

mnopqrstuvwxyz

1234567890

*?!/&$%#@ * ""..*
.,.,

ITC Cheltenham Book Italic 24 point

ABCDEFGHIJKLMNOPQRSTUVWXYZ
*abcdefghijklmnopqrstuvwxyz 1234567890 !?%&**

ITC Cheltenham Book Italic 30 point

ABCDEFGHIJKLMNOPQRSTUVWXYZ
abcdefghijklmnopqrstuvwxyz 123456789

ITC Cheltenham Book Italic Italic 36 point

ABCDEFGHIJKLMNOPQRSTUVWXY
abcdefghijklmnopqrstuvwxyz 1234

ITC Cheltenham Book Italic 48 point

ABCDEFGHIJKLMNOPQRS
abcdefghijklmnopqrstuv 1234

ITC Cheltenham Book Italic 60 point

ABCDEFGHIJKLMNO
abcdefghijklmnopq12

6/8 ITC Cheltenham Book talic

It was the best of times, it was the worst of times, it was the age of wisdom, it was the age of foolishness, it was the epoch of belief, it was the epoch of incredulity, it was the season of light, it was the season of darkness, it was the spring of hope, it was the winter of despair, we had everything before us, we had nothing before us, we were all going direct to Heaven, we were all going direct the other way-in short, the period was so far like the present period, that some of its noisiest authorities insisted on its being received, for good or for evil, in

8/10 ITC Cheltenham Book Italic

It was the best of times, it was the worst of times, it was the age of wisdom, it was the age of foolishness, it was the epoch of belief, it was the epoch of incredulity, it was the season of light, it was the season of darkness, it was the spring of hope, it was the winter of despair, we had everything before us, we had nothing before us, we were all going direct to Heaven, we were all going direct the other way-in short,

9/10 ITC Cheltenham Book Italic

It was the best of times, it was the worst of times, it was the age of wisdom, it was the age of foolishness, it was the epoch of belief, it was the epoch of incredulity, it was the season of light, it was the season of darkness, it was the spring of hope, it was the winter of despair, we had everything before us, we had nothing before us, we were all going direct to Heaven, we were

9/11 ITC Cheltenham Book Italic

It was the best of times, it was the worst of times, it was the age of wisdom, it was the age of foolishness, it was the epoch of belief, it was the epoch of incredulity, it was the season of light, it was the season of darkness, it was the spring of hope, it was the winter of despair, we had everything before us, we had nothing before us, we were all going direct to Heaven, we were

10/11 ITC Cheltenham Book Italic

It was the best of times, it was the worst of times, it was the age of wisdom, it was the age of foolishness, it was the epoch of belief, it was the epoch of incredulity, it was the season of light, it was the season of darkness, it was the spring of hope, it was the winter of despair, we had everything before us, we had nothing before us, we

10/12 ITC Cheltenham Book Italic

It was the best of times, it was the worst of times, it was the age of wisdom, it was the age of foolishness, it was the epoch of belief, it was the epoch of incredulity, it was the season of light, it was the season of darkness, it was the spring of hope, it was the winter of despair, we had everything before us, we had nothing before us, we

11/13 ITC Cheltenham Book Italic

It was the best of times, it was the worst of times, it was the age of wisdom, it was the age of foolishness, it was the epoch of belief, it was the epoch of incredulity, it was the season of light, it was the season of darkness, it was the spring of hope, it was the winter of despair, we had everything before us, we had

11/14 ITC Cheltenham Book Italic

It was the best of times, it was the worst of times, it was the age of wisdom, it was the age of foolishness, it was the epoch of belief, it was the epoch of incredulity, it was the season of light, it was the season of darkness, it was the spring of hope, it was the winter of despair, we had everything before us, we had

12/13 ITC Cheltenham Book Italic

It was the best of times, it was the worst of times, it was the age of wisdom, it was the age of foolishness, it was the epoch of belief, it was the epoch of incredulity, it was the season of light, it was the season of darkness, it was the spring of hope, it was the winter of despair, we

12/14 ITC Cheltenham Book Italic

It was the best of times, it was the worst of times, it was the age of wisdom, it was the age of foolishness, it was the epoch of belief, it was the epoch of incredulity, it was the season of light, it was the season of darkness, it was the spring of hope, it was the winter of despair, we

13/15 ITC Cheltenham Book Italic

It was the best of times, it was the worst of times, it was the age of wisdom, it was the age of foolishness, it was the epoch of belief, it was the epoch of incredulity, it was the season of light, it was the season of darkness, it was the spring of hope, it was

14/15 ITC Cheltenham Book Italic

It was the best of times, it was the worst of times, it was the age of wisdom, it was the age of foolishness, it was the epoch of belief, it was the epoch of incredulity, it was the season of light, it was the season of darkness, it was the spring

14/16 ITC Cheltenham Book Italic

It was the best of times, it was the worst of times, it was the age of wisdom, it was the age of foolishness, it was the epoch of belief, it was the epoch of incredulity, it was the season of light, it was the season of darkness, it was the spring

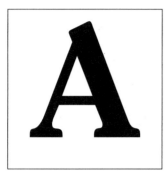

ITC Cheltenham Bold 72 point

ABCDEFGHIJKL
MNOPQRSTUV
WXYZ abcdefghij
klmnopqrstuvwx
yz 1234567890
?!/&$%#@*""·:;·,

ITC Cheltenham Bold 24 point

ABCDEFGHIJKLMNOPQRSTUVWXYZ
abcdefghijklmnopqrstuvwxyz 1234567890 !?%&

ITC Cheltenham Bold 30 point

ABCDEFGHIJKLMNOPQRSTUVWXYZ
abcdefghijklmnopqrstuvwxyz 123456

ITC Cheltenham Bold 36 point

ABCDEFGHIJKLMNOPQRSTUVW
abcdefghijklmnopqrstuvwxyz123

ITC Cheltenham Bold 48 point

ABCDEFGHIJKLMNOPQR
abcdefghijklmnopqrst 12

ITC Cheltenham Bold 60 point

ABCDEFGHIJKLMNO
abcdefghijklmnopq12

6/8 ITC Cheltenham Bold

It was the best of times, it was the worst of times, it was the age of wisdom, it was the age of foolishness, it was the epoch of belief, it was the epoch of incredulity, it was the season of light, it was the season of darkness, it was the spring of hope, it was the winter of despair, we had everything before us, we had nothing before us, we were all going direct to Heaven, we were all going direct the other way-in short, the period was so far like the present period, that some of its noisiest authorities insisted on its

8/10 ITC Cheltenham Bold

It was the best of times, it was the worst of times, it was the age of wisdom, it was the age of foolishness, it was the epoch of belief, it was the epoch of incredulity, it was the season of light, it was the season of darkness, it was the spring of hope, it was the winter of despair, we had everything before us, we had nothing before us, we were all going direct to Heaven, we were all going

9/10 ITC Cheltenham Bold

It was the best of times, it was the worst of times, it was the age of wisdom, it was the age of foolishness, it was the epoch of belief, it was the epoch of incredulity, it was the season of light, it was the season of darkness, it was the spring of hope, it was the winter of despair, we had everything before us, we had nothing before us, we were all

9/11 ITC Cheltenham Bold

It was the best of times, it was the worst of times, it was the age of wisdom, it was the age of foolishness, it was the epoch of belief, it was the epoch of incredulity, it was the season of light, it was the season of darkness, it was the spring of hope, it was the winter of despair, we had everything before us, we had nothing before us, we were all

10/11 ITC Cheltenham Bold

It was the best of times, it was the worst of times, it was the age of wisdom, it was the age of foolishness, it was the epoch of belief, it was the epoch of incredulity, it was the season of light, it was the season of darkness, it was the spring of hope, it was the winter of despair, we had everything before us, we

10/12 ITC Cheltenham Bold

It was the best of times, it was the worst of times, it was the age of wisdom, it was the age of foolishness, it was the epoch of belief, it was the epoch of incredulity, it was the season of light, it was the season of darkness, it was the spring of hope, it was the winter of despair, we had everything before us, we

11/13 ITC Cheltenham Bold

It was the best of times, it was the worst of times, it was the age of wisdom, it was the age of foolishness, it was the epoch of belief, it was the epoch of incredulity, it was the season of light, it was the season of darkness, it was the spring of hope, it was the winter of despair, we had everything before us, we had

11/14 ITC Cheltenham Bold

It was the best of times, it was the worst of times, it was the age of wisdom, it was the age of foolishness, it was the epoch of belief, it was the epoch of incredulity, it was the season of light, it was the season of darkness, it was the spring of hope, it was the winter of despair, we had had everything before us, we had

12/13 ITC Cheltenham Bold

It was the best of times, it was the worst of times, it was the age of wisdom, it was the age of foolishness, it was the epoch of belief, it was the epoch of incredulity, it was the season of light, it was the season of darkness, it was the spring of hope, it was

12/14 ITC Cheltenham Bold

It was the best of times, it was the worst of times, it was the age of wisdom, it was the age of foolishness, it was the epoch of belief, it was the epoch of incredulity, it was the season of light, it was the season of darkness, it was the spring of hope, it was

13/15 ITC Cheltenham Bold

It was the best of times, it was the worst of times, it was the age of wisdom, it was the age of foolishness, it was the epoch of belief, it was the epoch of incredulity, it was the season of light, it was the season of darkness, it was the spring

14/15 ITC Cheltenham Bold

It was the best of times, it was the worst of times, it was the age of wisdom, it was the age of foolishness, it was the epoch of belief, it was the epoch of incredulity, it was the season of light, it was the season of darkness,

14/16 ITC Cheltenham Bold

It was the best of times, it was the worst of times, it was the age of wisdom, it was the age of foolishness, it was the epoch of belief, it was the epoch of incredulity, it was the season of light, it was the season of darkness,

ITC Cheltenham Bold Italic 72 point

ABCDEFGHIJKL

MNOPQRSTUV

WXYZ abcdefghij

klmnopqrstuvwx

yz 1234567890

*?!/&$%#@ * " " .,.,*

ITC Cheltenham Bold Italic 24 point

ABCDEFGHIJKLMNOPQRSTUVWXYZ
abcdefghijklmnopqrstuvwxyz 1234567890 !?%

ITC Cheltenham Bold Italic 30 point

ABCDEFGHIJKLMNOPQRSTUVWXYZ
abcdefghijklmnopqrstuvwxyz 123456

ITC Cheltenham Bold Italic 36 point

ABCDEFGHIJKLMNOPQRSTUVWXZ
abcdefghijklmnopqrstuvwxyz 123

ITC Cheltenham Bold Italic 48 point

ABCDEFGHIJKLMNOPQR
abcdefghijklmnopqrstu 12

ITC Cheltenham Bold Italic 60 point

ABCDEFGHIJKLMNO
abcdefghijklmnopqr1

6/8 ITC Cheltenham Bold Italic

It was the best of times, it was the worst of times, it was the age of wisdom, it was the age of foolishness, it was the epoch of belief, it was the epoch of incredulity, it was the season of light, it was the season of darkness, it was the spring of hope, it was the winter of despair, we had everything before us, we had nothing before us, we were all going direct to Heaven, we were all going direct the other way-in short, the period was so far like the present period, that some of its noisiest

8/10 ITC Cheltenham Bold Italic

It was the best of times, it was the worst of times, it was the age of wisdom, it was the age of foolishness, it was the epoch of belief, it was the epoch of incredulity, it was the season of light, it was the season of darkness, it was the spring of hope, it was the winter of despair, we had everything before us, we had nothing before us, we were all going direct to Heaven, we were

9/10 ITC Cheltenham Bold Italic

It was the best of times, it was the worst of times, it was the age of wisdom, it was the age of foolishness, it was the epoch of belief, it was the epoch of incredulity, it was the season of light, it was the season of darkness, it was the spring of hope, it was the winter of despair, we had everything before us, we had nothing before us,

9/11 ITC Cheltenham Bold Italic

It was the best of times, it was the worst of times, it was the age of wisdom, it was the age of foolishness, it was the epoch of belief, it was the epoch of incredulity, it was the season of light, it was the season of darkness, it was the spring of hope, it was the winter of despair, we had everything before us, we had nothing before us,

10/11 Cheltenham Bold Italic

It was the best of times, it was the worst of times, it was the age of wisdom, it was the age of foolishness, it was the epoch of belief, it was the epoch of incredulity, it was the season of light, it was the season of darkness, it was the spring of hope, it was the winter of despair, we had everything before us, we

10/12 ITC Cheltenham Bold Italic

It was the best of times, it was the worst of times, it was the age of wisdom, it was the age of foolishness, it was the epoch of belief, it was the epoch of incredulity, it was the season of light, it was the season of darkness, it was the spring of hope, it was the winter of despair, we had everything before us, we

11/13 ITC Cheltenham Bold Italic

It was the best of times, it was the worst of times, it was the age of wisdom, it was the age of foolishness, it was the epoch of belief, it was the epoch of incredulity, it was the season of light, it was the season of darkness, it was the spring of hope, it was the winter of despair, we had everything before us, we

11/14 ITC Cheltenham Bold Italic

It was the best of times, it was the worst of times, it was the age of wisdom, it was the age of foolishness, it was the epoch of belief, it was the epoch of incredulity, it was the season of light, it was the season of darkness, it was the spring of hope, it was the winter of despair, we had everything before us, we

12/13 ITC Cheltenham Bold Italic

It was the best of times, it was the worst of times, it was the age of wisdom, it was the age of foolishness, it was the epoch of belief, it was the epoch of incredulity, it was the season of light, it was the season of darkness, it was the spring of

12/14 ITC Cheltenham Bold Italic

It was the best of times, it was the worst of times, it was the age of wisdom, it was the age of foolishness, it was the epoch of belief, it was the epoch of incredulity, it was the season of light, it was the season of darkness, it was the spring of

13/15 ITC Cheltenham Bold Italic

It was the best of times, it was the worst of times, it was the age of wisdom, it was the age of foolishness, it was the epoch of belief, it was the epoch of incredulity, it was the season of light, it was the season of darkness, it was

14/15 ITC Cheltenham Bold Italic

It was the best of times, it was the worst of times, it was the age of wisdom, it was the age of foolishness, it was the epoch of belief, it was the epoch of incredulity, it was the season of light, it was the season

14/16 ITC Cheltenham Bold Italic

It was the best of times, it was the worst of times, it was the age of wisdom, it was the age of foolishness, it was the epoch of belief, it was the epoch of incredulity, it was the season of light, it was the season

Clarendon Light 72 Point

ABCDEFGHIJK
LMNOPQRSTUV
WXYZabcdefghij
klmnopqrstuvw
xyz1234567890
?!/&$%#@*""".:;.,

Clarendon Light 10 point

ABCDEFGHIJKLMNOPQRSTUVWXYZ abcdefghij
klmnopqrstuvwxyz 1234567890 ?!/&$%#@*""":;.,

Clarendon Light 12 point

ABCDEFGHIJKLMNOPQRSTUVWXYZ abcdefghij
klmnopqrstuvwxyz 1234567890 ?!/&$%#@*""":;.,

Clarendon Light 13 point

ABCDEFGHIJKLMNOPQRSTUVWXYZ abcdefghij
klmnopqrstuvwxyz 1234567890 ?!/&$%#@*""":;.,

Clarendon Light 14 point

ABCDEFGHIJKLMNOPQRSTUVWXYZ abcdefghij
klmnopqrstuvwxyz 1234567890 ?!/&$%#@*""":;.,

Clarendon Light 16 point

ABCDEFGHIJKLMNOPQRSTUVWXYZ abcdefghij
klmnopqrstuvwxyz 1234567890 ?!/&$%#@*""":;.,

Clarendon Light 18 point

ABCDEFGHIJKLMNOPQRSTUVWXYZ abcdefghij
klmnopqrstuvwxyz 1234567890 ?!/&$%#@*""":;.,

Clarendon Light 20 point

ABCDEFGHIJKLMNOPQRSTUVWXYZ abcdefghij
klmnopqrstuvwxyz 1234567890 ?!/&$%#@*""":;.,

Clarendon Light 22 point

ABCDEFGHIJKLMNOPQRSTUVWXYZ abcdefghij
klmnopqrstuvwxyz 1234567890 ?!/&$%#@*""":;.,

6/8 Clarendon Light

It was the best of times, it was the worst of times, it was the age of wisdom, it was the age of foolishness, it was the epoch of belief, it was the epoch of incredulity, it was the season of light, it was the season of darkness, it was the spring of hope, it was the winter of despair, we had everything before us, we had nothing before us, we were all going direct to Heaven, we were all going direct the other way-in short, the period was so far like the present period, that some of its

8/10 Clarendon Light

It was the best of times, it was the worst of times, it was the age of wisdom, it was the age of foolishness, it was the epoch of belief, it was the epoch of incredulity, it was the season of light, it was the season of darkness, it was the spring of hope, it was the winter of despair, we had everything before us, we had nothing before us, we were all going direct to Heaven,

9/10 Clarendon Light

It was the best of times, it was the worst of times, it was the age of wisdom, it was the age of foolishness, it was the epoch of belief, it was the epoch of incredulity, it was the season of light, it was the season of darkness, it was the spring of hope, it was the winter of despair, we had everything before us, we had nothing before us,

9/11 Clarendon Light

It was the best of times, it was the worst of times, it was the age of wisdom, it was the age of foolishness, it was the epoch of belief, it was the epoch of incredulity, it was the season of light, it was the season of darkness, it was the spring of hope, it was the winter of despair, we had everything before us, we had nothing before us,

10/11 Clarendon Light

It was the best of times, it was the worst of times, it was the age of wisdom, it was the age of foolishness, it was the epoch of belief, it was the epoch of incredulity, it was the season of light, it was the season of darkness, it was the spring of hope, it was the winter of despair, we had everything before us, we

10/12 Clarendon Light

It was the best of times, it was the worst of times, it was the age of wisdom, it was the age of foolishness, it was the epoch of belief, it was the epoch of incredulity, it was the season of light, it was the season of darkness, it was the spring of hope, it was the winter of despair, we had everything before us, we

11/13 Clarendon Light

It was the best of times, it was the worst of times, it was the age of wisdom, it was the age of foolishness, it was the epoch of belief, it was the epoch of incredulity, it was the season of light, it was the season of darkness, it was the spring of hope, it was the winter

11/14 Clarendon Light

It was the best of times, it was the worst of times, it was the age of wisdom, it was the age of foolishness, it was the epoch of belief, it was the epoch of incredulity, it was the season of light, it was the season of darkness, it was the spring of hope, it was the winter

12/13 Clarendon Light

It was the best of times, it was the worst of times, it was the age of wisdom, it was the age of foolishness, it was the epoch of belief, it was the epoch of incredulity, it was the season of light, it was the season of darkness,it was the spring of

12/14 Clarendon Light

It was the best of times, it was the worst of times, it was the age of wisdom, it was the age of foolishness, it was the epoch of belief, it was the epoch of incredulity, it was the season of light, it was the season of darkness, it was the spring of

13/15 Clarendon Light

It was the best of times, it was the worst of times, it was the age of wisdom, it was the age of foolishness, it was the epoch of belief, it was the epoch of incredulity, it was the season of light, it was the season of darkness, it was

14/15 Clarendon Light

It was the best of times, it was the worst of times, it was the age of wisdom, it was the age of foolishness, it was the epoch of belief, it was the epoch of incredulity, it was the season of light, it was the season of

14/16 Clarendon Light

It was the best of times, it was the worst of times, it was the age of wisdom, it was the age of foolishness, it was the epoch of belief, it was the epoch of incredulity, it was the season of light, it was the season of

Clarendon 72 point

ABCDEFGHIJK
LMNOPQRSTUV
WXYZabcdefghi
jklmnopqrstuvw
xyz 1234567890
?!&$$$%#@*""":;.,

Clarendon 10 point

ABCDEFGHIJKLMNOPQRSTUVWXYZ abcdefghij
klmnopqrstuvwxyz 1234567890 ?!/&$%#@*“”:;.,

Clarendon 12 point

ABCDEFGHIJKLMNOPQRSTUVWXYZ abcdefghij
klmnopqrstuvwxyz 1234567890 ?!/&$%#@*“”:;.,

Clarendon 13 point

ABCDEFGHIJKLMNOPQRSTUVWXYZ abcdefghij
klmnopqrstuvwxyz 1234567890 ?!/&$%#@*“”:;.,

Clarendon 14 point

ABCDEFGHIJKLMNOPQRSTUVWXYZ abcdefghij
klmnopqrstuvwxyz 1234567890 ?!/&$%#@*“”:;.,

Clarendon 16 point

ABCDEFGHIJKLMNOPQRSTUVWXYZ abcdefghij
klmnopqrstuvwxyz 1234567890 ?!/&$%#@*“”:;.,

Clarendon 18 point

ABCDEFGHIJKLMNOPQRSTUVWXYZ abcdefghij
klmnopqrstuvwxyz 1234567890 ?!/&$%#@*“”:;.,

Clarendon 20 point

ABCDEFGHIJKLMNOPQRSTUVWXYZ abcdefghij
klmnopqrstuvwxyz 1234567890 ?!/&$%#@*“”:;.,

Clarendon 22 point

ABCDEFGHIJKLMNOPQRSTUVWXYZ abcdefghij
klmnopqrstuvwxyz 1234567890 ?!/&$%#@*“”:;.,

6/8 Clarendon

It was the best of times , it was the worst of times, it was the age of wisdom, it was the age of foolishness, it was the epoch of belief, it was the epoch of incredulity, it was the season of light, it was the season of darkness, it was the spring of hope, it was the winter of despair, we had everything before us, we had nothing before us, we were all going direct to Heaven, we were all going direct the other way-in short, the period was so far like the present period, that some of its

8/10 Clarendon

It was the best of times, it was the worst of times, it was the age of wisdom, it was the age of foolishness, it was the epoch of belief, it was the epoch of incredulity, it was the season of light, it was the season of darkness, it was the spring of hope, it was the winter of despair, we had everything before us, we had nothing before us, we were all going direct to Heaven,

9/10 Clarendon

It was the best of time, it was the worst of times, it was the age of wisdom, it was the age of foolishness, it was the epoch of belief, it was the epoch of incredulity, it was the season of light, it was the season of darkness, it was the spring of hope, it was the winter of despair, we had everything before us, we had nothing before us,

9/11 Clarendon

It was the best of times, it was the worst of times, it was the age of wisdom, it was the age of foolishness, it was the epoch of belief, it was the epoch of incredulity, it was the season of light, it was the season of darkness, it was the spring of hope, it was the winter of despair, we had everything before us, we had nothing before us,

10/11 Clarendon

It was the best of times, it was the worst of times, it was the age of wisdom, it was the age of foolishness, it was the epoch of belief, it was the epoch of incredulity, it was the season of light, it was the season of darkness, it was the spring of hope, it was the winter of despair, we had everything before us, we

10/12 Clarendon

It was the best of times, it was the worst of times, it was the age of wisdom, it was the age of foolishness, it was the epoch of belief, it was the epoch of incredulity, it was the season of light, it was the season of darkness, it was the spring of hope, it was the winter of despair, we had everything before us, we

11/13 Clarendon

It was the best of times, it was the worst of times, it was the age of wisdom, it was the age of foolishness, it was the epoch of belief, it was the epoch of incredulity, it was the season of light, it was the season of darkness, it was the spring of hope, it was the winter of despair, we had everything before

11/14 Clarendon

It was the best of times, it was the worst of times, it was the age of wisdom, it was the age of foolishness, it was the epoch of belief, it was the epoch of incredulity, it was the season of light, it was the season of darkness, it was the spring of hope, it was the winter of despair, we had everything before

12/13 Clarendon

It was the best of times, it was the worst of times, it was the age of wisdom, it was the age of foolishness, it was the epoch of belief, it was the epoch of incredulity, it was the season of light, it was the season of darkness, it was the spring of

12/14 Clarendon

It was the best of times, it was the worst of times, it was the age of wisdom, it was the age of foolishness, it was the epoch of belief, it was the epoch of incredulity, it was the season of light, it was the season of darkness, it was the spring of

13/15 Clarendon

It was the best of times, it was the worst of times, it was the age of wisdom, it was the age of foolishness, it was the epoch of belief, it was the epoch of incredulity, it was the season of light, it was the season of darkness, it was

14/15 Clarendon

It was the best of times, it was the worst of times, it was the age of wisdom, it was the age of foolishness, it was the epoch of belief, it was the epoch of incredulity, it was the season of light, it was the season of

14/16 Clarendon

It was the best of times, it was the worst of times, it was the age of wisdom, it was the age of foolishness, it was the epoch of belief, it was the epoch of incredulity, it was the season of light, it was the season of

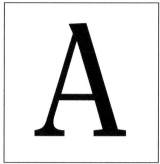

ITC Clearface 72 point

ABCDEFGHIJKL
MNOPQRSTUVW
XYZ abcdefghijkl
mnopqrstuvwxyz
1234567890
?!/&$%#@*""·;·,

ITC Clearface 24 point

ABCDEFGHIJKLMNOPQRSTUVWXYZ
abcdefghijklmnopqrstuvwxyz 1234567890 !?%&*

ITC Clearface 30 point

ABCDEFGHIJKLMNOPQRSTUVWXYZ
abcdefghijklmnopqrstuvwxyz 1234567890

ITC Clearface 36 point

ABCDEFGHIJKLMNOPQRSTUVWXY
abcdefghijklmnopqrstuvwxyz 12345

ITC Clearface 48 point

ABCDEFGHIJKLMNOPQRST
abcdefghijklmnopqrstuv 1234

ITC Clearface 60 point

ABCDEFGHIJKLMNOP
abcdefghijklmnopq1234

6/8 ITC Clearface

It was the best of times, it was the worst of times, it was the age of wisdom, it was the age of foolishness, it was the epoch of belief, it was the epoch of incredulity, it was the season of light, it was the season of darkness, it was the spring of hope, it was the winter of despair, we had everything before us, we had nothing before us, we were all going direct to Heaven, we were all going direct the other way-in short, the period was so far like the present period, that some of its noisiest authorities insisted on its being received, for good or for evil, in the superlative degree of comparison

8/10 ITC Clearface

It was the best of times, it was the worst of times, it was the age of wisdom, it was the age of foolishness, it was the epoch of belief, it was the epoch of incredulity, it was the season of light, it was the season of darkness, it was the spring of hope, it was the winter of despair, we had everything before us, we had nothing before us, we were all going direct to Heaven, we were all going direct the other way-in short, the period was so far like the

9/10 ITC Clearface

It was the best of times, it was the worst of times, it was the age of wisdom, it was the age of foolishness, it was the epoch of belief, it was the epoch of incredulity, it was the season of light, it was the season of darkness, it was the spring of hope, it was the winter of despair, we had everything before us, we had nothing before us, we were all going direct to Heaven, we were all going direct

9/11 ITC Clearface

It was the best of times, it was the worst of times, it was the age of wisdom, it was the age of foolishness, it was the epoch of belief, it was the epoch of incredulity, it was the season of light, it was the season of darkness, it was the spring of hope, it was the winter of despair, we had everything before us, we had nothing before us, we were all going direct to Heaven, we were all going direct

10/11 ITC Clearface

It was the best of times, it was the worst of times, it was the age of wisdom, it was the age of foolishness, it was the epoch of belief, it was the epoch of incredulity, it was the season of light, it was the season of darkness, it was the spring of hope, it was the winter of despair, we had everything before us, we had nothing before us, we were all going direct

10/12 ITC Clearface

It was the best of times, it was the worst of times, it was the age of wisdom, it was the age of foolishness, it was the epoch of belief, it was the epoch of incredulity, it was the season of light, it was the season of darkness, it was the spring of hope, it was the winter of despair, we had everything before us, we had nothing before us, we were all going direct

11/13 ITC Clearface

It was the best of times, it was the worst of times, it was the age of wisdom, it was the age of foolishness, it was the epoch of belief, it was the epoch of incredulity, it was the season of light, it was the season of darkness, it was the spring of hope, it was the winter of despair, we had everything before us, we had nothing

11/14 ITC Clearface

It was the best of times, it was the worst of times, it was the age of wisdom, it was the age of foolishness, it was the epoch of belief, it was the epoch of incredulity, it was the season of light, it was the season of darkness, it was the spring of hope, it was the winter of despair, we had everything before us, we had nothing

12/13 ITC Clearface

It was the best of times, it was the worst of times, it was the age of wisdom, it was the age of foolishness, it was the epoch of belief, it was the epoch of incredulity, it was the season of light, it was the season of darkness, it was the spring of hope, it was the winter of despair, we had everything before us, we had

12/14 ITC Clearface

It was the best of times, it was the worst of times, it was the age of wisdom, it was the age of foolishness, it was the epoch of belief, it was the epoch of incredulity, it was the season of light, it was the season of darkness, it was the spring of hope, it was the winter of despair, we had everything before us, we had

13/15 ITC Clearface

It was the best of times, it was the worst of times, it was the age of wisdom, it was the age of foolishness, it was the epoch of belief, it was the epoch of incredulity, it was the season of light, it was the season of darkness, it was the spring of hope, it was the winter of despair,

14/15 ITC Clearface

It was the best of times, it was the worst of times, it was the age of wisdom, it was the age of foolishness, it was the epoch of belief, it was the epoch of incredulity, it was the season of light, it was the season of darkness, it was the spring of hope, it was

14/16 ITC Clearface

It was the best of times, it was the worst of times, it was the age of wisdom, it was the age of foolishness, it was the epoch of belief, it was the epoch of incredulity, it was the season of light, it was the season of darkness, it was the spring of hope, it was

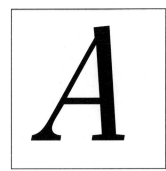

ITC Clearface Italic 72 point

ABCDEFGHIJKL
MNOPQRSTUVW
XYZ abcdefghijkl
mnopqrstuvwxyz
1234567890
?!/&$%#@"":;.,*

ITC Clearface Italic 24 point

ABCDEFGHIJKLMNOPQRSTUVWXYZ
*abcdefghijklmnopqrstuvwxyz 1234567890 !?%&**

ITC Clearface Italic 30 point

ABCDEFGHIJKLMNOPQRSTUVWXYZ
abcdefghijklmnopqrstuvwxyz 1234567890

ITC Clearface Italic 36 point

ABCDEFGHIJKLMNOPQRSTUVWXYZ
abcdefghijklmnopqrstuvwxyz 123456789

ITC Clearface Italic 48 point

ABCDEFGHIJKLMNOPQRST
abcdefghijklmnopqrstuv 12345

ITC Clearface Italic 60 point

ABCDEFGHIJKLMNOPQ
abcdefghijklmnopqrs 123

6/8 ITC Clearface Italic

It was the best of times, it was the worst of times, it was the age of wisdom, it was the age of foolishness, it was the epoch of belief, it was the epoch of incredulity, it was the season of light, it was the season of darkness, it was the spring of hope, it was the winter of despair, we had everything before us, we had nothing before us, we were all going direct to Heaven, we were all going direct the other way-in short, the period was so far like the present period, that some of its noisiest authorities insisted on its being received, for good or for evil, in the superlative degree of comparison

8/10 ITC Clearface Italic

It was the best of times, it was the worst of times, it was the age of wisdom, it was the age of foolishness, it was the epoch of belief, it was the epoch of incredulity, it was the season of light, it was the season of darkness, it was the spring of hope, it was the winter of despair, we had everything before us, we had nothing before us, we were all going direct to Heaven, we were all going direct the other way-in short, the period was so far

9/10 ITC Clearface Italic

It was the best of times, it was the worst of times, it was the age of wisdom, it was the age of foolishness, it was the epoch of belief, it was the epoch of incredulity, it was the season of light, it was the season of darkness, it was the spring of hope, it was the winter of despair, we had everything before us, we had nothing before us, we were all going direct to Heaven, we were all going

9/11 ITC Clearface Italic

It was the best of times, it was the worst of times, it was the age of wisdom, it was the age of foolishness, it was the epoch of belief, it was the epoch of incredulity, it was the season of light, it was the season of darkness, it was the spring of hope, it was the winter of despair, we had everything before us, we had nothing before us, we were all going direct to Heaven, we were all going

10/11 ITC Clearface Italic

It was the best of times, it was the worst of times, it was the age of wisdom, it was the age of foolishness, it was the epoch of belief, it was the epoch of incredulity, it was the season of light, it was the season of darkness, it was the spring of hope, it was the winter of despair, we had everything before us, we had nothing before us, we were all going

10/12 ITC Clearface Italic

It was the best of times, it was the worst of times, it was the age of wisdom, it was the age of foolishness, it was the epoch of belief, it was the epoch of incredulity, it was the season of light, it was the season of darkness, it was the spring of hope, it was the winter of despair, we had everything before us, we had nothing before us, we were all going

11/13 ITC Clearface Italic

It was the best of times, it was the worst of times, it was the age of wisdom, it was the age of foolishness, it was the epoch of belief, it was the epoch of incredulity, it was the season of light, it was the season of darkness, it was the spring of hope, it was the winter of despair, we had everything before us, we had

11/14 ITC Clearface Italic

It was the best of times, it was the worst of times, it was the age of wisdom, it was the age of foolishness, it was the epoch of belief, it was the epoch of incredulity, it was the season of light, it was the season of darkness, it was the spring of hope, it was the winter of despair, we had everything before us, we had

12/13 ITC Clearface Italic

It was the best of times, it was the worst of times, it was the age of wisdom, it was the age of foolishness, it was the epoch of belief, it was the epoch of incredulity, it was the season of light, it was the season of darkness, it was the spring of hope, it was the winter of despair, we had everything before us, we had

12/14 ITC Clearface Italic

It was the best of times, it was the worst of times, it was the age of wisdom, it was the age of foolishness, it was the epoch of belief, it was the epoch of incredulity, it was the season of light, it was the season of darkness, it was the spring of hope, it was the winter of despair, we had everything before us, we had

13/15 ITC Clearface Italic

It was the best of times, it was the worst of times, it was the age of wisdom, it was the age of foolishness, it was the epoch of belief, it was the epoch of incredulity, it was the season of light, it was the season of darkness, it was the spring of hope, it was the winter of despair,

14/15 ITC Clearface Italic

It was the best of times, it was the worst of times, it was the age of wisdom, it was the age of foolishness, it was the epoch of belief, it was the epoch of incredulity, it was the season of light, it was the season of darkness, it was the spring of hope, it was

14/16 ITC Clearface Italic

It was the best of times, it was the worst of times, it was the age of wisdom, it was the age of foolishness, it was the epoch of belief, it was the epoch of incredulity, it was the season of light, it was the season of darkness, it was the spring of hope, it was

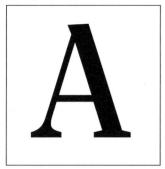

ITC Clearface Bold 72 point

ABCDEFGHIJKL
MNOPQRSTUV
WXYZ abcdefghij
klmnopqrstuvwx
yz 1234567890
?!/&$%#@*""·:·,·,

ITC Clearface Bold 24 point

ABCDEFGHIJKLMNOPQRSTUVWXYZ
abcdefghijklmnopqrstuvwxyz 1234567890 !?%&*

ITC Clearface Bold 30 point

ABCDEFGHIJKLMNOPQRSTUVWXYZ
abcdefghijklmnopqrstuvwxyz 12345678

ITC Clearface Bold 36 point

ABCDEFGHIJKLMNOPQRSTUVW
abcdefghijklmnopqrstuvwxyz 123456

ITC Clearface Bold 48 point

ABCDEFGHIJKLMNOPQRS
abcdefghijklmnopqrstuv 12

ITC Clearface Bold 60 point

ABCDEFGHIJKLMNO
abcdefghijklmnop 123

6/8 ITC Clearface Bold

It was the best of times, it was the worst of times, it was the age of wisdom, it was the age of foolishness, it was the epoch of belief, it was the epoch of incredulity, it was the season of light, it was the season of darkness, it was the spring of hope, it was the winter of despair, we had everything before us, we had nothing before us, we were all going direct to Heaven, we were all going direct the other way-in short, the period was so far like the present period, that some of its noisiest authorities insisted on its being received, for good or for evil, in the superlative degree of comparison

8/10 ITC Clearface Bold

It was the best of times, it was the worst of times, it was the age of wisdom, it was the age of foolishness, it was the epoch of belief, it was the epoch of incredulity, it was the season of light, it was the season of darkness, it was the spring of hope, it was the winter of despair, we had everything before us, we had nothing before us, we were all going direct to Heaven, we were all going direct the other way-in short, the period was so far like the

9/10 ITC Clearface Bold

It was the best of times, it was the worst of times, it was the age of wisdom, it was the age of foolishness, it was the epoch of belief, it was the epoch of incredulity, it was the season of light, it was the season of darkness, it was the spring of hope, it was the winter of despair, we had everything before us, we had nothing before us, we were all going direct to Heaven, we were all going direct

9/11 ITC Clearface Bold

It was the best of times, it was the worst of times, it was the age of wisdom, it was the age of foolishness, it was the epoch of belief, it was the epoch of incredulity, it was the season of light, it was the season of darkness, it was the spring of hope, it was the winter of despair, we had everything before us, we had nothing before us, we were all going direct to Heaven, we were all going direct

10/11 ITC Clearface Bold

It was the best of times, it was the worst of times, it was the age of wisdom, it was the age of foolishness, it was the epoch of belief, it was the epoch of incredulity, it was the season of light, it was the season of darkness, it was the spring of hope, it was the winter of despair, we had everything before us, we had nothing before us, we were all going direct

10/12 ITC Clearface Bold

It was the best of times, it was the worst of times, it was the age of wisdom, it was the age of foolishness, it was the epoch of belief, it was the epoch of incredulity, it was the season of light, it was the season of darkness, it was the spring of hope, it was the winter of despair, we had everything before us, we had nothing before us, we were all going direct

11/13 ITC Clearface Bold

It was the best of times, it was the worst of times, it was the age of wisdom, it was the age of foolishness, it was the epoch of belief, it was the epoch of incredulity, it was the season of light, it was the season of darkness, it was the spring of hope, it was the winter of despair, we had everything before us, we had nothing

11/14 ITC Clearface Bold

It was the best of times, it was the worst of times, it was the age of wisdom, it was the age of foolishness, it was the epoch of belief, it was the epoch of incredulity, it was the season of light, it was the season of darkness, it was the spring of hope, it was the winter of despair, we had everything before us, we had nothing

12/13 ITC Clearface Bold

It was the best of times, it was the worst of times, it was the age of wisdom, it was the age of foolishness, it was the epoch of belief, it was the epoch of incredulity, it was the season of light, it was the season of darkness, it was the spring of hope, it was the winter of despair, we had everything before us, we had

12/14 ITC Clearface Bold

It was the best of times, it was the worst of times, it was the age of wisdom, it was the age of foolishness, it was the epoch of belief, it was the epoch of incredulity, it was the season of light, it was the season of darkness, it was the spring of hope, it was the winter of despair, we had everything before us, we had

13/15 ITC Clearface Bold

It was the best of times, it was the worst of times, it was the age of wisdom, it was the age of foolishness, it was the epoch of belief, it was the epoch of incredulity, it was the season of light, it was the season of darkness, it was the spring of hope, it was the winter of despair,

14/15 ITC Clearface Bold

It was the best of times, it was the worst of times, it was the age of wisdom, it was the age of foolishness, it was the epoch of belief, it was the epoch of incredulity, it was the season of light, it was the season of darkness, it was the spring of hope, it was

14/16 ITC Clearface Bold

It was the best of times, it was the worst of times, it was the age of wisdom, it was the age of foolishness, it was the epoch of belief, it was the epoch of incredulity, it was the season of light, it was the season of darkness, it was the spring of hope, it was

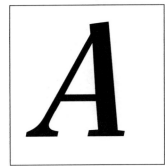

ITC Clearface Bold Italic 72 point

ABCDEFGHIJKL
MNOPQRSTUV
WXYZ abcdefghij
klmnopqrstuvwx
yz 1234567890
?!/&$%#@""*;:,

ITC Clearface Bold Italic 24 point

ABCDEFGHIJKLMNOPQRSTUVWXYZ
*abcdefghijklmnopqrstuvwxyz 1234567890 !?%&**

ITC Clearface Bold Italic 30 point

ABCDEFGHIJKLMNOPQRSTUVWXYZ
abcdefghijklmnopqrstuvwxyz 1234567890

ITC Clearface Bold Italic 36 point

ABCDEFGHIJKLMNOPQRSTUVWXZ
abcdefghijklmnopqrstuvwxyz 123456

ITC Clearface Bold Italic 48 point

ABCDEFGHIJKLMNOPQRS
abcdefghijklmnopqrst 1234

ITC Clearface Bold Italic 60 point

ABCDEFGHIJKLMNO
abcdefghijklmnop 123

6/8 ITC Clearface Bold Italic

It was the best of times, it was the worst of times, it was the age of wisdom, it was the age of foolishness, it was the epoch of belief, it was the epoch of incredulity, it was the season of light, it was the season of darkness, it was the spring of hope, it was the winter of despair, we had everything before us, we had nothing before us, we were all going direct to Heaven, we were all going direct the other way-in short, the period was so far like the present period, that some of its noisiest authorities insisted on its being received, for good or for evil, in the superlative degree of comparison

8/10 ITC Clearface Bold Italic

It was the best of times, it was the worst of times, it was the age of wisdom, it was the age of foolishness, it was the epoch of belief, it was the epoch of incredulity, it was the season of light, it was the season of darkness, it was the spring of hope, it was the winter of despair, we had everything before us, we had nothing before us, we were all going direct to Heaven, we were all going direct the other way-in short, the period was so far

9/10 ITC Clearface Bold Italic

It was the best of times, it was the worst of times, it was the age of wisdom, it was the age of foolishness, it was the epoch of belief, it was the epoch of incredulity, it was the season of light, it was the season of darkness, it was the spring of hope, it was the winter of despair, we had everything before us, we had nothing before us, we were all going direct to Heaven, we were all going

9/11 ITC Clearface Bold Italic

It was the best of times, it was the worst of times, it was the age of wisdom, it was the age of foolishness, it was the epoch of belief, it was the epoch of incredulity, it was the season of light, it was the season of darkness, it was the spring of hope, it was the winter of despair, we had everything before us, we had nothing before us, we were all going direct to Heaven, we were all going

10/11 ITC Clearface Bold Italic

It was the best of times, it was the worst of times, it was the age of wisdom, it was the age of foolishness, it was the epoch of belief, it was the epoch of incredulity, it was the season of light, it was the season of darkness, it was the spring of hope, it was the winter of despair, we had everything before us, we had nothing before us, we were all going

10/12 ITC Clearface Bold Italic

It was the best of times, it was the worst of times, it was the age of wisdom, it was the age of foolishness, it was the epoch of belief, it was the epoch of incredulity, it was the season of light, it was the season of darkness, it was the spring of hope, it was the winter of despair, we had everything before us, we had nothing before us, we were all going

11/13 ITC Clearface Bold Italic

It was the best of times, it was the worst of times, it was the age of wisdom, it was the age of foolishness, it was the epoch of belief, it was the epoch of incredulity, it was the season of light, it was the season of darkness, it was the spring of hope, it was the winter of despair, we had everything before us, we had nothing

11/14 ITC Clearface Bold Italic

It was the best of times, it was the worst of times, it was the age of wisdom, it was the age of foolishness, it was the epoch of belief, it was the epoch of incredulity, it was the season of light, it was the season of darkness, it was the spring of hope, it was the winter of despair, we had everything before us, we had nothing

12/13 ITC Clearface Bold Italic

It was the best of times, it was the worst of times, it was the age of wisdom, it was the age of foolishness, it was the epoch of belief, it was the epoch of incredulity, it was the season of light, it was the season of darkness, it was the spring of hope, it was the winter of despair, we had everything before us, we had

12/14 ITC Clearface Bold Italic

It was the best of times, it was the worst of times, it was the age of wisdom, it was the age of foolishness, it was the epoch of belief, it was the epoch of incredulity, it was the season of light, it was the season of darkness, it was the spring of hope, it was the winter of despair, we had everything before us, we had

13/15 ITC Clearface Bold Italic

It was the best of times, it was the worst of times, it was the age of wisdom, it was the age of foolishness, it was the epoch of belief, it was the epoch of incredulity, it was the season of light, it was the season of darkness, it was the spring of hope, it was the winter of despair,

14/15 ITC Clearface Bold Italic

It was the best of times, it was the worst of times, it was the age of wisdom, it was the age of foolishness, it was the epoch of belief, it was the epoch of incredulity, it was the season of light, it was the season of darkness, it was the spring of hope, it was

14/16 ITC Clearface Italic

It was the best of times, it was the worst of times, it was the age of wisdom, it was the age of foolishness, it was the epoch of belief, it was the epoch of incredulity, it was the season of light, it was the season of darkness, it was the spring of hope, it was

Cooper Black 72 point

ABCDEFGHIJK
LMNOPQRSTU
VWXYZabcdef
ghijklmnopqrs
tuvwxyz1234
567890?!&$@";

Cooper Black 10 point

ABCDEFGHIJKLMNOPQRSTUVWXYZ abcdefghij
klmnopqrstuvwxyz 1234567890 ?!/&$%#@*""":;.,

Cooper Black 12 point

ABCDEFGHIJKLMNOPQRSTUVWXYZ abcdefghij
klmnopqrstuvwxyz 1234567890 ?!/&$%#@*""":;.,

Cooper Black 13 point

ABCDEFGHIJKLMNOPQRSTUVWXYZ abcdefghij
klmnopqrstuvwxyz 1234567890 ?!/&$%#@*""":;.,

Cooper Black 14 point

ABCDEFGHIJKLMNOPQRSTUVWXYZ abcdefghij
klmnopqrstuvwxyz 1234567890 ?!/&$%#@*""":;.,

Cooper Black 16 point

ABCDEFGHIJKLMNOPQRSTUVWXYZ abcdefghij
klmnopqrstuvwxyz 1234567890 ?!/&$%#@*""":;.,

Cooper Black 18 point

ABCDEFGHIJKLMNOPQRSTUVWXYZ abcdefghij
klmnopqrstuvwxyz 1234567890 ?!/&$%#@*""":;.,

Cooper Black 20 point

ABCDEFGHIJKLMNOPQRSTUVWXYZ abcdefghij
klmnopqrstuvwxyz 1234567890 ?!/&$%#@*""":;.,

Cooper Black 22 point

ABCDEFGHIJKLMNOPQRSTUVWXYZ abcdefgh
ijklmnopqrstuvwxyz 1234567890 ?!/&$%#@*"

Cooper Black Italic 72 point

ABCDEFGHIJK
LMNOPQRSTU
VWXYZabcdefg
hijklmnopqrst
uvwxyz12345
67890?!&$%@";

Cooper Black Italic 10 point

ABCDEFGHIJKLMNOPQRSTUVWXYZ *abcdefghij*
*klmnopqrstuvwxyz 1234567890 ?!/&$%#@ * """:;.,*

Cooper Black Italic 12 point

ABCDEFGHIJKLMNOPQRSTUVWXYZ *abcdefghij*
*klmnopqrstuvwxyz 1234567890 ?!/&$%#@ * """:;.,*

Cooper Black Italic 13 point

ABCDEFGHIJKLMNOPQRSTUVWXYZ *abcdefghij*
*klmnopqrstuvwxyz 1234567890 ?!/&$%#@ * """:;.,*

Cooper Black Italic 14 point

ABCDEFGHIJKLMNOPQRSTUVWXYZ *abcdefghij*
*klmnopqrstuvwxyz 1234567890 ?!/&$%#@ * """:;.,*

Cooper Black Italic 16 point

ABCDEFGHIJKLMNOPQRSTUVWXYZ *abcdefghij*
*klmnopqrstuvwxyz 1234567890 ?!/&$%#@ * """:;.,*

Cooper Black Italic 18 point

ABCDEFGHIJKLMNOPQRSTUVWXYZ *abcdefghij*
*klmnopqrstuvwxyz 1234567890 ?!/&$%#@ * """:;.,*

Cooper Black Italic 20 point

ABCDEFGHIJKLMNOPQRSTUVWXYZ *abcdefghij*
*klmnopqrstuvwxyz 1234567890 ?!/&$%#@ * """:;.,*

Cooper Black Italic 22 point

ABCDEFGHIJKLMNOPQRSTUVWXYZ *abcdefgh*
*ijklmnopqrstuvwxyz 1234567890 ?!/&$%#@ * "*

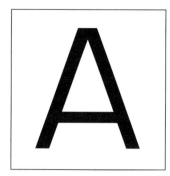

Eurostile 72 point

ABCDEFGHIJKL
MNOPQRSTUVW
XYZ abcdefghijkl
mnopqrstuvwxyz
1234567890
?!&$%#@ *""":;.,

Eurostile 24 point

ABCDEFGHIJKLMNOPQRSTUVWXYZ
abcdefghijklmnopqrstuvwxyz 1234567890

Eurostile 30 point

ABCDEFGHIJKLMNOPQRSTUVWXYZ
abcdefghijklmnopqrstuvwxyz 123456

Eurostile 36 point

ABCDEFGHIJKLMNOPQRSTUVW
abcdefghijklmnopqrstuvwxyz 123

Eurostile 48 point

ABCDEFGHIJKLMNOPQRS
abcdefghijklmnopqrstuv 12

Eurostile 60 point

ABCDEFGHIJKLMNO
abcdefghijklmnopqr 1

6/8 Eurostile

It was the best of times, it was the worst of times, it was the age of wisdom, it was the age of foolishness, it was the epoch of belief, it was the epoch of incredulity, it was the season of light, it was the season of darkness, it was the spring of hope, it was the winter of despair, we had everything before us, we had nothing before us, we were all going direct to Heaven, we were all going direct the other way-in short, the period was so far like the present period, that some of its noisiest authorities insisted

8/10 Eurostile

It was the best of times, it was the worst of times, it was the age of wisdom, it was the age of foolishness, it was the epoch of belief, it was the epoch of incredulity, it was the season of light, it was the season of darkness, it was the spring of hope, it was the winter of despair, we had everything before us, we had nothing before us, we were all going direct to Heaven, we were all

9/10 Eurostile

It was the best of times, it was the worst of times, it was the age of wisdom, it was the age of foolishness, it was the epoch of belief, it was the epoch of incredulity, it was the season of light, it was the season of darkness, it was the spring of hope, it was the winter of despair, we had everything before us, we had nothing before us, we

9/11 Eurostile

It was the best of times, it was the worst of times, it was the age of wisdom, it was the age of foolishness, it was the epoch of belief, it was the epoch of incredulity, it was the season of light, it was the season of darkness, it was the spring of hope, it was the winter of despair, we had everything before us, we had nothing before us, we

10/11 Eurostile

It was the best of times, it was the worst of times, it was the age of wisdom, it was the age of foolishness, it was the epoch of belief, it was the epoch of incredulity, it was the season of light, it was the season of darkness, it was the spring of hope, it was the winter of despair, we had everything before us, we

10/12 Eurostile

It was the best of times, it was the worst of times, it was the age of wisdom, it was the age of foolishness, it was the epoch of belief, it was the epoch of incredulity, it was the season of light, it was the season of darkness, it was the spring of hope, it was the winter of despair, we had everything before us, we

11/13 Eurostile

It was the best of times, it was the worst of times, it was the age of wisdom, it was the age of foolishness, it was the epoch of belief, it was the epoch of incredulity, it was the season of light, it was the season of darkness, it was the spring of hope, it was the winter of despair, we had everything before us, we

11/14 Eurostile

It was the best of times, it was the worst of times, it was the age of wisdom, it was the age of foolishness, it was the epoch of belief, it was the epoch of incredulity, it was the season of light, it was the season of darkness, it was the spring of hope, it was the winter of despair, we had everything before us, we

12/13 Eurostile

It was the best of times, it was the worst of times, it was the age of wisdom, it was the age of foolishness, it was the epoch of belief, it was the epoch of incredulity, it was the season of light, it was the season of darkness, it was the spring of hope, it was the winter

12/14 Eurostile

It was the best of times, it was the worst of times, it was the age of wisdom, it was the age of foolishness, it was the epoch of belief, it was the epoch of incredulity, it was the season of light, it was the season of darkness, it was the spring of hope, it was the winter

13/15 Eurostile

It was the best of times, it was the worst of times, it was the age of wisdom, it was the age of foolishness, it was the epoch of belief, it was the epoch of incredulity, it was the season of light, it was the season of darkness, it was the

14/15 Eurostile

It was the best of times, it was the worst of times, it was the age of wisdom, it was the age of foolishness, it was the epoch of belief, it was the epoch of incredulity, it was the season of light, it was the season of dark-

14/16 Eurostile

It was the best of times, it was the worst of times, it was the age of wisdom, it was the age of foolishness, it was the epoch of belief, it was the epoch of incredulity, it was the season of light, it was the season of dark-

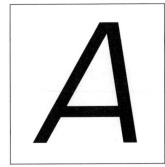

Eurostile Oblique 72 point

ABCDEFGHIJKL
MNOPQRSTUVW
XYZ abcdefghijkl
mnopqrstuvwxyz
1234567890
*?!&$%#@ * """;.,*

Eurostile Oblique 24 point

ABCDEFGHIJKLMNOPQRSTUVWXYZ
abcdefghijklmnopqrstuvwxyz 1234567890 !?%&*

Eurostile Oblique 30 point

ABCDEFGHIJKLMNOPQRSTUVWXYZ
abcdefghijklmnopqrstuvwxyz 123456

Eurostile Oblique 36 point

ABCDEFGHIJKLMNOPQRSTUVW
abcdefghijklmnopqrstuvwxyz 123

Eurostile Oblique 48 point

ABCDEFGHIJKLMNOPQRS
abcdefghijklmnopqrstu 123

Eurostile Oblique 60 point

ABCDEFGHIJKLMNO
abcdefghijklmnopq 12

6/8 Eurostile Oblique

It was the best of times, it was the worst of times, it was the age of wisdom, it was the age of foolishness, it was the epoch of belief, it was the epoch of incredulity, it was the season of light, it was the season of darkness, it was the spring of hope, it was the winter of despair, we had everything before us, we had nothing before us, we were all going direct to Heaven, we were all going direct the other way-in short, the period was so far like the present period, that some of its noisiest authorities insisted

8/10 Eurostile Oblique

It was the best of times, it was the worst of times, it was the age of wisdom, it was the age of foolishness, it was the epoch of belief, it was the epoch of incredulity, it was the season of light, it was the season of darkness, it was the spring of hope, it was the winter of despair, we had everything before us, we had nothing before us, we were all going direct to Heaven, we were all

9/10 Eurostile Oblique

It was the best of times, it was the worst of times, it was the age of wisdom, it was the age of foolishness, it was the epoch of belief, it was the epoch of incredulity, it was the season of light, it was the season of darkness, it was the spring of hope, it was the winter of despair, we had everything before us, we had nothing before us, we

9/11 Eurostile Oblique

It was the best of times, it was the worst of times, it was the age of wisdom, it was the age of foolishness, it was the epoch of belief, it was the epoch of incredulity, it was the season of light, it was the season of darkness, it was the spring of hope, it was the winter of despair, we had everything before us, we had nothing before us, we

10/11 Eurostile Oblique

It was the best of times, it was the worst of times, it was the age of wisdom, it was the age of foolishness, it was the epoch of belief, it was the epoch of incredulity, it was the season of light, it was the season of darkness, it was the spring of hope, it was the winter of despair, we had everything before us, we

10/12 Eurostile Oblique

It was the best of times, it was the worst of times, it was the age of wisdom, it was the age of foolishness, it was the epoch of belief, it was the epoch of incredulity, it was the season of light, it was the season of darkness, it was the spring of hope, it was the winter of despair, we had everything before us, we

11/13 Eurostile Oblique

It was the best of times, it was the worst of times, it was the age of wisdom, it was the age of foolishness, it was the epoch of belief, it was the epoch of incredulity, it was the season of light, it was the season of darkness, it was the spring of hope, it was the winter of despair, we had everything before us, we

11/14 Eurostile Oblique

It was the best of times, it was the worst of times, it was the age of wisdom, it was the age of foolishness, it was the epoch of belief, it was the epoch of incredulity, it was the season of light, it was the season of darkness, it was the spring of hope, it was the winter of despair, we had everything before us, we

12/13 Eurostile Oblique

It was the best of times, it was the worst of times, it was the age of wisdom, it was the age of foolishness, it was the epoch of belief, it was the epoch of incredulity, it was the season of light, it was the season of darkness, it was the spring of hope, it was the winter

12/14 Eurostile Oblique

It was the best of times, it was the worst of times, it was the age of wisdom, it was the age of foolishness, it was the epoch of belief, it was the epoch of incredulity, it was the season of light, it was the season of darkness, it was the spring of hope, it was the winter

13/15 Eurostile Oblique

It was the best of times, it was the worst of times, it was the age of wisdom, it was the age of foolishness, it was the epoch of belief, it was the epoch of incredulity, it was the season of light, it was the season of darkness, it was the

14/15 Eurostile Oblique

It was the best of times, it was the worst of times, it was the age of wisdom, it was the age of foolishness, it was the epoch of belief, it was the epoch of incredulity, it was the season of light, it was the season of dark-

14/16 Eurostile Oblique

It was the best of times, it was the worst of times, it was the age of wisdom, it was the age of foolishness, it was the epoch of belief, it was the epoch of incredulity, it was the season of light, it was the season of dark-

Eurostile Demi 72 point

ABCDEFGHIJKL
MNOPQRSTUV
WXYZabcdefghi
jklmnopqrstuvw
xyz1234567890
?!&$%#@*""".,;,

Eurostile Demi 24 point

ABCDEFGHIJKLMNOPQRSTUVWXYZ
abcdefghijklmnopqrstuvwxyz 1234567890!?%

Eurostile Demi 30 point

ABCDEFGHIJKLMNOPQRSTUVWXYZ
abcdefghijklmnopqrstuvwxyz 12345

Eurostile Demi 36 point

ABCDEFGHIJKLMNOPQRSTUV
abcdefghijklmnopqrstuvwxyz 12

Eurostile Demi 48 point

ABCDEFGHIJKLMNOPQR
abcdefghijklmnopqrstu 1

Eurostile Demi 60 point

ABCDEFGHIJKLMNO
abcdefghijklmnopq 1

6/8 Eurostile Demi

It was the best of times, it was the worst of times, it was the age of wisdom, it was the age of foolishness, it was the epoch of belief, it was the epoch of incredulity, it was the season of light, it was the season of darkness, it was the spring of hope, it was the winter of despair, we had everything before us, we had nothing before us, we were all going direct to Heaven, we were all going direct the other way-in short, the period was so far like the present period, that some of its

8/10 Eurostile Demi

It was the best of times, it was the worst of times, it was the age of wisdom, it was the age of foolishness, it was the epoch of belief, it was the epoch of incredulity, it was the season of light, it was the season of darkness, it was the spring of hope, it was the winter of despair, we had everything before us, we had nothing before us, we were all going direct

9/10 Eurostile Demi

It was the best of times, it was the worst of times, it was the age of wisdom, it was the age of foolishness, it was the epoch of belief, it was the epoch of incredulity, it was the season of light, it was the season of darkness, it was the spring of hope, it was the winter of despair, we had everything before us, we had nothing

9/11 Eurostile Demi

It was the best of times, it was the worst of times, it was the age of wisdom, it was the age of foolishness, it was the epoch of belief, it was the epoch of incredulity, it was the season of light, it was the season of darkness, it was the spring of hope, it was the winter of despair, we had everything before us, we had nothing

10/11 Eurostile Demi

It was the best of times, it was the worst of times, it was the age of wisdom, it was the age of foolishness, it was the epoch of belief, it was the epoch of incredulity, it was the season of light, it was the season of darkness, it was the spring of hope, it was the winter of despair, we had

10/12 Eurostile Demi

It was the best of times, it was the worst of times, it was the age of wisdom, it was the age of foolishness, it was the epoch of belief, it was the epoch of incredulity, it was the season of light, it was the season of darkness, it was the spring of hope, it was the winter of despair, we had everything before us, we

11/13 Eurostile Demi

It was the best of times, it was the worst of times, it was the age of wisdom, it was the age of foolishness, it was the epoch of belief, it was the epoch of incredulity, it was the season of light, it was the season of darkness, it was the spring of hope, it was

11/14 Eurostile Demi

It was the best of times, it was the worst of times, it was the age of wisdom, it was the age of foolishness, it was the epoch of belief, it was the epoch of incredulity, it was the season of light, it was the season of darkness, it was the spring of hope, it was

12/13 Eurostile Demi

It was the best of times, it was the worst of times, it was the age of wisdom, it was the age of foolishness, it was the epoch of belief, it was the epoch of incredulity, it was the season of light, it was the season of darkness, it was the spring of hope,

12/14 Eurostile Demi

It was the best of times, it was the worst of times, it was the age of wisdom, it was the age of foolishness, it was the epoch of belief, it was the epoch of incredulity, it was the season of light, it was the season of darkness, it was the spring of

13/15 Eurostile Demi

It was the best of times, it was the worst of times, it was the age of wisdom, it was the age of foolishness, it was the epoch of belief, it was the epoch of incredulity, it was the season of light, it was the season of dark-

14/15 Eurostile Demi

It was the best of times, it was the worst of times, it was the age of wisdom, it was the age of foolishness, it was the epoch of belief, it was the epoch of incredulity, it was the season of light, it was the season

14/16 Eurostile Demi

It was the best of times, it was the worst of times, it was the age of wisdom, it was the age of foolishness, it was the epoch of belief, it was the epoch of incredulity, it was the season of light, it was the season

Eurostile Demi Oblique 72 point

ABCDEFGHIJKL
MNOPQRSTUV
WXYZabcdefghij
klmnopqrstuvwx
yz1234567890
*?!&$$%#@ * "":;·,*

Eurostile Demi Oblique 24 point

ABCDEFGHIJKLMNOPQRSTUVWXYZ
abcdefghijklmnopqrstuvwxyz 1234567890 !?%

Eurostile Demi Oblique 30 point

ABCDEFGHIJKLMNOPQRSTUVWXYZ
abcdefghijklmnopqrstuvwxyz 1234567

Eurostile Demi Oblique 36 point

ABCDEFGHIJKLMNOPQRSTUV
abcdefghijklmnopqrstuvwxyz12

Eurostile Demi Oblique 48 point

ABCDEFGHIJKLMNOPQR
abcdefghijklmnopqrstu 12

Eurostile Demi Oblique 60 point

ABCDEFGHIJKLMNO
abcdefghijklmnopq 12

Eurostile Bold 72 point

ABCDEFGHIJKL
MNOPQRSTUV
WXYZabcdefghij
klmnopqrstuvwx
yz1234567890
?!&$%#@*""·,·,

Eurostile Bold 24 point

ABCDEFGHIJKLMNOPQRSTUVWXYZ
abcdefghijklmnopqrstuvwxyz 1234567890 !?

Eurostile Bold 30 point

ABCDEFGHIJKLMNOPQRSTUVWXYZ
abcdefghijklmnopqrstuvwxyz 123456

Eurostile Bold 36 point

ABCDEFGHIJKLMNOPQRSTUV
abcdefghijklmnopqrstuvwxy12

Eurostile Bold 48 point

ABCDEFGHIJKLMNOPQ
abcdefghijklmnopqrstu 1

Eurostile Bold 60 point

ABCDEFGHIJKLMN
abcdefghijklmnopq 1

Freestyle Script 72 point

ABCDEFGHIJKLMN

OPQRSTUVWXYZ

abcdefghijklmn

opqrstuvwxyz

1234567890

?!/&$%*""·;·.,

Freestyle Script 10 point

ABCDEFGHIJKLMNOPQRSTUVWXYZ abcdefghij

klmnopqrstuvwxyz 1234567890 ?!/&$%*"";:.,

Freestyle Script 12 point

ABCDEFGHIJKLMNOPQRSTUVWXYZ abcdefghij

klmnopqrstuvwxyz 1234567890 ?!/&$%*"";:.,

Freestyle Script 13 point

ABCDEFGHIJKLMNOPQRSTUVWXYZ abcdefghij

klmnopqrstuvwxyz 1234567890 ?!/&$%*"";:.,

Freestyle Script 14 point

ABCDEFGHIJKLMNOPQRSTUVWXYZ abcdefghij

klmnopqrstuvwxyz 1234567890 ?!/&$%*"";:.,

Freestyle Script 16 point

ABCDEFGHIJKLMNOPQRSTUVWXYZ abcdefghij

klmnopqrstuvwxyz 1234567890 ?!/&$%*"";:.,

Freestyle Script 18 point

ABCDEFGHIJKLMNOPQRSTUVWXYZ abcdefghij

klmnopqrstuvwxyz 1234567890 ?!/&$%*"";:.,

Freestyle Script 20 point

ABCDEFGHIJKLMNOPQRSTUVWXYZ abcdefghij

klmnopqrstuvwxyz 1234567890 ?!/&$%*"";:.,

Freestyle Script 22 point

ABCDEFGHIJKLMNOPQRSTUVWXYZ abcdefghij

klmnopqrstuvwxyz 1234567890 ?!/&$%*"";:.,

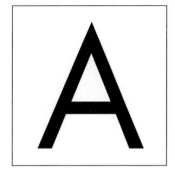

Futura Book 72 point

ABCDEFGHIJKL
MNOPQRSTUVW
XYZ abcdefghijkl
mnopqrstuvwxyz
1234567890
¿!/&$%#@*""·;·,

Futura Book 11 point

ABCDEFGHIJKLMNOPQRSTUVWXYZ abcdefghij
klmnopqrstuvwxyz 1234567890 ?!/&$%#@*"":;.,

Futura Book 12 point

ABCDEFGHIJKLMNOPQRSTUVWXYZ abcdefghij
klmnopqrstuvwxyz 1234567890 ?!/&$%#@*"":;.,

Futura Book 13 point

ABCDEFGHIJKLMNOPQRSTUVWXYZ abcdefghij
klmnopqrstuvwxyz 1234567890 ?!/&$%#@*"":;.,

Futura Book 14 point

ABCDEFGHIJKLMNOPQRSTUVWXYZ abcdefghij
klmnopqrstuvwxyz 1234567890 ?!/&$%#@*"":;.,

Futura Book 16 point

ABCDEFGHIJKLMNOPQRSTUVWXYZ abcdefghij
klmnopqrstuvwxyz 1234567890 ?!/&$%#@*"":;.,

Futura Book 18 point

ABCDEFGHIJKLMNOPQRSTUVWXYZ abcdefghij
klmnopqrstuvwxyz 1234567890 ?!/&$%#@*"":;.,

Futura Book 20 point

ABCDEFGHIJKLMNOPQRSTUVWXYZ abcdefghij
klmnopqrstuvwxyz 1234567890 ?!/&$%#@*"":;.,

Futura Book 22 point

ABCDEFGHIJKLMNOPQRSTUVWXYZ abcdefghij
klmnopqrstuvwxyz 1234567890 ?!/&$%#@*"":;.,

Futura Book 24 point

ABCDEFGHIJKLMNOPQRSTUVWXYZ
abcdefghijklmnopqrstuvwxyz 1234567890 !?%&*

Futura Book 30 point

ABCDEFGHIJKLMNOPQRSTUVWXYZ
abcdefghijklmnopqrstuvwxyz 12345678

Futura Book 36 point

ABCDEFGHIJKLMNOPQRSTUVW
abcdefghijklmnopqrstuvwxyz 1234

Futura Book 48 point

ABCDEFGHIJKLMNOPQ
abcdefghijklmnopqrstu 12

Futura Book 60 point

ABCDEFGHIJKLMN
abcdefghijklmnop 12

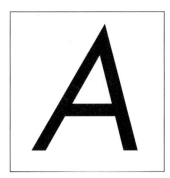

Futura Book Oblique 72 point

ABCDEFGHIJKL MNOPQRSTUVW XYZ abcdefghijkl mnopqrstuvwxyz 1234567890 ?!/&$%#@*""..

Futura Bold 72 point

ABCDEFGHIJKL MNOPQRSTUV WXYZ abcdefg hijklmnopqrstu vwxyz123456 ?!&$%#@*""";•;•

Futura Bold 11 point

ABCDEFGHIJKLMNOPQRSTUVWXYZ abcdefghij klmnopqrstuvwxyz 1234567890 ?!/&$%#@*""":;.,

Futura Bold 12 point

ABCDEFGHIJKLMNOPQRSTUVWXYZ abcdefghij klmnopqrstuvwxyz 1234567890 ?!/&$%#@*""":;.,

Futura Bold 13 point

ABCDEFGHIJKLMNOPQRSTUVWXYZ abcdefghij klmnopqrstuvwxyz 1234567890 ?!/&$%#@*""":;.,

Futura Bold 14 point

ABCDEFGHIJKLMNOPQRSTUVWXYZ abcdefghij klmnopqrstuvwxyz 1234567890 ?!/&$%#@*""":;.,

Futura Bold 16 point

ABCDEFGHIJKLMNOPQRSTUVWXYZ abcdefghij klmnopqrstuvwxyz 1234567890 ?!/&$%#@*""":;.,

Futura Bold 18 point

ABCDEFGHIJKLMNOPQRSTUVWXYZ abcdefghij klmnopqrstuvwxyz 1234567890 ?!/&$%#@*""":;.,

Futura Bold 20 point

ABCDEFGHIJKLMNOPQRSTUVWXYZ abcdefghij klmnopqrstuvwxyz 1234567890 ?!/&$%#@*""":;.,

Futura Bold 22 point

ABCDEFGHIJKLMNOPQRSTUVWXYZ abcdefghij klmnopqrstuvwxyz 1234567890 ?!/&$%#@*""":

Futura Bold Oblique 72 point

ABCDEFGHIJKL MNOPQRSTUV WXYZ abcdefg hijklmnopqrstu vwxyz123456 ?!&$$%#@*'''";,

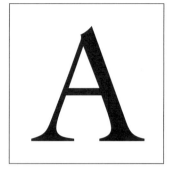

ITC Galliard Roman 72 Point

ABCDEFGHIJKL
MNOPQRSTUV
WXYZ abcdefghijk
lmnopqrstuvwxyz
1234567890
?!/&$%#@*""..:,,

ITC Galliard Roman 10 point

ABCDEFGHIJKLMNOPQRSTUVWXYZ abcdefghij
klmnopqrstuvwxyz 1234567890 ?!/&$%#@*""":;.,

ITC Galliard Roman 45 12 point

ABCDEFGHIJKLMNOPQRSTUVWXYZ abcdefghij
klmnopqrstuvwxyz 1234567890 ?!/&$%#@*""":;.,

ITC Galliard Roman 13 point

ABCDEFGHIJKLMNOPQRSTUVWXYZ abcdefghij
klmnopqrstuvwxyz 1234567890 ?!/&$%#@*""":;.,

ITC Galliard Roman 14 point

ABCDEFGHIJKLMNOPQRSTUVWXYZ abcdefghij
klmnopqrstuvwxyz 1234567890 ?!/&$%#@*""":;.,

ITC Galliard Roman 16 point

ABCDEFGHIJKLMNOPQRSTUVWXYZ abcdefghij
klmnopqrstuvwxyz 1234567890 ?!/&$%#@*""":;.,

ITC Galliard Roman 18 point

ABCDEFGHIJKLMNOPQRSTUVWXYZ abcdefghij
klmnopqrstuvwxyz 1234567890 ?!/&$%#@*""":;.,

ITC Galliard Roman 20 point

ABCDEFGHIJKLMNOPQRSTUVWXYZ abcdefghij
klmnopqrstuvwxyz 1234567890 ?!/&$%#@*""":;.,

ITC Galliard Roman 22 point

ABCDEFGHIJKLMNOPQRSTUVWXYZ abcdefghij
klmnopqrstuvwxyz 1234567890 ?!/&$%#@*""":;.,

ITC Galliard Roman 24 point

ABCDEFGHIJKLMNOPQRSTUVWXYZ
abcdefghijklmnopqrstuvwxyz 1234567890 !?%&*

ITC Galliard Roman 30 point

ABCDEFGHIJKLMNOPQRSTUVWXYZ
abcdefghijklmnopqrstuvwxyz 1234567890

ITC Galliard Roman 36 point

ABCDEFGHIJKLMNOPQRSTUV
abcdefghijklmnopqrstuvwxyz 12345

ITC Galliard Roman 48 point

ABCDEFGHIJKLMNOPQ
abcdefghijklmnopqrstu 123

ITC Galliard Roman 60 point

ABCDEFGHIJKLMN
abcdefghijklmnor 123

6/8 ITC Galliard Roman

It was the best of times, it was the worst of times, it was the age of wisdom, it was the age of foolishness, it was the epoch of belief, it was the epoch of incredulity, it was the season of light, it was the season of darkness, it was the spring of hope, it was the winter of despair, we had everything before us, we had nothing before us, we were all going direct to Heaven, we were all going direct the other way-in short, the period was so far like the present period, that some of its noisiest authorities insisted on its being received, for good or for evil, in the superlative

8/10 ITC Galliard Roman

It was the best of times, it was the worst of times, it was the age of wisdom, it was the age of foolishness, it was the epoch of belief, it was the epoch of incredulity, it was the season of light, it was the season of darkness, it was the spring of hope, it was the winter of despair, we had everything before us, we had nothing before us, we were all going direct to Heaven, we were all going direct the other way-in short, the period was so

9/10 ITC Galliard Roman

It was the best of times, it was the worst of times, it was the age of wisdom, it was the age of foolishness, it was the epoch of belief, it was the epoch of incredulity, it was the season of light, it was the season of darkness, it was the spring of hope, it was the winter of despair, we had everything before us, we had nothing before us, we were all going direct to Heaven,

9/11 ITC Galliard Roman

It was the best of times, it was the worst of times, it was the age of wisdom, it was the age of foolishness, it was the epoch of belief, it was the epoch of incredulity, it was the season of light, it was the season of darkness, it was the spring of hope, it was the winter of despair, we had everything before us, we had nothing before us, we were all going direct to Heaven,

10/11 ITC Galliard Roman

It was the best of times, it was the worst of times, it was the age of wisdom, it was the age of foolishness, it was the epoch of belief, it was the epoch of incredulity, it was the season of light, it was the season of darkness, it was the spring of hope, it was the winter of despair, we had everything before us, we had nothing before us, we

10/12 ITC Galliard Roman

It was the best of times, it was the worst of times, it was the age of wisdom, it was the age of foolishness, it was the epoch of belief, it was the epoch of incredulity, it was the season of light, it was the season of darkness, it was the spring of hope, it was the winter of despair, we had everything before us, we had nothing before us, we

11/13 ITC Galliard Roman

It was the best of times, it was the worst of times, it was the age of wisdom, it was the age of foolishness, it was the epoch of belief, it was the epoch of incredulity, it was the season of light, it was the season of darkness, it was the spring of hope, it was the winter of despair, we had everything before us, we had

11/14 ITC Galliard Roman

It was the best of times, it was the worst of times, it was the age of wisdom, it was the age of foolishness, it was the epoch of belief, it was the epoch of incredulity, it was the season of light, it was the season of darkness, it was the spring of hope, it was the winter of despair, we had everything before us, we had

12/13 ITC Galliard Roman

It was the best of times, it was the worst of times, it was the age of wisdom, it was the age of foolishness, it was the epoch of belief, it was the epoch of incredulity, it was the season of light, it was the season of darkness, it was the spring of hope, it was the winter of despair, we had everything before us, we

12/14 ITC Galliard Roman

It was the best of times, it was the worst of times, it was the age of wisdom, it was the age of foolishness, it was the epoch of belief, it was the epoch of incredulity, it was the season of light, it was the season of darkness, it was the spring of hope, it was the winter of despair, we had everything before us, we

13/15 ITC Galliard Roman

It was the best of times, it was the worst of times, it was the age of wisdom, it was the age of foolishness, it was the epoch of belief, it was the epoch of incredulity, it was the season of light, it was the season of darkness, it was the spring of hope, it was the

14/15 ITC Galliard Roman

It was the best of times, it was the worst of times, it was the age of wisdom, it was the age of foolishness, it was the epoch of belief, it was the epoch of incredulity, it was the season of light, it was the season of darkness, it was the spring of

14/16 ITC Galliard Roman

It was the best of times, it was the worst of times, it was the age of wisdom, it was the age of foolishness, it was the epoch of belief, it was the epoch of incredulity, it was the season of light, it was the season of darkness, it was the spring of

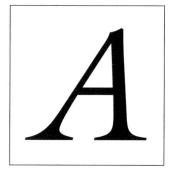

ITC Galliard Italic 72 point

ABCDEFGHIJK
LMNOPQRSTU
VWXYZ abcdefg
hijklmnopqrstuv
wxyz 1234567890
*?!&$%#@ * "".,.;,*

ITC Galliard Italic 10 point

ABCDEFGHIJKLMNOPQRSTUVWXYZ abcdefghij
klmnopqrstuvwxyz 1234567890 ?!/&$%#@""*:;.,*

ITC Galliard Italic 12 point

ABCDEFGHIJKLMNOPQRSTUVWXYZ abcdefghij
klmnopqrstuvwxyz 1234567890 ?!/&$%#@""*:;.,*

ITC Galliard Italic 13 point

ABCDEFGHIJKLMNOPQRSTUVWXYZ abcdefghij
klmnopqrstuvwxyz 1234567890 ?!/&$%#@""*:;.,*

ITC Galliard Italic 14 point

ABCDEFGHIJKLMNOPQRSTUVWXYZ abcdefghij
klmnopqrstuvwxyz 1234567890 ?!/&$%#@""*:;.,*

ITC Galliard Italic 16 point

ABCDEFGHIJKLMNOPQRSTUVWXYZ abcdefghij
klmnopqrstuvwxyz 1234567890 ?!/&$%#@""*:;.,*

ITC Galliard Italic 18 point

ABCDEFGHIJKLMNOPQRSTUVWXYZ abcdefghij
klmnopqrstuvwxyz 1234567890 ?!/&$%#@""*:;.,*

ITC Galliard Italic 20 point

ABCDEFGHIJKLMNOPQRSTUVWXYZ abcdefghij
klmnopqrstuvwxyz 1234567890 ?!/&$%#@""*:;.,*

ITC Galliard Italic 22 point

ABCDEFGHIJKLMNOPQRSTUVWXYZ abcdefghij
klmnopqrstuvwxyz 1234567890 ?!/&$%#@""*:;.,*

ITC Galliard Italic 24 point

ABCDEFGHIJKLMNOPQRSTUVWXYZ
abcdefghijklmnopqrstuvwxyz 1234567890 !?%&~*

ITC Galliard Italic 30 point

ABCDEFGHIJKLMNOPQRSTUVWXYZ
abcdefghijklmnopqrstuvwxyz 1234567890

ITC Galliard Italic 36 point

ABCDEFGHIJKLMNOPQRSTUV
abcdefghijklmnopqrstuvwxyz 123456

ITC Galliard Italic 48 point

ABCDEFGHIJKLMNOPQ
abcdefghijklmnopqrstu 1234

ITC Galliard Italic 60 point

ABCDEFGHIJKLMO
abcdefghijklmnopq123

6/8 ITC Galliard Italic

It was the best of times, it was the worst of times, it was the age of wisdom, it was the age of foolishness, it was the epoch of belief, it was the epoch of incredulity, it was the season of light, it was the season of darkness, it was the spring of hope, it was the winter of despair, we had everything before us, we had nothing before us, we were all going direct to Heaven, we were all going direct the other way-in short, the period was so far like the present period, that some of its noisiest authorities insisted on its being received, for good or for evil, in the superlative

8/10 ITC Galliard Italic

It was the best of times, it was the worst of times, it was the age of wisdom, it was the age of foolishness, it was the epoch of belief, it was the epoch of incredulity, it was the season of light, it was the season of darkness, it was the spring of hope, it was the winter of despair, we had everything before us, we had nothing before us, we were all going direct to Heaven, we were all going direct the other way-in short, the period was so far like the present period,

9/10 ITC Galliard Italic

It was the best of times, it was the worst of times, it was the age of wisdom, it was the age of foolishness, it was the epoch of belief, it was the epoch of incredulity, it was the season of light, it was the season of darkness, it was the spring of hope, it was the winter of despair, we had everything before us, we had nothing before us, we were all going direct to Heaven, we were all going direct the other way

9/11 ITC Galliard Italic

It was the best of times, it was the worst of times, it was the age of wisdom, it was the age of foolishness, it was the epoch of belief, it was the epoch of incredulity, it was the season of light, it was the season of darkness, it was the spring of hope, it was the winter of despair, we had everything before us, we had nothing before us, we were all going direct to Heaven, we were all going direct other way-in

10/11 ITC Galliard Italic

It was the best of times, it was the worst of times, it was the age of wisdom, it was the age of foolishness, it was the epoch of belief, it was the epoch of incredulity, it was the season of light, it was the season of darkness, it was the spring of hope, it was the winter of despair, we had everything before us, we had nothing before us, we were all going direct to Heaven, we

10/12 ITC Galliard Italic

It was the best of times, it was the worst of times, it was the age of wisdom, it was the age of foolishness, it was the epoch of belief, it was the epoch of incredulity, it was the season of light, it was the season of darkness, it was the spring of hope, it was the winter of despair, we had everything before us, we had nothing before us, we were all going direct to Heaven, we

11/13 ITC Galliard Italic

It was the best of times, it was the worst of times, it was the age of wisdom, it was the age of foolishness, it was the epoch of belief, it was the epoch of incredulity, it was the season of light, it was the season of darkness, it was the spring of hope, it was the winter of despair, we had everything before us, we had nothing before us, we were all going

11/14 ITC Galliard Italic

It was the best of times, it was the worst of times, it was the age of wisdom, it was the age of foolishness, it was the epoch of belief, it was the epoch of incredulity, it was the season of light, it was the season of darkness, it was the spring of hope, it was the winter of despair, we had everything before us, we had nothing before us, we were all going

12/13 ITC Galliard Italic

It was the best of times, it was the worst of times, it was the age of wisdom, it was the age of foolishness, it was the epoch of belief, it was the epoch of incredulity, it was the season of light, it was the season of darkness, it was the spring of hope, it was the winter of despair, we had everything before us, we

12/14 ITC Galliard Italic

It was the best of times, it was the worst of times, it was the age of wisdom, it was the age of foolishness, it was the epoch of belief, it was the epoch of incredulity, it was the season of light, it was the season of darkness, it was the spring of hope, it was the winter of despair, we had everything before us, we

13/15 ITC Galliard Italic

It was the best of times, it was the worst of times, it was the age of wisdom, it was the age of foolishness, it was the epoch of belief, it was the epoch of incredulity, it was the season of light, it was the season of darkness, it was the spring of hope, it was the winter of despair, we had everything before us, we

14/15 ITC Galliard Italic

It was the best of times, it was the worst of times, it was the age of wisdom, it was the age of foolishness, it was the epoch of belief, it was the epoch of incredulity, it was the season of light, it was the season of darkness, it was the

14/16 ITC Galliard Italic

It was the best of times, it was the worst of times, it was the age of wisdom, it was the age of foolishness, it was the epoch of belief, it was the epoch of incredulity, it was the season of light, it was the season of darkness, it was the

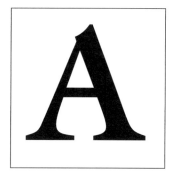

ITC Galliard Bold 72 point

ABCDEFGHIJK
LMNOPQRSTU
VWXYZabcdefgh
ijklmnopqrstuvw
xyz 1234567890
?!/&$$%#@*""..;,,

ITC Galliard Bold 10 point

ABCDEFGHIJKLMNOPQRSTUVWXYZ abcdefghij
klmnopqrstuvwxyz 1234567890 ?!/&$%#@*""":;.,

ITC Galliard Bold 12 point

ABCDEFGHIJKLMNOPQRSTUVWXYZ abcdefghij
klmnopqrstuvwxyz 1234567890 ?!/&$%#@*""":;.,

ITC Galliard Bold 13 point

ABCDEFGHIJKLMNOPQRSTUVWXYZ abcdefghij
klmnopqrstuvwxyz 1234567890 ?!/&$%#@*""":;.,

ITC Galliard Bold 14 point

ABCDEFGHIJKLMNOPQRSTUVWXYZ abcdefghij
klmnopqrstuvwxyz 1234567890 ?!/&$%#@*""":;.,

ITC Galliard Bold 16 point

ABCDEFGHIJKLMNOPQRSTUVWXYZ abcdefghij
klmnopqrstuvwxyz 1234567890 ?!/&$%#@*""":;.,

ITC Galliard Bold 18 point

ABCDEFGHIJKLMNOPQRSTUVWXYZ abcdefghij
klmnopqrstuvwxyz 1234567890 ?!/&$%#@*""":;.,

ITC Galliard Bold 20 point

ABCDEFGHIJKLMNOPQRSTUVWXYZ abcdefghij
klmnopqrstuvwxyz 1234567890 ?!/&$%#@*""":;.,

ITC Galliard Bold 22 point

ABCDEFGHIJKLMNOPQRSTUVWXYZ abcdefghij
klmnopqrstuvwxyz 1234567890 ?!/&$%#@*""":;.,

ITC Galliard Bold 24 point

ABCDEFGHIJKLMNOPQRSTUVWXYZ
abcdefghijklmnopqrstuvwxyz 1234567890 !?%&

ITC Galliard Bold 30 point

ABCDEFGHIJKLMNOPQRSTUVWXY
abcdefghijklmnopqrstuvwxyz 12345678

ITC Galliard Bold 36 point

ABCDEFGHIJKLMNOPQRSTU
abcdefghijklmnopqrstuvw 12345678

ITC Galliard Bold 48 point

ABCDEFGHIJKLMNOP
abcdefghijklmnopqrs 123

ITC Galliard Bold 60 point

ABCDEFGHIJKLM
abcdefghijklmno 123

6/8 ITC Galliard Bold

It was the best of times, it was the worst of times, it was the age of wisdom, it was the age of foolishness, it was the epoch of belief, it was the epoch of incredulity, it was the season of light, it was the season of darkness, it was the spring of hope, it was the winter of despair, we had everything before us, we had nothing before us, we were all going direct to Heaven, we were all going direct the other way-in short, the period was so far like the present period, that some of its noisiest authorities insisted on its

8/10 ITC Galliard Bold

It was the best of times, it was the worst of times, it was the age of wisdom, it was the age of foolishness, it was the epoch of belief, it was the epoch of incredulity, it was the season of light, it was the season of darkness, it was the spring of hope, it was the winter of despair, we had everything before us, we had nothing before us, we were all going direct to Heaven, we were all going direct

9/10 ITC Galliard Bold

It was the best of times, it was the worst of times, it was the age of wisdom, it was the age of foolishness, it was the epoch of belief, it was the epoch of incredulity, it was the season of light, it was the season of darkness, it was the spring of hope, it was the winter of despair, we had everything before us, we had nothing before us, we were all going direct

9/11 ITC Galliard Bold

It was the best of times, it was the worst of times, it was the age of wisdom, it was the age of foolishness, it was the epoch of belief, it was the epoch of incredulity, it was the season of light, it was the season of darkness, it was the spring of hope, it was the winter of despair, we had everything before us, we had nothing before us, we were all going direct

10/11 ITC Galliard Bold

It was the best of times, it was the worst of times, it was the age of wisdom, it was the age of foolishness, it was the epoch of belief, it was the epoch of incredulity, it was the season of light, it was the season of darkness, it was the spring of hope, it was the winter of despair, we had everything before us, we had we

10/12 ITC Galliard Bold

It was the best of times, it was the worst of times, it was the age of wisdom, it was the age of foolishness, it was the epoch of belief, it was the epoch of incredulity, it was the season of light, it was the season of darkness, it was the spring of hope, it was the winter of despair, we had everything before us, we had we

11/13 ITC Galliard Bold

It was the best of times, it was the worst of times, it was the age of wisdom, it was the age of foolishness, it was the epoch of belief, it was the epoch of incredulity, it was the season of light, it was the season of darkness, it was the spring of hope, it was the winter of despair, we had everything before us, we

11/14 ITC Galliard Bold

It was the best of times, it was the worst of times, it was the age of wisdom, it was the age of foolishness, it was the epoch of belief, it was the epoch of incredulity, it was the season of light, it was the season of darkness, it was the spring of hope, it was the winter of despair, we had everything before us, we

12/13 ITC Galliard Bold

It was the best of times, it was the worst of times, it was the age of wisdom, it was the age of foolishness, it was the epoch of belief, it was the epoch of incredulity, it was the season of light, it was the season of darkness, it was the spring of hope, it was

12/14 ITC Galliard Bold

It was the best of times, it was the worst of times, it was the age of wisdom, it was the age of foolishness, it was the epoch of belief, it was the epoch of incredulity, it was the season of light, it was the season of darkness, it was the spring of hope, it was

13/15 ITC Galliard Bold

It was the best of times, it was the worst of times, it was the age of wisdom, it was the age of foolishness, it was the epoch of belief, it was the epoch of incredulity, it was the season of light, it was the season of darkness, it was the spring of

14/15 ITC Galliard Bold

It was the best of times, it was the worst of times, it was the age of wisdom, it was the age of foolishness, it was the epoch of belief, it was the epoch of incredulity, it was the season of light, it was the season of darkness, it was the

14/16 ITC Galliard Bold

It was the best of times, it was the worst of times, it was the age of wisdom, it was the age of foolishness, it was the epoch of belief, it was the epoch of incredulity, it was the season of light, it was the season of darkness, it was the

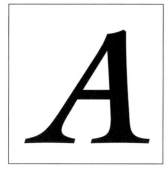

ITC Galliard Bold Italic 72 Point

ABCDEFGHIJK
LMNOPQRSTU
VWXYZabcdefgh
ijklmnopqrstuvw
xyz 1234567890
?!/&$%#@ ""·,;·,*

ITC Galliard Bold Italic 10 point

ABCDEFGHIJKLMNOPQRSTUVWXYZ abcdefghij
klmnopqrstuvwxyz 1234567890 ?!/&$%#@""*:;.,

ITC Galliard Bold Italic 12 point

ABCDEFGHIJKLMNOPQRSTUVWXYZ abcdefghij
klmnopqrstuvwxyz 1234567890 ?!/&$%#@""*:;.,

ITC Galliard Bold Italic 13 point

ABCDEFGHIJKLMNOPQRSTUVWXYZ abcdefghij
klmnopqrstuvwxyz 1234567890 ?!/&$%#@""*:;.,

ITC Galliard Bold Italic 14 point

ABCDEFGHIJKLMNOPQRSTUVWXYZ abcdefghij
klmnopqrstuvwxyz 1234567890 ?!/&$%#@""*:;.,

ITC Galliard Bold Italic 16 point

ABCDEFGHIJKLMNOPQRSTUVWXYZ abcdefghij
klmnopqrstuvwxyz 1234567890 ?!/&$%#@""*:;.,

ITC Galliard Bold Italic 18 point

ABCDEFGHIJKLMNOPQRSTUVWXYZ abcdefghij
klmnopqrstuvwxyz 1234567890 ?!/&$%#@""*:;.,

ITC Galliard Bold Italic 20 point

ABCDEFGHIJKLMNOPQRSTUVWXYZ abcdefghij
klmnopqrstuvwxyz 1234567890 ?!/&$%#@""*:;.,

ITC Galliard Bold Italic 22 point

ABCDEFGHIJKLMNOPQRSTUVWXYZ abcdefghij
klmnopqrstuvwxyz 1234567890 ?!/&$%#@""*:;.,

Galliard Bold Italic 24 point

ABCDEFGHIJKLMNOPQRSTUVWXYZ
abcdefghijklmnopqrstuvwxyz 1234567890 !?%&

Galliard Bold Italic 30 point

ABCDEFGHIJKLMNOPQRSTUVWXYZ
abcdefghijklmnopqrstuvwxyz 1234567890

Galliard Bold Italic 36 point

ABCDEFGHIJKLMNOPQRSTUV
abcdefghijklmnopqrstuv 123456789

Galliard Bold Italic 48 point

ABCDEFGHIJKLMNOP
abcdefghijklmnopqrst 123

Galliard Bold Italic 60 point

ABCDEFGHIJKLMO
abcdefghijklmnpq 123

6/8 ITC Galliard Bold Italic

It was the best of times, it was the worst of times, it was the age of wisdom, it was the age of foolishness, it was the epoch of belief, it was the epoch of incredulity, it was the season of light, it was the season of darkness, it was the spring of hope, it was the winter of despair, we had everything before us, we had nothing before us, we were all going direct to Heaven, we were all going direct the other way-in short, the period was so far like the present period, that some of its noisiest authorities insisted on its being received, for good or for evil, in the superlative

8/10 ITC Galliard Bold Italic

It was the best of times, it was the worst of times, it was the age of wisdom, it was the age of foolishness, it was the epoch of belief, it was the epoch of incredulity, it was the season of light, it was the season of darkness, it was the spring of hope, it was the winter of despair, we had everything before us, we had nothing before us, we were all going direct to Heaven, we were all going direct the other way-in short, the period was so far

9/10 ITC Galliard Bold Italic

It was the best of times, it was the worst of times, it was the age of wisdom, it was the age of foolishness, it was the epoch of belief, it was the epoch of incredulity, it was the season of light, it was the season of darkness, it was the spring of hope, it was the winter of despair, we had everything before us, we had nothing before us, we were all going direct the other way-in

9/11 ITC Galliard Bold Italic

It was the best of times, it was the worst of times, it was the age of wisdom, it was the age of foolishness, it was the epoch of belief, it was the epoch of incredulity, it was the season of light, it was the season of darkness, it was the spring of hope, it was the winter of despair, we had everything before us, we had nothing before us, we were all going direct the other way-in

10/11 ITC Galliard Bold Italic

It was the best of times, it was the worst of times, it was the age of wisdom, it was the age of foolishness, it was the epoch of belief, it was the epoch of incredulity, it was the season of light, it was the season of darkness, it was the spring of hope, it was the winter of despair, we had everything before us, we had nothing before us, we were all

10/12 ITC Galliard Bold Italic

It was the best of times , it was the worst of times, it was the age of wisdom, it was the age of foolishness, it was the epoch of belief, it was the epoch of incredulity, it was the season of light, it was the season of darkness, it was the spring of hope, it was the winter of despair, we had everything before us, we had nothing before us, we were all

11/13 ITC Galliard Bold Italic

It was the best of times, it was the worst of times, it was the age of wisdom, it was the age of foolishness, it was the epoch of belief, it was the epoch of incredulity, it was the season of light, it was the season of darkness, it was the spring of hope, it was the winter of despair, we had everything before us, we had nothing

11/14 ITC Galliard Bold Italic

It was the best of times, it was the worst of times, it was the age of wisdom, it was the age of foolishness, it was the epoch of belief, it was the epoch of incredulity, it was the season of light, it was the season of darkness, it was the spring of hope, it was the winter of despair, we had everything before us, we had nothing

12/13 ITC Galliard Bold Italic

It was the best of times, it was the worst of times, it was the age of wisdom, it was the age of foolishness, it was the epoch of belief, it was the epoch of incredulity, it was the season of light, it was the season of darkness, it was the spring of hope, it was the winter of despair, we had everything before us, we had

12/14 ITC Galliard Bold Italic

It was the best of times, it was the worst of times, it was the age of wisdom, it was the age of foolishness, it was the epoch of belief, it was the epoch of incredulity, it was the season of light, it was the season of darkness, it was the spring of hope, it was the winter of despair, we had everything before us , we had

13/15 ITC Galliard Bold Italic

It was the best of times, it was the worst of times, it was the age of wisdom, it was the age of foolishness, it was the epoch of belief, it was the epoch of incredulity, it was the season of light, it was the season of darkness, it was the spring of hope, it was the winter of despair,

14/15 ITC Galliard Bold Italic

It was the best of times, it was the worst of times, it was the age of wisdom, it was the age of foolishness, it was the epoch of belief, it was the epoch of incredulity, it was the season of light, it was the season of darkness, it was the spring of

14/16 ITC Galliard Bold Italic

It was the best of times, it was the worst of times, it was the age of wisdom, it was the age of foolishness, it was the epoch of belief, it was the epoch of incredulity, it was the season of light, it was the season of darkness, it was the spring of

Garamond Light 72 point

ABCDEFGHIJKL
MNOPQRSTUVW
XYZ abcdefghijkl
mnopqrstuvwxyz
1234567890
?!/&$%#@*"":;.,

ITC Garamond Light 11 point

ABCDEFGHIJKLMNOPQRSTUVWXYZ
abcdefghijklmnopqrstuvwxyz 1234567890 !?%&*

ITC Garamond Light 12 point

ABCDEFGHIJKLMNOPQRSTUVWXYZ
abcdefghijklmnopqrstuvwxyz 1234567890

ITC Garamond Light 13 point

ABCDEFGHIJKLMNOPQRSTUVWXYZ
abcdefghijklmnopqrstuvwxyz 1234567890

ITC Garamond Light 14 point

ABCDEFGHIJKLMNOPQRSTUVWXYZ
abcdefghijklmnopqrstuvwxyz 1234567890

ITC Garamond Light 16 point

ABCDEFGHIJKLMNOPQRSTUVWXYZ
abcdefghijklmnopqrstuvwxyz 1234567890

ITC Garamond Light 18 point

ABCDEFGHIJKLMNOPQRSTUVWXYZ
abcdefghijklmnopqrstuvwxyz 1234567890

ITC Garamond Light 20 point

ABCDEFGHIJKLMNOPQRSTUVWXYZ
abcdefghijklmnopqrstuvwxyz 1234567890

ITC Garamond Light 22 point

ABCDEFGHIJKLMNOPQRSTUVWXYZ
abcdefghijklmnopqrstuvwxyz 1234567890

ITC Garamond Light 24 point

ABCDEFGHIJKLMNOPQRSTUVWXYZ
abcdefghijklmnopqrstuvwxyz 1234567890 !?%&*

ITC Garamond Light 30 point

ABCDEFGHIJKLMNOPQRSTUVWXYZ
abcdefghijklmnopqrstuvwxyz 1234567890

ITC Garamond Light 36 point

ABCDEFGHIJKLMNOPQRSTUVWX
abcdefghijklmnopqrstuvwxyz 1234

ITC Garamond Light 48 point

ABCDEFGHIJKLMNOPQRS
abcdefghijklmnopqrst 123

ITC Garamond Light 60 point

ABCDEFGHIJKLMNO
abcdefghijklmnop 12

6/8 ITC Garamond Light

It was the best of times, it was the worst of times, it was the age of wisdom, it was the age of foolishness, it was the epoch of belief, it was the epoch of incredulity, it was the season of light, it was the season of darkness, it was the spring of hope, it was the winter of despair, we had everything before us, we had nothing before us, we were all going direct to Heaven, we were all going direct the other way-in short, the period was so far like the present period, that some of its noisiest authorities insisted on its being received, for good or for evil, in the

8/10 ITC Garamond Light

It was the best of times, it was the worst of times, it was the age of wisdom, it was the age of foolishness, it was the epoch of belief, it was the epoch of incredulity, it was the season of light, it was the season of darkness, it was the spring of hope, it was the winter of despair, we had everything before us, we had nothing before us, we were all going direct to Heaven, we were all going direct the other way-in

9/10 ITC Garamond Light

It was the best of times, it was the worst of times, it was the age of wisdom, it was the age of foolishness, it was the epoch of belief, it was the epoch of incredulity, it was the season of light, it was the season of darkness, it was the spring of hope, it was the winter of despair, we had everything before us, we had nothing before us, we were all going direct to Heaven, we were all going

9/11 ITC Garamond Light

It was the best of times, it was the worst of times, it was the age of wisdom, it was the age of foolishness, it was the epoch of belief, it was the epoch of incredulity, it was the season of light, it was the season of darkness, it was the spring of hope, it was the winter of despair, we had everything before us, we had nothing before us, we were all going direct to Heaven, we were all going

10/11 ITC Garamond Light

It was the best of times, it was the worst of times, it was the age of wisdom, it was the age of foolishness, it was the epoch of belief, it was the epoch of incredulity, it was the season of light, it was the season of darkness, it was the spring of hope, it was the winter of despair, we had everything before us, we had nothing before us, we were all going

10/12 ITC Garamond Light

It was the best of times, it was the worst of times, it was the age of wisdom, it was the age of foolishness, it was the epoch of belief, it was the epoch of incredulity, it was the season of light, it was the season of darkness, it was the spring of hope, it was the winter of despair, we had everything before us, we had nothing before us, we were all going

11/13 ITC Garamond Light

It was the best of times, it was the worst of times, it was the age of wisdom, it was the age of foolishness, it was the epoch of belief, it was the epoch of incredulity, it was the season of light, it was the season of darkness, it was the spring of hope, it was the winter of despair, we had everything before us, we had nothing

11/14 ITC Garamond Light

It was the best of times, it was the worst of times, it was the age of wisdom, it was the age of foolishness, it was the epoch of belief, it was the epoch of incredulity, it was the season of light, it was the season of darkness, it was the spring of hope, it was the winter of despair, we had everything before us, we had nothing

12/13 ITC Garamond Light

It was the best of times, it was the worst of times, it was the age of wisdom, it was the age of foolishness, it was the epoch of belief, it was the epoch of incredulity, it was the season of light, it was the season of darkness, it was the spring of hope, it was the winter of despair,

12/14 ITC Garamond Light

It was the best of times, it was the worst of times, it was the age of wisdom, it was the age of foolishness, it was the epoch of belief, it was the epoch of incredulity, it was the season of light, it was the season of darkness, it was the spring of hope, it was the winter of despair,

13/15 ITC Garamond Light

It was the best of times, it was the worst of times, it was the age of wisdom, it was the age of foolishness, it was the epoch of belief, it was the epoch of incredulity, it was the season of light, it was the season of darkness, it was the spring of hope, it was

14/15 ITC Garamond Light

It was the best of times, it was the worst of times, it was the age of wisdom, it was the age of foolishness, it was the epoch of belief, it was the epoch of incredulity, it was the season of light, it was the season of darkness, it was the spring

14/16 ITC Garamond Light

It was the best of times, it was the worst of times, it was the age of wisdom, it was the age of foolishness, it was the epoch of belief, it was the epoch of incredulity, it was the season of light, it was the season of darkness, it was the spring

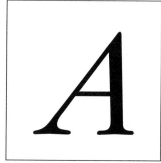

Garamond Light Italic 72 point

ABCDEFGHIJKL
MNOPQRSTUVW
XYZ abcdefghijkl
mnopqrstuvwxyz
1234567890
?!/&$%#@*""".,.,

ITC Garamond Light Italic 11 point

ABCDEFGHIJKLMNOPQRSTUVWXYZ
*abcdefghijklmnopqrstuvwxyz 1234567890 !?%&**

ITC Garamond Light Italic 12 point

ABCDEFGHIJKLMNOPQRSTUVWXYZ
abcdefghijklmnopqrstuvwxyz 1234567890

ITC Garamond Light Italic 13 point

ABCDEFGHIJKLMNOPQRSTUVWXYZ
abcdefghijklmnopqrstuvwxyz 1234567890

ITC Garamond Light Italic 14 point

ABCDEFGHIJKLMNOPQRSTUVWXYZ
abcdefghijklmnopqrstuvwxyz 1234567890

ITC Garamond Light Italic 16 point

ABCDEFGHIJKLMNOPQRSTUVWXYZ
abcdefghijklmnopqrstuvwxyz 1234567890

ITC Garamond Light Italic 18 point

ABCDEFGHIJKLMNOPQRSTUVWXYZ
abcdefghijklmnopqrstuvwxyz 1234567890

ITC Garamond Light Italic 20 point

ABCDEFGHIJKLMNOPQRSTUVWXYZ
abcdefghijklmnopqrstuvwxyz 1234567890

ITC Garamond Light Italic 22 point

ABCDEFGHIJKLMNOPQRSTUVWXYZ
abcdefghijklmnopqrstuvwxyz 1234567890

ITC Garamond Light Italic 24 point

ABCDEFGHIJKLMNOPQRSTUVWXYZ
abcdefghijklmnopqrstuvwxyz 1234567890 !?%&

ITC Garamond Light Italic 30 point

ABCDEFGHIJKLMNOPQRSTUVWXYZ
abcdefghijklmnopqrstuvwxyz 1234567890

ITC Garamond Light Italic 36 point

ABCDEFGHIJKLMNOPQRSTUVWX
abcdefghijklmnopqrstuvwxyz 1234

ITC Garamond Light Italic 48 point

ABCDEFGHIJKLMNOPQRS
abcdefghijklmnopqrst 123

ITC Garamond Light Italic 60 point

ABCDEFGHIJKLMNO
abcdefghijklmnop 12

6/8 ITC Garamond Light Italic

It was the best of times, it was the worst of times, it was the age of wisdom, it was the age of foolishness, it was the epoch of belief, it was the epoch of incredulity, it was the season of light, it was the season of darkness, it was the spring of hope, it was the winter of despair, we had everything before us, we had nothing before us, we were all going direct to Heaven, we were all going direct the other way-in short, the period was so far like the present period, that some of its noisiest authorities insisted on its being received,

8/10 ITC Garamond Light Italic

It was the best of times, it was the worst of times, it was the age of wisdom, it was the age of foolishness, it was the epoch of belief, it was the epoch of incredulity, it was the season of light, it was the season of darkness, it was the spring of hope, it was the winter of despair, we had everything before us, we had nothing before us, we were all going direct to Heaven, we were all going direct the other way-in short, the period was so far like the present period, that some of its noisiest authorities insisted on its being

9/10 ITC Garamond Light Italic

It was the best of times, it was the worst of times, it was the age of wisdom, it was the age of foolishness, it was the epoch of belief, it was the epoch of incredulity, it was the season of light, it was the season of darkness, it was the spring of hope, it was the winter of despair, we had everything before us, we had nothing before us, we were all going direct to Heaven, we were all going direct

9/11 ITC Garamond Light Italic

It was the best of times, it was the worst of times, it was the age of wisdom, it was the age of foolishness, it was the epoch of belief, it was the epoch of incredulity, it was the season of light, it was the season of darkness, it was the spring of hope, it was the winter of despair, we had everything before us, we had nothing before us, we were all going direct to Heaven, we were

10/11 ITC Garamond Light Italic

It was the best of times, it was the worst of times, it was the age of wisdom, it was the age of foolishness, it was the epoch of belief, it was the epoch of incredulity, it was the season of light, it was the season of darkness, it was the spring of hope, it was the winter of despair, we had everything before us, we had nothing before

10/12 ITC Garamond Light Italic

It was the best of times, it was the worst of times, it was the age of wisdom, it was the age of foolishness, it was the epoch of belief, it was the epoch of incredulity, it was the season of light, it was the season of darkness, it was the spring of hope, it was the winter of despair, we had everything before us, we had nothing before

11/13 ITC Garamond Light Italic

It was the best of times, it was the worst of times, it was the age of wisdom, it was the age of foolishness, it was the epoch of belief, it was the epoch of incredulity, it was the season of light, it was the season of darkness, it was the spring of hope, it was the winter of despair, we had everything before us, we

11/14 ITC Garamond Light Italic

It was the best of times, it was the worst of times, it was the age of wisdom, it was the age of foolishness, it was the epoch of belief, it was the epoch of incredulity, it was the season of light, it was the season of darkness, it was the spring of hope, it was the winter of despair, we had everything before us, we

12/13 ITC Garamond Light Italic

It was the best of times, it was the worst of times, it was the age of wisdom, it was the age of foolishness, it was the epoch of belief, it was the epoch of incredulity, it was the season of light, it was the season of darkness, it was the spring of hope, it was the winter of despair, we had everything before us, we

12/14 ITC Garamond Light Italic

It was the best of times, it was the worst of times, it was the age of wisdom, it was the age of foolishness, it was the epoch of belief, it was the epoch of incredulity, it was the season of light, it was the season of darkness, it was the spring of hope, it was the winter of despair, we had everything before us, we

13/15 ITC Garamond Light Italic

It was the best of times, it was the worst of times, it was the age of wisdom, it was the age of foolishness, it was the epoch of belief, it was the epoch of incredulity, it was the season of light, it was the season of darkness, it was the spring of

14/15 ITC Garamond Light Italic

It was the best of times, it was the worst of times, it was the age of wisdom, it was the age of foolishness, it was the epoch of belief, it was the epoch of incredulity, it was the season of light, it was the season of darkness, it was the

14/16 ITC Garamond Light Italic

It was the best of times, it was the worst of times, it was the age of wisdom, it was the age of foolishness, it was the epoch of belief, it was the epoch of incredulity, it was the season of light, it was the season of darkness, it was the

ITC Garamond Bold 72 point

ABCDEFGHIJKL
MNOPQRSTUVW
XYZabcdefghijk
lmnopqrstuvwx
yz 1234567890
?!/&$%#@*""";:.,

ITC Garamond Bold 11 point

ABCDEFGHIJKLMNOPQRSTUVWXYZ
abcdefghijklmnopqrstuvwxyz 1234567890 !?%&*

ITC Garamond Bold 12 point

ABCDEFGHIJKLMNOPQRSTUVWXYZ
abcdefghijklmnopqrstuvwxyz 1234567890

ITC Garamond Bold 13 point

ABCDEFGHIJKLMNOPQRSTUVWXYZ
abcdefghijklmnopqrstuvwxyz 1234567890

ITC Garamond Bold 14 point

ABCDEFGHIJKLMNOPQRSTUVWXYZ
abcdefghijklmnopqrstuvwxyz 1234567890

ITC Garamond Bold 16 point

ABCDEFGHIJKLMNOPQRSTUVWXYZ
abcdefghijklmnopqrstuvwxyz 1234567890

ITC Garamond Bold 18 point

ABCDEFGHIJKLMNOPQRSTUVWXYZ
abcdefghijklmnopqrstuvwxyz 1234567890

ITC Garamond Bold 20 point

ABCDEFGHIJKLMNOPQRSTUVWXYZ
abcdefghijklmnopqrstuvwxyz 1234567890

ITC Garamond Bold 22 point

ABCDEFGHIJKLMNOPQRSTUVWXYZ
abcdefghijklmnopqrstuvwxyz 1234567890

ITC Garamond Bold 24 point

ABCDEFGHIJKLMNOPQRSTUVWXYZ
abcdefghijklmnopqrstuvwxyz 1234567890 !?%&

ITC Garamond Bold 30 point

ABCDEFGHIJKLMNOPQRSTUVWXYZ
abcdefghijklmnopqrstuvwxyz 1234567

ITC Garamond Bold 36 point

ABCDEFGHIJKLMNOPQRSTUVW
abcdefghijklmnopqrstuvwxy 123

ITC Garamond Bold 48 point

ABCDEFGHIJKLMNOPQR
abcdefghijklmnopqrs 12

ITC Garamond Bold 60 point

ABCDEFGHIJKLMN
abcdefghijklmno 12

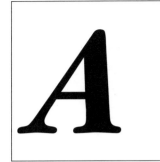

ITC Garamond Bold Italic 72 point

ABCDEFGHIJKL
MNOPQRSTUVW
XYZabcdefghijk
lmnopqrstuvwx
yz 1234567890
?!/&$%#@""'::,;,*

ITC Garamond Bold Italic 11 point

ABCDEFGHIJKLMNOPQRSTUVWXYZ
*abcdefghijklmnopqrstuvwxyz 1234567890 !?%&**

ITC Garamond Bold Italic 12 point

ABCDEFGHIJKLMNOPQRSTUVWXYZ
abcdefghijklmnopqrstuvwxyz 1234567890

ITC Garamond Bold Italic 13 point

ABCDEFGHIJKLMNOPQRSTUVWXYZ
abcdefghijklmnopqrstuvwxyz 1234567890

ITC Garamond Bold Italic 14 point

ABCDEFGHIJKLMNOPQRSTUVWXYZ
abcdefghijklmnopqrstuvwxyz 1234567890

ITC Garamond Bold Italic 16 point

ABCDEFGHIJKLMNOPQRSTUVWXYZ
abcdefghijklmnopqrstuvwxyz 1234567890

ITC Garamond Bold Italic 18 point

ABCDEFGHIJKLMNOPQRSTUVWXYZ
abcdefghijklmnopqrstuvwxyz 1234567890

ITC Garamond Bold Italic 20 point

ABCDEFGHIJKLMNOPQRSTUVWXYZ
abcdefghijklmnopqrstuvwxyz 1234567890

ITC Garamond Bold Italic 22 point

ABCDEFGHIJKLMNOPQRSTUVWXYZ
abcdefghijklmnopqrstuvwxyz 1234567890

ITC Garamond Bold Italic 24 point

ABCDEFGHIJKLMNOPQRSTUVWXYZ
abcdefghijklmnopqrstuvwxyz 1234567890 !?%&

ITC Garamond Bold Italic 30 point

ABCDEFGHIJKLMNOPQRSTUVWXYZ
abcdefghijklmnopqrstuvwxyz 1234567

ITC Garamond Bold Italic 36 point

ABCDEFGHIJKLMNOPQRSTUVW
abcdefghijklmnopqrstuvwxy 12

ITC Garamond Bold Italic 48 point

ABCDEFGHIJKLMNOPQ
abcdefghijklmnopqrs 12

ITC Garamond Bold Italic 60 point

ABCDEFGHIJKLMN
abcdefghijklmno 12

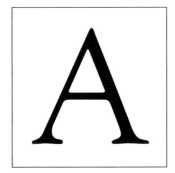

Goudy Old Style 72 point

ABCDEFGHIJKLM
NOPQRSTUVW
XYZ abcdefghijklm
nopqrstuvwxyz
1234567890
?!/&$%#@*""".:;.,

Goudy Old Style 10 point

ABCDEFGHIJKLMNOPQRSTUVWXYZ abcdefghij
klmnopqrstuvwxyz 1234567890 ?!/&$%#@*""";.,

Goudy Old Style 12 point

ABCDEFGHIJKLMNOPQRSTUVWXYZ abcdefghij
klmnopqrstuvwxyz 1234567890 ?!/&$%#@*""";.,

Goudy Old Style 13 point

ABCDEFGHIJKLMNOPQRSTUVWXYZ abcdefghij
klmnopqrstuvwxyz 1234567890 ?!/&$%#@*""";.,

Goudy Old Style 14 point

ABCDEFGHIJKLMNOPQRSTUVWXYZ abcdefghij
klmnopqrstuvwxyz 1234567890 ?!/&$%#@*""";.,

Goudy Old Style 16 point

ABCDEFGHIJKLMNOPQRSTUVWXYZ abcdefghij
klmnopqrstuvwxyz 1234567890 ?!/&$%#@*""";.,

Goudy Old Style 18 point

ABCDEFGHIJKLMNOPQRSTUVWXYZ abcdefghij
klmnopqrstuvwxyz 1234567890 ?!/&$%#@*""";.,

Goudy Old Style 20 point

ABCDEFGHIJKLMNOPQRSTUVWXYZ abcdefghij
klmnopqrstuvwxyz 1234567890 ?!/&$%#@*""";.,

Goudy Old Style 22 point

ABCDEFGHIJKLMNOPQRSTUVWXYZ abcdefghij
klmnopqrstuvwxyz 1234567890 ?!/&$%#@*""";.,

Goudy Old Style 24 point

ABCDEFGHIJKLMNOPQRSTUVWXYZ
abcdefghijklmnopqrstuvwxyz1234567890 !?%&*

Goudy Old Style 30 point

ABCDEFGHIJKLMNOPQRSTUVWXYZ
abcdefghijklmnopqrstuvwxyz 1234567890

Goudy Old Style 36 point

ABCDEFGHIJKLMNOPQRSTUVW
abcdefghijklmnopqrstuvwxyz1234567

Goudy Old Style 48 point

ABCDEFGHIJKLMNOPQR
abcdefghijklmnopqrst 12345

Goudy Old Style 60 point

ABCDEFGHIJKLMN
abcdefghijklmno 1234

6/8 Goudy Old Style

It was the best of times, it was the worst of times, it was the age of wisdom, it was the age of foolishness, it was the epoch of belief, it was the epoch of incredulity, it was the season of light, it was the season of darkness, it was the spring of hope, it was the winter of despair, we had everything before us, we had nothing before us, we were all going direct to Heaven, we were all going direct the other way-in short, the period was so far like the present period, that some of its noisiest authorities insisted on its being received, for good or for evil, in the superlative degree of comparison only.

8/10 Goudy Old Style

It was the best of times, it was the worst of times, it was the age of wisdom, it was the age of foolishness, it was the epoch of belief, it was the epoch of incredulity, it was the season of light, it was the season of darkness, it was the spring of hope, it was the winter of despair, we had everything before us, we had nothing before us, we were all going direct to Heaven, we were all going direct the other way-in short, the period was so far like the present period,

9/10 Goudy Old Style

It was the best of times, it was the worst of times, it was the age of wisdom, it was the age of foolishness, it was the epoch of belief, it was the epoch of incredulity, it was the season of light, it was the season of darkness, it was the spring of hope, it was the winter of despair, we had everything before us, we had nothing before us, we were all going direct to Heaven, we were all going direct the other way-

9/11 Goudy Old Style

It was the best of times, it was the worst of times, it was the age of wisdom, it was the age of foolishness, it was the epoch of belief, it was the epoch of incredulity, it was the season of light, it was the season of darkness, it was the spring of hope, it was the winter of despair, we had everything before us, we had nothing before us, we were all going direct to Heaven, we were all going direct the other way-

10/11 Goudy Old Style

It was the best of times, it was the worst of times, it was the age of wisdom, it was the age of foolishness, it was the epoch of belief, it was the epoch of incredulity, it was the season of light, it was the season of darkness, it was the spring of hope, it was the winter of despair, we had everything before us, we had nothing before us, we were all going direct to Heaven,

10/12 Goudy Old Style

It was the best of times, it was the worst of times, it was the age of wisdom, it was the age of foolishness, it was the epoch of belief, it was the epoch of incredulity, it was the season of light, it was the season of darkness, it was the spring of hope, it was the winter of despair, we had everything before us, we had nothing before us, we were all going direct to Heaven,

11/13 Goudy Old Style

It was the best of times, it was the worst of times, it was the age of wisdom, it was the age of foolishness, it was the epoch of belief, it was the epoch of incredulity, it was the season of light, it was the season of darkness, it was the spring of hope, it was the winter of despair, we had everything before us, we had nothing before us,

11/14 Goudy Old Style

It was the best of times, it was the worst of times, it was the age of wisdom, it was the age of foolishness, it was the epoch of belief, it was the epoch of incredulity, it was the season of light, it was the season of darkness, it was the spring of hope, it was the winter of despair, we had everything before us, we had nothing before us,

12/13 Goudy Old Style

It was the best of times, it was the worst of times, it was the age of wisdom, it was the age of foolishness, it was the epoch of belief, it was the epoch of incredulity, it was the season of light, it was the season of darkness, it was the spring of hope, it was the winter of despair, we had everything before us, we

12/14 Goudy Old Style

It was the best of times, it was the worst of times, it was the age of wisdom, it was the age of foolishness, it was the epoch of belief, it was the epoch of incredulity, it was the season of light, it was the season of darkness, it was the spring of hope, it was the winter of despair, we had everything before us, we

13/15 Goudy Old Style

It was the best of times, it was the worst of times, it was the age of wisdom, it was the age of foolishness, it was the epoch of belief, it was the epoch of incredulity, it was the season of light, it was the season of darkness, it was the spring of hope, it was the winter of despair, we had everything before us, we

14/15 Goudy Old Style

It was the best of times, it was the worst of times, it was the age of wisdom, it was the age of foolishness, it was the epoch of belief, it was the epoch of incredulity, it was the season of light, it was the season of darkness, it was the spring of hope, it was the winter of despair, we had everything before us, we

14/16 Goudy Old Style

It was the best of times, it was the worst of times, it was the age of wisdom, it was the age of foolishness, it was the epoch of belief, it was the epoch of incredulity, it was the season of light, it was the season of darkness, it was the spring of hope, it was the winter of despair, we had everything before us, we

Goudy Old Style Italic 72 point

ABCDEFGHIJKL
MNOPQRSTUV
WXYZ abcdefghijk
lmnopqrstuvwxyz
1234567890
?!&$%#@*""·.;.,

Goudy Old Style Italic 10 point

ABCDEFGHIJKLMNOPQRSTUVWXYZ abcdefghij
klmnopqrstuvwxyz 1234567890 ?!/&$%#@*“”:;.,

Goudy Old Style Italic 12 point

ABCDEFGHIJKLMNOPQRSTUVWXYZ abcdefghij
klmnopqrstuvwxyz 1234567890 ?!/&$%#@*“”:;.,

Goudy Old Style Italic 13 point

ABCDEFGHIJKLMNOPQRSTUVWXYZ abcdefghij
klmnopqrstuvwxyz 1234567890 ?!/&$%#@*“”:;.,

Goudy Old Style Italic 14 point

ABCDEFGHIJKLMNOPQRSTUVWXYZ abcdefghij
klmnopqrstuvwxyz 1234567890 ?!/&$%#@*“”:;.,

Goudy Old Style Italic 16 point

ABCDEFGHIJKLMNOPQRSTUVWXYZ abcdefghij
klmnopqrstuvwxyz 1234567890 ?!/&$%#@*“”:;.,

Goudy Old Style Italic18 point

ABCDEFGHIJKLMNOPQRSTUVWXYZ abcdefghij
klmnopqrstuvwxyz 1234567890 ?!/&$%#@*“”:;.,

Goudy Old Style Italic 20 point

ABCDEFGHIJKLMNOPQRSTUVWXYZ abcdefghij
klmnopqrstuvwxyz 1234567890 ?!/&$%#@*“”:;.,

Goudy Old Style Italic 22 point

ABCDEFGHIJKLMNOPQRSTUVWXYZ abcdefghij
klmnopqrstuvwxyz 1234567890 ?!/&$%#@*“”:;.,

Goudy Old Style Italic 24 point

ABCDEFGHIJKLMNOPQRSTUVWXYZ
abcdefghijklmnopqrstuvwxyz 1234567890 !?%&*

Goudy Old Style Italic 30 point

ABCDEFGHIJKLMNOPQRSTUVWXYZ
abcdefghijklmnopqrstuvwxy 1234567890

Goudy Old Style Italic 36 point

ABCDEFGHIJKLMNOPQRSTUVW
abcdefghijklmnopqrstuvwxyz 1234

Goudy Old Style Italic 48 point

ABCDEFGHIJKLMNOPQR
abcdefghijklmnopqrstuv 12345

Goudy Old Style Italic 60 point

ABCDEFGHIJKLMN
abcdefghijklmnopq 12345

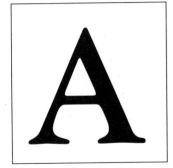

Goudy Bold 72 Point

ABCDEFGHIJKL
MNOPQRSTUV
WXYZabcdefghijk
lmnopqrstuvwxyz
1234567890
?!/&$%#@*""'':;.,

Goudy Bold 10 point

ABCDEFGHIJKLMNOPQRSTUVWXYZ abcdefghij
klmnopqrstuvwxyz 1234567890 ?!/&$%#@*""":;.,

Goudy Bold 12 point

ABCDEFGHIJKLMNOPQRSTUVWXYZ abcdefghij
klmnopqrstuvwxyz 1234567890 ?!/&$%#@*""":;.,

Goudy Bold 13 point

ABCDEFGHIJKLMNOPQRSTUVWXYZ abcdefghij
klmnopqrstuvwxyz 1234567890 ?!/&$%#@*""":;.,

Goudy Bold 14 point

ABCDEFGHIJKLMNOPQRSTUVWXYZ abcdefghij
klmnopqrstuvwxyz 1234567890 ?!/&$%#@*""":;.,

Goudy Bold 16 point

ABCDEFGHIJKLMNOPQRSTUVWXYZ abcdefghij
klmnopqrstuvwxyz 1234567890 ?!/&$%#@*""":;.,

Goudy Bold 18 point

ABCDEFGHIJKLMNOPQRSTUVWXYZ abcdefghij
klmnopqrstuvwxyz 1234567890 ?!/&$%#@*""":;.,

Goudy Bold 20 point

ABCDEFGHIJKLMNOPQRSTUVWXYZ abcdefghij
klmnopqrstuvwxyz 1234567890 ?!/&$%#@*""":;.,

Goudy Bold 22 point

ABCDEFGHIJKLMNOPQRSTUVWXYZ abcdefghij
klmnopqrstuvwxyz 1234567890 ?!/&$%#@*""":;.,

Goudy Bold 24 point

ABCDEFGHIJKLMNOPQRSTUVWXYZ
abcdefghijklmnopqrstuvwxyz 1234567890 !?%&

Goudy Bold 30 point

ABCDEFGHIJKLMNOPQRSTUVWXYZ
abcdefghijklmnopqrstuvwxyz 1234567890

Goudy Bold 36 point

ABCDEFGHIJKLMNOPQRSTUV
abcdefghijklmnopqrstuvwxyz 12345

Goudy Bold 48 point

ABCDEFGHIJKLMNOPQ
abcdefghijklmnopqrstu 123

Goudy Bold 60 point

ABCDEFGHIJKLMN
abcdefghijklmnop 123

Goudy Bold Italic 72 point

ABCDEFGHIJKL
MNOPQRSTUV
WXYZ abcdefghij
klmnopqrstuvwxyz
1234567890
?!/&$%#@*""::,

Goudy Bold Italic 10 point

ABCDEFGHIJKLMNOPQRSTUVWXYZ *abcdefghij*
klmnopqrstuvwxyz 1234567890 ?!/&$%#@""*:;.,

Goudy Bold Italic 12 point

ABCDEFGHIJKLMNOPQRSTUVWXYZ *abcdefghij*
klmnopqrstuvwxyz 1234567890 ?!/&$%#@""*:;.,

Goudy Bold Italic 13 point

ABCDEFGHIJKLMNOPQRSTUVWXYZ *abcdefghij*
klmnopqrstuvwxyz 1234567890 ?!/&$%#@""*:;.,

Goudy Bold Italic 14 point

ABCDEFGHIJKLMNOPQRSTUVWXYZ *abcdefghij*
klmnopqrstuvwxyz 1234567890 ?!/&$%#@""*:;.,

Goudy Bold Italic 16 point

ABCDEFGHIJKLMNOPQRSTUVWXYZ *abcdefghij*
klmnopqrstuvwxyz 1234567890 ?!/&$%#@""*:;.,

Goudy Bold Italic 18 point

ABCDEFGHIJKLMNOPQRSTUVWXYZ *abcdefghij*
klmnopqrstuvwxyz 1234567890 ?!/&$%#@""*:;.,

Goudy Bold Italic 20 point

ABCDEFGHIJKLMNOPQRSTUVWXYZ *abcdefghij*
klmnopqrstuvwxyz 1234567890 ?!/&$%#@""*:;.,

Goudy Bold Italic 22 point

ABCDEFGHIJKLMNOPQRSTUVWXYZ *abcdefghij*
klmnopqrstuvwxyz 1234567890 ?!/&$%#@""*:;.,

Goudy Bold Italic 24 point

ABCDEFGHIJKLMNOPQRSTUVWXYZ
abcdefghijklmnopqrstuvwxyzb 1234567890 !?%&

Goudy Bold Italic 30 point

ABCDEFGHIJKLMNOPQRSTUVWXYZ
abcdefghijklmnopqrstuvwxyz 123456789

Goudy Bold Italic 36 point

ABCDEFGHIJKLMNOPQRSTUV
abcdefghijklmnopqrstuvwxy 123456

Goudy Bold Italic 48 point

ABCDEFGHIJKLMNOPQ
abcdefghijklmnopqrstu 123

Goudy Bold Italic 60 point

ABCDEFGHIJKLMN
abcdefghijklmnopqr 12

Helvetica 72 point

ABCDEFGHIJKL
MNOPQRSTUVW
XYZ abcdefghijkl
mnopqrstuvwxyz
1234567890
?!/&$$%#@*""..:,.,

Helvetica 24 point

ABCDEFGHIJKLMNOPQRSTUVWXYZ
abcdefghijklmnopqrstuvwxyz 1234567890 !?%&*

Helvetica 30 point

ABCDEFGHIJKLMNOPQRSTUVWXYZ
abcdefghijklmnopqrstuvwxyz 1234567890

Helvetica 36 point

ABCDEFGHIJKLMNOPQRSTUVWXY
abcdefghijklmnopqrstuvwxyz 12345678

Helvetica 48 point

ABCDEFGHIJKLMNOPQR
abcdefghijklmnopqrstuv 123

Helvetica 60 point

ABCDEFGHIJKLMNOP
abcdefghijklmnopq 1234

6/8 Helvetica

It was the best of times, it was the worst of times, it was the age of wisdom, it was the age of foolishness, it was the epoch of belief, it was the epoch of incredulity, it was the season of light, it was the season of darkness, it was the spring of hope, it was the winter of despair, we had everything before us, we had nothing before us, we were all going direct to Heaven, we were all going direct the other way-in short, the period was so far like the present period, that some of its noisiest authorities insisted on its being received, for good or for evil,

8/10 Helvetica

It was the best of times, it was the worst of times, it was the age of wisdom, it was the age of foolishness, it was the epoch of belief, it was the epoch of incredulity, it was the season of light, it was the season of darkness, it was the spring of hope, it was the winter of despair, we had everything before us, we had nothing before us, we were all going direct to Heaven, we were all going direct the other way-in

9/10 Helvetica

It was the best of times, it was the worst of times, it was the age of wisdom, it was the age of foolishness, it was the epoch of belief, it was the epoch of incredulity, it was the season of light, it was the season of darkness, it was the spring of hope, it was the winter of despair, we had everything before us, we had nothing before us, we were all going direct to Heaven

9/11 Helvetica

It was the best of times, it was the worst of times, it was the age of wisdom, it was the age of foolishness, it was the epoch of belief, it was the epoch of incredulity, it was the season of light, it was the season of darkness, it was the spring of hope, it was the winter of despair, we had everything before us, we had nothing before us, we were all going direct to Heaven

10/11 Helvetica

It was the best of times, it was the worst of times, it was the age of wisdom, it was the age of foolishness, it was the epoch of belief, it was the epoch of incredulity, it was the season of light, it was the season of darkness, it was the spring of hope, it was the winter of despair, we had everything before us, we had nothing before us,

10/12 Helvetica

It was the best of times, it was the worst of times, it was the age of wisdom, it was the age of foolishness, it was the epoch of belief, it was the epoch of incredulity, it was the season of light, it was the season of darkness, it was the spring of hope, it was the winter of despair, we had everything before us, we had nothing before us,

11/13 Helvetica

It was the best of times, it was the worst of times, it was the age of wisdom, it was the age of foolishness, it was the epoch of belief, it was the epoch of incredulity, it was the season of light, it was the season of darkness, it was the spring of hope, it was the winter of despair, we had everything before us, we had

11/14 Helvetica

It was the best of times, it was the worst of times, it was the age of wisdom, it was the age of foolishness, it was the epoch of belief, it was the epoch of incredulity, it was the season of light, it was the season of darkness, it was the spring of hope, it was the winter of despair, we had everything before us, we had

12/13 Helvetica

It was the best of times, it was the worst of times, it was the age of wisdom, it was the age of foolishness, it was the epoch of belief, it was the epoch of incredulity, it was the season of light, it was the season of darkness, it was the spring of hope, it was the winter of despair,

12/14 Helvetica

It was the best of times, it was the worst of times, it was the age of wisdom, it was the age of foolishness, it was the epoch of belief, it was the epoch of incredulity, it was the season of light, it was the season of darkness, it was the spring of hope, it was the winter of despair,

13/15 Helvetica

It was the best of times, it was the worst of times, it was the age of wisdom, it was the age of foolishness, it was the epoch of belief, it was the epoch of incredulity, it was the season of light, it was the season of darkness, it was the spring of hope, it was the winter of despair,

14/15 Helvetica

It was the best of times, it was the worst of times, it was the age of wisdom, it was the age of foolishness, it was the epoch of belief, it was the epoch of incredulity, it was the season of light, it was the season of darkness, it was the

14/16 Helvetica

It was the best of times, it was the worst of times, it was the age of wisdom, it was the age of foolishness, it was the epoch of belief, it was the epoch of incredulity, it was the season of light, it was the season of darkness, it was the

Helvetica Oblique 72 point

ABCDEFGHIJKL
MNOPQRSTUVW
XYZ abcdefghijkl
mnopqrstuvwxyz
1234567890
?!/&$%#@*""'.,.,

Helvetica Oblique 24 point

ABCDEFGHIJKLMNOPQRSTUVWXYZ
*abcdefghijklmnopqrstuvwxyz 1234567890 !?%&**

Helvetica Oblique 30 point

ABCDEFGHIJKLMNOPQRSTUVWXYZ
abcdefghijklmnopqrstuvwxyz 1234567890

Helvetica Oblique 36 point

ABCDEFGHIJKLMNOPQRSTUVWX
abcdefghijklmnopqrstuvwxyz 1234567

Helvetica Oblique 48 point

ABCDEFGHIJKLMNOPQRS
abcdefghijklmnopqrstuv 1234

Helvetica Oblique 60 point

ABCDEFGHIJKLMNOP
abcdefghijklmnopqrst 12

6/8 Helvetica Oblique

It was the best of times, it was the worst of times, it was the age of wisdom, it was the age of foolishness, it was the epoch of belief, it was the epoch of incredulity, it was the season of light, it was the season of darkness, it was the spring of hope, it was the winter of despair, we had everything before us, we had nothing before us, we were all going direct to Heaven, we were all going direct the other way-in short, the period was so far like the present period, that some of its noisiest authorities insisted on its being received, for good or for evil,

8/10 Helvetica Oblique

It was the best of times, it was the worst of times, it was the age of wisdom, it was the age of foolishness, it was the epoch of belief, it was the epoch of incredulity, it was the season of light, it was the season of darkness, it was the spring of hope, it was the winter of despair, we had everything before us, we had nothing before us, we were all going direct to Heaven, we were all going direct the other way-in

9/10 Helvetica Oblique

It was the best of times, it was the worst of times, it was the age of wisdom, it was the age of foolishness, it was the epoch of belief, it was the epoch of incredulity, it was the season of light, it was the season of darkness, it was the spring of hope, it was the winter of despair, we had everything before us, we had nothing before us, we were all going direct to Heaven,

9/11 Helvetica Oblique

It was the best of times, it was the worst of times, it was the age of wisdom, it was the age of foolishness, it was the epoch of belief, it was the epoch of incredulity, it was the season of light, it was the season of darkness, it was the spring of hope, it was the winter of despair, we had everything before us, we had nothing before us, we were all going direct to Heaven,

10/11 Helvetica Oblique

It was the best of times, it was the worst of times, it was the age of wisdom, it was the age of foolishness, it was the epoch of belief, it was the epoch of incredulity, it was the season of light, it was the season of darkness, it was the spring of hope, it was the winter of despair, we had everything before us, we had nothing before us,

10/12 Helvetica Oblique

It was the best of times, it was the worst of times, it was the age of wisdom, it was the age of foolishness, it was the epoch of belief, it was the epoch of incredulity, it was the season of light, it was the season of darkness, it was the spring of hope, it was the winter of despair, we had everything before us, we had nothing before us,

11/13 Helvetica Oblique

It was the best of times, it was the worst of times, it was the age of wisdom, it was the age of foolishness, it was the epoch of belief, it was the epoch of incredulity, it was the season of light, it was the season of darkness, it was the spring of hope, it was the winter of despair, we had everything before us, we had

11/14 Helvetica Oblique

It was the best of times, it was the worst of times, it was the age of wisdom, it was the age of foolishness, it was the epoch of belief, it was the epoch of incredulity, it was the season of light, it was the season of darkness, it was the spring of hope, it was the winter of despair, we had everything before us, we had

12/13 Helvetica Oblique

It was the best of times, it was the worst of times, it was the age of wisdom, it was the age of foolishness, it was the epoch of belief, it was the epoch of incredulity, it was the season of light, it was the season of darkness, it was the spring of hope, it was the winter of despair,

12/14 Helvetica Oblique

It was the best of times, it was the worst of times, it was the age of wisdom, it was the age of foolishness, it was the epoch of belief, it was the epoch of incredulity, it was the season of light, it was the season of darkness, it was the spring of hope, it was the winter of despair,

13/15 Helvetica Oblique

It was the best of times, it was the worst of times, it was the age of wisdom, it was the age of foolishness, it was the epoch of belief, it was the epoch of incredulity, it was the season of light, it was the season of darkness, it was the spring of hope, it

14/15 Helvetica Oblique

It was the best of times, it was the worst of times, it was the age of wisdom, it was the age of foolishness, it was the epoch of belief, it was the epoch of incredulity, it was the season of light, it was the season of darkness, it was the

14/16 Helvetica Oblique

It was the best of times, it was the worst of times, it was the age of wisdom, it was the age of foolishness, it was the epoch of belief, it was the epoch of incredulity, it was the season of light, it was the season of darkness, it was the

Helvetica Bold 72 point

ABCDEFGHIJKL MNOPQRSTUV WXYZ abcdefghij klmnopqrstuvwx yz 1234567890 ?!/&$%#@*""".:;,

Helvetica Bold 24 point

ABCDEFGHIJKLMNOPQRSTUVWXYZ
abcdefghijklmnopqrstuvwxyz 1234567890 !?%&*

Helvetica Bold 30 point

ABCDEFGHIJKLMNOPQRSTUVWXYZ
abcdefghijklmnopqrstuvwxyz 12345678

Helvetica Bold 36 point

ABCDEFGHIJKLMNOPQRSTUVWXY
abcdefghijklmnopqrstuvwxyz 123456

Helvetica Bold 48 point

ABCDEFGHIJKLMNOPQRS
abcdefghijklmnopqrstu 123

Helvetica Bold 60 point

ABCDEFGHIJKLMNO
abcdefghijklmnopq 12

6/8 Helvetica Bold

It was the best of times, it was the worst of times, it was the age of wisdom, it was the age of foolishness, it was the epoch of belief, it was the epoch of incredulity, it was the season of light, it was the season of darkness, it was the spring of hope, it was the winter of despair, we had everything before us, we had nothing before us, we were all going direct to Heaven, we were all going direct the other way-in short, the period was so far like the present period, that some of its noisiest authorities insisted on

8/10 Helvetica Bold

It was the best of times, it was the worst of times, it was the age of wisdom, it was the age of foolishness, it was the epoch of belief, it was the epoch of incredulity, it was the season of light, it was the season of darkness, it was the spring of hope, it was the winter of despair, we had everything before us, we had nothing before us, we were all going direct to Heaven, we were all

9/10 Helvetica Bold

It was the best of times, it was the worst of times, it was the age of wisdom, it was the age of foolishness, it was the epoch of belief, it was the epoch of incredulity, it was the season of light, it was the season of darkness, it was the spring of hope, it was the winter of despair, we had everything before us, we had nothing before us, we

9/11 Helvetica Bold

It was the best of times, it was the worst of times, it was the age of wisdom, it was the age of foolishness, it was the epoch of belief, it was the epoch of incredulity, it was the season of light, it was the season of darkness, it was the spring of hope, it was the winter of despair, we had everything before us, we had nothing before us, we

10/11 Helvetica Bold

It was the best of times, it was the worst of times, it was the age of wisdom, it was the age of foolishness, it was the epoch of belief, it was the epoch of incredulity, it was the season of light, it was the season of darkness, it was the spring of hope, it was the winter of despair, we had everything before us, we

10/12 Helvetica Bold

It was the best of times, it was the worst of times, it was the age of wisdom, it was the age of foolishness, it was the epoch of belief, it was the epoch of incredulity, it was the season of light, it was the season of darkness, it was the spring of hope, it was the winter of despair, we had everything before us, we

11/13 Helvetica Bold

It was the best of times, it was the worst of times, it was the age of wisdom, it was the age of foolishness, it was the epoch of belief, it was the epoch of incredulity, it was the season of light, it was the season of darkness, it was the spring of hope, it was the winter of despair,

11/14 Helvetica Bold

It was the best of times, it was the worst of times, it was the age of wisdom, it was the age of foolishness, it was the epoch of belief, it was the epoch of incredulity, it was the season of light, it was the season of darkness, it was the spring of hope, it was the winter of despair,

12/13 Helvetica Bold

It was the best of times, it was the worst of times, it was the age of wisdom, it was the age of foolishness, it was the epoch of belief, it was the epoch of incredulity, it was the season of light, it was the season of darkness, it was the spring of hope, it

12/14 Helvetica Bold

It was the best of times, it was the worst of times, it was the age of wisdom, it was the age of foolishness, it was the epoch of belief, it was the epoch of incredulity, it was the season of light, it was the season of darkness, it was the spring of hope, it

13/15 Helvetica Bold

It was the best of times, it was the worst of times, it was the age of wisdom, it was the age of foolishness, it was the epoch of belief, it was the epoch of incredulity, it was the season of light, it was the season of darkness, it was the

14/15 Helvetica Bold

It was the best of times, it was the worst of times, it was the age of wisdom, it was the age of foolishness, it was the epoch of belief, it was the epoch of incredulity, it was the season of light, it was the season of

14/16 Helvetica Bold

It was the best of times, it was the worst of times, it was the age of wisdom, it was the age of foolishness, it was the epoch of belief, it was the epoch of incredulity, it was the season of light, it was the season of

Helvetica Bold Oblique 72 point

ABCDEFGHIJKL MNOPQRSTUV WXYZ abcdefghij klmnopqrstuvwx yz 1234567890 ?!/&$%#@*""";:,

Helvetica Bold Oblique 24 point

ABCDEFGHIJKLMNOPQRSTUVWXYZ
abcdefghijklmnopqrstuvwxyz 1234567890 !?%

Helvetica Bold Oblique 30 point

ABCDEFGHIJKLMNOPQRSTUVWXYZ
abcdefghijklmnopqrstuvwxyz 123456

Helvetica Bold Oblique 36 point

ABCDEFGHIJKLMNOPQRSTUVWX
abcdefghijklmnopqrstuvwxyz 12345

Helvetica Bold Oblique 48 point

ABCDEFGHIJKLMNOPQR
abcdefghijklmnopqrstuv12

Helvetica Bold Oblique 60 point

ABCDEFGHIJKLMNO
abcdefghijklmnopq12

6/8 Helvetica Bold Oblique

It was the best of times, it was the worst of times, it was the age of wisdom, it was the age of foolishness, it was the epoch of belief, it was the epoch of incredulity, it was the season of light, it was the season of darkness, it was the spring of hope, it was the winter of despair, we had everything before us, we had nothing before us, we were all going direct to Heaven, we were all going direct the other way-in short, the period was so far like the present period, that some of its noisiest authorities insisted on

8/10 Helvetica Bold Oblique

It was the best of times, it was the worst of times, it was the age of wisdom, it was the age of foolishness, it was the epoch of belief, it was the epoch of incredulity, it was the season of light, it was the season of darkness, it was the spring of hope, it was the winter of despair, we had everything before us, we had nothing before us, we were all going direct to Heaven, we were all

9/10 Helvetica Bold Oblique

It was the best of times, it was the worst of times, it was the age of wisdom, it was the age of foolishness, it was the epoch of belief, it was the epoch of incredulity, it was the season of light, it was the season of darkness, it was the spring of hope, it was the winter of despair, we had everything before us, we had nothing before us, we

9/11 Helvetica Bold Oblique

It was the best of times, it was the worst of times, it was the age of wisdom, it was the age of foolishness, it was the epoch of belief, it was the epoch of incredulity, it was the season of light, it was the season of darkness, it was the spring of hope, it was the winter of despair, we had everything before us, we had nothing before us, we

10/11 Helvetica Bold Oblique

It was the best of times, it was the worst of times, it was the age of wisdom, it was the age of foolishness, it was the epoch of belief, it was the epoch of incredulity, it was the season of light, it was the season of darkness, it was the spring of hope, it was the winter of despair, we had everything before us, we

10/12 Helvetica Bold Oblique

It was the best of times, it was the worst of times, it was the age of wisdom, it was the age of foolishness, it was the epoch of belief, it was the epoch of incredulity, it was the season of light, it was the season of darkness, it was the spring of hope, it was the winter of despair, we had everything before us, we

11/13 Helvetica Bold Oblique

It was the best of times, it was the worst of times, it was the age of wisdom, it was the age of foolishness, it was the epoch of belief, it was the epoch of incredulity, it was the season of light, it was the season of darkness, it was the spring of hope, it was the winter of despair, we had everything

11/14 Helvetica Bold Oblique

It was the best of times, it was the worst of times, it was the age of wisdom, it was the age of foolishness, it was the epoch of belief, it was the epoch of incredulity, it was the season of light, it was the season of darkness, it was the spring of hope, it was the winter of despair,

12/13 Helvetica Bold Oblique

It was the best of times, it was the worst of times, it was the age of wisdom, it was the age of foolishness, it was the epoch of belief, it was the epoch of incredulity, it was the season of light, it was the season of darkness, it was the spring of hope, it

12/14 Helvetica Bold Oblique

It was the best of times, it was the worst of times, it was the age of wisdom, it was the age of foolishness, it was the epoch of belief, it was the epoch of incredulity, it was the season of light, it was the season of darkness, it was the spring of hope, it

13/15 Helvetica Bold Oblique

It was the best of times, it was the worst of times, it was the age of wisdom, it was the age of foolishness, it was the epoch of belief, it was the epoch of incredulity, it was the season of light, it was the season of darkness, it was the

14/15 Helvetica Bold Oblique

It was the best of times, it was the worst of times, it was the age of wisdom, it was the age of foolishness, it was the epoch of belief, it was the epoch of incredulity, it was the season of light, it was the season of

14/16 Helvetica Bold Oblique

It was the best of times, it was the worst of times, it was the age of wisdom, it was the age of foolishness, it was the epoch of belief, it was the epoch of incredulity, it was the season of light, it was the season of

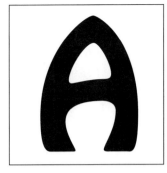

Hobo 72 Point

ABCDEFGHIJKL
MNOPQRSTUV
WXYZ abcdefgh
ijklmnopqrstuv
wxyz 12345678
90 ?!&$%*""";

Hobo 10 point

ABCDEFGHIJKLMNOPQRSTUVWXYZ abcdefghij
klmnopqrstuvwxyz 1234567890 ?!/&$%*""":;.,

Hobo 12 point

ABCDEFGHIJKLMNOPQRSTUVWXYZ abcdefghij
klmnopqrstuvwxyz 1234567890 ?!/&$%*""":;.,

Hobo 13 point

ABCDEFGHIJKLMNOPQRSTUVWXYZ abcdefghij
klmnopqrstuvwxyz 1234567890 ?!/&$%*""":;.,

Hobo 14 point

ABCDEFGHIJKLMNOPQRSTUVWXYZ abcdefghij
klmnopqrstuvwxyz 1234567890 ?!/&$%*""":;.,

Hobo 16 point

ABCDEFGHIJKLMNOPQRSTUVWXYZ abcdefghij
klmnopqrstuvwxyz 1234567890 ?!/&$%*""":;.,

Hobo 18 point

ABCDEFGHIJKLMNOPQRSTUVWXYZ abcdefghij
klmnopqrstuvwxyz 1234567890 ?!/&$%*""":;.,

Hobo 20 point

ABCDEFGHIJKLMNOPQRSTUVWXYZ abcdefghij
klmnopqrstuvwxyz 1234567890 ?!/&$%*""":;.,

Hobo 22 point

ABCDEFGHIJKLMNOPQRSTUVWXYZ abcdefghij
klmnopqrstuvwxyz 1234567890 ?!/&$%*""":;.,

Hobo 24 point

ABCDEFGHIJKLMNOPQRSTUVWXYZ
abcdefghijklmnopqrstuvwxyz 1234567890 !?%&*

Hobo 30 point

ABCDEFGHIJKLMNOPQRSTUVWXYZ
abcdefghijklmnopqrstuvwxyz 123456789

Hobo 36 point

ABCDEFGHIJKLMNOPQRSTUVWXZ
abcdefghijklmnopqrstuvwx 12345

Hobo 48 point

ABCDEFGHIJKLMNOPQR
abcdefghijklmnopqrst 123

Hobo 60 point

ABCDEFGHIJKLMNOP
abcdefghijklmnop 1234

Italia Book 72 Point

ABCDEFGHIJKLM
NOPQRSTUVWX
YZ abcdefghijklm
nopqrstuvwxyz
1234567890
?!/&$%#@*""":;.,

Italia Book 24 point

ABCDEFGHIJKLMNOPQRSTUVWXYZ
abcdefghijklmnopqrstuvwxyz 1234567890 !?%&*

Italia Book 30 point

ABCDEFGHIJKLMNOPQRSTUVWXYZ
abcdefghijklmnopqrstuvwxyz 123456789

Italia Book 36 point

ABCDEFGHIJKLMNOPQRSTUVWXZ
abcdefghijklmnopqrstuvwxyz 12345

Italia Book 48 point

ABCDEFGHIJKLMNOPQRS
abcdefghijklmnopqrstuv 12

Italia Book 60 point

ABCDEFGHIJKLMNOP
abcdefghijklmnopqrs 12

6/8 Italia Book

It was the best of times, it was the worst of times, it was the age of wisdom, it was the age of foolishness, it was the epoch of belief, it was the epoch of incredulity, it was the season of light, it was the season of darkness, it was the spring of hope, it was the winter of despair, we had everything before us, we had nothing before us, we were all going direct to Heaven, we were all going direct the other way-in short, the period was so far like the present period, that some of its noisiest authorities insisted on its being received, for good or for evil, in the superlative

8/10 Italia Book

It was the best of times, it was the worst of times, it was the age of wisdom, it was the age of foolishness, it was the epoch of belief, it was the epoch of incredulity, it was the season of light, it was the season of darkness, it was the spring of hope, it was the winter of despair, we had everything before us, we had nothing before us, we were all going direct to Heaven, we were all going direct the other way-in short, the period was so

9/10 Italia Book

It was the best of times, it was the worst of times, it was the age of wisdom, it was the age of foolishness, it was the epoch of belief, it was the epoch of incredulity, it was the season of light, it was the season of darkness, it was the spring of hope, it was the winter of despair, we had everything before us, we had nothing before us, we were all going direct the other way-in

9/11 Italia Book

It was the best of times, it was the worst of times, it was the age of wisdom, it was the age of foolishness, it was the epoch of belief, it was the epoch of incredulity, it was the season of light, it was the season of darkness, it was the spring of hope, it was the winter of despair, we had everything before us, we had nothing before us, we were all going direct the other way-in

10/11 Italia Book

It was the best of times, it was the worst of times, it was the age of wisdom, it was the age of foolishness, it was the epoch of belief, it was the epoch of incredulity, it was the season of light, it was the season of darkness, it was the spring of hope, it was the winter of despair, we had everything before us, we had we had nothing before

10/12 Italia Book

It was the best of times, it was the worst of times, it was the age of wisdom, it was the age of foolishness, it was the epoch of belief, it was the epoch of incredulity, it was the season of light, it was the season of darkness, it was the spring of hope, it was the winter of despair, we had everything before us, we had we had nothing before

11/13 Italia Book

It was the best of times, it was the worst of times, it was the age of wisdom, it was the age of foolishness, it was the epoch of belief, it was the epoch of incredulity, it was the season of light, it was the season of darkness, it was the spring of hope, it was the winter of despair, we had everything before us, we

11/14 Italia Book

It was the best of times, it was the worst of times, it was the age of wisdom, it was the age of foolishness, it was the epoch of belief, it was the epoch of incredulity, it was the season of light, it was the season of darkness, it was the spring of hope, it was the winter of despair, we had everything before us, we

12/13 Italia Book

It was the best of times, it was the worst of times, it was the age of wisdom, it was the age of foolishness, it was the epoch of belief, it was the epoch of incredulity, it was the season of light, it was the season of darkness, it was the spring of hope, it was the winter of despair, we had everything before us, we

12/14 Italia Book

It was the best of times, it was the worst of times, it was the age of wisdom, it was the age of foolishness, it was the epoch of belief, it was the epoch of incredulity, it was the season of light, it was the season of darkness, it was the spring of hope, it was the winter of despair, we had everything before us, we

13/15 Italia Book

It was the best of times, it was the worst of times, it was the age of wisdom, it was the age of foolishness, it was the epoch of belief, it was the epoch of incredulity, it was the season of light, it was the season of darkness, it was the spring of hope, it was

14/15 Italia Book

It was the best of times, it was the worst of times, it was the age of wisdom, it was the age of foolishness, it was the epoch of belief, it was the epoch of incredulity, it was the season of light, it was the season of darkness, it was the spring of

14/16 Italia Book

It was the best of times, it was the worst of times, it was the age of wisdom, it was the age of foolishness, it was the epoch of belief, it was the epoch of incredulity, it was the season of light, it was the season of darkness, it was the spring of

Italia Medium 72 point

ABCDEFGHIJKL
MNOPQRSTUVW
XYZ abcdefghijkl
mnopqrstuvwxyz
1234567890
?!/&$%#@*""":;.,

Italia Medium 10 point

ABCDEFGHIJKLMNOPQRSTUVWXYZ abcdefghij
klmnopqrstuvwxyz 1234567890 ?!/&$%#@*"""::;.,

Italia Medium 12 point

ABCDEFGHIJKLMNOPQRSTUVWXYZ abcdefghij
klmnopqrstuvwxyz 1234567890 ?!/&$%#@*"""::;.,

Italia Medium 13 point

ABCDEFGHIJKLMNOPQRSTUVWXYZ abcdefghij
klmnopqrstuvwxyz 1234567890 ?!/&$%#@*"""::;.,

Italia Medium 14 point

ABCDEFGHIJKLMNOPQRSTUVWXYZ abcdefghij
klmnopqrstuvwxyz 1234567890 ?!/&$%#@*"""::;.,

Italia Medium 16 point

ABCDEFGHIJKLMNOPQRSTUVWXYZ abcdefghij
klmnopqrstuvwxyz 1234567890 ?!/&$%#@*"""::;.,

Italia Medium 18 point

ABCDEFGHIJKLMNOPQRSTUVWXYZ abcdefghij
klmnopqrstuvwxyz 1234567890 ?!/&$%#@*"""::;.,

Italia Medium 20 point

ABCDEFGHIJKLMNOPQRSTUVWXYZ abcdefghij
klmnopqrstuvwxyz 1234567890 ?!/&$%#@*"""::;.,

Italia Medium 22 point

ABCDEFGHIJKLMNOPQRSTUVWXYZ abcdefghij
klmnopqrstuvwxyz 1234567890 ?!/&$%#@*"""::;.,

6/8 Italia Medium

It was the best of times, it was the worst of times, it was the age of wisdom, it was the age of foolishness, it was the epoch of belief, it was the epoch of incredulity, it was the season of light, it was the season of darkness, it was the spring of hope, it was the winter of despair, we had everything before us, we had nothing before us, we were all going direct to Heaven, we were all going direct the other way-in short, the period was so far like the present period, that some of its noisiest authorities insisted on its being received, for good or for evil, in

8/10 Italia Medium

It was the best of times, it was the worst of times, it was the age of wisdom, it was the age of foolishness, it was the epoch of belief, it was the epoch of incredulity, it was the season of light, it was the season of darkness, it was the spring of hope, it was the winter of despair, we had everything before us, we had nothing before us, we were all going direct to Heaven, we were all going direct the other way-in short, the period

9/10 Italia Medium

It was the best of times, it was the worst of times, it was the age of wisdom, it was the age of foolishness, it was the epoch of belief, it was the epoch of incredulity, it was the season of light, it was the season of darkness, it was the spring of hope, it was the winter of despair, we had everything before us, we had nothing before us, we were all going direct to Heaven, we were all going

9/11 Italia Medium

It was the best of times, it was the worst of times, it was the age of wisdom, it was the age of foolishness, it was the epoch of belief, it was the epoch of incredulity, it was the season of light, it was the season of darkness, it was the spring of hope, it was the winter of despair, we had everything before us, we had nothing before us, we were all going direct to Heaven, we were all going

10/11 Italia Medium

It was the best of times, it was the worst of times, it was the age of wisdom, it was the age of foolishness, it was the epoch of belief, it was the epoch of incredulity, it was the season of light, it was the season of darkness, it was the spring of hope, it was the winter of despair, we had everything before us, we had nothing before us, we were all going

10/12 Italia Medium

It was the best of times, it was the worst of times, it was the age of wisdom, it was the age of foolishness, it was the epoch of belief, it was the epoch of incredulity, it was the season of light, it was the season of darkness, it was the spring of hope, it was the winter of despair, we had everything before us, we had nothing before us, we were all going

11/13 Italia Medium

It was the best of times, it was the worst of times, it was the age of wisdom, it was the age of foolishness, it was the epoch of belief, it was the epoch of incredulity, it was the season of light, it was the season of darkness, it was the spring of hope, it was the winter of despair, we had everything before us, we had

11/14 Italia Medium

It was the best of times, it was the worst of times, it was the age of wisdom, it was the age of foolishness, it was the epoch of belief, it was the epoch of incredulity, it was the season of light, it was the season of darkness, it was the spring of hope, it was the winter of despair, we had everything before us, we had

12/13 Italia Medium

It was the best of times, it was the worst of times, it was the age of wisdom, it was the age of foolishness, it was the epoch of belief, it was the epoch of incredulity, it was the season of light, it was the season of darkness, it was the spring of hope, it was the winter of despair, we had everything before

12/14 Italia Medium

It was the best of times, it was the worst of times, it was the age of wisdom, it was the age of foolishness, it was the epoch of belief, it was the epoch of incredulity, it was the season of light, it was the season of darkness, it was the spring of hope, it was the winter of despair, we had everything before

13/15 Italia Medium

It was the best of times , it was the worst of times, it was the age of wisdom, it was the age of foolishness, it was the epoch of belief, it was the epoch of incredulity, it was the season of light, it was the season of darkness, it was the spring of hope, it was

14/15 Italia Medium

It was the best of times, it was the worst of times, it was the age of wisdom, it was the age of foolishness, it was the epoch of belief, it was the epoch of incredulity, it was the season of light, it was the season of darkness, it was the spring of hope, it was

14/16 Italia Medium

It was the best of times, it was the worst of times, it was the age of wisdom, it was the age of foolishness, it was the epoch of belief, it was the epoch of incredulity, it was the season of light, it was the season of darkness, it was the spring of hope, it was

Italia Bold 72 Point

ABCDEFGHIJKL
MNOPQRSTUV
WXYZ abcdefgh
ijklmnopqrstuvw
xyz 1234567890
?!/&$%#@*""'':;.,

Italia Bold 10 point

ABCDEFGHIJKLMNOPQRSTUVWXYZ abcdefghij
klmnopqrstuvwxyz 1234567890 ?!/&$%#@*""":;.,

Italia Bold 12 point

ABCDEFGHIJKLMNOPQRSTUVWXYZ abcdefghij
klmnopqrstuvwxyz 1234567890 ?!/&$%#@*""":;.,

Italia Bold 13 point

ABCDEFGHIJKLMNOPQRSTUVWXYZ abcdefghij
klmnopqrstuvwxyz 1234567890 ?!/&$%#@*""":;.,

Italia Bold 14 point

ABCDEFGHIJKLMNOPQRSTUVWXYZ abcdefghij
klmnopqrstuvwxyz 1234567890 ?!/&$%#@*""":;.,

Italia Bold 16 point

ABCDEFGHIJKLMNOPQRSTUVWXYZ abcdefghij
klmnopqrstuvwxyz 1234567890 ?!/&$%#@*""":;.,

Italia Bold 18 point

ABCDEFGHIJKLMNOPQRSTUVWXYZ abcdefghij
klmnopqrstuvwxyz 1234567890 ?!/&$%#@*""":;.,

Italia Bold 20 point

ABCDEFGHIJKLMNOPQRSTUVWXYZ abcdefghij
klmnopqrstuvwxyz 1234567890 ?!/&$%#@*""":;.,

Italia Bold 22 point

ABCDEFGHIJKLMNOPQRSTUVWXYZ abcdefghij
klmnopqrstuvwxyz 1234567890 ?!/&$%#@*""":;.,

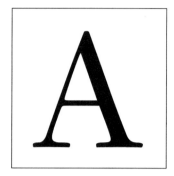

Janson Text Roman 55 72 point

ABCDEFGHIJK
LMNOPQRSTU
VWXYZ abcdefg
hijklmnopqrstuv
wxyz1234567890
?!/&$%#@*""'.:;.,

Janson Text 55 Roman 10 point

ABCDEFGHIJKLMNOPQRSTUVWXYZ abcdefghij
klmnopqrstuvwxyz 1234567890 ?!/&$%#@*“”:;.,

Janson Text 55 Roman 12 point

ABCDEFGHIJKLMNOPQRSTUVWXYZ abcdefghij
klmnopqrstuvwxyz 1234567890 ?!/&$%#@*“”:;.,

Janson Text 55 Roman 13 point

ABCDEFGHIJKLMNOPQRSTUVWXYZ abcdefghij
klmnopqrstuvwxyz 1234567890 ?!/&$%#@*“”:;.,

Janson Text 55 Roman 14 point

ABCDEFGHIJKLMNOPQRSTUVWXYZ abcdefghij
klmnopqrstuvwxyz 1234567890 ?!/&$%#@*“”:;.,

Janson Text 55 Roman 16 point

ABCDEFGHIJKLMNOPQRSTUVWXYZ abcdefghij
klmnopqrstuvwxyz 1234567890 ?!/&$%#@*“”:;.,

Janson Text 55 Roman 18 point

ABCDEFGHIJKLMNOPQRSTUVWXYZ abcdefghij
klmnopqrstuvwxyz 1234567890 ?!/&$%#@*“”:;.,

Janson Text 55 Roman 20 point

ABCDEFGHIJKLMNOPQRSTUVWXYZ abcdefghij
klmnopqrstuvwxyz 1234567890 ?!/&$%#@*“”:;.,

Janson Text 55 Roman 22 point

ABCDEFGHIJKLMNOPQRSTUVWXYZ abcdefghij
klmnopqrstuvwxyz 1234567890 ?!/&$%#@*“”:;.,

Janson Text 55 Roman 24 point

ABCDEFGHIJKLMNOPQRSTUVWXYZ
abcdefghijklmnopqrstuvwxyz 1234567890 !?%&*

Janson Text 55 Roman 30 point

ABCDEFGHIJKLMNOPQRSTUVWXYZ
abcdefghijklmnopqrstuvwxyz 1234567890

Janson Text 55 Roman 36 point

ABCDEFGHIJKLMNOPQRSTUV
abcdefghijklmnopqrstuvwx 1234567

Janson Text 55 Roman 48 point

ABCDEFGHIJKLMNOP
abcdefghijklmnopqrstu 123

Janson Text 55 Roman 60 point

ABCDEFGHIJKLM
abcdefghijklmnop 123

6/8 Janson Text 55 Roman

It was the best of times, it was the worst of times, it was the age of wisdom, it was the age of foolishness, it was the epoch of belief, it was the epoch of incredulity, it was the season of light, it was the season of darkness, it was the spring of hope, it was the winter of despair, we had everything before us, we had nothing before us, we were all going direct to Heaven, we were all going direct the other way-in short, the period was so far like the present period, that some of its noisiest authorities insisted on its being received, for good or for evil, in the superlative degree of

8/10 Janson Text 55 Roman

It was the best of times, it was the worst of times, it was the age of wisdom, it was the age of foolishness, it was the epoch of belief, it was the epoch of incredulity, it was the season of light, it was the season of darkness, it was the spring of hope, it was the winter of despair, we had everything before us, we had nothing before us, we were all going direct to Heaven, we were all going direct the other way-in short, the period was so

9/10 Janson Text 55 Roman

It was the best of times, it was the worst of times, it was the age of wisdom, it was the age of foolishness, it was the epoch of belief, it was the epoch of incredulity, it was the season of light, it was the season of darkness, it was the spring of hope, it was the winter of despair, we had everything before us, we had nothing before us, we were all going direct to Heaven, we were all going

9/11 Janson Text 55 Roman

It was the best of times, it was the worst of times, it was the age of wisdom, it was the age of foolishness, it was the epoch of belief, it was the epoch of incredulity, it was the season of light, it was the season of darkness, it was the spring of hope, it was the winter of despair, we had everything before us, we had nothing before us, we were all going direct to Heaven, we were all going

10/11 Janson Text 55 Roman

It was the best of times, it was the worst of times, it was the age of wisdom, it was the age of foolishness, it was the epoch of belief, it was the epoch of incredulity, it was the season of light, it was the season of darkness, it was the spring of hope, it was the winter of despair, we had everything before us, we had nothing before us, we were all going

10/12 Janson Text 55 Roman

It was the best of times, it was the worst of times, it was the age of wisdom, it was the age of foolishness, it was the epoch of belief, it was the epoch of incredulity, it was the season of light, it was the season of darkness, it was the spring of hope, it was the winter of despair, we had everything before us, we had nothing before us, we were all going

11/13 Janson Text 55 Roman

It was the best of times, it was the worst of times, it was the age of wisdom, it was the age of foolishness, it was the epoch of belief, it was the epoch of incredulity, it was the season of light, it was the season of darkness, it was the spring of hope, it was the winter of despair, we had everything before us, we had

11/14 Janson Text 55 Roman

It was the best of times, it was the worst of times, it was the age of wisdom, it was the age of foolishness, it was the epoch of belief, it was the epoch of incredulity, it was the season of light, it was the season of darkness, it was the spring of hope, it was the winter of despair, we had everything before us, we had

12/13 Janson Text 55 Roman

It was the best of times, it was the worst of times, it was the age of wisdom, it was the age of foolishness, it was the epoch of belief, it was the epoch of incredulity, it was the season of light, it was the season of darkness, it was the spring of hope, it was the winter of despair, we had everything before us, we

12/14 Janson Text 55 Roman

It was the best of times, it was the worst of times, it was the age of wisdom, it was the age of foolishness, it was the epoch of belief, it was the epoch of incredulity, it was the season of light, it was the season of darkness, it was the spring of hope, it was the winter of despair, we had everything before us, we

13/15 Janson Text 55 Roman

It was the best of times, it was the worst of times, it was the age of wisdom, it was the age of foolishness, it was the epoch of belief, it was the epoch of incredulity, it was the season of light, it was the season of darkness, it was the spring of hope, it was the winter

14/15 Janson Text 55 Roman

It was the best of times, it was the worst of times, it was the age of wisdom, it was the age of foolishness, it was the epoch of belief, it was the epoch of incredulity, it was the season of light, it was the season of darkness, it was the spring of

14/16 Janson Text 55 Roman

It was the best of times, it was the worst of times, it was the age of wisdom, it was the age of foolishness, it was the epoch of belief, it was the epoch of incredulity, it was the season of light, it was the season of darkness, it was the spring of

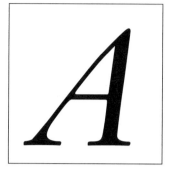

Janson Text 56 Italic 72 point

ABCDEFGHIJKL
MNOPQRSTUV
WXYZ abcdefghij
klmnopqrstuvwxyz
1234567890
?!&$%#@*""·;·,

Janson Text 56 Italic 10 point

*ABCDEFGHIJKLMNOPQRSTUVWXYZ abcdefghij
klmnopqrstuvwxyz 1234567890 ?!/&$%#@*“”:;.,*

Janson Text 56 Italic 12 point

*ABCDEFGHIJKLMNOPQRSTUVWXYZ abcdefghij
klmnopqrstuvwxyz 1234567890 ?!/&$%#@*“”:;.,*

Janson Text 56 Italic 13 point

*ABCDEFGHIJKLMNOPQRSTUVWXYZ abcdefghij
klmnopqrstuvwxyz 1234567890 ?!/&$%#@*“”:;.,*

Janson Text 56 Italic 14 point

*ABCDEFGHIJKLMNOPQRSTUVWXYZ abcdefghij
klmnopqrstuvwxyz 1234567890 ?!/&$%#@*“”:;.,*

Janson Text 56 Italic 16 point

*ABCDEFGHIJKLMNOPQRSTUVWXYZ abcdefghij
klmnopqrstuvwxyz 1234567890 ?!/&$%#@*“”:;.,*

Janson Text 56 Italic 18 point

*ABCDEFGHIJKLMNOPQRSTUVWXYZ abcdefghij
klmnopqrstuvwxyz 1234567890 ?!/&$%#@*“”:;.,*

Janson Text 56 Italic 20 point

*ABCDEFGHIJKLMNOPQRSTUVWXYZ abcdefghij
klmnopqrstuvwxyz 1234567890 ?!/&$%#@*“”:;.,*

Janson Text 56 Italic 22 point

*ABCDEFGHIJKLMNOPQRSTUVWXYZ abcdefghij
klmnopqrstuvwxyz 1234567890 ?!/&$%#@*“”:;.,*

Janson Text 56 Italic 24 point

ABCDEFGHIJKLMNOPQRSTUVWXYZ
*abcdefghijklmnopqrstuvwxyz 1234567890 !?%&**

Janson Text 56 Italic 30 point

ABCDEFGHIJKLMNOPQRSTUVWXYZ
abcdefghijklmnopqrstuvwxy 1234567890

Janson Text 56 Italic 36 point

ABCDEFGHIJKLMNOPQRSTUVW
abcdefghijklmnopqrstuvwxyz 1234567

Janson Text 56 Italic 48 point

ABCDEFGHIJKLMNOPQ
abcdefghijklmnopqrstuvwxyz 123

Janson Text 56 Italic 60 point

ABCDEFGHIJKLMN
abcdefghijklmnopqr 123

6/8 Janson Text 56 Italic

It was the best of times, it was the worst of times, it was the age of wisdom, it was the age of foolishness, it was the epoch of belief, it was the epoch of incredulity, it was the season of light, it was the season of darkness, it was the spring of hope, it was the winter of despair, we had everything before us, we had nothing before us, we were all going direct to Heaven, we were all going direct the other way-in short, the period was so far like the present period, that some of its noisiest authorities insisted on its being received, for good or for evil, in the superlative degree of comparison only.

8/10 Janson Text 56 Italic

It was the best of times, it was the worst of times, it was the age of wisdom, it was the age of foolishness, it was the epoch of belief, it was the epoch of incredulity, it was the season of light, it was the season of darkness, it was the spring of hope, it was the winter of despair, we had everything before us, we had nothing before us, we were all going direct to Heaven, we were all going direct the other way-in short, the period was so far like the present period, that some

9/10 Janson Text 56 Italic

It was the best of times, it was the worst of times, it was the age of wisdom, it was the age of foolishness, it was the epoch of belief, it was the epoch of incredulity, it was the season of light, it was the season of darkness, it was the spring of hope, it was the winter of despair, we had everything before us, we had nothing before us, we were all going direct to Heaven, we were all going direct the other way-in short, the period

9/11 Janson Text 56 Italic

It was the best of times, it was the worst of times, it was the age of wisdom, it was the age of foolishness, it was the epoch of belief, it was the epoch of incredulity, it was the season of light, it was the season of darkness, it was the spring of hope, it was the winter of despair, we had everything before us, we had nothing before us, we were all going direct to Heaven, we were all going direct the other way-in short, the period

10/11 Janson Text 56 Italic

It was the best of times, it was the worst of times, it was the age of wisdom, it was the age of foolishness, it was the epoch of belief, it was the epoch of incredulity, it was the season of light, it was the season of darkness, it was the spring of hope, it was the winter of despair, we had everything before us, we had nothing before us, we were all going direct to Heaven, we were all

10/12 Janson Text 56 Italic

It was the best of times, it was the worst of times, it was the age of wisdom, it was the age of foolishness, it was the epoch of belief, it was the epoch of incredulity, it was the season of light, it was the season of darkness, it was the spring of hope, it was the winter of despair, we had everything before us, we had nothing before us, we were all going direct to Heaven, we were all

11/13 Janson Text 56 Italic

It was the best of times, it was the worst of times, it was the age of wisdom, it was the age of foolishness, it was the epoch of belief, it was the epoch of incredulity, it was the season of light, it was the season of darkness, it was the spring of hope, it was the winter of despair, we had everything before us, we had nothing before us, we were all going direct to Heaven, we were

11/14 Janson Text 56 Italic

It was the best of times, it was the worst of times, it was the age of wisdom, it was the age of foolishness, it was the epoch of belief, it was the epoch of incredulity, it was the season of light, it was the season of darkness, it was the spring of hope, it was the winter of despair, we had everything before us, we had nothing before us, we were all going direct to Heaven, we were

12/13 Janson Text 56 Italic

It was the best of times, it was the worst of times, it was the age of wisdom, it was the age of foolishness, it was the epoch of belief, it was the epoch of incredulity, it was the season of light, it was the season of darkness, it was the spring of hope, it was the winter of despair, we had everything before us, we had nothing

12/14 Janson Text 56 Italic

It was the best of times, it was the worst of times, it was the age of wisdom, it was the age of foolishness, it was the epoch of belief, it was the epoch of incredulity, it was the season of light, it was the season of darkness, it was the spring of hope, it was the winter of despair, we had everything before us, we had nothing

13/15 Janson Text 56 Italic

It was the best of times, it was the worst of times, it was the age of wisdom, it was the age of foolishness, it was the epoch of belief, it was the epoch of incredulity, it was the season of light, it was the season of darkness, it was the spring of hope, it was the winter of despair, we had everything before

14/15 Janson Text 56 Italic

It was the best of times, it was the worst of times, it was the age of wisdom, it was the age of foolishness, it was the epoch of belief, it was the epoch of incredulity, it was the season of light, it was the season of darkness, it was the spring of hope, it was the winter of despair, we had everything before us, we

14/16 Janson Text 56 Italic

It was the best of times, it was the worst of times, it was the age of wisdom, it was the age of foolishness, it was the epoch of belief, it was the epoch of incredulity, it was the season of light, it was the season of darkness, it was the spring of hope, it was the winter of despair, we had everything before us, we

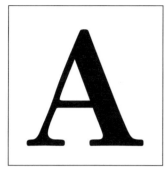

Janson Text 75 Bold 72 point

ABCDEFGHIJK
LMNOPQRSTU
VWXYZabcdefg
hijklmnopqrstuv
wxyz1234567890
?!&$%#@*""".;,

Janson Text 75 Bold 10 point

ABCDEFGHIJKLMNOPQRSTUVWXYZ abcdefghij klmnopqrstuvwxyz 1234567890 ?!/&$%#@*""":;.,

Janson Text 75 Bold 12 point

ABCDEFGHIJKLMNOPQRSTUVWXYZ abcdefghij klmnopqrstuvwxyz 1234567890 ?!/&$%#@*""":;.,

Janson Text 75 Bold 13 point

ABCDEFGHIJKLMNOPQRSTUVWXYZ abcdefghij klmnopqrstuvwxyz 1234567890 ?!/&$%#@*""":;.,

Janson Text 75 Bold 14 point

ABCDEFGHIJKLMNOPQRSTUVWXYZ abcdefghij klmnopqrstuvwxyz 1234567890 ?!/&$%#@*""":;.,

Janson Text 75 Bold 16 point

ABCDEFGHIJKLMNOPQRSTUVWXYZ abcdefghij klmnopqrstuvwxyz 1234567890 ?!/&$%#@*""":;.,

Janson Text 75 Bold 18 point

ABCDEFGHIJKLMNOPQRSTUVWXYZ abcdefghij klmnopqrstuvwxyz 1234567890 ?!/&$%#@*""":;.,

Janson Text 75 Bold 20 point

ABCDEFGHIJKLMNOPQRSTUVWXYZ abcdefghij klmnopqrstuvwxyz 1234567890 ?!/&$%#@*""":;.,

Janson Text 75 Bold 22 point

ABCDEFGHIJKLMNOPQRSTUVWXYZ abcdefghij klmnopqrstuvwxyz 1234567890 ?!/&$%#@*""":;.,

Janson Text 75 Bold 24 point

ABCDEFGHIJKLMNOPQRSTUVWXYZ
abcdefghijklmnopqrstuvwxy 1234567890 !?%&

Janson Text 75 Bold 30 point

ABCDEFGHIJKLMNOPQRSTUVWXY
abcdefghijklmnopqrstuvwxyz 123456

Janson Text 75 Bold 36 point

ABCDEFGHIJKLMNOPQRSTU
abcdefghijklmnopqrstuvwx 123

Janson Text 75 Bold 48 point

ABCDEFGHIJKLMNOP
abcdefghijklmnopqr 12

Janson Text 75 Bold 60 point

ABCDEFGHIJKLM
abcdefghijklmno 12

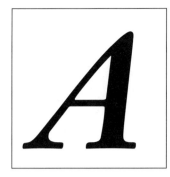

Janson Text 76 Bold Italic 64 point

ABCDEFGHIJK

LMNOPQRSTU

VWXYZabcdefgh

ijklmnopqrstuvw

xyz 1234567890

?!/&$$%#@""*.;.,*

Janson Text 76 Bold Italic 10 point

ABCDEFGHIJKLMNOPQRSTUVWXYZ abcdefghij klmnopqrstuvwxyz 1234567890 ?!/&$%#@""::.,*

Janson Text 75 Bold Italic 12 point

ABCDEFGHIJKLMNOPQRSTUVWXYZ abcdefghij klmnopqrstuvwxyz 1234567890 ?!/&$%#@""::.,*

Janson Text 75 Bold Italic 13 point

ABCDEFGHIJKLMNOPQRSTUVWXYZ abcdefghij klmnopqrstuvwxyz 1234567890 ?!/&$%#@""::.,*

Janson Text 75 Bold Italic 14 point

ABCDEFGHIJKLMNOPQRSTUVWXYZ abcdefghij klmnopqrstuvwxyz 1234567890 ?!/&$%#@""::.,*

Janson Text 75 Bold Italic 16 point

ABCDEFGHIJKLMNOPQRSTUVWXYZ abcdefghij klmnopqrstuvwxyz 1234567890 ?!/&$%#@""::.,*

Janson Text 75 Bold Italic 18 point

ABCDEFGHIJKLMNOPQRSTUVWXYZ abcdefghij klmnopqrstuvwxyz 1234567890 ?!/&$%#@""::.,*

Janson Text 75 Bold Italic 20 point

ABCDEFGHIJKLMNOPQRSTUVWXYZ abcdefghij klmnopqrstuvwxyz 1234567890 ?!/&$%#@""::.,*

Janson Text 75 Bold Italic 22 point

ABCDEFGHIJKLMNOPQRSTUVWXYZ abcdefghij klmnopqrstuvwxyz 1234567890 ?!/&$%#@""::.,*

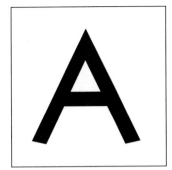

ITC Kabel Medium 72 point

ABCDEFGHIJKLM
NOPQRSTUVWX
YZabcdefghijklm
nopqrstuvwxyz
1234567890
?!/&$%#@*""·,;·,

ITC Kabel Medium 10 point

ABCDEFGHIJKLMNOPQRSTUVWXYZ abcdefghij
klmnopqrstuvwxyz 1234567890 ?!/&$%#@*"":;.,

ITC Kabel Medium 12 point

ABCDEFGHIJKLMNOPQRSTUVWXYZ abcdefghij
klmnopqrstuvwxyz 1234567890 ?!/&$%#@*"":;.,

ITC Kabel Medium 13 point

ABCDEFGHIJKLMNOPQRSTUVWXYZ abcdefghij
klmnopqrstuvwxyz 1234567890 ?!/&$%#@*"":;.,

ITC Kabel Medium 14 point

ABCDEFGHIJKLMNOPQRSTUVWXYZ abcdefghij
klmnopqrstuvwxyz 1234567890 ?!/&$%#@*"":;.,

ITC Kabel Medium 16 point

ABCDEFGHIJKLMNOPQRSTUVWXYZ abcdefghij
klmnopqrstuvwxyz 1234567890 ?!/&$%#@*"":;.,

ITC Kabel Medium 18 point

ABCDEFGHIJKLMNOPQRSTUVWXYZ abcdefghij
klmnopqrstuvwxyz 1234567890 ?!/&$%#@*"":;.,

ITC Kabel Medium 20 point

ABCDEFGHIJKLMNOPQRSTUVWXYZ abcdefghij
klmnopqrstuvwxyz 1234567890 ?!/&$%#@*"":;.,

ITC Kabel Medium 22 point

ABCDEFGHIJKLMNOPQRSTUVWXYZ abcdefghij
klmnopqrstuvwxyz 1234567890 ?!/&$%#@*"":;.,

ITC Kabel Medium 24 point

ABCDEFGHIJKLMNOPQRSTUVWXYZ
abcdefghijklmnopqrstuvwxyz 1234567890 !?%&*

ITC Kabel Medium 30 point

ABCDEFGHIJKLMNOPQRSTUVWXYZ
abcdefghijklmnopqrstuvwxyz 1234567890

ITC Kabel Medium 36 point

ABCDEFGHIJKLMNOPQRSTUVWXZ
abcdefghijklmnopqrstuvw 1234567

ITC Kabel Medium 48 point

ABCDEFGHIJKLMNOPQRSTU
abcdefghijklmnopqrst 123

ITC Kabel Medium 60 point

ABCDEFGHIJKLMNOP
abcdefghijklmno 123

Kaukmann 72 point

ABCDEFGHIJKLM
NOPQRSTUVWX
YZ abcdefghijklm
nopqrstuvwxyz
1234567890
?!/&$%#@*""'.;.,

Kaufmann 10 point

ABCDEFGHIJKLMNOP2RSTUVWXYZ abcdefghij
klmnopqrstuvwxyz 1234567890 ?!/&$%#@*"".;.,

Kaufmann 12 point

ABCDEFGHIJKLMNOP2RSTUVWXYZ abcdefghij
klmnopqrstuvwxyz 1234567890 ?!/&$%#@*"".;.,

Kaufmann 13 point

ABCDEFGHIJKLMNOP2RSTUVWXYZ abcdefghij
klmnopqrstuvwxyz 1234567890 ?!/&$%#@*"".;.,

Kaufmann 14 point

ABCDEFGHIJKLMNOP2RSTUVWXYZ abcdefghij
klmnopqrstuvwxyz 1234567890 ?!/&$%#@*"".;.,

Kaufmann 16 point

ABCDEFGHIJKLMNOP2RSTUVWXYZ abcdefghij
klmnopqrstuvwxyz 1234567890 ?!/&$%#@*"".;.,

Kaufmann 18 point

ABCDEFGHIJKLMNOP2RSTUVWXYZ abcdefghij
klmnopqrstuvwxyz 1234567890 ?!/&$%#@*"".;.,

Kaufmann 20 point

ABCDEFGHIJKLMNOP2RSTUVWXYZ abcdefghij
klmnopqrstuvwxyz 1234567890 ?!/&$%#@*"".;.,

Kaufmann 22 point

ABCDEFGHIJKLMNOP2RSTUVWXYZ abcdefghij
klmnopqrstuvwxyz 1234567890 ?!/&$%#@*"".;.,

Kaufmann 24 point

ABCDEFGHIJKLMNOP2RSTUVWXYZ
abcdefghijklmnopqrstuvwxyz 1234567890 !?%&*

Kaufmann 30 point

ABCDEFGHIJKLMNOP2RSTUVWXYZ
abcdefghijklmnopqrstuvwxyz 1234567890

Kaufmann 36 point

ABCDEFGHIJKLMNOP2RSTUVWXZ
abcdefghijklmnopqrstuvwxyz 1234567

Kaufmann 48 point

ABCDEFGHIJKLMNOP2RST
abcdefghijklmnopqrstuvwxy 1234

Kaufmann 60 point

ABCDEFGHIJKLMNO
abcdefghijklmnopqrs 1234

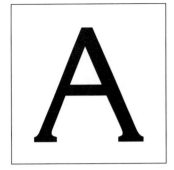

ITC Korinna Regular 72 point

ABCDEFGHIJK
LMNOPQRSTU
VWXYZ abcdefg
hijklmnopqrstu
vwxyz 12345678
90?!&$%#@*""•;

ITC Korinna Regular 10 point

ABCDEFGHIJKLMNOPQRSTUVWXYZ abcdefghij
klmnopqrstuvwxyz 1234567890 ?!/&$%#@*""":;.,

ITC Korinna Regular 12 point

ABCDEFGHIJKLMNOPQRSTUVWXYZ abcdefghij
klmnopqrstuvwxyz 1234567890 ?!/&$%#@*""":;.,

ITC Korinna Regular 13 point

ABCDEFGHIJKLMNOPQRSTUVWXYZ abcdefghij
klmnopqrstuvwxyz 1234567890 ?!/&$%#@*""":;.,

ITC Korinna Regular 14 point

ABCDEFGHIJKLMNOPQRSTUVWXYZ abcdefghij
klmnopqrstuvwxyz 1234567890 ?!/&$%#@*""":;.,

ITC Korinna Regular 16 point

ABCDEFGHIJKLMNOPQRSTUVWXYZ abcdefghij
klmnopqrstuvwxyz 1234567890 ?!/&$%#@*""":;.,

ITC Korinna Regular 18 point

ABCDEFGHIJKLMNOPQRSTUVWXYZ abcdefghij
klmnopqrstuvwxyz 1234567890 ?!/&$%#@*""":;.,

ITC Korinna Regular 20 point

ABCDEFGHIJKLMNOPQRSTUVWXYZ abcdefghij
klmnopqrstuvwxyz 1234567890 ?!/&$%#@*""":;.,

ITC Korinna Regular 22 point

ABCDEFGHIJKLMNOPQRSTUVWXYZ abcdefghij
klmnopqrstuvwxyz 1234567890 ?!/&$%#@*""":;.,

ITC Korinna Regular 24 point

ABCDEFGHIJKLMNOPQRSTUVWXYZ
abcdefghijklmnopqrstuvwxyz 1234567890 !?%&*

ITC Korinna Regular 30 point

ABCDEFGHIJKLMNOPQRSTUVWXYZ
abcdefghijklmnopqrstuvwxyz 1234567890

ITC Korinna Regular 36 point

ABCDEFGHIJKLMNOPQRSTUVWXZ
abcdefghijklmnopqrstuvwxyz 1234567

ITC Korinna Regular 48 point

ABCDEFGHIJKLMNOPQRS
abcdefghijklmnopqrstuv 123

ITC Korinna Regular 60 point

ABCDEFGHIJKLMNO
abcdefghijklmnopq 123

6/8 ITC Korinna Regular

It was the best of times, it was the worst of times, it was the age of wisdom, it was the age of foolishness, it was the epoch of belief, it was the epoch of incredulity, it was the season of light, it was the season of darkness, it was the spring of hope, it was the winter of despair, we had everything before us, we had nothing before us, we were all going direct to Heaven, we were all going direct the other way-in short, the period was so far like the present period, that some of its noisiest authorities insisted on its being

8/10 ITC Korinna Regular

It was the best of times, it was the worst of times, it was the age of wisdom, it was the age of foolishness, it was the epoch of belief, it was the epoch of incredulity, it was the season of light, it was the season of darkness, it was the spring of hope, it was the winter of despair, we had everything before us, we had nothing before us, we were all going direct to Heaven, we were all going

9/10 ITC Korinna Regular

It was the best of times, it was the worst of times, it was the age of wisdom, it was the age of foolishness, it was the epoch of belief, it was the epoch of incredulity, it was the season of light, it was the season of darkness, it was the spring of hope, it was the winter of despair, we had everything before us, we had nothing before us, we were all going

9/11 ITC Korinna Regular

It was the best of times, it was the worst of times, it was the age of wisdom, it was the age of foolishness, it was the epoch of belief, it was the epoch of incredulity, it was the season of light, it was the season of darkness, it was the spring of hope, it was the winter of despair, we had everything before us, we had nothing before us, we were all going

10/11 ITC Korinna Regular

It was the best of times, it was the worst of times, it was the age of wisdom, it was the age of foolishness, it was the epoch of belief, it was the epoch of incredulity, it was the season of light, it was the season of darkness, it was the spring of hope, it was the winter of despair, we had everything before us, we had nothing before us,

10/12 ITC Korinna Regular

It was the best of times, it was the worst of times, it was the age of wisdom, it was the age of foolishness, it was the epoch of belief, it was the epoch of incredulity, it was the season of light, it was the season of darkness, it was the spring of hope, it was the winter of despair, we had everything before us, we had nothing before us,

11/13 ITC Korinna Regular

It was the best of times, it was the worst of times, it was the age of wisdom, it was the age of foolishness, it was the epoch of belief, it was the epoch of incredulity, it was the season of light, it was the season of darkness, it was the spring of hope, it was the winter of despair, we had

11/14 ITC Korinna Regular

It was the best of times, it was the worst of times, it was the age of wisdom, it was the age of foolishness, it was the epoch of belief, it was the epoch of incredulity, it was the season of light, it was the season of darkness, it was the spring of hope, it was the winter of despair, we had

12/13 ITC Korinna Regular

It was the best of times, it was the worst of times, it was the age of wisdom, it was the age of foolishness, it was the epoch of belief, it was the epoch of incredulity, it was the season of light, it was the season of darkness, it was the spring of hope, it was

12/14 ITC Korinna Regular

It was the best of times, it was the worst of times, it was the age of wisdom, it was the age of foolishness, it was the epoch of belief, it was the epoch of incredulity, it was the season of light, it was the season of darkness, it was the spring of hope, it was

13/15 ITC Korinna Regular

It was the best of times, it was the worst of times, it was the age of wisdom, it was the age of foolishness, it was the epoch of belief, it was the epoch of incredulity, it was the season of light, it was the season of darkness, it was the spring of

14/15 ITC Korinna Regular

It was the best of times, it was the worst of times, it was the age of wisdom, it was the age of foolishness, it was the epoch of belief, it was the epoch of incredulity, it was the season of light, it was the season of darkness, it was the spring of

14/16 ITC Korinna Regular

It was the best of times, it was the worst of times, it was the age of wisdom, it was the age of foolishness, it was the epoch of belief, it was the epoch of incredulity, it was the season of light, it was the season of darkness, it was the spring of

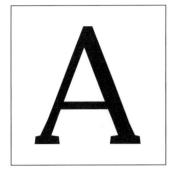

Lucida Roman 72 Point

ABCDEFGHIJKL
MNOPQRSTUVW
XYZ abcdefghijk
lmnopqrstuvw
xyz1234567890
?!/&$%#@*""":;.,

Lucida Roman 10 point

ABCDEFGHIJKLMNOPQRSTUVWXYZ abcdefghij
klmnopqrstuvwxyz 1234567890 ?!/&$%#@*""":;.,

Lucida Roman 12 point

ABCDEFGHIJKLMNOPQRSTUVWXYZ abcdefghij
klmnopqrstuvwxyz 1234567890 ?!/&$%#@*""":;.,

Lucida Roman 13 point

ABCDEFGHIJKLMNOPQRSTUVWXYZ abcdefghij
klmnopqrstuvwxyz 1234567890 ?!/&$%#@*""":;.,

Lucida Roman 14 point

ABCDEFGHIJKLMNOPQRSTUVWXYZ abcdefghij
klmnopqrstuvwxyz 1234567890 ?!/&$%#@*""":;.,

Lucida Roman 16 point

ABCDEFGHIJKLMNOPQRSTUVWXYZ abcdefghij
klmnopqrstuvwxyz 1234567890 ?!/&$%#@*""":;.,

Lucida Roman 18 point

ABCDEFGHIJKLMNOPQRSTUVWXYZ abcdefghij
klmnopqrstuvwxyz 1234567890 ?!/&$%#@*""":;.,

Lucida Roman 20 point

ABCDEFGHIJKLMNOPQRSTUVWXYZ abcdefghij
klmnopqrstuvwxyz 1234567890 ?!/&$%#@*""":;.,

Lucida Roman 22 point

ABCDEFGHIJKLMNOPQRSTUVWXYZ abcdefghij
klmnopqrstuvwxyz 1234567890 ?!/&$%#@*""":;.,

Lucida Roman 24 point

ABCDEFGHIJKLMNOPQRSTUVWXYZ
abcdefghijklmnopqrstuvwxyz 1234567890 !?%&*

Lucida Roman 30 point

ABCDEFGHIJKLMNOPQRSTUVWXYZ
abcdefghijklmnopqrstuvwxyz 1234567

Lucida Roman 36 point

ABCDEFGHIJKLMNOPQRSTUVWXZ
abcdefghijklmnopqrstuvwxy123

Lucida Roman 48 point

ABCDEFGHIJKLMNOPQRS
abcdefghijklmnopqrst123

Lucida Roman 60 point

ABCDEFGHIJKLMNO
abcdefghijklmno 123

6/8 Lucida Roman

It was the best of times, it was the worst of times, it was the age of wisdom, it was the age of foolishness, it was the epoch of belief, it was the epoch of incredulity, it was the season of light, it was the season of darkness, it was the spring of hope, it was the winter of despair, we had everything before us, we had nothing before us, we were all going direct to Heaven, we were all going direct the other way-in short, the period was so far like the present period, that some

8/10 Lucida Roman

It was the best of times, it was the worst of times, it was the age of wisdom, it was the age of foolishness, it was the epoch of belief, it was the epoch of incredulity, it was the season of light, it was the season of darkness, it was the spring of hope, it was the winter of despair, we had everything before us, we had nothing before us, we were all going direct

9/10 Lucida Roman

It was the best of times, it was the worst of times, it was the age of wisdom, it was the age of foolishness, it was the epoch of belief, it was the epoch of incredulity, it was the season of light, it was the season of darkness, it was the spring of hope, it was the winter of despair, we had everything before us, we had

9/11 Lucida Roman

It was the best of times, it was the worst of times, it was the age of wisdom, it was the age of foolishness, it was the epoch of belief, it was the epoch of incredulity, it was the season of light, it was the season of darkness, it was the spring of hope, it was the winter of despair, we had everything before us, we had

10/11 Lucida Roman

It was the best of times, it was the worst of times, it was the age of wisdom, it was the age of foolishness, it was the epoch of belief, it was the epoch of incredulity, it was the season of light, it was the season of darkness, it was the spring of hope, it was the winter of despair, we had everything before us, we had

10/12 Lucida Roman

It was the best of times, it was the worst of times, it was the age of wisdom, it was the age of foolishness, it was the epoch of belief, it was the epoch of incredulity, it was the season of light, it was the season of darkness, it was the spring of hope, it was the winter of despair, we had everything before us, we had

11/13 Lucida Roman

It was the best of times, it was the worst of times, it was the age of wisdom, it was the age of foolishness, it was the epoch of belief, it was the epoch of incredulity, it was the season of light, it was the season of darkness, it was the spring of hope, it was the winter of despair,

11/14 Lucida Roman

It was the best of times, it was the worst of times, it was the age of wisdom, it was the age of foolishness, it was the epoch of belief, it was the epoch of incredulity, it was the season of light, it was the season of darkness, it was the spring of hope, it was the winter of despair,

12/13 Lucida Roman

It was the best of times, it was the worst of times, it was the age of wisdom, it was the age of foolishness, it was the epoch of belief, it was the epoch of incredulity, it was the season of light, it was the season of darkness, it was the

12/14 Lucida Roman

It was the best of times, it was the worst of times, it was the age of wisdom, it was the age of foolishness, it was the epoch of belief, it was the epoch of incredulity, it was the season of light, it was the season of darkness, it was the

13/15 Lucida Roman

It was the best of times, it was the worst of times, it was the age of wisdom, it was the age of foolishness, it was the epoch of belief, it was the epoch of incredulity, it was the season of light, it was the season of

14/15 Lucida Roman

It was the best of times, it was the worst of times, it was the age of wisdom, it was the age of foolishness, it was the epoch of belief, it was the epoch of incredulity, it was the season of light, it was the

14/16 Lucida Roman

It was the best of times, it was the worst of times, it was the age of wisdom, it was the age of foolishness, it was the epoch of belief, it was the epoch of incredulity, it was the season of light, it was the

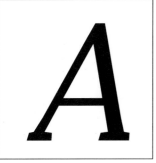

Lucida Italic 72 point

ABCDEFGHIJKLM
NOPQRSTUVWX
YZ abcdefghijkl
mnopqrstuvwx
yz 1234567890
?!&$%#@*"".:,;

Lucida Italic 10 point

ABCDEFGHIJKLMNOPQRSTUVWXYZ abcdefghij
klmnopqrstuvwxyz 1234567890 ?!/&$%#@"":;.,*

Lucida Italic 12 point

ABCDEFGHIJKLMNOPQRSTUVWXYZ abcdefghij
klmnopqrstuvwxyz 1234567890 ?!/&$%#@"":;.,*

Lucida Italic 13 point

ABCDEFGHIJKLMNOPQRSTUVWXYZ abcdefghij
klmnopqrstuvwxyz 1234567890 ?!/&$%#@"":;.,*

Lucida Italic 14 point

ABCDEFGHIJKLMNOPQRSTUVWXYZ abcdefghij
klmnopqrstuvwxyz 1234567890 ?!/&$%#@"":;.,*

Lucida Italic 16 point

ABCDEFGHIJKLMNOPQRSTUVWXYZ abcdefghij
klmnopqrstuvwxyz 1234567890 ?!/&$%#@"":;.,*

Lucida Italic 18 point

ABCDEFGHIJKLMNOPQRSTUVWXYZ abcdefghij
klmnopqrstuvwxyz 1234567890 ?!/&$%#@"":;.,*

Lucida Italic 20 point

ABCDEFGHIJKLMNOPQRSTUVWXYZ abcdefghij
klmnopqrstuvwxyz 1234567890 ?!/&$%#@"":;.,*

Lucida Italic 22 point

ABCDEFGHIJKLMNOPQRSTUVWXYZ abcdefghij
klmnopqrstuvwxyz 1234567890 ?!/&$%#@"":;.,*

Lucida Italic 24 point

ABCDEFGHIJKLMNOPQRSTUVWXYZ
abcdefghijklmnopqrstuvwxyz 1234567890 !?%&*

Lucida Italic 30 point

ABCDEFGHIJKLMNOPQRSTUVWXYZ
abcdefghijklmnopqrstuvwxy 123456789

Lucida Italic 36 point

ABCDEFGHIJKLMNOPQRSTUVW
abcdefghijklmnopqrstuvwxyz 123

Lucida Italic 48 point

ABCDEFGHIJKLMNOPQRST
abcdefghijklmnopqrst 12

Lucida Italic 60 point

ABCDEFGHIJKLMNOP
abcdefghijklmnpq12

6/8 Lucida Italic

It was the best of times, it was the worst of times, it was the age of wisdom, it was the age of foolishness, it was the epoch of belief, it was the epoch of incredulity, it was the season of light, it was the season of darkness, it was the spring of hope, it was the winter of despair, we had everything before us, we had nothing before us, we were all going direct to Heaven, we were all going direct the other way-in short, the period was so far like the present period, that some of its noisiest authorities insisted on

8/10 Lucida Italic

It was the best of times, it was the worst of times, it was the age of wisdom, it was the age of foolishness, it was the epoch of belief, it was the epoch of incredulity, it was the season of light, it was the season of darkness, it was the spring of hope, it was the winter of despair, we had everything before us, we had nothing before us, we were all going direct to Heaven,

9/10 Lucida Italic

It was the best of times, it was the worst of times, it was the age of wisdom, it was the age of foolishness, it was the epoch of belief, it was the epoch of incredulity, it was the season of light, it was the season of darkness, it was the spring of hope, it was the winter of despair, we had everything before us, we had nothing

9/11 Lucida Italic

It was the best of times, it was the worst of times, it was the age of wisdom, it was the age of foolishness, it was the epoch of belief, it was the epoch of incredulity, it was the season of light, it was the season of darkness, it was the spring of hope, it was the winter of despair, we had everything before us, we had nothing

10/11 Lucida Italic

It was the best of times, it was the worst of times, it was the age of wisdom, it was the age of foolishness, it was the epoch of belief, it was the epoch of incredulity, it was the season of light, it was the season of darkness, it was the spring of hope, it was the winter of despair, we had everything before us, we had

10/12 Lucida Italic

It was the best of times, it was the worst of times, it was the age of wisdom, it was the age of foolishness, it was the epoch of belief, it was the epoch of incredulity, it was the season of light, it was the season of darkness, it was the spring of hope, it was the winter

11/13 Lucida Italic

It was the best of times, it was the worst of times, it was the age of wisdom, it was the age of foolishness, it was the epoch of belief, it was the epoch of incredulity, it was the season of light, it was the season of darkness, it was the spring of hope, it was

11/14 Lucida Italic

It was the best of times, it was the worst of times, it was the age of wisdom, it was the age of foolishness, it was the epoch of belief, it was the epoch of incredulity, it was the season of light, it was the season of darkness, it was the spring of hope, it was

12/13 Lucida Italic

It was the best of times, it was the worst of times, it was the age of wisdom, it was the age of foolishness, it was the epoch of belief, it was the epoch of incredulity, it was the season of light, it was the season of darkness, it was the spring of

12/14 Lucida Italic

It was the best of times, it was the worst of times, it was the age of wisdom, it was the age of foolishness, it was the epoch of belief, it was the epoch of incredulity, it was the season of light, it was the season of darkness, it was the spring of

13/15 Lucida Italic

It was the best of times, it was the worst of times, it was the age of wisdom, it was the age of foolishness, it was the epoch of belief, it was the epoch of incredulity, it was the season of light, it was the season of darkness,

14/15 Lucida Italic

It was the best of times, it was the worst of times, it was the age of wisdom, it was the age of foolishness, it was the epoch of belief, it was the epoch of incredulity, it was the season of light, it was the season

14/16 Lucida Italic

It was the best of times, it was the worst of times, it was the age of wisdom, it was the age of foolishness, it was the epoch of belief, it was the epoch of incredulity, it was the season of light, it was the season

Lucida Bold 72 point

ABCDEFGHIJKL
MNOPQRSTUV
WXYZ abcdefg
hijklmnopqrstu
vwxyz12345678
90 ?!/&$%#@*

Lucida Bold 10 point

ABCDEFGHIJKLMNOPQRSTUVWXYZ abcdefghij klmnopqrstuvwxyz 1234567890 ?!/&$%#@*"":;.,

Lucida Bold 12 point

ABCDEFGHIJKLMNOPQRSTUVWXYZ abcdefghij klmnopqrstuvwxyz 1234567890 ?!/&$%#@*"":;.,

Lucida Bold 13 point

ABCDEFGHIJKLMNOPQRSTUVWXYZ abcdefghij klmnopqrstuvwxyz 1234567890 ?!/&$%#@*"":;.,

Lucida Bold 14 point

ABCDEFGHIJKLMNOPQRSTUVWXYZ abcdefghij klmnopqrstuvwxyz 1234567890 ?!/&$%#@*"":;.,

Lucida Bold 16 point

ABCDEFGHIJKLMNOPQRSTUVWXYZ abcdefghij klmnopqrstuvwxyz 1234567890 ?!/&$%#@*"":;.,

Lucida Bold 18 point

ABCDEFGHIJKLMNOPQRSTUVWXYZ abcdefghij klmnopqrstuvwxyz 1234567890 ?!/&$%#@*"":;.,

Lucida Bold 20 point

ABCDEFGHIJKLMNOPQRSTUVWXYZ abcdefghij klmnopqrstuvwxyz 1234567890 ?!/&$%#@*"":;.,

Lucida Bold 22 point

ABCDEFGHIJKLMNOPQRSTUVWXYZ abcdefghij klmnopqrstuvwxyz 1234567890 ?!/&$%#@*",.

Lucida Bold 24 point

**ABCDEFGHIJKLMNOPQRSTUVWXYZ
abcdefghijklmnopqrstuvwxyz 1234567890 !?**

Lucida Bold 30 point

**ABCDEFGHIJKLMNOPQRSTUVWXYZ
abcdefghijklmnopqrstuvwxyz 1234**

Lucida Bold 36 point

**ABCDEFGHIJKLMNOPQRSTUV
abcdefghijklmnopqrstuvwxy 1**

Lucida Bold 48 point

**ABCDEFGHIJKLMNOPQ
abcdefghijklmnopqr 1**

Lucida Bold 60 point

**ABCDEFGHIJKLMN
abcdefghijklmno**

Lucida Bold Italic 72 Point

ABCDEFGHIJKL MNOPQRSTUW XYZ abcdefghij klmnopqrstuvw xyz 12345678 90 ?!/&$%#@*❋"".

Lucida Bold Italic 10 point

ABCDEFGHIJKLMNOPQRSTUVWXYZ abcdefghij klmnopqrstuvwxyz 1234567890 ?!/&$%#@""'":;.,*

Lucida Bold Italic 12 point

ABCDEFGHIJKLMNOPQRSTUVWXYZ abcdefghij klmnopqrstuvwxyz 1234567890 ?!/&$%#@""'":;.,*

Lucida Bold Italic 13 point

ABCDEFGHIJKLMNOPQRSTUVWXYZ abcdefghij klmnopqrstuvwxyz 1234567890 ?!/&$%#@""'":;.,*

Lucida Bold Italic 14 point

ABCDEFGHIJKLMNOPQRSTUVWXYZ abcdefghij klmnopqrstuvwxyz 1234567890 ?!/&$%#@""'":;.,*

Lucida Bold Italic 16 point

ABCDEFGHIJKLMNOPQRSTUVWXYZ abcdefghij klmnopqrstuvwxyz 1234567890 ?!/&$%#@""'":;.,*

Lucida Bold Italic 18 point

ABCDEFGHIJKLMNOPQRSTUVWXYZ abcdefghij klmnopqrstuvwxyz 1234567890 ?!/&$%#@""'":;.,*

Lucida Bold Italic 20 point

ABCDEFGHIJKLMNOPQRSTUVWXYZ abcdefghij klmnopqrstuvwxyz 1234567890 ?!/&$%#@""'":;.,*

Lucida Bold Italic 22 point

ABCDEFGHIJKLMNOPQRSTUVWXYZ abcdefghij klmnopqrstuvwxyz 1234567890 ?!/&$%#@""'":*

Lucida Bold Italic 24 point

ABCDEFGHIJKLMNOPQRSTUVWXYZ
abcdefghijklmnopqrstuvwxyzb1234567890 !?

Lucida Bold Italic 30 point

ABCDEFGHIJKLMNOPQRSTUVWXYZ
abcdefghijklmnopqrstuvwxyz 1234

Lucida Bold Italic 36 point

ABCDEFGHIJKLMNOPQRSTUV
abcdefghijklmnopqrstuvw 123

Lucida Bold Italic 48 point

ABCDEFGHIJKLMNOPQ
abcdefghijklmnop 123

Lucida Bold Italic 60 point

ABCDEFGHIJKLMN
abcdefghijklmn 12

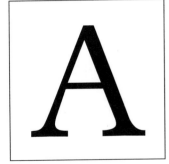

Melior 72 point

ABCDEFGHIJKL
MNOPQRSTUV
WXYZ abcdefghi
jklmnopqrstuvw
xyz 1234567890
?!/&$%#@*" ".:;.,

Melior 10 point

ABCDEFGHIJKLMNOPQRSTUVWXYZ abcdefghij
klmnopqrstuvwxyz 1234567890 ?!/&$%#@*""":;.,

Melior 12 point

ABCDEFGHIJKLMNOPQRSTUVWXYZ abcdefghij
klmnopqrstuvwxyz 1234567890 ?!/&$%#@*""":;.,

Melior 13 point

ABCDEFGHIJKLMNOPQRSTUVWXYZ abcdefghij
klmnopqrstuvwxyz 1234567890 ?!/&$%#@*""":;.,

Melior 14 point

ABCDEFGHIJKLMNOPQRSTUVWXYZ abcdefghij
klmnopqrstuvwxyz 1234567890 ?!/&$%#@*""":;.,

Melior 16 point

ABCDEFGHIJKLMNOPQRSTUVWXYZ abcdefghij
klmnopqrstuvwxyz 1234567890 ?!/&$%#@*""":;.,

Melior 18 point

ABCDEFGHIJKLMNOPQRSTUVWXYZ abcdefghij
klmnopqrstuvwxyz 1234567890 ?!/&$%#@*""":;.,

Melior 20 point

ABCDEFGHIJKLMNOPQRSTUVWXYZ abcdefghij
klmnopqrstuvwxyz 1234567890 ?!/&$%#@*""":;.,

Melior 22 point

ABCDEFGHIJKLMNOPQRSTUVWXYZ abcdefghij
klmnopqrstuvwxyz 1234567890 ?!/&$%#@*""":;.,

Melior 24 point

ABCDEFGHIJKLMNOPQRSTUVWXYZ
abcdefghijklmnopqrstuvwxyz 1234567890 !?%&*

Melior 30 point

ABCDEFGHIJKLMNOPQRSTUVWXYZ
abcdefghijklmnopqrstuvwxyz 12345678

Melior 36 point

ABCDEFGHIJKLMNOPQRSTUV
abcdefghijklmnopqrstuvwxyz 123

Melior 48 point

ABCDEFGHIJKLMNOPQ
abcdefghijklmnopqrs 123

Melior 60 point

ABCDEFGHIJKLMN
abcdefghijklmnop 123

6/8 Melior

It was the best of times, it was the worst of times, it was the age of wisdom, it was the age of foolishness, it was the epoch of belief, it was the epoch of incredulity, it was the season of light, it was the season of darkness, it was the spring of hope, it was the winter of despair, we had everything before us, we had nothing before us, we were all going direct to Heaven, we were all going direct the other way-in short, the period was so far like the present period, that some of its noisiest authorities insisted on its being received,

8/10 Melior

It was the best of times, it was the worst of times, it was the age of wisdom, it was the age of foolishness, it was the epoch of belief, it was the epoch of incredulity, it was the season of light, it was the season of darkness, it was the spring of hope, it was the winter of despair, we had everything before us, we had nothing before us, we were all going direct to Heaven, we were all going

9/10 Melior

It was the best of times, it was the worst of times, it was the age of wisdom, it was the age of foolishness, it was the epoch of belief, it was the epoch of incredulity, it was the season of light, it was the season of darkness, it was the spring of hope, it was the winter of despair, we had everything before us, we had nothing before us, we were all going

9/11 Melior

It was the best of times, it was the worst of times, it was the age of wisdom, it was the age of foolishness, it was the epoch of belief, it was the epoch of incredulity, it was the season of light, it was the season of darkness, it was the spring of hope, it was the winter of despair, we had everything before us, we had nothing before us, we were all going

10/11 Melior

It was the best of times, it was the worst of times, it was the age of wisdom, it was the age of foolishness, it was the epoch of belief, it was the epoch of incredulity, it was the season of light, it was the season of darkness, it was the spring of hope, it was the winter of despair, we had everything before us, we had

10/12 Melior

It was the best of times, it was the worst of times, it was the age of wisdom, it was the age of foolishness, it was the epoch of belief, it was the epoch of incredulity, it was the season of light, it was the season of darkness, it was the spring of hope, it was the winter of despair, we had everything before us, we had

11/13 Melior

It was the best of times, it was the worst of times, it was the age of wisdom, it was the age of foolishness, it was the epoch of belief, it was the epoch of incredulity, it was the season of light, it was the season of darkness, it was the spring of hope, it was the winter of despair, we had

11/14 Melior

It was the best of times, it was the worst of times, it was the age of wisdom, it was the age of foolishness, it was the epoch of belief, it was the epoch of incredulity, it was the season of light, it was the season of darkness, it was the spring of hope, it was the winter of despair, we had

12/13 Melior

It was the best of times, it was the worst of times, it was the age of wisdom, it was the age of foolishness, it was the epoch of belief, it was the epoch of incredulity, it was the season of light, it was the season of darkness, it was the spring of hope, it was

12/14 Melior

It was the best of times, it was the worst of times, it was the age of wisdom, it was the age of foolishness, it was the epoch of belief, it was the epoch of incredulity, it was the season of light, it was the season of darkness, it was the spring of hope, it was

13/15 Melior

It was the best of times, it was the worst of times, it was the age of wisdom, it was the age of foolishness, it was the epoch of belief, it was the epoch of incredulity, it was the season of light, it was the season of darkness, it was the spring of

14/15 Melior

It was the best of times, it was the worst of times, it was the age of wisdom, it was the age of foolishness, it was the epoch of belief, it was the epoch of incredulity, it was the season of light, it was the season of darkness, it

14/16 Melior

It was the best of times, it was the worst of times, it was the age of wisdom, it was the age of foolishness, it was the epoch of belief, it was the epoch of incredulity, it was the season of light, it was the season of darkness, it

Melior Italic 72 point

ABCDEFGHIJKL
MNOPQRSTUV
WXYZ abcdefghi
jklmnopqrstuvw
xyz 1234567890
?!&$%#@"";.,;.,*

Melior Italic 10 point

ABCDEFGHIJKLMNOPQRSTUVWXYZ abcdefghij
klmnopqrstuvwxyz 1234567890 ?!/&$%#@""":;.,*

Melior Italic 12 point

ABCDEFGHIJKLMNOPQRSTUVWXYZ abcdefghij
klmnopqrstuvwxyz 1234567890 ?!/&$%#@""":;.,*

Melior Italic 13 point

ABCDEFGHIJKLMNOPQRSTUVWXYZ abcdefghij
klmnopqrstuvwxyz 1234567890 ?!/&$%#@""":;.,*

Melior Italic 14 point

ABCDEFGHIJKLMNOPQRSTUVWXYZ abcdefghij
klmnopqrstuvwxyz 1234567890 ?!/&$%#@""":;.,*

Melior Italic 16 point

ABCDEFGHIJKLMNOPQRSTUVWXYZ abcdefghij
klmnopqrstuvwxyz 1234567890 ?!/&$%#@""":;.,*

Melior Italic 18 point

ABCDEFGHIJKLMNOPQRSTUVWXYZ abcdefghij
klmnopqrstuvwxyz 1234567890 ?!/&$%#@""":;.,*

Melior Italic 20 point

ABCDEFGHIJKLMNOPQRSTUVWXYZ abcdefghij
klmnopqrstuvwxyz 1234567890 ?!/&$%#@""":;.,*

Melior Italic 22 point

ABCDEFGHIJKLMNOPQRSTUVWXYZ abcdefghij
klmnopqrstuvwxyz 1234567890 ?!/&$%#@""":;.,*

6/8 Melior Italic

It was the best of times, it was the worst of times, it was the age of wisdom, it was the age of foolishness, it was the epoch of belief, it was the epoch of incredulity, it was the season of light, it was the season of darkness, it was the spring of hope, it was the winter of despair, we had everything before us, we had nothing before us, we were all going direct to Heaven, we were all going direct the other way-in short, the period was so far like the present period, that some of its noisiest authorities insisted on its being received,

8/10 Melior Italic

It was the best of times, it was the worst of times, it was the age of wisdom, it was the age of foolishness, it was the epoch of belief, it was the epoch of incredulity, it was the season of light, it was the season of darkness, it was the spring of hope, it was the winter of despair, we had everything before us, we had nothing before us, we were all going direct to Heaven, we were all going direct

9/10 Melior Italic

It was the best of times, it was the worst of times, it was the age of wisdom, it was the age of foolishness, it was the epoch of belief, it was the epoch of incredulity, it was the season of light, it was the season of darkness, it was the spring of hope, it was the winter of despair, we had everything before us, we had nothing before us, we were all going

9/11 Melior Italic

It was the best of times, it was the worst of times, it was the age of wisdom, it was the age of foolishness, it was the epoch of belief, it was the epoch of incredulity, it was the season of light, it was the season of darkness, it was the spring of hope, it was the winter of despair, we had everything before us, we had nothing before us, we were all going

10/11 Melior Italic

It was the best of times, it was the worst of times, it was the age of wisdom, it was the age of foolishness, it was the epoch of belief, it was the epoch of incredulity, it was the season of light, it was the season of darkness, it was the spring of hope, it was the winter of despair, we had everything before us, we

10/12 Melior Italic

It was the best of times, it was the worst of times, it was the age of wisdom, it was the age of foolishness, it was the epoch of belief, it was the epoch of incredulity, it was the season of light, it was the season of darkness, it was the spring of hope, it was the winter of despair, we had everything before us,

11/13 Melior Italic

It was the best of times, it was the worst of times, it was the age of wisdom, it was the age of foolishness, it was the epoch of belief, it was the epoch of incredulity, it was the season of light, it was the season of darkness, it was the spring of hope, it was the winter of despair, we had everything before us, we

11/14 Melior Italic

It was the best of times, it was the worst of times, it was the age of wisdom, it was the age of foolishness, it was the epoch of belief, it was the epoch of incredulity, it was the season of light, it was the season of darkness, it was the spring of hope, it was the winter of despair, we had everything before us, we

12/13 Melior Italic

It was the best of times, it was the worst of times, it was the age of wisdom, it was the age of foolishness, it was the epoch of belief, it was the epoch of incredulity, it was the season of light, it was the season of darkness, it was the spring of hope, it was

12/14 Melior Italic

It was the best of times, it was the worst of times, it was the age of wisdom, it was the age of foolishness, it was the epoch of belief, it was the epoch of incredulity, it was the season of light, it was the season of darkness, it was the spring of hope, it was

13/15 Melior Italic

It was the best of times, it was the worst of times, it was the age of wisdom, it was the age of foolishness, it was the epoch of belief, it was the epoch of incredulity, it was the season of light, it was the season of darkness, it was the spring of

14/15 Melior Italic

It was the best of times, it was the worst of times, it was the age of wisdom, it was the age of foolishness, it was the epoch of belief, it was the epoch of incredulity, it was the season of light, it was the season of darkness, it

14/16 Melior Italic

It was the best of times, it was the worst of times, it was the age of wisdom, it was the age of foolishness, it was the epoch of belief, it was the epoch of incredulity, it was the season of light, it was the season of darkness, it

Melior Bold 72 point

ABCDEFGHIJKL
MNOPQRSTUV
WXYZabcdefghi
jklmnopqrstuvw
xyz 1234567890
?!/&$%#@*""";.,

Melior Bold 10 point

**ABCDEFGHIJKLMNOPQRSTUVWXYZ abcdefghij
klmnopqrstuvwxyz 1234567890 ?!/&$%#@*""":;.,**

Melior Bold 12 point

**ABCDEFGHIJKLMNOPQRSTUVWXYZ abcdefghij
klmnopqrstuvwxyz 1234567890 ?!/&$%#@*""":;.,**

Melior Bold 13 point

**ABCDEFGHIJKLMNOPQRSTUVWXYZ abcdefghij
klmnopqrstuvwxyz 1234567890 ?!/&$%#@*""":;.,**

Melior Bold 14 point

**ABCDEFGHIJKLMNOPQRSTUVWXYZ abcdefghij
klmnopqrstuvwxyz 1234567890 ?!/&$%#@*""":;.,**

Melior Bold 16 point

**ABCDEFGHIJKLMNOPQRSTUVWXYZ abcdefghij
klmnopqrstuvwxyz 1234567890 ?!/&$%#@*""":;.,**

Melior Bold 18 point

**ABCDEFGHIJKLMNOPQRSTUVWXYZ abcdefghij
klmnopqrstuvwxyz 1234567890 ?!/&$%#@*""":;.,**

Melior Bold 20 point

**ABCDEFGHIJKLMNOPQRSTUVWXYZ abcdefghij
klmnopqrstuvwxyz 1234567890 ?!/&$%#@*""":;.,**

Melior Bold 22 point

**ABCDEFGHIJKLMNOPQRSTUVWXYZ abcdefghij
klmnopqrstuvwxyz 1234567890 ?!/&$%#@*""":;.,**

Melior Bold 24 point

ABCDEFGHIJKLMNOPQRSTUVWXYZ
abcdefghijklmnopqrstuvwxyz 1234567890 !?%&

Melior Bold 30 point

ABCDEFGHIJKLMNOPQRSTUVWXYZ
abcdefghijklmnopqrstuvwxyz 12345678

Melior Bold 36 point

ABCDEFGHIJKLMNOPQRSTUV
abcdefghijklmnopqrstuvwx 1234

Melior Bold 48 point

ABCDEFGHIJKLMNOPQ
abcdefghijklmnopqr 123

Melior Bold 60 point

ABCDEFGHIJKLMN
abcdefghijklmn 123

Melior Bold Italic 72 point

ABCDEFGHIJKL
MNOPQRSTUV
WXYZ abcdefghi
jklmnopqrstuvw
xyz 1234567890
*?!/&$%#@ * " ",.;,*

Meloir Bold Italic 10 point

ABCDEFGHIJKLMNOPQRSTUVWXYZ abcdefghij
klmnopqrstuvwxyz 1234567890 ?!/&$%#@""";.,*

Meloir Bold Italic 12 point

ABCDEFGHIJKLMNOPQRSTUVWXYZ abcdefghij
klmnopqrstuvwxyz 1234567890 ?!/&$%#@""";.,*

Meloir Bold Italic 13 point

ABCDEFGHIJKLMNOPQRSTUVWXYZ abcdefghij
klmnopqrstuvwxyz 1234567890 ?!/&$%#@""";.,*

Meloir Bold Italic 14 point

ABCDEFGHIJKLMNOPQRSTUVWXYZ abcdefghij
klmnopqrstuvwxyz 1234567890 ?!/&$%#@""";.,*

Meloir Bold Italic 16 point

ABCDEFGHIJKLMNOPQRSTUVWXYZ abcdefghij
klmnopqrstuvwxyz 1234567890 ?!/&$%#@""";.,*

Meloir Bold Italic 18 point

ABCDEFGHIJKLMNOPQRSTUVWXYZ abcdefghij
klmnopqrstuvwxyz 1234567890 ?!/&$%#@""";.,*

Meloir Bold Italic 20 point

ABCDEFGHIJKLMNOPQRSTUVWXYZ abcdefghij
klmnopqrstuvwxyz 1234567890 ?!/&$%#@""";.,*

Meloir Bold Italic 22 point

ABCDEFGHIJKLMNOPQRSTUVWXYZ abcdefghij
klmnopqrstuvwxyz 1234567890 ?!/&$%#@""";.,*

Meloir Bold Italic 24 point

ABCDEFGHIJKLMNOPQRSTUVWXYZ
abcdefghijklmnopqrstuvwxyzb1234567890 !?%&

Meloir Bold Italic 30 point

ABCDEFGHIJKLMNOPQRSTUVWXYZ
abcdefghijklmnopqrstuvwxyz 1234567

Meloir Bold Italic 36 point

ABCDEFGHIJKLMNOPQRSTU
abcdefghijklmnopqrstuvwxy 123

Meloir Bold Italic 48 point

ABCDEFGHIJKLMNOPQ
abcdefghijklmnopq 123

Meloir Bold Italic 60 point

ABCDEFGHIJKLMN
abcdefghijklmn 123

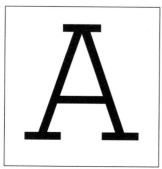

Memphis Light 72 point

ABCDEFGHIJKL
MNOPQRSTUV
WXYZ abcdefg
hijklm nopqrstu
vwxyz1234567
890?!/&$%#@*""";.

Memphis Light 24 point

ABCDEFGHIJKLMNOPQRSTUVWXYZ
abcdefghijklmnopqrstuvwxyz 1234567890 !?%&*

Memphis Light 30 point

ABCDEFGHIJKLMNOPQRSTUVWXYZ
abcdefghijklmnopqrstuvwxyz 12345678

Memphis Light 36 point

ABCDEFGHIJKLMNOPQRSTUVWX
abcdefghijklmnopqrstuvwxyz 1234

Memphis Light 48 point

ABCDEFGHIJKLMNOPQR
abcdefghijklmnopqrst 123

Memphis Light 60 point

ABCDEFGHIJKLMNO
abcdefghijklmnopq 12

6/8 Memphis Light

It was the best of times, it was the worst of times, it was the age of wisdom, it was the age of foolishness, it was the epoch of belief, it was the epoch of incredulity, it was the season of light, it was the season of darkness, it was the spring of hope, it was the winter of despair, we had everything before us, we had nothing before us, we were all going direct to Heaven, we were all going direct the other way-in short, the period was so far like the present period, that some of its noisiest authorities insisted on its being

8/10 Memphis Light

It was the best of times, it was the worst of times, it was the age of wisdom, it was the age of foolishness, it was the epoch of belief, it was the epoch of incredulity, it was the season of light, it was the season of darkness, it was the spring of hope, it was the winter of despair, we had everything before us, we had nothing before us, we were all going direct to Heaven, we were all going direct the other

9/10 Memphis Light

It was the best of times, it was the worst of times, it was the age of wisdom, it was the age of foolishness, it was the epoch of belief, it was the epoch of incredulity, it was the season of light, it was the season of darkness, it was the spring of hope, it was the winter of despair, we had everything before us, we had nothing before us, we were all going

9/11 Memphis Light

It was the best of times, it was the worst of times, it was the age of wisdom, it was the age of foolishness, it was the epoch of belief, it was the epoch of incredulity, it was the season of light, it was the season of darkness, it was the spring of hope, it was the winter of despair, we had everything before us, we had nothing before us, we were all going

10/11 Memphis Light

It was the best of times, it was the worst of times, it was the age of wisdom, it was the age of foolishness, it was the epoch of belief, it was the epoch of incredulity, it was the season of light, it was the season of darkness, it was the spring of hope, it was the winter of despair, we had everything before us, we had

10/12 Memphis Light

It was the best of times, it was the worst of times, it was the age of wisdom, it was the age of foolishness, it was the epoch of belief, it was the epoch of incredulity, it was the season of light, it was the season of darkness, it was the spring of hope, it was the winter of despair, we had everything before us, we had

11/13 Memphis Light

It was the best of times, it was the worst of times, it was the age of wisdom, it was the age of foolishness, it was the epoch of belief, it was the epoch of incredulity, it was the season of light, it was the season of darkness, it was the spring of hope, it was the winter of despair, we had everything before us, we

11/14 Memphis Light

It was the best of times, it was the worst of times, it was the age of wisdom, it was the age of foolishness, it was the epoch of belief, it was the epoch of incredulity, it was the season of light, it was the season of darkness, it was the spring of hope, it was the winter of despair, we had everything before us, we

12/13 Memphis Light

It was the best of times, it was the worst of times, it was the age of wisdom, it was the age of foolishness, it was the epoch of belief, it was the epoch of incredulity, it was the season of light, it was the season of darkness, it was the spring of hope, it was the winter of

12/14 Memphis Light

It was the best of times, it was the worst of times, it was the age of wisdom, it was the age of foolishness, it was the epoch of belief, it was the epoch of incredulity, it was the season of light, it was the season of darkness, it was the spring of hope, it was the winter of

13/15 Memphis Light

It was the best of times, it was the worst of times, it was the age of wisdom, it was the age of foolishness, it was the epoch of belief, it was the epoch of incredulity, it was the season of light, it was the season of darkness, it was the spring of

14/15 Memphis Light

It was the best of times, it was the worst of times, it was the age of wisdom, it was the age of foolishness, it was the epoch of belief, it was the epoch of incredulity, it was the season of light, it was the season of darkness, it was the

14/16 Memphis Light

It was the best of times, it was the worst of times, it was the age of wisdom, it was the age of foolishness, it was the epoch of belief, it was the epoch of incredulity, it was the season of light, it was the season of darkness, it was the

Memphis Medium 72 point

ABCDEFGHIJKL
MNOPQRSTUV
WXYZ abcdefg
hijklmnopqrstu
vwxyz 1234567
890?!/&$%#@*""";

Memphis Medium 24 point

ABCDEFGHIJKLMNOPQRSTUVWXYZ
abcdefghijklmnopqrstuvwxyz 1234567890 !?%&*

Memphis Medium 30 point

ABCDEFGHIJKLMNOPQRSTUVWXYZ
abcdefghijklmnopqrstuvwxyz 1234567

Memphis Medium 36 point

ABCDEFGHIJKLMNOPQRSTUVWX
abcdefghijklmnopqrstuvwxyz 12345

Memphis Medium 48 point

ABCDEFGHIJKLMNOPQRS
abcdefghijklmnopqrstuv 12

Memphis Medium 60 point

ABCDEFGHIJKLMNO
abcdefghijklmnopq 12

6/8 Memphis Medium

It was the best of times, it was the worst of times, it was the age of wisdom, it was the age of foolishness, it was the epoch of belief, it was the epoch of incredulity, it was the season of light, it was the season of darkness, it was the spring of hope, it was the winter of despair, we had everything before us, we had nothing before us, we were all going direct to Heaven, we were all going direct the other way-in short, the period was so far like the present period, that some of its noisiest authorities insisted on its

8/10 Memphis Medium

It was the best of times, it was the worst of times, it was the age of wisdom, it was the age of foolishness, it was the epoch of belief, it was the epoch of incredulity, it was the season of light, it was the season of darkness, it was the spring of hope, it was the winter of despair, we had everything before us, we had nothing before us, we were all going direct to Heaven, we were all

9/10 Memphis Medium

It was the best of times, it was the worst of times, it was the age of wisdom, it was the age of foolishness, it was the epoch of belief, it was the epoch of incredulity, it was the season of light, it was the season of darkness, it was the spring of hope, it was the winter of despair, we had everything before us, we had nothing before us, we

9/11 Memphis Medium

It was the best of times, it was the worst of times, it was the age of wisdom, it was the age of foolishness, it was the epoch of belief, it was the epoch of incredulity, it was the season of light, it was the season of darkness, it was the spring of hope, it was the winter of despair, we had everything before us, we had nothing before us, we

10/11 Memphis Medium

It was the best of times, it was the worst of times, it was the age of wisdom, it was the age of foolishness, it was the epoch of belief, it was the epoch of incredulity, it was the season of light, it was the season of darkness, it was the spring of hope, it was the winter of despair, we had everything before us, we

10/12 Memphis Medium

It was the best of times, it was the worst of times, it was the age of wisdom, it was the age of foolishness, it was the epoch of belief, it was the epoch of incredulity, it was the season of light, it was the season of darkness, it was the spring of hope, it was the winter of despair, we had everything before us, we

11/13 Memphis Medium

It was the best of times, it was the worst of times, it was the age of wisdom, it was the age of foolishness, it was the epoch of belief, it was the epoch of incredulity, it was the season of light, it was the season of darkness, it was the spring of hope, it was the winter of despair, we had everything before us, we had

11/14 Memphis Medium

It was the best of times, it was the worst of times, it was the age of wisdom, it was the age of foolishness, it was the epoch of belief, it was the epoch of incredulity, it was the season of light, it was the season of darkness, it was the spring of hope, it was the winter of despair, we had everything before us, we had

12/13 Memphis Medium

It was the best of times, it was the worst of times, it was the age of wisdom, it was the age of foolishness, it was the epoch of belief, it was the epoch of incredulity, it was the season of light, it was the season of darkness, it was the spring of hope, it was the winter of despair,

12/14 Memphis Medium

It was the best of times, it was the worst of times, it was the age of wisdom, it was the age of foolishness, it was the epoch of belief, it was the epoch of incredulity, it was the season of light, it was the season of darkness, it was the spring of hope, it was the winter of despair,

13/15 Memphis Medium

It was the best of times, it was the worst of times, it was the age of wisdom, it was the age of foolishness, it was the epoch of belief, it was the epoch of incredulity, it was the season of light, it was the season of darkness, it was the

14/15 Memphis Medium

It was the best of times, it was the worst of times, it was the age of wisdom, it was the age of foolishness, it was the epoch of belief, it was the epoch of incredulity, it was the season of light, it was the season of

14/16 Memphis Medium

It was the best of times, it was the worst of times, it was the age of wisdom, it was the age of foolishness, it was the epoch of belief, it was the epoch of incredulity, it was the season of light, it was the season of

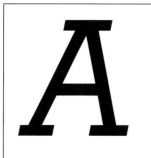

Memphis Medium Italic 72 point

ABCDEFGHIJKL

MNOPQRSTUV

WXYZ abcdefgh

ijklmnopqrstuv

wxyz 1234567

890?!/&$$%#@'""";*

Memphis Medium Italic 24 point

ABCDEFGHIJKLMNOPQRSTUVWXYZ
abcdefghijklmnopqrstuvwxyz 1234567890 !?%&*

Memphis Medium Italic 30 point

ABCDEFGHIJKLMNOPQRSTUVWXYZ
abcdefghijklmnopqrstuvwxyz 1234567

Memphis Medium Italic 36 point

ABCDEFGHIJKLMNOPQRSTUVW
abcdefghijklmnopqrstuvwxyz 12345

Memphis Medium Italic 48 point

ABCDEFGHIJKLMNOPQR
abcdefghijklmnopqrstuv 12

Memphis Medium Italic 60 point

ABCDEFGHIJKLMNO
abcdefghijklmnop 123

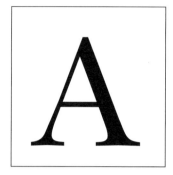

ITC New Baskerville Roman 72 point

ABCDEFGHIJKL
MNOPQRSTUV
WXYZabcdefghi
jklmnopqrstuvw
xyz 1234567890
?!/&$%#@*""..:;.,

ITC New Baskerville Roman 10 point

ABCDEFGHIJKLMNOPQRSTUVWXYZ abcdefghij
klmnopqrstuvwxyz 1234567890 ?!/&$%#@*""":;.,

ITC New Baskerville Roman 12 point

ABCDEFGHIJKLMNOPQRSTUVWXYZ abcdefghij
klmnopqrstuvwxyz 1234567890 ?!/&$%#@*""":;.,

ITC New Baskerville Roman 13 point

ABCDEFGHIJKLMNOPQRSTUVWXYZ abcdefghij
klmnopqrstuvwxyz 1234567890 ?!/&$%#@*""":;.,

ITC New Baskerville Roman 14 point

ABCDEFGHIJKLMNOPQRSTUVWXYZ abcdefghij
klmnopqrstuvwxyz 1234567890 ?!/&$%#@*""":;.,

ITC New Baskerville Roman 16 point

ABCDEFGHIJKLMNOPQRSTUVWXYZ abcdefghij
klmnopqrstuvwxyz 1234567890 ?!/&$%#@*""":;.,

ITC New Baskerville Roman 18 point

ABCDEFGHIJKLMNOPQRSTUVWXYZ abcdefghij
klmnopqrstuvwxyz 1234567890 ?!/&$%#@*""":;.,

ITC New Baskerville Roman 20 point

ABCDEFGHIJKLMNOPQRSTUVWXYZ abcdefghij
klmnopqrstuvwxyz 1234567890 ?!/&$%#@*""":;.,

ITC New Baskerville Roman 22 point

ABCDEFGHIJKLMNOPQRSTUVWXYZ abcdefghij
klmnopqrstuvwxyz 1234567890 ?!/&$%#@*""":;.,

ITC New Baskerville Roman 24 point

ABCDEFGHIJKLMNOPQRSTUVWXYZ
abcdefghijklmnopqrstuvwxyz1234567890 !?%&*

ITC New Baskerville Roman 30 point

ABCDEFGHIJKLMNOPQRSTUVWXYZ
abcdefghijklmnopqrstuvwxyz 1234567890

ITC New Baskerville Roman 36 point

ABCDEFGHIJKLMNOPQRSTUVW
abcdefghijklmnopqrstuvwxyz 1234

ITC New Baskerville Roman 48 point

ABCDEFGHIJKLMNOPQR
abcdefghijklmnopqrst 123

ITC New Baskerville Roman 60 point

ABCDEFGHIJKLMN
abcdefghijklmno123

6/8 ITC New Baskerville Roman

It was the best of times, it was the worst of times, it was the age of wisdom, it was the age of foolishness, it was the epoch of belief, it was the epoch of incredulity, it was the season of light, it was the season of darkness, it was the spring of hope, it was the winter of despair, we had everything before us, we had nothing before us, we were all going direct to Heaven, we were all going direct the other way-in short, the period was so far like the present period, that some of its noisiest authorities insisted on its being received, for good or for evil, in the

8/10 ITC New Baskerville Roman

It was the best of times, it was the worst of times, it was the age of wisdom, it was the age of foolishness, it was the epoch of belief, it was the epoch of incredulity, it was the season of light, it was the season of darkness, it was the spring of hope, it was the winter of despair, we had everything before us, we had nothing before us, we were all going direct to Heaven, we were all going direct the other way-in short, the period

9/10 ITC New Baskerville Roman

It was the best of times, it was the worst of times, it was the age of wisdom, it was the age of foolishness, it was the epoch of belief, it was the epoch of incredulity, it was the season of light, it was the season of darkness, it was the spring of hope, it was the winter of despair, we had everything before us, we had nothing before us, we were all going direct to Heaven, we were

9/11 ITC New Baskerville Roman

It was the best of times, it was the worst of times, it was the age of wisdom, it was the age of foolishness, it was the epoch of belief, it was the epoch of incredulity, it was the season of light, it was the season of darkness, it was the spring of hope, it was the winter of despair, we had everything before us, we had nothing before us, we were all going direct to Heaven, we were

10/11 ITC New Baskerville Roman

It was the best of times, it was the worst of times, it was the age of wisdom, it was the age of foolishness, it was the epoch of belief, it was the epoch of incredulity, it was the season of light, it was the season of darkness, it was the spring of hope, it was the winter of despair, we had everything before us, we had nothing before us, we

10/12 ITC New Baskerville Roman

It was the best of times, it was the worst of times, it was the age of wisdom, it was the age of foolishness, it was the epoch of belief, it was the epoch of incredulity, it was the season of light, it was the season of darkness, it was the spring of hope, it was the winter of despair, we had everything before us, we had nothing before us, we

11/13 ITC New Baskerville Roman

It was the best of times, it was the worst of times, it was the age of wisdom, it was the age of foolishness, it was the epoch of belief, it was the epoch of incredulity, it was the season of light, it was the season of darkness, it was the spring of hope, it was the winter of despair, we had everything before us, we

11/14 ITC New Baskerville Roman

It was the best of times, it was the worst of times, it was the age of wisdom, it was the age of foolishness, it was the epoch of belief, it was the epoch of incredulity, it was the season of light, it was the season of darkness, it was the spring of hope, it was the winter of despair, we had everything before us, we

12/13 ITC New Baskerville Roman

It was the best of times, it was the worst of times, it was the age of wisdom, it was the age of foolishness, it was the epoch of belief, it was the epoch of incredulity, it was the season of light, it was the season of darkness, it was the spring of hope, it was the winter of despair, we had everything before us, we

12/14 ITC New Baskerville Roman

It was the best of times, it was the worst of times, it was the age of wisdom, it was the age of foolishness, it was the epoch of belief, it was the epoch of incredulity, it was the season of light, it was the season of darkness, it was the spring of hope, it was the winter of despair, we had everything before us, we

13/15 ITC New Baskerville Roman

It was the best of times, it was the worst of times, it was the age of wisdom, it was the age of foolishness, it was the epoch of belief, it was the epoch of incredulity, it was the season of light, it was the season of darkness, it was the spring of hope, it was the winter of despair, we had everything before us, we

14/15 ITC New Baskerville Roman

It was the best of times, it was the worst of times, it was the age of wisdom, it was the age of foolishness, it was the epoch of belief, it was the epoch of incredulity, it was the season of light, it was the season of darkness, it was the spring of

14/16 ITC New Baskerville Roman

It was the best of times, it was the worst of times, it was the age of wisdom, it was the age of foolishness, it was the epoch of belief, it was the epoch of incredulity, it was the season of light, it was the season of darkness, it was the spring of

ITC New Baskerville Italic 72 point

ABCDEFGHIJKL
MNOPQRSTUV
WXYZ abcdefgh
ijklmnopqrstuvw
xyz 1234567890
?!&$%#@""";.,,*

ITC New Baskerville Italic 10 point

ABCDEFGHIJKLMNOPQRSTUVWXYZ abcdefghij klmnopqrstuvwxyz 1234567890 ?!/&$%#@""：;.，*

ITC New Baskerville Italic 12 point

ABCDEFGHIJKLMNOPQRSTUVWXYZ abcdefghij klmnopqrstuvwxyz 1234567890 ?!/&$%#@""：;.，*

ITC New Baskerville Italic 13 point

ABCDEFGHIJKLMNOPQRSTUVWXYZ abcdefghij klmnopqrstuvwxyz 1234567890 ?!/&$%#@""：;.，*

ITC New Baskerville Italic 14 point

ABCDEFGHIJKLMNOPQRSTUVWXYZ abcdefghij klmnopqrstuvwxyz 1234567890 ?!/&$%#@""：;.，*

ITC New Baskerville Italic 16 point

ABCDEFGHIJKLMNOPQRSTUVWXYZ abcdefghij klmnopqrstuvwxyz 1234567890 ?!/&$%#@""：;.，*

ITC New Baskerville Italic 18 point

ABCDEFGHIJKLMNOPQRSTUVWXYZ abcdefghij klm nopqrstuvwxyz 1234567890 ?!/&$%#@""：;.，*

ITC New Baskerville Italic 20 point

ABCDEFGHIJKLMNOPQRSTUVWXYZ abcdefghij klmnopqrstuvwxyz 1234567890 ?!/&$%#@""：;.，*

ITC New Baskerville Italic 22 point

ABCDEFGHIJKLMNOPQRSTUVWXYZ abcdefghij klmnopqrstuvwxyz 1234567890 ?!/&$%#@""：;.，*

ITC New Baskerville Italic 24 point

ABCDEFGHIJKLMNOPQRSTUVWXYZ
*abcdefghijklmnopqrstuvwxyz 1234567890 !?%&**

ITC New Baskerville Italic 30 point

ABCDEFGHIJKLMNOPQRSTUVWXYZ
abcdefghijklmnopqrstuvwxy 1234567890

ITC New Baskerville Italic 36 point

ABCDEFGHIJKLMNOPQRSTUVWX
abcdefghijklmnopqrstuvwxyz 123456789

ITC New Baskerville Italic 48 point

ABCDEFGHIJKLMNOPQR
abcdefghijklmnopqrstuv 1234

ITC New Baskerville Italic 60 point

ABCDEFGHIJKLMNO
abcdefghijklmnopq 123

6/8 ITC New Baskerville Italic

It was the best of times, it was the worst of times, it was the age of wisdom, it was the age of foolishness, it was the epoch of belief, it was the epoch of incredulity, it was the season of light, it was the season of darkness, it was the spring of hope, it was the winter of despair, we had everything before us, we had nothing before us, we were all going direct to Heaven, we were all going direct the other way-in short, the period was so far like the present period, that some of its noisiest authorities insisted on its being received, for good or for evil, in the superlative degree of comparison only.

8/10 ITC New Baskerville Italic

It was the best of times, it was the worst of times, it was the age of wisdom, it was the age of foolishness, it was the epoch of belief, it was the epoch of incredulity, it was the season of light, it was the season of darkness, it was the spring of hope, it was the winter of despair, we had everything before us, we had nothing before us, we were all going direct to Heaven, we were all going direct the other way-in short, the period was so far like the present period, that some of

9/10 ITC New Baskerville Italic

It was the best of times, it was the worst of times, it was the age of wisdom, it was the age of foolishness, it was the epoch of belief, it was the epoch of incredulity, it was the season of light, it was the season of darkness, it was the spring of hope, it was the winter of despair, we had everything before us, we had nothing before us, we were all going direct to Heaven, we were all going direct the other way-in short, the period was

9/11 ITC New Baskerville Italic

It was the best of times, it was the worst of times, it was the age of wisdom, it was the age of foolishness, it was the epoch of belief, it was the epoch of incredulity, it was the season of light, it was the season of darkness, it was the spring of hope, it was the winter of despair, we had everything before us, we had nothing before us, we were all going direct to Heaven, we were all going direct the other way-in short, the period was

10/11 ITC New Baskerville Roman Italic

It was the best of times, it was the worst of times, it was the age of wisdom, it was the age of foolishness, it was the epoch of belief, it was the epoch of incredulity, it was the season of light, it was the season of darkness, it was the spring of hope, it was the winter of despair, we had everything before us, we had nothing before us, we were all going direct to Heaven, we were all going direct the other way-

10/12 ITC New Baskerville Roman Italic

It was the best of times, it was the worst of times, it was the age of wisdom, it was the age of foolishness, it was the epoch of belief, it was the epoch of incredulity, it was the season of light, it was the season of darkness, it was the spring of hope, it was the winter of despair, we had everything before us, we had nothing before us, we were all going direct to Heaven, we were all going direct the other way-

11/13 ITC New Baskerville Roman Italic

It was the best of times, it was the worst of times, it was the age of wisdom, it was the age of foolishness, it was the epoch of belief, it was the epoch of incredulity, it was the season of light, it was the season of darkness, it was the spring of hope, it was the winter of despair, we had everything before us, we had nothing before us, we were all going

11/14 ITC New Baskerville Roman Italic

It was the best of times, it was the worst of times, it was the age of wisdom, it was the age of foolishness, it was the epoch of belief, it was the epoch of incredulity, it was the season of light, it was the season of darkness, it was the spring of hope, it was the winter of despair, we had everything before us, we had nothing before us, we were all going

12/13 ITC New Baskerville Roman Italic

It was the best of times, it was the worst of times, it was the age of wisdom, it was the age of foolishness, it was the epoch of belief, it was the epoch of incredulity, it was the season of light, it was the season of darkness, it was the spring of hope, it was the winter of despair, we had everything before us, we had nothing

12/14 ITC New Baskerville Roman Italic

It was the best of times, it was the worst of times, it was the age of wisdom, it was the age of foolishness, it was the epoch of belief, it was the epoch of incredulity, it was the season of light, it was the season of darkness, it was the spring of hope, it was the winter of despair, we had everything before us, we had nothing

13/15 ITC New Baskerville Roman Italic

It was the best of times, it was the worst of times, it was the age of wisdom, it was the age of foolishness, it was the epoch of belief, it was the epoch of incredulity, it was the season of light, it was the season of darkness, it was the spring of hope, it was the winter of despair, we had everything before

14/15 ITC New Baskerville Roman Italic

It was the best of times, it was the worst of times, it was the age of wisdom, it was the age of foolishness, it was the epoch of belief, it was the epoch of incredulity, it was the season of light, it was the season of darkness, it was the spring of hope, it was the winter of despair, we had everything before us, we

14/16 ITC New Baskerville Roman Italic

It was the best of times, it was the worst of times, it was the age of wisdom, it was the age of foolishness, it was the epoch of belief, it was the epoch of incredulity, it was the season of light, it was the season of darkness, it was the spring of hope, it was the winter of despair, we had everything before us, we

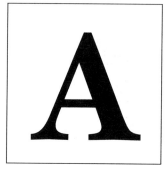

ITC New Baskerville Bold 72 point

ABCDEFGHIJKL MNOPQRSTUV WXYZ abcdefgh ijklmnopqrstuvw xyz 1234567890 ?!/&$%#@*""".;•,

ITC New Baskerville Bold 10 point

ABCDEFGHIJKLMNOPQRSTUVWXYZ abcdefghij
klmnopqrstuvwxyz 1234567890 ?!/&$%#@*""":;.,

ITC New Baskerville Bold 12 point

ABCDEFGHIJKLMNOPQRSTUVWXYZ abcdefghij
klmnopqrstuvwxyz 1234567890 ?!/&$%#@*""":;.,

ITC New Baskerville Bold 13 point

ABCDEFGHIJKLMNOPQRSTUVWXYZ abcdefghij
klmnopqrstuvwxyz 1234567890 ?!/&$%#@*""":;.,

ITC New Baskerville Bold 14 point

ABCDEFGHIJKLMNOPQRSTUVWXYZ abcdefghij
klmnopqrstuvwxyz 1234567890 ?!/&$%#@*""":;.,

ITC New Baskerville Bold 16 point

ABCDEFGHIJKLMNOPQRSTUVWXYZ abcdefghij
klmnopqrstuvwxyz 1234567890 ?!/&$%#@*""":;.,

ITC New Baskerville Bold 18 point

ABCDEFGHIJKLMNOPQRSTUVWXYZ abcdefghij
klmnopqrstuvwxyz 1234567890 ?!/&$%#@*""":;.,

ITC New Baskerville Bold 20 point

ABCDEFGHIJKLMNOPQRSTUVWXYZ abcdefghij
klmnopqrstuvwxyz 1234567890 ?!/&$%#@*""":;.,

ITC New Baskerville Bold 22 point

ABCDEFGHIJKLMNOPQRSTUVWXYZ abcdefghij
klmnopqrstuvwxyz 1234567890 ?!/&$%#@*""":;.,

ITC New Baskerville Bold 24 point

ABCDEFGHIJKLMNOPQRSTUVWXYZ
abcdefghijklmnopqrstuvwxyz 1234567890 !?%&

ITC New Baskerville Bold 30 point

ABCDEFGHIJKLMNOPQRSTUVWXYZ
abcdefghijklmnopqrstuvwxyz 1234567890

ITC New Baskerville Bold 36 point

ABCDEFGHIJKLMNOPQRSTUV
abcdefghijklmnopqrstuvwxz 12345

ITC New Baskerville Bold 48 point

ABCDEFGHIJKLMNOPQ
abcdefghijklmnopqrs 1234

ITC New Baskerville Bold 60 point

ABCDEFGHIJKLMN
abcdefghijklmno 123

ITC New Baskerville Bold Italic 72 point

ABCDEFGHIJKL
MNOPQRSTUV
WXYZ abcdefghijk
lmnopqrstuvwxyz
1234567890
?!/&$%#@""·,.,*

ITC New Baskerville Bold Italic 10 point

ABCDEFGHIJKLMNOPQRSTUVWXYZ abcdefghij
klmnopqrstuvwxy z 1234567890 ?!/&$%#@""*:;.,

ITC New Baskerville Bold Italic 12 point

ABCDEFGHIJKLMNOPQRSTUVWXYZ abcdefghij
klmnopqrstuvwxyz 1234567890 ?!/&$%#@""*:;.,

ITC New Baskerville Bold Italic 13 point

ABCDEFGHIJKLMNOPQRSTUVWXYZ abcdefghij
klmnopqrs tuv wxyz 1234567890 ?!/&$%#@""*:;.,

ITC New Baskerville Bold Italic 14 point

ABCDEFGHIJKLMNOPQRSTUVWXYZ abcdefghij
klmnopqrstuvwxyz 1234567890 ?!/&$%#@""*:;.,

ITC New Baskerville Bold Italic 16 point

ABCDEFGHIJKLMNOPQRSTUVWXYZ abcdefghij
klmnopqrstuvwxyz 1234567890 ?!/&$%#@""*:;.,

ITC New Baskerville Bold Italic 18 point

ABCDEFGHIJKLMNOPQRSTUVWXYZ abcdefghij
klmnopqrstuvwxyz 1234567890 ?!/&$%#@""*:;.,

ITC New Baskerville Bold Italic 20 point

ABCDEFGHIJKLMNOPQRSTUVWXYZ abcdefghij
klmnopqrs tuvwxyz 1234567890 ?!/&$%#@""*:;.,

ITC New Baskerville Bold Italic 22 point

ABCDEFGHIJKLMNOPQRSTUVWXY Z abcdefghij
klmnopqrs tuvwxyz 1234567890 ?!/&$%#@""*:;.,

ITC New Baskerville Bold Italic 24 point

ABCDEFGHIJKLMNOPQRSTUVWXYZ
abcdefghijklmnopqrstuvwxyz 1234567890 !?%&

ITC New Baskerville Bold Italic 30 point

ABCDEFGHIJKLMNOPQRSTUVWXYZ
abcdefghijklmnopqrstuvwxyz 123456789

ITC New Baskerville Bold Italic 36 point

ABCDEFGHIJKLMNOPQRSTUV
abcdefghijklmnopqrstuvwxyz 1234

ITC New Baskerville Bold Italic 48 point

ABCDEFGHIJKLMNOPQ
abcdefghijklmnopqrst 123

ITC New Baskerville Bold Italic 60 point

ABCDEFGHIJKLMN
abcdefghijklmnop 123

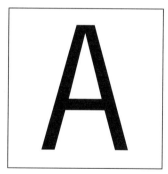

News Gothic 72 Point

ABCDEFGHIJKLM
NOPQRSTUVWXYZ
abcdefghijklmnop
qrstuvwxyz
1234567890
?!/&$%#@*""..
.,.,

News Gothic 10 point

ABCDEFGHIJKLMNOPQRSTUVWXYZ abcdefghij
klmnopqrstuvwxyz 1234567890 ?!/&$%#@*"":;.,

News Gothic 12 point

ABCDEFGHIJKLMNOPQRSTUVWXYZ abcdefghij
klmnopqrstuvwxyz 1234567890 ?!/&$%#@*"":;.,

News Gothic 13 point

ABCDEFGHIJKLMNOPQRSTUVWXYZ abcdefghij
klmnopqrstuvwxyz 1234567890 ?!/&$%#@*"":;.,

News Gothic 14 point

ABCDEFGHIJKLMNOPQRSTUVWXYZ abcdefghij
klmnopqrstuvwxyz 1234567890 ?!/&$%#@*"":;.,

News Gothic 16 point

ABCDEFGHIJKLMNOPQRSTUVWXYZ abcdefghij
klmnopqrstuvwxyz 1234567890 ?!/&$%#@*"":;.,

News Gothic 18 point

ABCDEFGHIJKLMNOPQRSTUVWXYZ abcdefghij
klmnopqrstuvwxyz 1234567890 ?!/&$%#@*"":;.,

News Gothic 20 point

ABCDEFGHIJKLMNOPQRSTUVWXYZ abcdefghij
klmnopqrstuvwxyz 1234567890 ?!/&$%#@*"":;.,

News Gothic 22 point

ABCDEFGHIJKLMNOPQRSTUVWXYZ abcdefghij
klmnopqrstuvwxyz 1234567890 ?!/&$%#@*"":;.,

News Gothic 24 point

ABCDEFGHIJKLMNOPQRSTUVWXYZ
abcdefghijklmnopqrstuvwxyz1234567890 !?%&*

News Gothic 30 point

ABCDEFGHIJKLMNOPQRSTUVWXYZ
abcdefghijklmnopqrstuvwxyz 1234567890

News Gothic 36 point

ABCDEFGHIJKLMNOPQRSTUVWXZ
abcdefghijklmnopqrstuvwxyz1234567

News Gothic 48 point

ABCDEFGHIJKLMNOPQRST
abcdefghijklmnopqrst123

News Gothic 60 point

ABCDEFGHIJKLMNO
abcdefghijklmnop 123

6/8 ITC News Gothic

It was the best of times, it was the worst of times, it was the age of wisdom, it was the age of foolishness, it was the epoch of belief, it was the epoch of incredulity, it was the season of light, it was the season of darkness, it was the spring of hope, it was the winter of despair, we had everything before us, we had nothing before us, we were all going direct to Heaven, we were all going direct the other way-in short, the period was so far like the present period, that some of its noisiest authorities insisted on its being received, for good or for evil, in the superlative

8/10 News Gothic

It was the best of times, it was the worst of times, it was the age of wisdom, it was the age of foolishness, it was the epoch of belief, it was the epoch of incredulity, it was the season of light, it was the season of darkness, it was the spring of hope, it was the winter of despair, we had everything before us, we had nothing before us, we were all going direct to Heaven, we were all going direct the other way-in short, the period was so far like the present period, that

9/10 ITC News Gothic

It was the best of times, it was the worst of times, it was the age of wisdom, it was the age of foolishness, it was the epoch of belief, it was the epoch of incredulity, it was the season of light, it was the season of darkness, it was the spring of hope, it was the winter of despair, we had everything before us, we had nothing before us, we were all going direct to Heaven, we were all

9/11 ITC News Gothic

It was the best of times, it was the worst of times, it was the age of wisdom, it was the age of foolishness, it was the epoch of belief, it was the epoch of incredulity, it was the season of light, it was the season of darkness, it was the spring of hope, it was the winter of despair, we had everything before us, we had nothing before us, we were all going direct to Heaven, we were all

10/11 News Gothic

It was the best of times, it was the worst of times, it was the age of wisdom, it was the age of foolishness, it was the epoch of belief, it was the epoch of incredulity, it was the season of light, it was the season of darkness, it was the spring of hope, it was the winter of despair, we had everything before us, we had nothing before us, we were all

10/12 News Gothic

It was the best of times, it was the worst of times, it was the age of wisdom, it was the age of foolishness, it was the epoch of belief, it was the epoch of incredulity, it was the season of light, it was the season of darkness, it was the spring of hope, it was the winter of despair, we had everything before us, we had nothing before us, we were all

11/13 News Gothic

It was the best of times, it was the worst of times, it was the age of wisdom, it was the age of foolishness, it was the epoch of belief, it was the epoch of incredulity, it was the season of light, it was the season of darkness, it was the spring of hope, it was the winter of despair, we had everything before us, we had

11/14 News Gothic

It was the best of times, it was the worst of times, it was the age of wisdom, it was the age of foolishness, it was the epoch of belief, it was the epoch of incredulity, it was the season of light, it was the season of darkness, it was the spring of hope, it was the winter of despair, we had everything before us, we had

12/13 News Gothic

It was the best of times, it was the worst of times, it was the age of wisdom, it was the age of foolishness, it was the epoch of belief, it was the epoch of incredulity, it was the season of light, it was the season of darkness, it was the spring of hope, it was the winter of despair, we had everything before us, we

12/14 News Gothic

It was the best of times, it was the worst of times, it was the age of wisdom, it was the age of foolishness, it was the epoch of belief, it was the epoch of incredulity, it was the season of light, it was the season of darkness, it was the spring of hope, it was the winter of despair, we had everything before us, we

13/15 News Gothic

It was the best of times, it was the worst of times, it was the age of wisdom, it was the age of foolishness, it was the epoch of belief, it was the epoch of incredulity, it was the season of light, it was the season of darkness, it was the spring of hope, it was

14/15 News Gothic

It was the best of times, it was the worst of times, it was the age of wisdom, it was the age of foolishness, it was the epoch of belief, it was the epoch of incredulity, it was the season of light, it was the season of darkness, it was the spring of hope, it was the winter

14/16 News Gothic

It was the best of times, it was the worst of times, it was the age of wisdom, it was the age of foolishness, it was the epoch of belief, it was the epoch of incredulity, it was the season of light, it was the season of darkness, it was the spring of hope, it was the winter

News Gothic Oblique 72 point

ABCDEFGHIJKL
MNOPQRSTUV
WXYZ abcdefgh
ijklmnopqrstuv
wxyz1234567890
?!&$%#@*""·,·,

News Gothic Oblique 10 point

ABCDEFGHIJKLMNOPQRSTUVWXYZ abcdefghij
klmnopqrstuvwxyz 1234567890 ?!/&$%#@*"";.,

News Gothic Oblique 12 point

ABCDEFGHIJKLMNOPQRSTUVWXYZ abcdefghij
klmnopqrstuvwxyz 1234567890 ?!/&$%#@*"";.,

News Gothic Oblique 13 point

ABCDEFGHIJKLMNOPQRSTUVWXYZ abcdefghij
klmnopqrstuvwxyz 1234567890 ?!/&$%#@*"";.,

News Gothic Oblique 14 point

ABCDEFGHIJKLMNOPQRSTUVWXYZ abcdefghij
klmnopqrstuvwxyz 1234567890 ?!/&$%#@*"";.,

News Gothic Oblique 16 point

ABCDEFGHIJKLMNOPQRSTUVWXYZ abcdefghij
klmnopqrstuvwxyz 1234567890 ?!/&$%#@*"";.,

News Gothic Oblique 18 point

ABCDEFGHIJKLMNOPQRSTUVWXYZ abcdefghij
klmnopqrstuvwxyz 1234567890 ?!/&$%#@*"";.,

News Gothic Oblique 20 point

ABCDEFGHIJKLMNOPQRSTUVWXYZ abcdefghij
klmnopqrstuvwxyz 1234567890 ?!/&$%#@*"";.,

News Gothic Oblique 22 point

ABCDEFGHIJKLMNOPQRSTUVWXYZ abcdefghij
klmnopqrstuvwxyz 1234567890 ?!/&$%#@*"";.,

News Gothic Oblique 24 point

ABCDEFGHIJKLMNOPQRSTUVWXYZ
abcdefghijklmnopqrstuvwxyz 1234567890 !?%&*

News Gothic Oblique 30 point

ABCDEFGHIJKLMNOPQRSTUVWXYZ
abcdefghijklmnopqrstuvwxy 1234567890

News Gothic Oblique 36 point

ABCDEFGHIJKLMNOPQRSTUVWXY
abcdefghijklmnopqrstuvwxyz 1234

News Gothic Oblique 48 point

ABCDEFGHIJKLMNOPQRSTU
abcdefghijklmnopqrstuv 12

News Gothic Oblique 60 point

ABCDEFGHIJKLMNOPQR
abcdefghijklmnopqrs 12

6/8 News Gothic Oblique

It was the best of times, it was the worst of times, it was the age of wisdom, it was the age of foolishness, it was the epoch of belief, it was the epoch of incredulity, it was the season of light, it was the season of darkness, it was the spring of hope, it was the winter of despair, we had everything before us, we had nothing before us, we were all going direct to Heaven, we were all going direct the other way-in short, the period was so far like the present period, that some of its noisiest authorities insisted on its being received, for good or for evil, in the superlative

8/10 News Gothic Oblique

It was the best of times, it was the worst of times, it was the age of wisdom, it was the age of foolishness, it was the epoch of belief, it was the epoch of incredulity, it was the season of light, it was the season of darkness, it was the spring of hope, it was the winter of despair, we had everything before us, we had nothing before us, we were all going direct to Heaven, we were all going direct the other way-in short, the period was so far

9/10 News Gothic Oblique

It was the best of times, it was the worst of times, it was the age of wisdom, it was the age of foolishness, it was the epoch of belief, it was the epoch of incredulity, it was the season of light, it was the season of darkness, it was the spring of hope, it was the winter of despair, we had everything before us, we had nothing before us, we were all going direct to Heaven, we were all

9/11 News Gothic Oblique

It was the best of times, it was the worst of times, it was the age of wisdom, it was the age of foolishness, it was the epoch of belief, it was the epoch of incredulity, it was the season of light, it was the season of darkness, it was the spring of hope, it was the winter of despair, we had everything before us, we had nothing before us, we were all going direct to Heaven, we were all

10/11 News Gothic Oblique

It was the best of times, it was the worst of times, it was the age of wisdom, it was the age of foolishness, it was the epoch of belief, it was the epoch of incredulity, it was the season of light, it was the season of darkness, it was the spring of hope, it was the winter of despair, we had everything before us, we had nothing before us, we were all going direct

10/12 News Gothic Oblique

It was the best of times, it was the worst of times, it was the age of wisdom, it was the age of foolishness, it was the epoch of belief, it was the epoch of incredulity, it was the season of light, it was the season of darkness, it was the spring of hope, it was the winter of despair, we had everything before us, we had nothing before us, we were all going direct

11/13 News Gothic Oblique

It was the best of times, it was the worst of times, it was the age of wisdom, it was the age of foolishness, it was the epoch of belief, it was the epoch of incredulity, it was the season of light, it was the season of darkness, it was the spring of hope, it was the winter of despair, we had everything before us, we had nothing before us,

11/14 News Gothic Oblique

It was the best of times, it was the worst of times, it was the age of wisdom, it was the age of foolishness, it was the epoch of belief, it was the epoch of incredulity, it was the season of light, it was the season of darkness, it was the spring of hope, it was the winter of despair, we had everything before us, we had nothing before us,

12/13 News Gothic Oblique

It was the best of times, it was the worst of times, it was the age of wisdom, it was the age of foolishness, it was the epoch of belief, it was the epoch of incredulity, it was the season of light, it was the season of darkness, it was the spring of hope, it was the winter of despair, we had everything before us, we

12/14 News Gothic Oblique

It was the best of times, it was the worst of times, it was the age of wisdom, it was the age of foolishness, it was the epoch of belief, it was the epoch of incredulity, it was the season of light, it was the season of darkness, it was the spring of hope, it was the winter of despair, we had everything before us, we

13/15 News Gothic Oblique

It was the best of times, it was the worst of times, it was the age of wisdom, it was the age of foolishness, it was the epoch of belief, it was the epoch of incredulity, it was the season of light, it was the season of darkness, it was the spring of hope, it was the winter of despair, we had everything before us, we

14/15 News Gothic Oblique

It was the best of times, it was the worst of times, it was the age of wisdom, it was the age of foolishness, it was the epoch of belief, it was the epoch of incredulity, it was the season of light, it was the season of darkness, it was the spring of hope, it was the winter

14/16 News Gothic Oblique

It was the best of times, it was the worst of times, it was the age of wisdom, it was the age of foolishness, it was the epoch of belief, it was the epoch of incredulity, it was the season of light, it was the season of darkness, it was the spring of hope, it was the winter

News Gothic Italic 72 point

ABCDEFGHIJKL
MNOPQRSTUVW
XYZ abcdefghijkl
mnopqrstuvwxyz
1234567890
?!/&$%#@*""..
.,;,

News Gothic Bold 10 point

ABCDEFGHIJKLMNOPQRSTUVWXYZ abcdefghij
klmnopqrstuvwxyz 1234567890 ?!/&$%#@*""":;.,

News Gothic Bold 12 point

ABCDEFGHIJKLMNOPQRSTUVWXYZ abcdefghij
klmnopqrstuvwxyz 1234567890 ?!/&$%#@*""":;.,

News Gothic Bold 13 point

ABCDEFGHIJKLMNOPQRSTUVWXYZ abcdefghij
klmnopqrstuvwxyz 1234567890 ?!/&$%#@*""":;.,

News Gothic Bold 14 point

ABCDEFGHIJKLMNOPQRSTUVWXYZ abcdefghij
klmnopqrstuvwxyz 1234567890 ?!/&$%#@*""":;.,

News Gothic Bold 16 point

ABCDEFGHIJKLMNOPQRSTUVWXYZ abcdefghij
klmnopqrstuvwxyz 1234567890 ?!/&$%#@*""":;.,

News Gothic Bold 18 point

ABCDEFGHIJKLMNOPQRSTUVWXYZ abcdefghij
klmnopqrstuvwxyz 1234567890 ?!/&$%#@*""":;.,

News Gothic Bold 20 point

ABCDEFGHIJKLMNOPQRSTUVWXYZ abcdefghij
klmnopqrstuvwxyz 1234567890 ?!/&$%#@*""":;.,

News Gothic Bold 22 point

ABCDEFGHIJKLMNOPQRSTUVWXYZ abcdefghij
klmnopqrstuvwxyz 1234567890 ?!/&$%#@*""":;.,

News Gothic Bold 24 point

ABCDEFGHIJKLMNOPQRSTUVWXYZ
abcdefghijklmnopqrstuvwxyz 1234567890 !?%&

News Gothic Bold 30 point

ABCDEFGHIJKLMNOPQRSTUVWXYZ
abcdefghijklmnopqrstuvwxyz 12345678

News Gothic Bold 36 point

ABCDEFGHIJKLMNOPQRSTUVWXZ
abcdefghijklmnopqrstuvwxy 123456

News Gothic Bold 48 point

ABCDEFGHIJKLMNOPQR
abcdefghijklmnopqrs 12

News Gothic Bold 60 point

ABCDEFGHIJKLMNO
abcdefghijklmnop 123

News Gothic Bold Oblique 72 point

ABCDEFGHIJKLM
NOPQRSTUVWX
YZ abcdefghijklm
nopqrstuvwxyz
1234567890
?!/&$%#@*""·;·,

News Gothic Bold Oblique 10 point

ABCDEFGHIJKLMNOPQRSTUVWXYZ abcdefghij
klmnopqrstuvwxyz 1234567890 ?!/&$%#@*""":;.,

News Gothic Bold Oblique 12 point

ABCDEFGHIJKLMNOPQRSTUVWXYZ abcdefghij
klmnopqrstuvwxyz 1234567890 ?!/&$%#@*""":;.,

News Gothic Bold Oblique 13 point

ABCDEFGHIJKLMNOPQRSTUVWXYZ abcdefghij
klmnopqrstuvwxyz 1234567890 ?!/&$%#@*""":;.,

News Gothic Bold Oblique 14 point

ABCDEFGHIJKLMNOPQRSTUVWXYZ abcdefghij
klmnopqrstuvwxyz 1234567890 ?!/&$%#@*""":;.,

News Gothic Bold Oblique 16 point

ABCDEFGHIJKLMNOPQRSTUVWXYZ abcdefghij
klmnopqrstuvwxyz 1234567890 ?!/&$%#@*""":;.,

News Gothic Bold Oblique 18 point

ABCDEFGHIJKLMNOPQRSTUVWXYZ abcdefghij
klmnopqrstuvwxyz 1234567890 ?!/&$%#@*""":;.,

News Gothic Bold Oblique 20 point

ABCDEFGHIJKLMNOPQRSTUVWXYZ abcdefghij
klmnopqrstuvwxyz 1234567890 ?!/&$%#@*""":;.,

News Gothic Bold Oblique 22 point

ABCDEFGHIJKLMNOPQRSTUVWXYZ abcdefghij
klmnopqrstuvwxyz 1234567890 ?!/&$%#@*""":;.,

News Gothic Bold Oblique 24 point

ABCDEFGHIJKLMNOPQRSTUVWXYZ
abcdefghijklmnopqrstuvwxyzb1234567890 !?%&

News Gothic Bold Oblique 30 point

ABCDEFGHIJKLMNOPQRSTUVWXYZ
abcdefghijklmnopqrstuvwxyz 123456

News Gothic Bold Oblique 36 point

ABCDEFGHIJKLMNOPQRSTUVWX
abcdefghijklmnopqrstuvwxy 123

News Gothic Bold Oblique 48 point

ABCDEFGHIJKLMNOPQR
abcdefghijklmnopqr 123

News Gothic Bold Oblique 60 point

ABCDEFGHIJKLMNO
abcdefghijklmnop12

OCR-A 72 point

ABCDEFGHIJK
LMNOPQRSTUV
WXYZabcdefg
hijklmnopqr
stuvwxyz123
567890!$%#:

OCR-A 10 point

ABCDEFGHIJKLMNOPQRSTUVWXYZ abcdefghij
klmnopqrstuvwxyz 1234567890 ?!/&$%#@*:;.¬

OCR-A 12 point

ABCDEFGHIJKLMNOPQRSTUVWXYZ abcdefghij
klmnopqrstuvwxyz 1234567890 ?!/&$%#@*:;.¬

OCR-A 13 point

ABCDEFGHIJKLMNOPQRSTUVWXYZ abcdefghij
klmnopqrstuvwxyz 1234567890 ?!/&$%#@*:;.¬

OCR-A 14 point

ABCDEFGHIJKLMNOPQRSTUVWXYZ abcdefghij
klmnopqrstuvwxyz 1234567890 ?!/&$%#@*:;.¬

OCR-A 16 point

ABCDEFGHIJKLMNOPQRSTUVWXYZ abcdefghij
klmnopqrstuvwxyz 1234567890 ?!/&$%#@*:;.¬

OCR-A 18 point

ABCDEFGHIJKLMNOPQRSTUVWXYZ abcdefghij
klmnopqrstuvwxyz 1234567890 ?!/&$%#@*:;.¬

OCR-A 20 point

ABCDEFGHIJKLMNOPQRSTUVWXYZ abcdefghij
klmnopqrstuvwxyz 1234567890 ?!/&$%#@*:;.¬

OCR-A 22 point

ABCDEFGHIJKLMNOPQRSTUVWXYZ abcdefghij
klmnopqrstuvwxyz1234567890 ?!/&$%#@*:;.¬

OCR-B 72 point

ABCDEFGHIJKL
MNOPQRSTUVW
XYZabcdefgh
ijklmnopqrs
tuvwxyz12345
67890?!/$%#@

OCR-B 10 point

ABCDEFGHIJKLMNOPQRSTUVWXYZ abcdefghij
klmnopqrstuvwxyz 1234567890 ?!/&$%#@*"":;.,

OCR-B 12 point

ABCDEFGHIJKLMNOPQRSTUVWXYZ abcdefghij
klmnopqrstuvwxyz 1234567890 ?!/&$%#@*"":;.,

OCR-B 13 point

ABCDEFGHIJKLMNOPQRSTUVWXYZ abcdefghij
klmnopqrstuvwxyz 1234567890 ?!/&$%#@*"":;.,

OCR-B 14 point

ABCDEFGHIJKLMNOPQRSTUVWXYZ abcdefghij
klmnopqrstuvwxyz 1234567890 ?!/&$%#@*"":;.,

OCR-B 16 point

ABCDEFGHIJKLMNOPQRSTUVWXYZ abcdefghij
klmnopqrstuvwxyz 1234567890 ?!/&$%#@*"":;.,

OCR-B 18 point

ABCDEFGHIJKLMNOPQRSTUVWXYZ abcdefghij
klmnopqrstuvwxyz 1234567890 ?!/&$%#@*"":;.,

OCR-B 20 point

ABCDEFGHIJKLMNOPQRSTUVWXYZ abcdefghij
klmnopqrstuvwxyz 1234567890 ?!/&$%#@*"":;.,

OCR-B 22 point

ABCDEFGHIJKLMNOPQRSTUVWXYZ abcdefghij
klmnopqrstuvwxyz1234567890 ?!/&$%#@*"":;.,

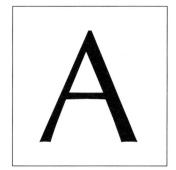

Optima 72 point

ABCDEFGHIJKL
MNOPQRSTUVW
XYZ abcdefghijkl
mnopqrstuvwxyz
1234567890
?!/&$%#@*""·:·,·,

Optima 24 point

ABCDEFGHIJKLMNOPQRSTUVWXYZ
abcdefghijklmnopqrstuvwxyz 1234567890 !?%&*

Optima 30 point

ABCDEFGHIJKLMNOPQRSTUVWXYZ
abcdefghijklmnopqrstuvwxyz1234567890

Optima 36 point

ABCDEFGHIJKLMNOPQRSTUVWXYZ
abcdefghijklmnopqrstuvwxyz 1234567

Optima 48 point

ABCDEFGHIJKLMNOPQRST
abcdefghijklmnopqrstuv 1234

Optima 60 point

ABCDEFGHIJKLMNOP
abcdefghijklmnopq 123

6/8 Optima

It was the best of times, it was the worst of times, it was the age of wisdom, it was the age of foolishness, it was the epoch of belief, it was the epoch of incredulity, it was the season of light, it was the season of darkness, it was the spring of hope, it was the winter of despair, we had everything before us, we had nothing before us, we were all going direct to Heaven, we were all going direct the other way-in short, the period was so far like the present period, that some of its noisiest authorities insisted on its being received, for good or for evil, in the

8/10 Optima

It was the best of times, it was the worst of times, it was the age of wisdom, it was the age of foolishness, it was the epoch of belief, it was the epoch of incredulity, it was the season of light, it was the season of darkness, it was the spring of hope, it was the winter of despair, we had everything before us, we had nothing before us, we were all going direct to Heaven, we were all going direct the other way-in short, the period

9/10 Optima

It was the best of times, it was the worst of times, it was the age of wisdom, it was the age of foolishness, it was the epoch of belief, it was the epoch of incredulity, it was the season of light, it was the season of darkness, it was the spring of hope, it was the winter of despair, we had everything before us, we had nothing before us, we were all going direct to Heaven, we were all going

9/11 Optima

It was the best of times, it was the worst of times, it was the age of wisdom, it was the age of foolishness, it was the epoch of belief, it was the epoch of incredulity, it was the season of light, it was the season of darkness, it was the spring of hope, it was the winter of despair, we had everything before us, we had nothing before us, we were all going direct to Heaven, we were all going

10/11 Optima

It was the best of times , it was the worst of times, it was the age of wisdom, it was the age of foolishness, it was the epoch of belief, it was the epoch of incredulity, it was the season of light, it was the season of darkness, it was the spring of hope, it was the winter of despair, we had everything before us, we had nothing before us, we

10/12 Optima

It was the best of times, it was the worst of times, it was the age of wisdom, it was the age of foolishness, it was the epoch of belief, it was the epoch of incredulity, it was the season of light, it was the season of darkness, it was the spring of hope, it was the winter of despair, we had everything before us, we had nothing before us, we

11/13 Optima

It was the best of times, it was the worst of times, it was the age of wisdom, it was the age of foolishness, it was the epoch of belief, it was the epoch of incredulity, it was the season of light, it was the season of darkness, it was the spring of hope, it was the winter of despair, we had everything before us, we had nothing before

11/14 Optima

It was the best of times , it was the worst of times, it was the age of wisdom, it was the age of foolishness, it was the epoch of belief, it was the epoch of incredulity, it was the season of light, it was the season of darkness, it was the spring of hope, it was the winter of despair, we had everything before us, we had nothing before

12/13 Optima

It was the best of times , it was the worst of times, it was the age of wisdom, it was the age of foolishness, it was the epoch of belief, it was the epoch of incredulity, it was the season of light, it was the season of darkness, it was the spring of hope, it was the winter of despair, we had everything before

12/14 Optima

It was the best of times , it was the worst of times, it was the age of wisdom, it was the age of foolishness, it was the epoch of belief, it was the epoch of incredulity, it was the season of light, it was the season of darkness, it was the spring of hope, it was the winter of despair, we had everything before

13/15 Optima

It was the best of times , it was the worst of times, it was the age of wisdom, it was the age of foolishness, it was the epoch of belief, it was the epoch of incredulity, it was the season of light, it was the season of darkness, it was the spring of hope, it was

14/15 Optima

It was the best of times , it was the worst of times, it was the age of wisdom, it was the age of foolishness, it was the epoch of belief, it was the epoch of incredulity, it was the season of light, it was the season of darkness, it was the winter of

14/16 Optima

It was the best of times , it was the worst of times, it was the age of wisdom, it was the age of foolishness, it was the epoch of belief, it was the epoch of incredulity, it was the season of light, it was the season of darkness, it was the winter of

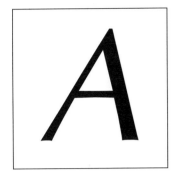

Optima Oblique 72 point

ABCDEFGHIJKL
MNOPQRSTUVW
XYZ abcdefghijkl
mnopqrstuvwxyz
1234567890
?!/&$%#@*""·;·,

Optima Oblique 24 point

ABCDEFGHIJKLMNOPQRSTUVWXYZ
abcdefghijklmnopqrstuvwxyz 1234567890 !?%&*

Optima Oblique 30 point

ABCDEFGHIJKLMNOPQRSTUVWXYZ
abcdefghijklmnopqrstuvwxyz 123456789

Optima Oblique 36 point

ABCDEFGHIJKLMNOPQRSTUVWXYZ
abcdefghijklmnopqrstuvwxy 1234567890

Optima Oblique 48 point

ABCDEFGHIJKLMNOPQRST
abcdefghijklmnopqrstuv 1234

Optima Oblique 60 point

ABCDEFGHIJKLMNO
abcdefghijklmnopqr 12

6/8 Optima Oblique

It was the best of times, it was the worst of times, it was the age of wisdom, it was the age of foolishness, it was the epoch of belief, it was the epoch of incredulity, it was the season of light, it was the season of darkness, it was the spring of hope, it was the winter of despair, we had everything before us, we had nothing before us, we were all going direct to Heaven, we were all going direct the other way-in short, the period was so far like the present period, that some of its noisiest authorities insisted on its being received, for good or for evil, in the

8/10 Optima Oblique

It was the best of times, it was the worst of times, it was the age of wisdom, it was the age of foolishness, it was the epoch of belief, it was the epoch of incredulity, it was the season of light, it was the season of darkness, it was the spring of hope, it was the winter of despair, we had everything before us, we had nothing before us, we were all going direct to Heaven, we were all going direct the other way-in short, the period

9/10 Optima Oblique

It was the best of times, it was the worst of times, it was the age of wisdom, it was the age of foolishness, it was the epoch of belief, it was the epoch of incredulity, it was the season of light, it was the season of darkness, it was the spring of hope, it was the winter of despair, we had everything before us, we had nothing before us, we were all going direct to Heaven, we were

9/11 Optima Oblique

It was the best of times, it was the worst of times, it was the age of wisdom, it was the age of foolishness, it was the epoch of belief, it was the epoch of incredulity, it was the season of light, it was the season of darkness, it was the spring of hope, it was the winter of despair, we had everything before us, we had nothing before us, we were all going direct to Heaven, we were

10/11 Optima Oblique

It was the best of times, it was the worst of times, it was the age of wisdom, it was the age of foolishness, it was the epoch of belief, it was the epoch of incredulity, it was the season of light, it was the season of darkness, it was the spring of hope, it was the winter of despair, we had everything before us, we had nothing before us, we

10/12 Optima Oblique

It was the best of times, it was the worst of times, it was the age of wisdom, it was the age of foolishness, it was the epoch of belief, it was the epoch of incredulity, it was the season of light, it was the season of darkness, it was the spring of hope, it was the winter of despair, we had everything before us, we had nothing before us, we

11/13 Optima Oblique

It was the best of times, it was the worst of times, it was the age of wisdom, it was the age of foolishness, it was the epoch of belief, it was the epoch of incredulity, it was the season of light, it was the season of darkness, it was the spring of hope, it was the winter of despair, we had everything before us, we had nothing before

11/14 Optima Oblique

It was the best of times, it was the worst of times, it was the age of wisdom, it was the age of foolishness, it was the epoch of belief, it was the epoch of incredulity, it was the season of light, it was the season of darkness, it was the spring of hope, it was the winter of despair, we had everything before us, we had nothing before

12/13 Optima Oblique

It was the best of times, it was the worst of times, it was the age of wisdom, it was the age of foolishness, it was the epoch of belief, it was the epoch of incredulity, it was the season of light, it was the season of darkness, it was the spring of hope, it was the winter of despair, we had everything before

12/14 Optima Oblique

It was the best of times, it was the worst of times, it was the age of wisdom, it was the age of foolishness, it was the epoch of belief, it was the epoch of incredulity, it was the season of light, it was the season of darkness, it was the spring of hope, it was the winter of despair, we had everything before

13/15 Optima Oblique

It was the best of times, it was the worst of times, it was the age of wisdom, it was the age of foolishness, it was the epoch of belief, it was the epoch of incredulity, it was the season of light, it was the season of darkness, it was the spring of hope, it was

14/15 Optima Oblique

It was the best of times, it was the worst of times, it was the age of wisdom, it was the age of foolishness, it was the epoch of belief, it was the epoch of incredulity, it was the season of light, it was the season of darkness, it was the spring of

14/16 Optima Oblique

It was the best of times, it was the worst of times, it was the age of wisdom, it was the age of foolishness, it was the epoch of belief, it was the epoch of incredulity, it was the season of light, it was the season of darkness, it was the spring of

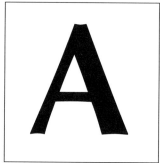

Optima Bold 72 point

ABCDEFGHIJKL
MNOPQRSTUV
WXYZ abcdefghij
klmnopqrstuvwx
yz 1234567890
?!/&$%#@*""";,;,

Optima Bold 24 point

ABCDEFGHIJKLMNOPQRSTUVWXYZ
abcdefghijklmnopqrstuvwxyz 1234567890 !?%&*

Optima Bold 30 point

ABCDEFGHIJKLMNOPQRSTUVWXYZ
abcdefghijklmnopqrstuvwxyz 12345678

Optima Bold 36 point

ABCDEFGHIJKLMNOPQRSTUVWX
abcdefghijklmnopqrstuvwxyz 1234

Optima Bold 48 point

ABCDEFGHIJKLMNOPQRST
abcdefghijklmnopqrstuv 123

Optima Bold 60 point

ABCDEFGHIJKLMNOP
abcdefghijklmnopq 123

6/8 Otima Bold

It was the best of times, it was the worst of times, it was the age of wisdom, it was the age of foolishness, it was the epoch of belief, it was the epoch of incredulity, it was the season of light, it was the season of darkness, it was the spring of hope, it was the winter of despair, we had everything before us, we had nothing before us, we were all going direct to Heaven, we were all going direct the other way-in short, the period was so far like the present period, that some of its noisiest authorities insisted on its being received, for good or for evil, in

8/10 Optima Bold

It was the best of times, it was the worst of times, it was the age of wisdom, it was the age of foolishness, it was the epoch of belief, it was the epoch of incredulity, it was the season of light, it was the season of darkness, it was the spring of hope, it was the winter of despair, we had everything before us, we had nothing before us, we were all going direct to Heaven, we were all going direct the other way-in

9/10 Optima Bold

It was the best of times, it was the worst of times, it was the age of wisdom, it was the age of foolishness, it was the epoch of belief, it was the epoch of incredulity, it was the season of light, it was the season of darkness, it was the spring of hope, it was the winter of despair, we had everything before us, we had nothing before us, we were all going direct to Heaven, we were all going direct the other way-in short, the period was so far like

9/11 Optima Bold

It was the best of times, it was the worst of times, it was the age of wisdom, it was the age of foolishness, it was the epoch of belief, it was the epoch of incredulity, it was the season of light, it was the season of darkness, it was the spring of hope, it was the winter of despair, we had everything before us, we had nothing before us, we were all going direct to Heaven,

10/11 Optima Bold

It was the best of times, it was the worst of times, it was the age of wisdom, it was the age of foolishness, it was the epoch of belief, it was the epoch of incredulity, it was the season of light, it was the season of darkness, it was the spring of hope, it was the winter of despair, we had everything before us, we had nothing before us,

10/12 Optima Bold

It was the best of times, it was the worst of times, it was the age of wisdom, it was the age of foolishness, it was the epoch of belief, it was the epoch of incredulity, it was the season of light, it was the season of darkness, it was the spring of hope, it was the winter of despair, we had everything before us, we had nothing before us,

11/13 Optima Bold

It was the best of times, it was the worst of times, it was the age of wisdom, it was the age of foolishness, it was the epoch of belief, it was the epoch of incredulity, it was the season of light, it was the season of darkness, it was the spring of hope, it was the winter of despair, we had everything before us, we had

11/14 Optima Bold

It was the best of times, it was the worst of times, it was the age of wisdom, it was the age of foolishness, it was the epoch of belief, it was the epoch of incredulity, it was the season of light, it was the season of darkness, it was the spring of hope, it was the winter of despair, we had everything before us, we had

12/13 Optima Bold

It was the best of times, it was the worst of times, it was the age of wisdom, it was the age of foolishness, it was the epoch of belief, it was the epoch of incredulity, it was the season of light, it was the season of darkness, it was the spring of hope, it was the winter of despair, we

12/14 Optima Bold

It was the best of times, it was the worst of times, it was the age of wisdom, it was the age of foolishness, it was the epoch of belief, it was the epoch of incredulity, it was the season of light, it was the season of darkness, it was the spring of hope, it was the winter of despair, we

13/15 Optima Bold

It was the best of times, it was the worst of times, it was the age of wisdom, it was the age of foolishness, it was the epoch of belief, it was the epoch of incredulity, it was the season of light, it was the season of darkness, it was the spring of hope, it was

14/15 Optima Bold

It was the best of times, it was the worst of times, it was the age of wisdom, it was the age of foolishness, it was the epoch of belief, it was the epoch of incredulity, it was the season of light, it was the season of darkness, it was the

14/16 Optima Bold

It was the best of times, it was the worst of times, it was the age of wisdom, it was the age of foolishness, it was the epoch of belief, it was the epoch of incredulity, it was the season of light, it was the season of darkness, it was the

Optima Oblique 72 point

ABCDEFGHIJKL
MNOPQRSTUVW
XYZ abcdefghijkl
mnopqrstuvwxyz
1234567890
?!/&$%#@*""";.,

Optima Bold Oblique 24 point

ABCDEFGHIJKLMNOPQRSTUVWXYZ
abcdefghijklmnopqrstuvwxyz 1234567890 !?%&*

Optima Bold Oblique 30 point

ABCDEFGHIJKLMNOPQRSTUVWXYZ
abcdefghijklmnopqrstuvwxyz 1234567

Optima Bold Oblique 36 point

ABCDEFGHIJKLMNOPQRSTUVW
abcdefghijklmnopqrstuvwxyz 1234

Optima Bold Oblique 48 point

ABCDEFGHIJKLMNOPQRS
abcdefghijklmnopqrstuv 123

Optima Bold Oblique 60 point

ABCDEFGHIJKLMNO
abcdefghijklmnopq 12

6/8 Otima Bold Oblique

It was the best of times, it was the worst of times, it was the age of wisdom, it was the age of foolishness, it was the epoch of belief, it was the epoch of incredulity, it was the season of light, it was the season of darkness, it was the spring of hope, it was the winter of despair, we had everything before us, we had nothing before us, we were all going direct to Heaven, we were all going direct the other way-in short, the period was so far like the present period, that some of its noisiest authorities insisted on its being received, for good or for evil, in

8/1 Optima Bold Oblique

It was the best of times, it was the worst of times, it was the age of wisdom, it was the age of foolishness, it was the epoch of belief, it was the epoch of incredulity, it was the season of light, it was the season of darkness, it was the spring of hope, it was the winter of despair, we had everything before us, we had nothing before us, we were all going direct to Heaven, we were all going direct the other way-

9/10 Optima Bold Oblique

It was the best of times, it was the worst of times, it was the age of wisdom, it was the age of foolishness, it was the epoch of belief, it was the epoch of incredulity, it was the season of light, it was the season of darkness, it was the spring of hope, it was the winter of despair, we had everything before us, we had nothing before us, we were all going direct to Heaven, we were all going direct the other way-in short, the period was so far like

9/11 Optima Bold Oblique

It was the best of times, it was the worst of times, it was the age of wisdom, it was the age of foolishness, it was the epoch of belief, it was the epoch of incredulity, it was the season of light, it was the season of darkness, it was the spring of hope, it was the winter of despair, we had everything before us, we had nothing before us, we were all going direct to Heaven,

10/11 Optima Bold Oblique

It was the best of times, it was the worst of times, it was the age of wisdom, it was the age of foolishness, it was the epoch of belief, it was the epoch of incredulity, it was the season of light, it was the season of darkness, it was the spring of hope, it was the winter of despair, we had everything before us, we had nothing before us,

10/12 Optima Bold Oblique

It was the best of times, it was the worst of times, it was the age of wisdom, it was the age of foolishness, it was the epoch of belief, it was the epoch of incredulity, it was the season of light, it was the season of darkness, it was the spring of hope, it was the winter of despair, we had everything before us, we had nothing before us,

11/13 Optima Bold Oblique

It was the best of times , it was the worst of times, it was the age of wisdom, it was the age of foolishness, it was the epoch of belief, it was the epoch of incredulity, it was the season of light, it was the season of darkness, it was the spring of hope, it was the winter of despair, we had everything before us, we had

11/14 Optima Bold Oblique

It was the best of times , it was the worst of times, it was the age of wisdom, it was the age of foolishness, it was the epoch of belief, it was the epoch of incredulity, it was the season of light, it was the season of darkness, it was the spring of hope, it was the winter of despair, we had everything before us, we had

12/13 Optima Bold Oblique

It was the best of times , it was the worst of times, it was the age of wisdom, it was the age of foolishness, it was the epoch of belief, it was the epoch of incredulity, it was the season of light, it was the season of darkness, it was the spring of hope, it was the winter of despair, we

12/14 Optima Bold Oblique

It was the best of times, it was the worst of times, it was the age of wisdom, it was the age of foolishness, it was the epoch of belief, it was the epoch of incredulity, it was the season of light, it was the season of darkness, it was the spring of hope, it was the winter of despair, we

13/15 Optima Bold Oblique

It was the best of times, it was the worst of times, it was the age of wisdom, it was the age of foolishness, it was the epoch of belief, it was the epoch of incredulity, it was the season of light, it was the season of darkness, it was the spring of hope, it was

14/15 Optima Bold Italic

It was the best of times, it was the worst of times, it was the age of wisdom, it was the age of foolishness, it was the epoch of belief, it was the epoch of incredulity, it was the season of light, it was the season of darkness, it was the

14/16 Optima Bold Oblique

It was the best of times, it was the worst of times, it was the age of wisdom, it was the age of foolishness, it was the epoch of belief, it was the epoch of incredulity, it was the season of light, it was the season of darkness, it was the

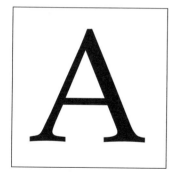

Palatino 72 point

ABCDEFGHIJKL
MNOPQRSTUV
WXYZ abcdefghij
klmnopqrstuvw
xyz 1234567890
?!/&$%#@*""".:.;.,

Palatino 24 point

ABCDEFGHIJKLMNOPQRSTUVWXYZ
abcdefghijklmnopqrstuvwxyz 1234567890 !?%&*

Palatino 30 point

ABCDEFGHIJKLMNOPQRSTUVWXYZ
abcdefghijklmnopqrstuvwxyz 123456789

Palatino 36 point

ABCDEFGHIJKLMNOPQRSTUVW
abcdefghijklmnopqrstuvwxyz 1234

Palatino 48 point

ABCDEFGHIJKLMNOPQ
abcdefghijklmnopqrstu 12

Palatino 60 point

ABCDEFGHIJKLMN
abcdefghijklmnop 12

6/8 Palatino

It was the best of times, it was the worst of times, it was the age of wisdom, it was the age of foolishness, it was the epoch of belief, it was the epoch of incredulity, it was the season of light, it was the season of darkness, it was the spring of hope, it was the winter of despair, we had everything before us, we had nothing before us, we were all going direct to Heaven, we were all going direct the other way-in short, the period was so far like the present period, that some of its noisiest authorities insisted on its being received, for good or for evil,

8/10 Palatino

It was the best of times, it was the worst of times, it was the age of wisdom, it was the age of foolishness, it was the epoch of belief, it was the epoch of incredulity, it was the season of light, it was the season of darkness, it was the spring of hope, it was the winter of despair, we had everything before us, we had nothing before us, we were all going direct to Heaven, we were all going direct the other way-in

9/10 Palatino

It was the best of times, it was the worst of times, it was the age of wisdom, it was the age of foolishness, it was the epoch of belief, it was the epoch of incredulity, it was the season of light, it was the season of darkness, it was the spring of hope, it was the winter of despair, we had everything before us, we had nothing before us, we were all going direct to Heaven,

9/11 Palatino

It was the best of times, it was the worst of times, it was the age of wisdom, it was the age of foolishness, it was the epoch of belief, it was the epoch of incredulity, it was the season of light, it was the season of darkness, it was the spring of hope, it was the winter of despair, we had everything before us, we had nothing before us, we were all going direct to Heaven,

10/11 Palatino

It was the best of times, it was the worst of times, it was the age of wisdom, it was the age of foolishness, it was the epoch of belief, it was the epoch of incredulity, it was the season of light, it was the season of darkness, it was the spring of hope, it was the winter of despair, we had everything before us, we had nothing before us,

10/12 Palatino

It was the best of times , it was the worst of times, it was the age of wisdom, it was the age of foolishness, it was the epoch of belief, it was the epoch of incredulity, it was the season of light, it was the season of darkness, it was the spring of hope, it was the winter of despair, we had everything before us, we had nothing before us,

11/13 Palatino

It was the best of times, it was the worst of times, it was the age of wisdom, it was the age of foolishness, it was the epoch of belief, it was the epoch of incredulity, it was the season of light, it was the season of darkness, it was the spring of hope, it was the winter of despair, we had everything before us, we had

11/14 Palatino

It was the best of times, it was the worst of times, it was the age of wisdom, it was the age of foolishness, it was the epoch of belief, it was the epoch of incredulity, it was the season of light, it was the season of darkness, it was the spring of hope, it was the winter of despair, we had everything before us, we had

12/13 Palatino

It was the best of times, it was the worst of times, it was the age of wisdom, it was the age of foolishness, it was the epoch of belief, it was the epoch of incredulity, it was the season of light, it was the season of darkness, it was the spring of hope, it was the winter of despair,

12/14 Palatino

It was the best of times, it was the worst of times, it was the age of wisdom, it was the age of foolishness, it was the epoch of belief, it was the epoch of incredulity, it was the season of light, it was the season of darkness, it was the spring of hope, it was the winter of despair,

13/15 Palatino

It was the best of times, it was the worst of times, it was the age of wisdom, it was the age of foolishness, it was the epoch of belief, it was the epoch of incredulity, it was the season of light, it was the season of darkness, it was the spring of hope, it was the winter of despair,

14/15 Palatino

It was the best of times, it was the worst of times, it was the age of wisdom, it was the age of foolishness, it was the epoch of belief, it was the epoch of incredulity, it was the season of light, it was the season of darkness, it was the

14/16 Palatino

It was the best of times, it was the worst of times, it was the age of wisdom, it was the age of foolishness, it was the epoch of belief, it was the epoch of incredulity, it was the season of light, it was the season of darkness, it was the

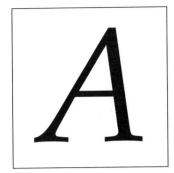

Palatino Italic 72 point

ABCDEFGHIJKL

MNOPQRSTUV

WXYZ abcdefghi

jklmnopqrstuvw

xyz 1234567890

?!/&$%#@""":;.,*

Palatino Italic 24 point

ABCDEFGHIJKLMNOPQRSTUVWXYZ
abcdefghijklmnopqrstuvwxyz 1234567890 !?%&*

Palatino Italic 30 point

ABCDEFGHIJKLMNOPQRSTUVWXYZ
abcdefghijklmnopqrstuvwxyz 1234567890

Palatino Italic 36 point

ABCDEFGHIJKLMNOPQRSTUVW
abcdefghijklmnopqrstuvwxyz 1234567

Palatino Italic 48 point

ABCDEFGHIJKLMNOPQR
abcdefghijklmnopqrstuv 123

Palatino Italic 60 point

ABCDEFGHIJKLMN
abcdefghijklmnopqrs 12

6/8 Palatino Italic

It was the best of times, it was the worst of times, it was the age of wisdom, it was the age of foolishness, it was the epoch of belief, it was the epoch of incredulity, it was the season of light, it was the season of darkness, it was the spring of hope, it was the winter of despair, we had everything before us, we had nothing before us, we were all going direct to Heaven, we were all going direct the other way-in short, the period was so far like the present period, that some of its noisiest authorities insisted on its being received, for good or for evil, in the superlative degree of comparison only.

8/10 Palatino Italic

It was the best of times, it was the worst of times, it was the age of wisdom, it was the age of foolishness, it was the epoch of belief, it was the epoch of incredulity, it was the season of light, it was the season of darkness, it was the spring of hope, it was the winter of despair, we had everything before us, we had nothing before us, we were all going direct to Heaven, we were all going direct the other way-in short, the period was so far like the present period

9/10 Palatino Italic

It was the best of times, it was the worst of times, it was the age of wisdom, it was the age of foolishness, it was the epoch of belief, it was the epoch of incredulity, it was the season of light, it was the season of darkness, it was the spring of hope, it was the winter of despair, we had everything before us, we had nothing before us, we were all going direct to Heaven, we were all going direct

9/11 Palatino Italic

It was the best of times, it was the worst of times, it was the age of wisdom, it was the age of foolishness, it was the epoch of belief, it was the epoch of incredulity, it was the season of light, it was the season of darkness, it was the spring of hope, it was the winter of despair, we had everything before us, we had nothing before us, we were all going direct to Heaven, we were all going direct

10/11 Palatino Italic

It was the best of times, it was the worst of times, it was the age of wisdom, it was the age of foolishness, it was the epoch of belief, it was the epoch of incredulity, it was the season of light, it was the season of darkness, it was the spring of hope, it was the winter of despair, we had everything before us, we had nothing before us, we were all going direct to Heaven,

10/12 Palatino Italic

It was the best of times, it was the worst of times, it was the age of wisdom, it was the age of foolishness, it was the epoch of belief, it was the epoch of incredulity, it was the season of light, it was the season of darkness, it was the spring of hope, it was the winter of despair, we had everything before us, we had nothing before us, we were all going direct to Heaven,

11/13 Palatino Italic

It was the best of times, it was the worst of times, it was the age of wisdom, it was the age of foolishness, it was the epoch of belief, it was the epoch of incredulity, it was the season of light, it was the season of darkness, it was the spring of hope, it was the winter of despair, we had everything before us, we had nothing before us, we were all going

11/14 Palatino Italic

It was the best of times, it was the worst of times, it was the age of wisdom, it was the age of foolishness, it was the epoch of belief, it was the epoch of incredulity, it was the season of light, it was the season of darkness, it was the spring of hope, it was the winter of despair, we had everything before us, we had nothing before us, we were all going

12/13 Palatino Italic

It was the best of times, it was the worst of times, it was the age of wisdom, it was the age of foolishness, it was the epoch of belief, it was the epoch of incredulity, it was the season of light, it was the season of darkness, it was the spring of hope, it was the winter of despair, we had everything before us, we

12/14 Palatino Italic

It was the best of times, it was the worst of times, it was the age of wisdom, it was the age of foolishness, it was the epoch of belief, it was the epoch of incredulity, it was the season of light, it was the season of darkness, it was the spring of hope, it was the winter of despair, we had everything before us, we

13/15 Palatino Italic

It was the best of times, it was the worst of times, it was the age of wisdom, it was the age of foolishness, it was the epoch of belief, it was the epoch of incredulity, it was the season of light, it was the season of darkness, it was the spring of hope, it was the winter of despair, we had everything before us, we

14/15 Palatino Italic

It was the best of times, it was the worst of times, it was the age of wisdom, it was the age of foolishness, it was the epoch of belief, it was the epoch of incredulity, it was the season of light, it was the season of darkness, it was the spring of hope, it was the winter

14/16 Palatino Italic

It was the best of times, it was the worst of times, it was the age of wisdom, it was the age of foolishness, it was the epoch of belief, it was the epoch of incredulity, it was the season of light, it was the season of darkness, it was the spring of hope, it was the winter

Palatino Bold 72 point

ABCDEFGHIJKL
MNOPQRSTUV
WXYZ abcdefghi
jklmnopqrstuvw
xyz 1234567890
?!/&$$%#@*""'.,:;,'

Palatino Bold 24 point

ABCDEFGHIJKLMNOPQRSTUVWXYZ
abcdefghijklmnopqrstuvwxyz 1234567890 !?%&*

Palatino Bold 30 point

ABCDEFGHIJKLMNOPQRSTUVWXYZ
abcdefghijklmnopqrstuvwxyz 12345678

Palatino Bold 36 point

ABCDEFGHIJKLMNOPQRSTUV
abcdefghijklmnopqrstuvwxyz 123

Palatino Bold 48 point

ABCDEFGHIJKLMNOPQ
abcdefghijklmnopqrst 12

Palatino Bold 60 point

ABCDEFGHIJKLMOP
abcdefghijklmnopq 12

6/8 Palatino Bold

It was the best of times, it was the worst of times, it was the age of wisdom, it was the age of foolishness, it was the epoch of belief, it was the epoch of incredulity, it was the season of light, it was the season of darkness, it was the spring of hope, it was the winter of despair, we had everything before us, we had nothing before us, we were all going direct to Heaven, we were all going direct the other way-in short, the period was so far like the present period, that some of its noisiest authorities insisted on its being received,

8/10 Palatino Bold

It was the best of times, it was the worst of times, it was the age of wisdom, it was the age of foolishness, it was the epoch of belief, it was the epoch of incredulity, it was the season of light, it was the season of darkness, it was the spring of hope, it was the winter of despair, we had everything before us, we had nothing before us, we were all going direct to Heaven, we were all going direct

9/10 Palatino Bold

It was the best of times, it was the worst of times, it was the age of wisdom, it was the age of foolishness, it was the epoch of belief, it was the epoch of incredulity, it was the season of light, it was the season of darkness, it was the spring of hope, it was the winter of despair, we had everything before us, we had nothing before us, we were all going

9/11 Palatino Bold

It was the best of times, it was the worst of times, it was the age of wisdom, it was the age of foolishness, it was the epoch of belief, it was the epoch of incredulity, it was the season of light, it was the season of darkness, it was the spring of hope, it was the winter of despair, we had everything before us, we had nothing before us, we were all going

10/11 Palatino Bold

It was the best of times, it was the worst of times, it was the age of wisdom, it was the age of foolishness, it was the epoch of belief, it was the epoch of incredulity, it was the season of light, it was the season of darkness, it was the spring of hope, it was the winter of despair, we had everything before us, we had

10/12 Palatino Bold

It was the best of times, it was the worst of times, it was the age of wisdom, it was the age of foolishness, it was the epoch of belief, it was the epoch of incredulity, it was the season of light, it was the season of darkness, it was the spring of hope, it was the winter of despair, we had everything before us, we had

11/13 Palatino Bold

It was the best of times, it was the worst of times, it was the age of wisdom, it was the age of foolishness, it was the epoch of belief, it was the epoch of incredulity, it was the season of light, it was the season of darkness, it was the spring of hope, it was the winter of despair, we had everything before us, we

11/14 Palatino Bold

It was the best of times, it was the worst of times, it was the age of wisdom, it was the age of foolishness, it was the epoch of belief, it was the epoch of incredulity, it was the season of light, it was the season of darkness, it was the spring of hope, it was the winter of despair, we had everything before us, we

12/13 Palatino Bold

It was the best of times, it was the worst of times, it was the age of wisdom, it was the age of foolishness, it was the epoch of belief, it was the epoch of incredulity, it was the season of light, it was the season of darkness, it was the spring of hope, it was the winter

12/14 Palatino Bold

It was the best of times, it was the worst of times, it was the age of wisdom, it was the age of foolishness, it was the epoch of belief, it was the epoch of incredulity, it was the season of light, it was the season of darkness, it was the spring of hope, it was the winter

13/15 Palatino Bold

It was the best of times, it was the worst of times, it was the age of wisdom, it was the age of foolishness, it was the epoch of belief, it was the epoch of incredulity, it was the season of light, it was the season of darkness, it was the spring of

14/15 Palatino Bold

It was the best of times, it was the worst of times, it was the age of wisdom, it was the age of foolishness, it was the epoch of belief, it was the epoch of incredulity, it was the season of light, it was the season of darkness, it was

14/16 Palatino Bold

It was the best of times, it was the worst of times, it was the age of wisdom, it was the age of foolishness, it was the epoch of belief, it was the epoch of incredulity, it was the season of light, it was the season of darkness, it was

Palatino Bold Italic 72 points

ABCDEFGHIJKL
MNOPQRSTUV
WXYZ abcdefghi
jklmnopqrstuvw
xyz 1234567890
*?!/&$%#@ *""',.;,'*

Palatino Bold Italic 24 point

ABCDEFGHIJKLMNOPQRSTUVWXYZ
abcdefghijklmnopqrstuvwxyz 1234567890 !?%&*

Palatino Bold Italic 30 point

ABCDEFGHIJKLMNOPQRSTUVWXYZ
abcdefghijklmnopqrstuvwxyz 123456789

Palatino Bold Italic 36 point

ABCDEFGHIJKLMNOPQRSTUVW
abcdefghijklmnopqrstuvwxyz 1234

Palatino Bold Italic 48 point

ABCDEFGHIJKLMNOPQ
abcdefghijklmnopqrstu 12

Palatino Bold Italic 60 point

ABCDEFGHIJKLMN
abcdefghijklmnop 12

6/8 Palatino Bold Italic

It was the best of times, it was the worst of times, it was the age of wisdom, it was the age of foolishness, it was the epoch of belief, it was the epoch of incredulity, it was the season of light, it was the season of darkness, it was the spring of hope, it was the winter of despair, we had everything before us, we had nothing before us, we were all going direct to Heaven, we were all going direct the other way-in short, the period was so far like the present period, that some of its noisiest authorities insisted on its being received, for good or

8/10 Palatino Bold Italic

It was the best of times, it was the worst of times, it was the age of wisdom, it was the age of foolishness, it was the epoch of belief, it was the epoch of incredulity, it was the season of light, it was the season of darkness, it was the spring of hope, it was the winter of despair, we had everything before us, we had nothing before us, we were all going direct to Heaven, we were all going direct the other way-in

9/10 Palatino Bold Italic

It was the best of times, it was the worst of times, it was the age of wisdom, it was the age of foolishness, it was the epoch of belief, it was the epoch of incredulity, it was the season of light, it was the season of darkness, it was the spring of hope, it was the winter of despair, we had everything before us, we had nothing before us, we were all going direct

9/11 Palatino Bold Italic

It was the best of times, it was the worst of times, it was the age of wisdom, it was the age of foolishness, it was the epoch of belief, it was the epoch of incredulity, it was the season of light, it was the season of darkness, it was the spring of hope, it was the winter of despair, we had everything before us, we had nothing before us, we were all going direct

10/11 Palatino Bold Italic

It was the best of times, it was the worst of times, it was the age of wisdom, it was the age of foolishness, it was the epoch of belief, it was the epoch of incredulity, it was the season of light, it was the season of darkness, it was the spring of hope, it was the winter of despair, we had everything before us, we had nothing before us,

10/12 Palatino Bold Italic

It was the best of times, it was the worst of times, it was the age of wisdom, it was the age of foolishness, it was the epoch of belief, it was the epoch of incredulity, it was the season of light, it was the season of darkness, it was the spring of hope, it was the winter of despair, we had everything before us, we had nothing before us,

11/13 Palatino Bold Italic

It was the best of times, it was the worst of times, it was the age of wisdom, it was the age of foolishness, it was the epoch of belief, it was the epoch of incredulity, it was the season of light, it was the season of darkness, it was the spring of hope, it was the winter of despair, we had everything before us, we

11/14 Palatino Bold Italic

It was the best of times, it was the worst of times, it was the age of wisdom, it was the age of foolishness, it was the epoch of belief, it was the epoch of incredulity, it was the season of light, it was the season of darkness, it was the spring of hope, it was the winter of despair, we had everything before us, we

12/13 Palatino Bold Italic

It was the best of times, it was the worst of times, it was the age of wisdom, it was the age of foolishness, it was the epoch of belief, it was the epoch of incredulity, it was the season of light, it was the season of darkness, it was the spring of hope, it was the winter

12/14 Palatino Bold Italic

It was the best of times, it was the worst of times, it was the age of wisdom, it was the age of foolishness, it was the epoch of belief, it was the epoch of incredulity, it was the season of light, it was the season of darkness, it was the spring of hope, it was the winter of

13/15 Palatino Bold Italic

It was the best of times, it was the worst of times, it was the age of wisdom, it was the age of foolishness, it was the epoch of belief, it was the epoch of incredulity, it was the season of light, it was the season of darkness, it was the spring of hope, it

14/15 Palatino Bold Italic

It was the best of times, it was the worst of times, it was the age of wisdom, it was the age of foolishness, it was the epoch of belief, it was the epoch of incredulity, it was the season of light, it was the season of darkness, it was the

14/16 Palatino Bold Italic

It was the best of times, it was the worst of times, it was the age of wisdom, it was the age of foolishness, it was the epoch of belief, it was the epoch of incredulity, it was the season of light, it was the season of darkness, it was the

Park Avenue 72 point

ABCDEFGHIJKL
MNOPQRSTUV
WXYZ abcdefghijklmnopq
rstuvwxyz 1234567890
?!/&$% # @ *""..,

Park Avenue 10 point

ABCDEFGHIJKLMNOPQRSTUVWXYZ abcdefghij

klmnopqrstuvwxyz 1234567890 ?!/&$%#@*""::.,

Park Avenue 12 point

ABCDEFGHIJKLMNOPQRSTUVWXYZ abcdefghij

klmnopqrstuvwxyz 1234567890 ?!/&$%#@*""::.,

Park Avenue 13 point

ABCDEFGHIJKLMNOPQRSTUVWXYZ abcdefghij

klmnopqrstuvwxyz 1234567890 ?!/&$%#@*""::.,

Park Avenue 14 point

ABCDEFGHIJKLMNOPQRSTUVWXYZ abcdefghij

klmnopqrstuvwxyz 1234567890 ?!/&$%#@*""::.,

Park Avenue 16 point

ABCDEFGHIJKLMNOPQRSTUVWXYZ abcdefghij

klmnopqrstuvwxyz 1234567890 ?!/&$%#@*""::.,

Park Avenue 18 point

ABCDEFGHIJKLMNOPQRSTUVWXYZ abcdefghij

klmnopqrstuvwxyz 1234567890 ?!/&$%#@*""::.,

Park Avenue 20 point

ABCDEFGHIJKLMNOPQRSTUVWXYZ abcdefghij

klmnopqrstuvwxyz 1234567890 ?!/&$%#@*""::.,

Park Avenue 22 point

ABCDEFGHIJKLMNOPQRSTUVWXYZ abcdefghij

klmnopqrstuvwxyz 1234567890 ?!/&$%#@*""::.,

Revue 72 point

ABCDEFGHIJK
LMNOPQRSTUV
WXYZabcdefghij
klmnopqrstuvw
xyz1234567890
?!/&$%*""".;.,

Revue 24 point

ABCDEFGHIJKLMNOPQRSTUVWXYZ
abcdefghijklmnopqrstuvwxyz 1234567890!?%&*

Revue 30 point

ABCDEFGHIJKLMNOPQRSTUVWXYZ
abcdefghijklmnopqrstuvwxyz 123456

Revue 30 36 point

ABCDEFGHIJKLMNOPQRSTUVWX
abcdefghijklmnopqrstuv 12345

Revue 48 point

ABCDEGHIJKLMNOPQRS
abcdefghijklmnopqr 123

Revue 60 point

ABCDEFGHIJKLMN
abcdefghijklmn 123

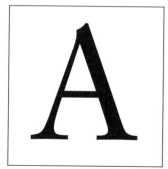

Sabon 72 point

ABCDEFGHIJKL
MNOPQRSTUV
WXYZ abcdefghijkl
mnopqrstuvwxyz
1234567890
?!/&$%#@* " ".;,

Sabon 24 point

ABCDEFGHIJKLMNOPQRSTUVWXYZ
abcdefghijklmnopqrstuvwxyz 1234567890 !?%&

Sabon 30 point

ABCDEFGHIJKLMNOPQRSTUVWXYZ
abcdefghijklmnopqrstuvwxyz 1234567890

Sabon 36 point

ABCDEFGHIJKLMNOPQRSTUV
abcdefghijklmnopqrstuvwxy 12345

Sabon 48 point

ABCDEFGHIJKLMNOPQ
abcdefghijklmnopqrstu 123

Sabon 60 point

ABCDEFGHIJKLMN
abcdefghijklmnop 123

6/8 Sabon

It was the best of times, it was the worst of times, it was the age of wisdom, it was the age of foolishness, it was the epoch of belief, it was the epoch of incredulity, it was the season of light, it was the season of darkness, it was the spring of hope, it was the winter of despair, we had everything before us, we had nothing before us, we were all going direct to Heaven, we were all going direct the other way-in short, the period was so far like the present period, that some of its noisiest authorities insisted on its being received, for good or for evil, in the

8/10 Sabon

It was the best of times, it was the worst of times, it was the age of wisdom, it was the age of foolishness, it was the epoch of belief, it was the epoch of incredulity, it was the season of light, it was the season of darkness, it was the spring of hope, it was the winter of despair, we had everything before us, we had nothing before us, we were all going direct to Heaven, we were all going direct the other way-in short,

9/10 Sabon

It was the best of times, it was the worst of times, it was the age of wisdom, it was the age of foolishness, it was the epoch of belief, it was the epoch of incredulity, it was the season of light, it was the season of darkness, it was the spring of hope, it was the winter of despair, we had everything before us, we had nothing before us, we were all going direct to Heaven, we were

9/11 Sabon

It was the best of times, it was the worst of times, it was the age of wisdom, it was the age of foolishness, it was the epoch of belief, it was the epoch of incredulity, it was the season of light, it was the season of darkness, it was the spring of hope, it was the winter of despair, we had everything before us, we had nothing before us, we were all going direct to Heaven, we were

10/11 Sabon

It was the best of times, it was the worst of times, it was the age of wisdom, it was the age of foolishness, it was the epoch of belief, it was the epoch of incredulity, it was the season of light, it was the season of darkness, it was the spring of hope, it was the winter of despair, we had everything before us, we had nothing before us, we

10/12 Sabon

It was the best of times, it was the worst of times, it was the age of wisdom, it was the age of foolishness, it was the epoch of belief, it was the epoch of incredulity, it was the season of light, it was the season of darkness, it was the spring of hope, it was the winter of despair, we had everything before us, we had nothing before us, we

11/13 Sabon

It was the best of times, it was the worst of times, it was the age of wisdom, it was the age of foolishness, it was the epoch of belief, it was the epoch of incredulity, it was the season of light, it was the season of darkness, it was the spring of hope, it was the winter of despair, we had everything before us, we

11/14 Sabon

It was the best of times, it was the worst of times, it was the age of wisdom, it was the age of foolishness, it was the epoch of belief, it was the epoch of incredulity, it was the season of light, it was the season of darkness, it was the spring of hope, it was the winter of despair, we had everything before us, we

12/13 Sabon

It was the best of times, it was the worst of times, it was the age of wisdom, it was the age of foolishness, it was the epoch of belief, it was the epoch of incredulity, it was the season of light, it was the season of darkness, it was the spring of hope, it was the winter of despair, we had everything before

12/14 Sabon

It was the best of times, it was the worst of times, it was the age of wisdom, it was the age of foolishness, it was the epoch of belief, it was the epoch of incredulity, it was the season of light, it was the season of darkness, it was the spring of hope, it was the winter of despair, we had everything before

13/15 Sabon

It was the best of times, it was the worst of times, it was the age of wisdom, it was the age of foolishness, it was the epoch of belief, it was the epoch of incredulity, it was the season of light, it was the season of darkness, it was the spring of hope, it was

14/15 Sabon

It was the best of times, it was the worst of times, it was the age of wisdom, it was the age of foolishness, it was the epoch of belief, it was the epoch of incredulity, it was the season of light, it was the season of darkness, it was the spring of

14/16 Sabon

It was the best of times, it was the worst of times, it was the age of wisdom, it was the age of foolishness, it was the epoch of belief, it was the epoch of incredulity, it was the season of light, it was the season of darkness, it was the spring of

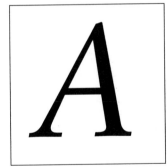

Sabon Italic 72 point

ABCDEFGHIJKL
MNOPQRSTUV
WXYZ *abcdefghij*
klmnopqrstuvw
xyz1234567890
?!&$%#@ " " *" :;.,*

Sabon Italic 24 point

ABCDEFGHIJKLMNOPQRSTUVWXYZ
abcdefghijklmnopqrstuvwxyz 1234567890 !?%&

Sabon Italic 30 point

ABCDEFGHIJKLMNOPQRSTUVWXYZ
abcdefghijklmnopqrstuvwxyz 1234567890

Sabon Italic 36 point

ABCDEFGHIJKLMNOPQRSTUVW
abcdefghijklmnopqrstuvwxyz 12345678

Sabon Italic 48 point

ABCDEFGHIJKLMNOPQ
abcdefghijklmnopqrstu 12345

Sabon Italic 60 point

ABCDEFGHIJKLMN
abcdefghijklmnopqrs 12

6/8 Sabon Italic

It was the best of times, it was the worst of times, it was the age of wisdom, it was the age of foolishness, it was the epoch of belief, it was the epoch of incredulity, it was the season of light, it was the season of darkness, it was the spring of hope, it was the winter of despair, we had everything before us, we had nothing before us, we were all going direct to Heaven, we were all going direct the other way-in short, the period was so far like the present period, that some of its noisiest authorities insisted on its being received, for good or for evil, in the

8/10 Sabon Italic

It was the best of times, it was the worst of times, it was the age of wisdom, it was the age of foolishness, it was the epoch of belief, it was the epoch of incredulity, it was the season of light, it was the season of darkness, it was the spring of hope, it was the winter of despair, we had everything before us, we had nothing before us, we were all going direct to Heaven, we were all going direct the other way-in short,

9/10 Sabon Italic

It was the best of times, it was the worst of times, it was the age of wisdom, it was the age of foolishness, it was the epoch of belief, it was the epoch of incredulity, it was the season of light, it was the season of darkness, it was the spring of hope, it was the winter of despair, we had everything before us, we had nothing before us, we were all going direct to Heaven, we were

9/11 Sabon Italic

It was the best of times, it was the worst of times, it was the age of wisdom, it was the age of foolishness, it was the epoch of belief, it was the epoch of incredulity, it was the season of light, it was the season of darkness, it was the spring of hope, it was the winter of despair, we had everything before us, we had nothing before us, we were all going direct to Heaven, we were

10/11 Sabon Italic

It was the best of times, it was the worst of times, it was the age of wisdom, it was the age of foolishness, it was the epoch of belief, it was the epoch of incredulity, it was the season of light, it was the season of darkness, it was the spring of hope, it was the winter of despair, we had everything before us, we had nothing before us, we

10/12 Sabon Italic

It was the best of times, it was the worst of times, it was the age of wisdom, it was the age of foolishness, it was the epoch of belief, it was the epoch of incredulity, it was the season of light, it was the season of darkness, it was the spring of hope, it was the winter of despair, we had everything before us, we had nothing before us, we

11/13 Sabon Italic

It was the best of times, it was the worst of times, it was the age of wisdom, it was the age of foolishness, it was the epoch of belief, it was the epoch of incredulity, it was the season of light, it was the season of darkness, it was the spring of hope, it was the winter of despair, we had everything before us, we

11/14 Sabon Italic

It was the best of times, it was the worst of times, it was the age of wisdom, it was the age of foolishness, it was the epoch of belief, it was the epoch of incredulity, it was the season of light, it was the season of darkness, it was the spring of hope, it was the winter of despair, we had everything before us, we

12/13 Sabon Italic

It was the best of times, it was the worst of times, it was the age of wisdom, it was the age of foolishness, it was the epoch of belief, it was the epoch of incredulity, it was the season of light, it was the season of darkness, it was the spring of hope, it was the winter of despair, we had everything before

12/14 Sabon Italic

It was the best of times, it was the worst of times, it was the age of wisdom, it was the age of foolishness, it was the epoch of belief, it was the epoch of incredulity, it was the season of light, it was the season of darkness, it was the spring of hope, it was the winter of despair, we had everything before

13/15 Sabon Italic

It was the best of times, it was the worst of times, it was the age of wisdom, it was the age of foolishness, it was the epoch of belief, it was the epoch of incredulity, it was the season of light, it was the season of darkness, it was the spring of hope, it was

14/15 Sabon Italic

It was the best of times, it was the worst of times, it was the age of wisdom, it was the age of foolishness, it was the epoch of belief, it was the epoch of incredulity, it was the season of light, it was the season of darkness, it was the spring of

14/16 Sabon Italic

It was the best of times, it was the worst of times, it was the age of wisdom, it was the age of foolishness, it was the epoch of belief, it was the epoch of incredulity, it was the season of light, it was the season of darkness, it was the spring of

Sabon Bold 72 point

ABCDEFGHIJKL
MNOPQRSTUV
WXYZ abcdefghij
klmnopqrstuvwx
yz 1234567890
?!/&$%#@*""*.,;.,

Sabon Bold 24 point

ABCDEFGHIJKLMNOPQRSTUVWXYZ
abcdefghijklmnopqrstuvwxyz 1234567890 !?%&*

Sabon Bold 30 point

ABCDEFGHIJKLMNOPQRSTUVWXYZ
abcdefghijklmnopqrstuvwxyz 1234567890

Sabon Bold 36 point

ABCDEFGHIJKLMNOPQRSTUV
abcdefghijklmnopqrstuvwxyz 123456

Sabon Bold 48 point

ABCDEFGHIJKLMNOPQ
abcdefghijklmnopqrstuv 1234

Sabon Bold 60 point

ABCDEFGHIJKLMN
abcdefghijklmnopqr 12

6/8 Sabon Bold

It was the best of times, it was the worst of times, it was the age of wisdom, it was the age of foolishness, it was the epoch of belief, it was the epoch of incredulity, it was the season of light, it was the season of darkness, it was the spring of hope, it was the winter of despair, we had everything before us, we had nothing before us, we were all going direct to Heaven, we were all going direct the other way-in short, the period was so far like the present period, that some of its noisiest authorities insisted on its being received, for good or for evil, in the

8/10 Sabon Bold

It was the best of times, it was the worst of times, it was the age of wisdom, it was the age of foolishness, it was the epoch of belief, it was the epoch of incredulity, it was the season of light, it was the season of darkness, it was the spring of hope, it was the winter of despair, we had everything before us, we had nothing before us, we were all going direct to Heaven, we were all going direct the other way-in short,

9/10 Sabon Bold

It was the best of times, it was the worst of times, it was the age of wisdom, it was the age of foolishness, it was the epoch of belief, it was the epoch of incredulity, it was the season of light, it was the season of darkness, it was the spring of hope, it was the winter of despair, we had everything before us, we had nothing before us, we were all going direct to Heaven, we were

9/11 Sabon Bold

It was the best of times, it was the worst of times, it was the age of wisdom, it was the age of foolishness, it was the epoch of belief, it was the epoch of incredulity, it was the season of light, it was the season of darkness, it was the spring of hope, it was the winter of despair, we had everything before us, we had nothing before us, we were all going direct to Heaven, we were

10/11 Sabon Bold

It was the best of times, it was the worst of times, it was the age of wisdom, it was the age of foolishness, it was the epoch of belief, it was the epoch of incredulity, it was the season of light, it was the season of darkness, it was the spring of hope, it was the winter of despair, we had everything before us, we had nothing before us, we

10/12 Sabon Bold

It was the best of times, it was the worst of times, it was the age of wisdom, it was the age of foolishness, it was the epoch of belief, it was the epoch of incredulity, it was the season of light, it was the season of darkness, it was the spring of hope, it was the winter of despair, we had everything before us, we had nothing before us, we

11/13 Sabon Bold

It was the best of times, it was the worst of times, it was the age of wisdom, it was the age of foolishness, it was the epoch of belief, it was the epoch of incredulity, it was the season of light, it was the season of darkness, it was the spring of hope, it was the winter of despair, we had everything before us, we

11/14 Sabon Bold

It was the best of times, it was the worst of times, it was the age of wisdom, it was the age of foolishness, it was the epoch of belief, it was the epoch of incredulity, it was the season of light, it was the season of darkness, it was the spring of hope, it was the winter of despair, we had everything before us, we

12/13 Sabon Bold

It was the best of times, it was the worst of times, it was the age of wisdom, it was the age of foolishness, it was the epoch of belief, it was the epoch of incredulity, it was the season of light, it was the season of darkness, it was the spring of hope, it was the winter of despair, we had everything before

12/14 Sabon Bold

It was the best of times, it was the worst of times, it was the age of wisdom, it was the age of foolishness, it was the epoch of belief, it was the epoch of incredulity, it was the season of light, it was the season of darkness, it was the spring of hope, it was the winter of despair, we had everything before

13/15 Sabon Bold

It was the best of times, it was the worst of times, it was the age of wisdom, it was the age of foolishness, it was the epoch of belief, it was the epoch of incredulity, it was the season of light, it was the season of darkness, it was the spring of hope, it was

14/15 Sabon Bold

It was the best of times, it was the worst of times, it was the age of wisdom, it was the age of foolishness, it was the epoch of belief, it was the epoch of incredulity, it was the season of light, it was the season of darkness, it was the spring of

14/16 Sabon Bold

It was the best of times, it was the worst of times, it was the age of wisdom, it was the age of foolishness, it was the epoch of belief, it was the epoch of incredulity, it was the season of light, it was the season of darkness, it was the spring of

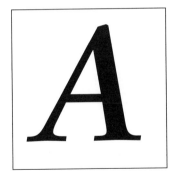

Sabon Bold Italic 72 point

*ABCDEFGHIJKL
MNOPQRSTUV
WXYZ abcdefghij
klmnopqrstuvwx
yz 1234567890
?!/&$%#@*""".;.,*

Sabon Bold Italic 24 point

ABCDEFGHIJKLMNOPQRSTUVWXYZ
abcdefghijklmnopqrstuvwxyz 1234567890 !?%&*

Sabon Bold Italic 30 point

ABCDEFGHIJKLMNOPQRSTUVWXYZ
abcdefghijklmnopqrstuvwxyz 12345678

Sabon Bold Italic 36 point

ABCDEFGHIJKLMNOPQRSTUV
abcdefghijklmnopqrstuvwxyz 1234

Sabon Bold Italic 48 point

ABCDEFGHIJKLMNOPQ
abcdefghijklmnopqrst 123

Sabon Bold Italic 60 point

ABCDEFGHIJKLMN
abcdefghijklmnop 12

6/8 Sabon Bold Italic

It was the best of times, it was the worst of times, it was the age of wisdom, it was the age of foolishness, it was the epoch of belief, it was the epoch of incredulity, it was the season of light, it was the season of darkness, it was the spring of hope, it was the winter of despair, we had everything before us, we had nothing before us, we were all going direct to Heaven, we were all going direct the other way-in short, the period was so far like the present period, that some of its noisiest authorities insisted on its being received, for good or for evil, in the

8/10 Sabon Bold Italic

It was the best of times, it was the worst of times, it was the age of wisdom, it was the age of foolishness, it was the epoch of belief, it was the epoch of incredulity, it was the season of light, it was the season of darkness, it was the spring of hope, it was the winter of despair, we had everything before us, we had nothing before us, we were all going direct to Heaven, we were all going direct the other way-in short,

9/10 Sabon Bold Italic

It was the best of times, it was the worst of times, it was the age of wisdom, it was the age of foolishness, it was the epoch of belief, it was the epoch of incredulity, it was the season of light, it was the season of darkness, it was the spring of hope, it was the winter of despair, we had everything before us, we had nothing before us, we were all going direct to Heaven,

9/11 Sabon Bold Italic

It was the best of times, it was the worst of times, it was the age of wisdom, it was the age of foolishness, it was the epoch of belief, it was the epoch of incredulity, it was the season of light, it was the season of darkness, it was the spring of hope, it was the winter of despair, we had everything before us, we had nothing before us, we were all going direct to Heaven,

10/11 Sabon Bold Italic

It was the best of times, it was the worst of times, it was the age of wisdom, it was the age of foolishness, it was the epoch of belief, it was the epoch of incredulity, it was the season of light, it was the season of darkness, it was the spring of hope, it was the winter of despair, we had everything before us, we had nothing before us, we

10/12 Sabon Bold Italic

It was the best of times, it was the worst of times, it was the age of wisdom, it was the age of foolishness, it was the epoch of belief, it was the epoch of incredulity, it was the season of light, it was the season of darkness, it was the spring of hope, it was the winter of despair, we had everything before us, we had nothing before us, we

11/13 Sabon Bold Italic

It was the best of times, it was the worst of times, it was the age of wisdom, it was the age of foolishness, it was the epoch of belief, it was the epoch of incredulity, it was the season of light, it was the season of darkness, it was the spring of hope, it was the winter of despair, we had everything before us, we

11/14 Sabon Bold Italic

It was the best of times, it was the worst of times, it was the age of wisdom, it was the age of foolishness, it was the epoch of belief, it was the epoch of incredulity, it was the season of light, it was the season of darkness, it was the spring of hope, it was the winter of despair, we had everything before us, we

12/13 Sabon Bold Italic

It was the best of times, it was the worst of times, it was the age of wisdom, it was the age of foolishness, it was the epoch of belief, it was the epoch of incredulity, it was the season of light, it was the season of darkness, it was the spring of hope, it was the winter of despair, we

12/14 Sabon Bold Italic

It was the best of times, it was the worst of times, it was the age of wisdom, it was the age of foolishness, it was the epoch of belief, it was the epoch of incredulity, it was the season of light, it was the season of darkness, it was the spring of hope, it was the winter of despair, we

13/15 Sabon Bold Italic

It was the best of times, it was the worst of times, it was the age of wisdom, it was the age of foolishness, it was the epoch of belief, it was the epoch of incredulity, it was the season of light, it was the season of darkness, it was the spring of hope, it was

14/15 Sabon Bold Italic

It was the best of times, it was the worst of times, it was the age of wisdom, it was the age of foolishness, it was the epoch of belief, it was the epoch of incredulity, it was the season of light, it was the season of darkness, it was the spring

14/16 Sabon Italic

It was the best of times, it was the worst of times, it was the age of wisdom, it was the age of foolishness, it was the epoch of belief, it was the epoch of incredulity, it was the season of light, it was the season of darkness, it was the spring

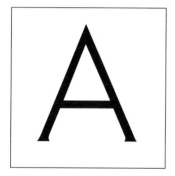

ITC Serif Gothic Light 72 point

ABCDEFGHIJKL
MNOPQRSTUV
WXYZ abcdefghij
klmnopqrstuvw
xyz1234567890
?!/&$%#@*""" .,:;.,

ITC Serif Gothic Light 24 point

ABCDEFGHIJKLMNOPQRSTUVWXYZ
abcdefghijklmnopqrstuvwxyz 1234567890 !?%&*

ITC Serif Gothic Light 30 point

ABCDEFGHIJKLMNOPQRSTUVWXYZ
abcdefghijklmnopqrstuvwxyz 123456789

ITC Serif Gothic Light 36 point

ABCDEFGHIJKLMNOPQRSTUVWXYZ
abcdefghijklmnopqrstuvwxy 1234

ITC Serif Gothic Light 40 point

ABCDEFGHIJKLMNOPQRST
abcdefghijklmnopqrs 123

ITC Serif Gothic Light 60 point

ABCDEFGHIJKLMNOP
abcdefghijklmno 123

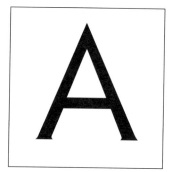

ITC Serif Gothic 72 point

ABCDEFGHIJKL
MNOPQRSTUV
WXYZabcdefghi
jklmnopqrstuvw
xyz1234567890
?!&$%#@*"'":.;.,

ITC Serif Gothic 24 point

ABCDEFGHIJKLMNOPQRSTUVWXYZ
abcdefghijklmnopqrstuvwxyz 1234567890 !?%

ITC Serif Gothic 30 point

ABCDEFGHIJKLMNOPQRSTUVWXYZ
abcdefghijklmnopqrstuvwxyz 1234567

ITC Serif Gothic 36 point

ABCDEFGHIJKLMNOPQRSTUVWXYZ
abcdefghijklmnopqrstuvwxyz 123

ITC Serif Gothic 48 point

ABCDEFGHIJKLMNOPQRST
abcdefghijklmnopqrs123

ITC Serif Gothic 60 point

ABCDEFGHIJKLMNOP
abcdefghijklmnop 12

ITC Serif Gothic Bold 72 point

ABCDEFGHIJKL
MNOPQRSTUV
WXYZ abcdefghij
klmnopqrstuvwx
yz 1234567890
?!/&$%#@*'"'":.;·,

ITC Serif Gothic Bold 24 point

ABCDEFGHIJKLMNOPQRSTUVWXYZ
abcdefghijklmnopqrstuvwxyz 1234567890 !?%&*

ITC Serif Gothic Bold 30 point

ABCDEFGHIJKLMNOPQRSTUVWXYZ
abcdefghijklmnopqrstuvwxyz 1234567

ITC Serif Gothic Bold 36 point

ABCDEFGHIJKLMNOPQRSTUVWXZ
abcdefghijklmnopqrstuvwxyz 123

ITC Serif Gothic Bold 48 point

ABCDEFGHIJKLMNOPQR
abcdefghijklmnopqrst 123

ITC Serif Gothic Bold 60 point

ABCDEFGHIJKLMNOP
abcdefghijklmno 12

ITC Serif Gothic Extra Bold 72 point

ABCDEFGHIJKL
MNOPQRSTUV
WXYZ abcdefghij
klmnopqrstuvwx
yz 1234567890
?!/&$%#@*'""::.,

ITC Serif Gothic Extra Bold 24 point

ABCDEFGHIJKLMNOPQRSTUVWXYZ
abcdefghijklmnopqrstuvwxyz 1234567890 !?%&*

ITC Serif Gothic Extra Bold 30 point

ABCDEFGHIJKLMNOPQRSTUVWXYZ
abcdefghijklmnopqrstuvwxyz 1234567

ITC Serif Gothic Extra Bold 36 point

ABCDEFGHIJKLMNOPQRSTUVWXYZ
abcdefghijklmnopqrstuvwxyz 123

ITC Serif Gothic Extra Bold 40 point

ABCDEFGHIJKLMNOPQRST
abcdefghijklmnopqrs 123

ITC Serif Gothic Extra Bold 60 point

ABCDEFGHIJKLMNOP
abcdefghijklmno 12

ITC Serif Gothic Heavy 72 point

ABCDEFGHIJKL
MNOPQRSTUV
WXYZ abcdefghij
klmnopqrstuvwx
yz 1234567890
?!/&$%#@*`''":;.,

ITC Serif Gothic Heavy 24 point

ABCDEFGHIJKLMNOPQRSTUVWXYZ
abcdefghijklmnopqrstuvwxyz 1234567890 !?%&

ITC Serif Gothic Heavy 30 point

ABCDEFGHIJKLMNOPQRSTUVWXYZ
abcdefghijklmnopqrstuvwxyz 1234567

ITC Serif Gothic Heavy 36 point

ABCDEFGHIJKLMNOPQRSTUVWXY
abcdefghijklmnopqrstuvwxyz 12

ITC Serif Gothic Heavy 40 point

ABCDEFGHIJKLMNOPQRST
abcdefghijklmnopqrs 12

ITC Serif Gothic Heavy 60 point

ABCDEFGHIJKLMNOP
abcdefghijklmno 12

ITC Serif Gothic Heavy 72 point

ABCDEFGHIJKL
MNOPQRSTUV
WXYZ abcdefghij
klmnopqrstuvwx
yz 1234567890
?!/&$%#@*'\'\'\"\".;,'

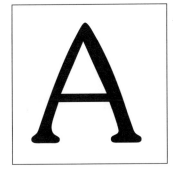

ITC Souvenir Light 72 point

ABCDEFGHIJK
LMNOPQRSTU
VWXYZ abcdefgh
ijklmnopqrstuvw
xyz1234567890
?!/&$%#@*" ".:;.,

ITC Souvenir Light 10 point

ABCDEFGHIJKLMNOPQRSTUVWXYZ abcdefghij
klmnopqrstuvwxyz 1234567890 ?!/&$%#@*""":;.,

ITC Souvenir Light 12 point

ABCDEFGHIJKLMNOPQRSTUVWXYZ abcdefghij
klmnopqrstuvwxyz 1234567890 ?!/&$%#@*""":;.,

ITC Souvenir Light 13 point

ABCDEFGHIJKLMNOPQRSTUVWXYZ abcdefghij
klmnopqrstuvwxyz 1234567890 ?!/&$%#@*""":;.,

ITC Souvenir Light 14 point

ABCDEFGHIJKLMNOPQRSTUVWXYZ abcdefghij
klmnopqrstuvwxyz 1234567890 ?!/&$%#@*""":;.,

ITC Souvenir Light 16 point

ABCDEFGHIJKLMNOPQRSTUVWXYZ abcdefghij
klmnopqrstuvwxyz 1234567890 ?!/&$%#@*""":;.,

ITC Souvenir Light 18 point

ABCDEFGHIJKLMNOPQRSTUVWXYZ abcdefghij
klmnopqrstuvwxyz 1234567890 ?!/&$%#@*""":;.,

ITC Souvenir Light 20 point

ABCDEFGHIJKLMNOPQRSTUVWXYZ abcdefghij
klmnopqrstuvwxyz 1234567890 ?!/&$%#@*""":;.,

ITC Souvenir Light 22 point

ABCDEFGHIJKLMNOPQRSTUVWXYZ abcdefghij
klmnopqrstuvwxyz 1234567890 ?!/&$%#@*""":;.,

ITC Souvenir Light 24 point

ABCDEFGHIJKLMNOPQRSTUVWXYZ
abcdefghijklmnopqrstuvwxyz 1234567890 !?%&*

ITC Souvenir Light 30 point

ABCDEFGHIJKLMNOPQRSTUVWXYZ
abcdefghijklmnopqrstuvwxyz 1234567890

ITC Souvenir Light 36 point

ABCDEFGHIJKLMNOPQRSTUVW
abcdefghijklmnopqrstuvwxyz 12345

ITC Souvenir Light 48 point

ABCDEFGHIJKLMNOPQ
abcdefghijklmnopqrst 1234

ITC Souvenir Light 60 point

ABCDEFGHIJKLMN
abcdefghijklmno 1234

6/8 ITC Souvenir Light

It was the best of times, it was the worst of times, it was the age of wisdom, it was the age of foolishness, it was the epoch of belief, it was the epoch of incredulity, it was the season of light, it was the season of darkness, it was the spring of hope, it was the winter of despair, we had everything before us, we had nothing before us, we were all going direct to Heaven, we were all going direct the other way-in short, the period was so far like the present period, that some of its noisiest authorities insisted on its being received, for good or for evil, in the

8/10 ITC Souvenir Light

It was the best of times, it was the worst of times, it was the age of wisdom, it was the age of foolishness, it was the epoch of belief, it was the epoch of incredulity, it was the season of light, it was the season of darkness, it was the spring of hope, it was the winter of despair, we had everything before us, we had nothing before us, we were all going direct to Heaven, we were all going direct the other way-in short, the period

9/10 ITC Souvenir Light

It was the best of times, it was the worst of times, it was the age of wisdom, it was the age of foolishness, it was the epoch of belief, it was the epoch of incredulity, it was the season of light, it was the season of darkness, it was the spring of hope, it was the winter of despair, we had everything before us, we had nothing before us, we were all going direct to Heaven, we were

9/11 ITC Souvenir Light

It was the best of times, it was the worst of times, it was the age of wisdom, it was the age of foolishness, it was the epoch of belief, it was the epoch of incredulity, it was the season of light, it was the season of darkness, it was the spring of hope, it was the winter of despair, we had everything before us, we had nothing before us, we were all going direct to Heaven, we were

10/11 ITC Souvenir Light

It was the best of times, it was the worst of times, it was the age of wisdom, it was the age of foolishness, it was the epoch of belief, it was the epoch of incredulity, it was the season of light, it was the season of darkness, it was the spring of hope, it was the winter of despair, we had everything before us, we had nothing before us, we

10/12 ITC Souvenir Light

It was the best of times, it was the worst of times, it was the age of wisdom, it was the age of foolishness, it was the epoch of belief, it was the epoch of incredulity, it was the season of light, it was the season of darkness, it was the spring of hope, it was the winter of despair, we had everything before us, we had nothing before us, we

11/13 ITC Souvenir Light

It was the best of times, it was the worst of times, it was the age of wisdom, it was the age of foolishness, it was the epoch of belief, it was the epoch of incredulity, it was the season of light, it was the season of darkness, it was the spring of hope, it was the winter of despair, we had everything before us, we

11/14 ITC Souvenir Light

It was the best of times, it was the worst of times, it was the age of wisdom, it was the age of foolishness, it was the epoch of belief, it was the epoch of incredulity, it was the season of light, it was the season of darkness, it was the spring of hope, it was the winter of despair, we had everything before us, we

12/13 ITC Souvenir Light

It was the best of times, it was the worst of times, it was the age of wisdom, it was the age of foolishness, it was the epoch of belief, it was the epoch of incredulity, it was the season of light, it was the season of darkness, it was the spring of hope, it was

12/14 ITC Souvenir Light

It was the best of times, it was the worst of times, it was the age of wisdom, it was the age of foolishness, it was the epoch of belief, it was the epoch of incredulity, it was the season of light, it was the season of darkness, it was the spring of hope, it was

13/15 ITC Souvenir Light

It was the best of times, it was the worst of times, it was the age of wisdom, it was the age of foolishness, it was the epoch of belief, it was the epoch of incredulity, it was the season of light, it was the season of darkness, it was the spring of hope, it was

14/15 ITC Souvenir Light

It was the best of times, it was the worst of times, it was the age of wisdom, it was the age of foolishness, it was the epoch of belief, it was the epoch of incredulity, it was the season of light, it was the season of darkness, it was the spring

14/16 ITC Souvenir Light

It was the best of times, it was the worst of times, it was the age of wisdom, it was the age of foolishness, it was the epoch of belief, it was the epoch of incredulity, it was the season of light, it was the season of darkness, it was the spring

STENCIL 72 POINT

ABCDEFGHIJ
KLMNOPQRS
TUVWXYZ
1234567890
?!&$%* " " .;•,

STENCIL 24 POINT

ABCDEFGHIJKLMNOPQRSTUVWXYZ
1234567890 ?!/&$%*""::.,

STENCIL 30 POINT

ABCDEFGHIJKLMNOPQRSTUVWXYZ
1234567890 ?!/&$%*""::.,

STENCIL 36 POINT

ABCDEFGHIJKLMNOPQRSTUV
1234567890 ?!/&$%*""::.,

STENCIL 48 POINT

ABCDEFGHIJKLMNOPQ
1234567890!/&$%*"";:.

TENCIL 60 POINT

ABCDEFGHIJKLM
1234567890?!/&$%

Stone Sans 72 point

ABCDEFGHIJKL
MNOPQRSTUV
WXYZ abcdefghi
jklmnopqrstuvw
xyz1234567890
?!&$%#@*""˙;˙,

Stone Sans 10 point

ABCDEFGHIJKLMNOPQRSTUVWXYZ abcdefghij
klmnopqrstuvwxyz 1234567890 ?!/&$%#@*"":;.,

Stone Sans 45 12 point

ABCDEFGHIJKLMNOPQRSTUVWXYZ abcdefghij
klmnopqrstuvwxyz 1234567890 ?!/&$%#@*"":;.,

Stone Sans 13 point

ABCDEFGHIJKLMNOPQRSTUVWXYZ abcdefghij
klmnopqrstuvwxyz 1234567890 ?!/&$%#@*"":;.,

Stone Sans 14 point

ABCDEFGHIJKLMNOPQRSTUVWXYZ abcdefghij
klmnopqrstuvwxyz 1234567890 ?!/&$%#@*"":;.,

Stone Sans 16 point

ABCDEFGHIJKLMNOPQRSTUVWXYZ abcdefghij
klmnopqrstuvwxyz 1234567890 ?!/&$%#@*"":;.,

Stone Sans 18 point

ABCDEFGHIJKLMNOPQRSTUVWXYZ abcdefghij
klmnopqrstuvwxyz 1234567890 ?!/&$%#@*"":;.,

Stone Sans 20 point

ABCDEFGHIJKLMNOPQRSTUVWXYZ abcdefghij
klmnopqrstuvwxyz 1234567890 ?!/&$%#@*"":;.,

Stone Sans 22 point

ABCDEFGHIJKLMNOPQRSTUVWXYZ abcdefghij
klmnopqrstuvwxyz 1234567890 ?!/&$%#@*"":;.,

Stone Sans 24 point

ABCDEFGHIJKLMNOPQRSTUVWXYZ
abcdefghijklmnopqrstuvwxyz1234567890 !?%&*

Stone Sans 30 point

ABCDEFGHIJKLMNOPQRSTUVWXYZ
abcdefghijklmnopqrstuvwxyz 123456789

Stone Sans 36 point

ABCDEFGHIJKLMNOPQRSTUVWXZ
abcdefghijklmnopqrstuvwxyz1234

Stone Sans 48 point

ABCDEFGHIJKLMNOPQRS
abcdefghijklmnopqrst 123

Stone Sans 60 point

ABCDEFGHIJKLMNO
abcdefghijklmnopq123

6/8 Stone Sans

It was the best of times, it was the worst of times, it was the age of wisdom, it was the age of foolishness, it was the epoch of belief, it was the epoch of incredulity, it was the season of light, it was the season of darkness, it was the spring of hope, it was the winter of despair, we had everything before us, we had nothing before us, we were all going direct to Heaven, we were all going direct the other way-in short, the period was so far like the present period, that some of its noisiest authorities insisted on its being received, for good or for evil,

8/10 Stone Sans

It was the best of times, it was the worst of times, it was the age of wisdom, it was the age of foolishness, it was the epoch of belief, it was the epoch of incredulity, it was the season of light, it was the season of darkness, it was the spring of hope, it was the winter of despair, we had everything before us, we had nothing before us, we were all going direct to Heaven, we were all going direct the other way-in

9/10 Stone Sans

It was the best of times, it was the worst of times, it was the age of wisdom, it was the age of foolishness, it was the epoch of belief, it was the epoch of incredulity, it was the season of light, it was the season of darkness, it was the spring of hope, it was the winter of despair, we had everything before us, we had nothing before us, we were all going direct to Heaven,

9/11 Stone Sans

It was the best of times, it was the worst of times, it was the age of wisdom, it was the age of foolishness, it was the epoch of belief, it was the epoch of incredulity, it was the season of light, it was the season of darkness, it was the spring of hope, it was the winter of despair, we had everything before us, we had nothing before us, we were all going direct to Heaven,

10/11 Stone Sans

It was the best of times, it was the worst of times, it was the age of wisdom, it was the age of foolishness, it was the epoch of belief, it was the epoch of incredulity, it was the season of light, it was the season of darkness, it was the spring of hope, it was the winter of despair, we had everything before us, we had nothing before us,

10/12 Stone Sans

It was the best of times, it was the worst of times, it was the age of wisdom, it was the age of foolishness, it was the epoch of belief, it was the epoch of incredulity, it was the season of light, it was the season of darkness, it was the spring of hope, it was the winter of despair, we had everything before us, we had nothing before us,

11/13 Stone Sans

It was the best of times, it was the worst of times, it was the age of wisdom, it was the age of foolishness, it was the epoch of belief, it was the epoch of incredulity, it was the season of light, it was the season of darkness, it was the spring of hope, it was the winter of despair, we had everything before us, we had

11/14 Stone Sans

It was the best of times, it was the worst of times, it was the age of wisdom, it was the age of foolishness, it was the epoch of belief, it was the epoch of incredulity, it was the season of light, it was the season of darkness, it was the spring of hope, it was the winter of despair, we had everything before us, we had

12/13 Stone Sans

It was the best of times, it was the worst of times, it was the age of wisdom, it was the age of foolishness, it was the epoch of belief, it was the epoch of incredulity, it was the season of light, it was the season of darkness, it was the spring of hope, it was the winter of despair,

12/14 Stone Sans

It was the best of times, it was the worst of times, it was the age of wisdom, it was the age of foolishness, it was the epoch of belief, it was the epoch of incredulity, it was the season of light, it was the season of darkness, it was the spring of hope, it was the winter of despair,

13/15 Stone Sans

It was the best of times, it was the worst of times, it was the age of wisdom, it was the age of foolishness, it was the epoch of belief, it was the epoch of incredulity, it was the season of light, it was the season of darkness, it was the spring of hope, it was the winter of despair,

14/15 Stone Sans

It was the best of times, it was the worst of times, it was the age of wisdom, it was the age of foolishness, it was the epoch of belief, it was the epoch of incredulity, it was the season of light, it was the season of darkness, it was the spring of

14/16 Stone Sans

It was the best of times, it was the worst of times, it was the age of wisdom, it was the age of foolishness, it was the epoch of belief, it was the epoch of incredulity, it was the season of light, it was the season of darkness, it was the spring of

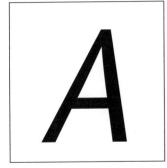

Stone Sans Italic 72 point

ABCDEFGHIJKLM
NOPQRSTUVW
XYZ abcdefghijkl
mnopqrstuvwxyz
1234567890
?!/&$%#@""..*
.,.,

Stone Sans Italic 10 point

ABCDEFGHIJKLMNOPQRSTUVWXYZ abcdefghij
klmnopqrstuvwxyz 1234567890 ?!/&$%#@*""";.,

Stone Sans Italic 12 point

ABCDEFGHIJKLMNOPQRSTUVWXYZ abcdefghij
klmnopqrstuvwxyz 1234567890 ?!/&$%#@*""";.,

Stone Sans Italic 13 point

ABCDEFGHIJKLMNOPQRSTUVWXYZ abcdefghij
klmnopqrstuvwxyz 1234567890 ?!/&$%#@*""";.,

Stone Sans Italic 14 point

ABCDEFGHIJKLMNOPQRSTUVWXYZ abcdefghij
klmnopqrstuvwxyz 1234567890 ?!/&$%#@*""";.,

Stone Sans Italic 16 point

ABCDEFGHIJKLMNOPQRSTUVWXYZ abcdefghij
klmnopqrstuvwxyz 1234567890 ?!/&$%#@*""";.,

Stone Sans Italic 18 point

ABCDEFGHIJKLMNOPQRSTUVWXYZ abcdefghij
klmnopqrstuvwxyz 1234567890 ?!/&$%#@*""";.,

Stone Sans Italic 20 point

ABCDEFGHIJKLMNOPQRSTUVWXYZ abcdefghij
klmnopqrstuvwxyz 1234567890 ?!/&$%#@*""";.,

Stone Sans Italic 22 point

ABCDEFGHIJKLMNOPQRSTUVWXYZ abcdefghij
klmnopqrstuvwxyz 1234567890 ?!/&$%#@*""";.,

Stone Sans Italic 24 points

ABCDEFGHIJKLMNOPQRSTUVWXYZ
abcdefghijklmnopqrstuvwxyz 1234567890 !?%&

Stone Sans Italic 30 point

ABCDEFGHIJKLMNOPQRSTUVWXYZ
abcdefghijklmnopqrstuvwxyz 1234567890

Stone Sans Italic 36 point

ABCDEFGHIJKLMNOPQRSTUVWXZ
abcdefghijklmnopqrstuvwxy 123456

Stone Sans Italic 48 point

ABCDEFGHIJKLMNOPQRRS
abcdefghijklmnopqrstu 123

Stone Sans Italic 60 point

ABCDEFGHIJKLMNOP
abcdefghijklmnopqr 123

6/8 Stone Sans Italic

It was the best of times, it was the worst of times, it was the age of wisdom, it was the age of foolishness, it was the epoch of belief, it was the epoch of incredulity, it was the season of light, it was the season of darkness, it was the spring of hope, it was the winter of despair, we had everything before us, we had nothing before us, we were all going direct to Heaven, we were all going direct the other way-in short, the period was so far like the present period, that some of its noisiest authorities insisted on its being received, for good or for evil, in the superlative degree

8/10 Stone Sans Italic

It was the best of times, it was the worst of times, it was the age of wisdom, it was the age of foolishness, it was the epoch of belief, it was the epoch of incredulity, it was the season of light, it was the season of darkness, it was the spring of hope, it was the winter of despair, we had everything before us, we had nothing before us, we were all going direct to Heaven, we were all going direct the other way-in short, the period was so far

9/10 Stone Sans Italic

It was the best of times, it was the worst of times, it was the age of wisdom, it was the age of foolishness, it was the epoch of belief, it was the epoch of incredulity, it was the season of light, it was the season of darkness, it was the spring of hope, it was the winter of despair, we had everything before us, we had nothing before us, we were all going direct to Heaven, we were all

9/11 Stone Sans Italic

It was the best of times, it was the worst of times, it was the age of wisdom, it was the age of foolishness, it was the epoch of belief, it was the epoch of incredulity, it was the season of light, it was the season of darkness, it was the spring of hope, it was the winter of despair, we had everything before us, we had nothing before us, we were all going direct to Heaven, we were all

10/11 Stone Sans Italic

It was the best of times, it was the worst of times, it was the age of wisdom, it was the age of foolishness, it was the epoch of belief, it was the epoch of incredulity, it was the season of light, it was the season of darkness, it was the spring of hope, it was the winter of despair, we had everything before us, we had nothing before us, we were all going

10/12 Stone Sans Italic

It was the best of times, it was the worst of times, it was the age of wisdom, it was the age of foolishness, it was the epoch of belief, it was the epoch of incredulity, it was the season of light, it was the season of darkness, it was the spring of hope, it was the winter of despair, we had everything before us, we had nothing before us, we were all going

11/13 Stone Sans Italic

It was the best of times, it was the worst of times, it was the age of wisdom, it was the age of foolishness, it was the epoch of belief, it was the epoch of incredulity, it was the season of light, it was the season of darkness, it was the spring of hope, it was the winter of despair, we had everything before us, we had

11/14 Stone Sans Italic

It was the best of times, it was the worst of times, it was the age of wisdom, it was the age of foolishness, it was the epoch of belief, it was the epoch of incredulity, it was the season of light, it was the season of darkness, it was the spring of hope, it was the winter of despair, we had everything before us, we had nothing before us,

12/13 Stone Sans Italic

It was the best of times, it was the worst of times, it was the age of wisdom, it was the age of foolishness, it was the epoch of belief, it was the epoch of incredulity, it was the season of light, it was the season of darkness, it was the spring of hope, it was the winter of despair, we had everything before us, we

12/14 Stone Sans Italic

It was the best of times, it was the worst of times, it was the age of wisdom, it was the age of foolishness, it was the epoch of belief, it was the epoch of incredulity, it was the season of light, it was the season of darkness, it was the spring of hope, it was the winter of despair, we had everything before us, we

13/15 Stone Sans Italic

It was the best of times, it was the worst of times, it was the age of wisdom, it was the age of foolishness, it was the epoch of belief, it was the epoch of incredulity, it was the season of light, it was the season of darkness, it was the spring of hope, it was

14/15 Stone Sans Italic

It was the best of times, it was the worst of times, it was the age of wisdom, it was the age of foolishness, it was the epoch of belief, it was the epoch of incredulity, it was the season of light, it was the season of darkness, it was the spring of

14/16 Stone Sans Italic

It was the best of times, it was the worst of times, it was the age of wisdom, it was the age of foolishness, it was the epoch of belief, it was the epoch of incredulity, it was the season of light, it was the season of darkness, it was the spring of

Stone Sans Bold 72 point

ABCDEFGHIJK
LMNOPQRSTUV
WXYZabcdefg
hijklmnopqrst
uvwxyz123456
7890?!&$%#@*

Stone Sans Bold 10 point

**ABCDEFGHIJKLMNOPQRSTUVWXYZ abcdefghij
klmnopqrstuvwxyz 1234567890 ?!/&$%#@*""";:.,**

Stone Sans Bold 12 point

**ABCDEFGHIJKLMNOPQRSTUVWXYZ abcdefghij
klmnopqrstuvwxyz 1234567890 ?!/&$%#@*""";:.,**

Stone Sans Bold 13 point

**ABCDEFGHIJKLMNOPQRSTUVWXYZ abcdefghij
klmnopqrstuvwxyz 1234567890 ?!/&$%#@*""";:.,**

Stone Sans Bold 14 point

**ABCDEFGHIJKLMNOPQRSTUVWXYZ abcdefghij
klmnopqrstuvwxyz 1234567890 ?!/&$%#@*""";:.,**

Stone Sans Bold 16 point

**ABCDEFGHIJKLMNOPQRSTUVWXYZ abcdefghij
klmnopqrstuvwxyz 1234567890 ?!/&$%#@*""";:.,**

Stone Sans Bold 18 point

**ABCDEFGHIJKLMNOPQRSTUVWXYZ abcdefghij
klmnopqrstuvwxyz 1234567890 ?!/&$%#@*""";:.,**

Stone Sans Bold 20 point

**ABCDEFGHIJKLMNOPQRSTUVWXYZ abcdefghij
klmnopqrstuvwxyz 1234567890 ?!/&$%#@*""";:.,**

Stone Sans Bold 22 point

**ABCDEFGHIJKLMNOPQRSTUVWXYZ abcdefghj
klmnopqrstuvwxyz 1234567890 ?!/&$%#@*""**

Stone Sans Bold 24 point

ABCDEFGHIJKLMNOPQRSTUVWXYZ
abcdefghijklmnopqrstuvwxyz 1234567890

Stone Sans Bold 30 point

ABCDEFGHIJKLMNOPQRSTUVWXYZ
abcdefghijklmnopqrstuvwxy 123456

Stone Sans Bold 36 point

ABCDEFGHIJKLMNOPQRSTUVW
abcdefghijklmnopqrstuvw123

Stone Sans Bold 48 point

ABCDEFGHIJKLMNOPQ
abcdefghijklmnop 123

Stone Sans Bold 60 point

ABCDEFGHIJKLMN
abcdefghijklm 12

6/8 Stone Sans Bold

It was the best of times, it was the worst of times, it was the age of wisdom, it was the age of foolishness, it was the epoch of belief, it was the epoch of incredulity, it was the season of light, it was the season of darkness, it was the spring of hope, it was the winter of despair, we had everything before us, we had nothing before us, we were all going direct to Heaven, we were all going direct the other way-in short, the period was so far like the present period,

8/10 Stone Sans Bold

It was the best of times, it was the worst of times, it was the age of wisdom, it was the age of foolishness, it was the epoch of belief, it was the epoch of incredulity, it was the season of light, it was the season of darkness, it was the spring of hope, it was the winter of despair, we had everything before us, we had nothing before us, we were all going

9/10 Stone Sans Bold

It was the best of times, it was the worst of times, it was the age of wisdom, it was the age of foolishness, it was the epoch of belief, it was the epoch of incredulity, it was the season of light, it was the season of darkness, it was the spring of hope, it was the winter of despair, we had everything before us, we had

9/11 Stone Sans Bold

It was the best of times, it was the worst of times, it was the age of wisdom, it was the age of foolishness, it was the epoch of belief, it was the epoch of incredulity, it was the season of light, it was the season of darkness, it was the spring of hope, it was the winter of despair, we had everything before us, we had

10/11 Stone Sans Bold

It was the best of times, it was the worst of times, it was the age of wisdom, it was the age of foolishness, it was the epoch of belief, it was the epoch of incredulity, it was the season of light, it was the season of darkness, it was the spring of hope, it was the winter of despair, we

10/12 Stone Sans Bold

It was the best of times, it was the worst of times, it was the age of wisdom, it was the age of foolishness, it was the epoch of belief, it was the epoch of incredulity, it was the season of light, it was the season of darkness, it was the spring of hope, it was the winter of despair, we

11/13 Stone Sans Bold

It was the best of times, it was the worst of times, it was the age of wisdom, it was the age of foolishness, it was the epoch of belief, it was the epoch of incredulity, it was the season of light, it was the season of darkness, it was the spring of hope, it was

11/14 Stone Sans Bold

It was the best of times, it was the worst of times, it was the age of wisdom, it was the age of foolishness, it was the epoch of belief, it was the epoch of incredulity, it was the season of light, it was the season of darkness, it was the spring of hope, it was

12/13 Stone Sans Bold

It was the best of times, it was the worst of times, it was the age of wisdom, it was the age of foolishness, it was the epoch of belief, it was the epoch of incredulity, it was the season of light, it was the season of darkness, it was the

12/14 Stone Sans Bold

It was the best of times, it was the worst of times, it was the age of wisdom, it was the age of foolishness, it was the epoch of belief, it was the epoch of incredulity, it was the season of light, it was the season of darkness, it was the

13/15 Stone Sans Bold

It was the best of times, it was the worst of times, it was the age of wisdom, it was the age of foolishness, it was the epoch of belief, it was the epoch of incredulity, it was the season of light, it was the season of

14/15 Stone Sans Bold

It was the best of times, it was the worst of times, it was the age of wisdom, it was the age of foolishness, it was the epoch of belief, it was the epoch of incredulity, it was the season of light, it was the

14/16 Stone Sans Bold

It was the best of times, it was the worst of times, it was the age of wisdom, it was the age of foolishness, it was the epoch of belief, it was the epoch of incredulity, it was the season of light, it was the

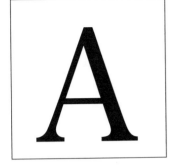

Stone Serif 72 point

ABCDEFGHIJKL
MNOPQRSTUV
WXYZ abcdefghij
klmnopqrstuvw
xyz 1234567890
?!/&$%#@*""..;.,

Stone Serif 10 point

ABCDEFGHIJKLMNOPQRSTUVWXYZ abcdefghij
klmnopqrstuvwxyz 1234567890 ?!/&$%#@*""":.,

Stone Serif 45 12 point

ABCDEFGHIJKLMNOPQRSTUVWXYZ abcdefghij
klmnopqrstuvwxyz 1234567890 ?!/&$%#@*""":.,

Stone Serif 13 point

ABCDEFGHIJKLMNOPQRSTUVWXYZ abcdefghij
klmnopqrstuvwxyz 1234567890 ?!/&$%#@*""":.,

Stone Serif 14 point

ABCDEFGHIJKLMNOPQRSTUVWXYZ abcdefghij
klmnopqrstuvwxyz 1234567890 ?!/&$%#@*""":.,

Stone Serif 16 point

ABCDEFGHIJKLMNOPQRSTUVWXYZ abcdefghij
klmnopqrstuvwxyz 1234567890 ?!/&$%#@*""":.,

Stone Serif 18 point

ABCDEFGHIJKLMNOPQRSTUVWXYZ abcdefghij
klmnopqrstuvwxyz 1234567890 ?!/&$%#@*""":.,

Stone Serif 20 point

ABCDEFGHIJKLMNOPQRSTUVWXYZ abcdefghij
klmnopqrstuvwxyz 1234567890 ?!/&$%#@*""":.,

Stone Serif 22 point

ABCDEFGHIJKLMNOPQRSTUVWXYZ abcdefghij
klmnopqrstuvwxyz 1234567890 ?!/&$%#@*""":.,

Stone Serif 24 point

ABCDEFGHIJKLMNOPQRSTUVWXYZ
abcdefghijklmnopqrstuvwxyz 1234567890 !?%&*

Stone Serif 30 point

ABCDEFGHIJKLMNOPQRSTUVWXYZ
abcdefghijklmnopqrstuvwxyz 12345678

Stone Serif 36 point

ABCDEFGHIJKLMNOPQRSTUVW
abcdefghijklmnopqrstuvwxyz 123

Stone Serif 48 point

ABCDEFGHIJKLMNOPQRS
abcdefghijklmnopqrstu 123

Stone Serif 60 point

ABCDEFGHIJKLMNO
abcdefghijklmnop 123

6/8 Stone Serif

It was the best of times, it was the worst of times, it was the age of wisdom, it was the age of foolishness, it was the epoch of belief, it was the epoch of incredulity, it was the season of light, it was the season of darkness, it was the spring of hope, it was the winter of despair, we had everything before us, we had nothing before us, we were all going direct to Heaven, we were all going direct the other way-in short, the period was so far like the present period, that some of its noisiest authorities insisted on its being

8/10 Stone Serif

It was the best of times, it was the worst of times, it was the age of wisdom, it was the age of foolishness, it was the epoch of belief, it was the epoch of incredulity, it was the season of light, it was the season of darkness, it was the spring of hope, it was the winter of despair, we had everything before us, we had nothing before us, we were all going direct to Heaven, we were all going

9/10 Stone Serif

It was the best of times, it was the worst of times, it was the age of wisdom, it was the age of foolishness, it was the epoch of belief, it was the epoch of incredulity, it was the season of light, it was the season of darkness, it was the spring of hope, it was the winter of despair, we had everything before us, we had nothing before us, we were all going

9/11 Stone Serif

It was the best of times, it was the worst of times, it was the age of wisdom, it was the age of foolishness, it was the epoch of belief, it was the epoch of incredulity, it was the season of light, it was the season of darkness, it was the spring of hope, it was the winter of despair, we had everything before us, we had nothing before us, we were all going

10/11 Stone Serif

It was the best of times, it was the worst of times, it was the age of wisdom, it was the age of foolishness, it was the epoch of belief, it was the epoch of incredulity, it was the season of light, it was the season of darkness, it was the spring of hope, it was the winter of despair, we had everything before us, we had

10/12 Stone Serif

It was the best of times, it was the worst of times, it was the age of wisdom, it was the age of foolishness, it was the epoch of belief, it was the epoch of incredulity, it was the season of light, it was the season of darkness, it was the spring of hope, it was the winter of despair, we had everything before us, we had

11/13 Stone Serif

It was the best of times, it was the worst of times, it was the age of wisdom, it was the age of foolishness, it was the epoch of belief, it was the epoch of incredulity, it was the season of light, it was the season of darkness, it was the spring of hope, it was the winter of despair, we had everything before

11/14 Stone Serif

It was the best of times, it was the worst of times, it was the age of wisdom, it was the age of foolishness, it was the epoch of belief, it was the epoch of incredulity, it was the season of light, it was the season of darkness, it was the spring of hope, it was the winter of despair, we had everything before

12/13 Stone Serif

It was the best of times, it was the worst of times, it was the age of wisdom, it was the age of foolishness, it was the epoch of belief, it was the epoch of incredulity, it was the season of light, it was the season of darkness, it was the spring of hope, it was the winter of despair,

12/14 Stone Serif

It was the best of times, it was the worst of times, it was the age of wisdom, it was the age of foolishness, it was the epoch of belief, it was the epoch of incredulity, it was the season of light, it was the season of darkness, it was the spring of hope, it was the winter of despair,

13/15 Stone Serif

It was the best of times, it was the worst of times, it was the age of wisdom, it was the age of foolishness, it was the epoch of belief, it was the epoch of incredulity, it was the season of light, it was the season of darkness, it was the spring of hope, it was

14/15 Stone Serif

It was the best of times, it was the worst of times, it was the age of wisdom, it was the age of foolishness, it was the epoch of belief, it was the epoch of incredulity, it was the season of light, it was the season of darkness, it was the spring

14/16 Stone Serif

It was the best of times, it was the worst of times, it was the age of wisdom, it was the age of foolishness, it was the epoch of belief, it was the epoch of incredulity, it was the season of light, it was the season of darkness, it was the spring

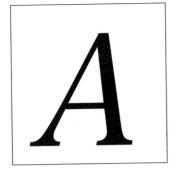

Stone Serif Italic 72 point

ABCDEFGHIJKLM
NOPQRSTUVW
XYZ abcdefghijkl
mnopqrstuvwxyz
1234567890
?!/&$%#@""·,·,*

Stone Serif Italic 10 point

ABCDEFGHIJKLMNOPQRSTUVWXYZ abcdefghij
klmnopqrstuvwxyz 1234567890 ?!/&$%#@"":;.,*

Stone Serif Italic 12 point

ABCDEFGHIJKLMNOPQRSTUVWXYZ abcdefghij
klmnopqrstuvwxyz 1234567890 ?!/&$%#@"":;.,*

Stone Serif Italic 13 point

ABCDEFGHIJKLMNOPQRSTUVWXYZ abcdefghij
klmnopqrstuvwxyz 1234567890 ?!/&$%#@"":;.,*

Stone Serif Italic 14 point

ABCDEFGHIJKLMNOPQRSTUVWXYZ abcdefghij
klmnopqrstuvwxyz 1234567890 ?!/&$%#@"":;.,*

Stone Serif Italic 16 point

ABCDEFGHIJKLMNOPQRSTUVWXYZ abcdefghij
klmnopqrstuvwxyz 1234567890 ?!/&$%#@"":;.,*

Stone Serif Italic 18 point

ABCDEFGHIJKLMNOPQRSTUVWXYZ abcdefghij
klmnopqrstuvwxyz 1234567890 ?!/&$%#@"":;.,*

Stone Serif Italic 20 point

ABCDEFGHIJKLMNOPQRSTUVWXYZ abcdefghij
klmnopqrstuvwxyz 1234567890 ?!/&$%#@"":;.,*

Stone Serif Italic 22 point

ABCDEFGHIJKLMNOPQRSTUVWXYZ abcdefghij
klmnopqrstuvwxyz 1234567890 ?!/&$%#@"":;.,*

Stone Serif Italic 24 point

ABCDEFGHIJKLMNOPQRSTUVWXYZ
abcdefghijklmnopqrstuvwxyz 1234567890 !?%&

Stone Serif Italic 30 point

ABCDEFGHIJKLMNOPQRSTUVWXYZ
abcdefghijklmnopqrstuvwxyz 1234567890

Stone Serif Italic 36 point

ABCDEFGHIJKLMNOPQRSTUVWXZ
abcdefghijklmnopqrstuvwxy 1234567890

Stone Serif Italic 48 point

ABCDEFGHIJKLMNOPQR
abcdefghijklmnopqrstu 12

Stone Serif Italic 60 point

ABCDEFGHIJKLMNOP
abcdefghijklmnopq 123

6/8 Stone Serif Italic

It was the best of times, it was the worst of times, it was the age of wisdom, it was the age of foolishness, it was the epoch of belief, it was the epoch of incredulity, it was the season of light, it was the season of darkness, it was the spring of hope, it was the winter of despair, we had everything before us, we had nothing before us, we were all going direct to Heaven, we were all going direct the other way-in short, the period was so far like the present period, that some of its noisiest authorities insisted on its being received, for good or for evil, in the superlative

8/10 Stone Serif Italic

It was the best of times, it was the worst of times, it was the age of wisdom, it was the age of foolishness, it was the epoch of belief, it was the epoch of incredulity, it was the season of light, it was the season of darkness, it was the spring of hope, it was the winter of despair, we had everything before us, we had nothing before us, we were all going direct to Heaven, we were all going direct the other way-in short, the

9/10 Stone Serif Italic

It was the best of times, it was the worst of times, it was the age of wisdom, it was the age of foolishness, it was the epoch of belief, it was the epoch of incredulity, it was the season of light, it was the season of darkness, it was the spring of hope, it was the winter of despair, we had everything before us, we had nothing before us, we were all going direct to Heaven, we were all

9/11 Stone Serif Italic

It was the best of times, it was the worst of times, it was the age of wisdom, it was the age of foolishness, it was the epoch of belief, it was the epoch of incredulity, it was the season of light, it was the season of darkness, it was the spring of hope, it was the winter of despair, we had everything before us, we had nothing before us, we were all going direct to Heaven, we were all

10/11 Stone Serif Italic

It was the best of times, it was the worst of times, it was the age of wisdom, it was the age of foolishness, it was the epoch of belief, it was the epoch of incredulity, it was the season of light, it was the season of darkness, it was the spring of hope, it was the winter of despair, we had everything before us, we had nothing before us, we

10/12 Stone Serif Italic

It was the best of times, it was the worst of times, it was the age of wisdom, it was the age of foolishness, it was the epoch of belief, it was the epoch of incredulity, it was the season of light, it was the season of darkness, it was the spring of hope, it was the winter of despair, we had everything before us, we had nothing before us, we

11/13 Stone Serif Italic

It was the best of times, it was the worst of times, it was the age of wisdom, it was the age of foolishness, it was the epoch of belief, it was the epoch of incredulity, it was the season of light, it was the season of darkness, it was the spring of hope, it was the winter of despair, we had everything before us, we

11/14 Stone Serif Italic

It was the best of times, it was the worst of times, it was the age of wisdom, it was the age of foolishness, it was the epoch of belief, it was the epoch of incredulity, it was the season of light, it was the season of darkness, it was the spring of hope, it was the winter of despair, we had everything before us, we had nothing before

12/13 Stone Serif Italic

It was the best of times, it was the worst of times, it was the age of wisdom, it was the age of foolishness, it was the epoch of belief, it was the epoch of incredulity, it was the season of light, it was the season of darkness, it was the spring of hope, it was the winter of despair, we had everything before us, we

12/14 Stone Serif Italic

It was the best of times, it was the worst of times, it was the age of wisdom, it was the age of foolishness, it was the epoch of belief, it was the epoch of incredulity, it was the season of light, it was the season of darkness, it was the spring of hope, it was the winter of despair, we had everything before us, we

13/15 Stone Serif Italic

It was the best of times, it was the worst of times, it was the age of wisdom, it was the age of foolishness, it was the epoch of belief, it was the epoch of incredulity, it was the season of light, it was the season of darkness, it was the spring of hope, it was

14/15 Stone Serif Italic

It was the best of times, it was the worst of times, it was the age of wisdom, it was the age of foolishness, it was the epoch of belief, it was the epoch of incredulity, it was the season of light, it was the season of darkness, it was the spring of

14/16 Stone Serif Italic

It was the best of times, it was the worst of times, it was the age of wisdom, it was the age of foolishness, it was the epoch of belief, it was the epoch of incredulity, it was the season of light, it was the season of darkness, it was the spring of

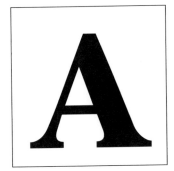

Stone Serif Bold 72 point

ABCDEFGHIJK
LMNOPQRSTU
VWXYZabcdefg
hijklmnopqrst
uvwxyz 123456
7890?!&$%#@*

Stone Serif Bold 10 point

ABCDEFGHIJKLMNOPQRSTUVWXYZ abcdefghij
klmnopqrstuvwxyz 1234567890 ?!/&$%#@*""":;.,

Stone Serif Bold 12 point

ABCDEFGHIJKLMNOPQRSTUVWXYZ abcdefghij
klmnopqrstuvwxyz 1234567890 ?!/&$%#@*""":;.,

Stone Serif Bold 13 point

ABCDEFGHIJKLMNOPQRSTUVWXYZ abcdefghij
klmnopqrstuvwxyz 1234567890 ?!/&$%#@*""":;.,

Stone Serif Bold 14 point

ABCDEFGHIJKLMNOPQRSTUVWXYZ abcdefghij
klmnopqrstuvwxyz 1234567890 ?!/&$%#@*""":;.,

Stone Serif Bold 16 point

ABCDEFGHIJKLMNOPQRSTUVWXYZ abcdefghij
klmnopqrstuvwxyz 1234567890 ?!/&$%#@*""":;.,

Stone Serif Bold 18 point

ABCDEFGHIJKLMNOPQRSTUVWXYZ abcdefghij
klmnopqrstuvwxyz 1234567890 ?!/&$%#@*""":;.,

Stone Serif Bold 20 point

ABCDEFGHIJKLMNOPQRSTUVWXYZ abcdefghij
klmnopqrstuvwxyz 1234567890 ?!/&$%#@*""":;.,

Stone Serif Bold 22 point

ABCDEFGHIJKLMNOPQRSTUVWXYZ abcdefghj
klmnopqrstuvwxyz 1234567890 ?!/&$%#@*""

Stone Serif Bold 24 point

ABCDEFGHIJKLMNOPQRSTUVWXYZ
abcdefghijklmnopqrstuvwxyz 1234567890

Stone Serif Bold 30 point

ABCDEFGHIJKLMNOPQRSTUVWX
abcdefghijklmnopqrstuvwxy 1234

Stone Serif Bold 36 point

ABCDEFGHIJKLMNOPQRSTU
abcdefghijklmnopqrstuv 123

Stone Serif Bold 48 point

ABCDEFGHIJKLMNOP
abcdefghijklmnop 12

Stone Serif Bold 60 point

ABCDEFGHIJKLM
abcdefghijklmn 12

6/8 Stone Serif Bold

It was the best of times, it was the worst of times, it was the age of wisdom, it was the age of foolishness, it was the epoch of belief, it was the epoch of incredulity, it was the season of light, it was the season of darkness, it was the spring of hope, it was the winter of despair, we had everything before us, we had nothing before us, we were all going direct to Heaven, we were all going direct the other way-in short, the period was so far

8/10 Stone Serif Bold

It was the best of times, it was the worst of times, it was the age of wisdom, it was the age of foolishness, it was the epoch of belief, it was the epoch of incredulity, it was the season of light, it was the season of darkness, it was the spring of hope, it was the winter of despair, we had everything before us, we had nothing before us, we

9/10 Stone Serif Bold

It was the best of times, it was the worst of times, it was the age of wisdom, it was the age of foolishness, it was the epoch of belief, it was the epoch of incredulity, it was the season of light, it was the season of darkness, it was the spring of hope, it was the winter of despair, we had everything before us, we

9/11 Stone Serif Bold

It was the best of times, it was the worst of times, it was the age of wisdom, it was the age of foolishness, it was the epoch of belief, it was the epoch of incredulity, it was the season of light, it was the season of darkness, it was the spring of hope, it was the winter of despair, we had everything before us, we

10/11 Stone Serif Bold

It was the best of times, it was the worst of times, it was the age of wisdom, it was the age of foolishness, it was the epoch of belief, it was the epoch of incredulity, it was the season of light, it was the season of darkness, it was the spring of hope, it was the winter

10/12 Stone Serif Bold

It was the best of times, it was the worst of times, it was the age of wisdom, it was the age of foolishness, it was the epoch of belief, it was the epoch of incredulity, it was the season of light, it was the season of darkness, it was the spring of hope, it was the winter

11/13 Stone Serif Bold

It was the best of times, it was the worst of times, it was the age of wisdom, it was the age of foolishness, it was the epoch of belief, it was the epoch of incredulity, it was the season of light, it was the season of darkness, it was the spring

11/14 Stone Serif Bold

It was the best of times, it was the worst of times, it was the age of wisdom, it was the age of foolishness, it was the epoch of belief, it was the epoch of incredulity, it was the season of light, it was the season of darkness, it was the spring

12/13 Stone Serif Bold

It was the best of times, it was the worst of times, it was the age of wisdom, it was the age of foolishness, it was the epoch of belief, it was the epoch of incredulity, it was the season of light, it was the season of darkness,

12/14 Stone Serif Bold

It was the best of times, it was the worst of times, it was the age of wisdom, it was the age of foolishness, it was the epoch of belief, it was the epoch of incredulity, it was the season of light, it was the season of darkness,

13/15 Stone Serif Bold

It was the best of times, it was the worst of times, it was the age of wisdom, it was the age of foolishness, it was the epoch of belief, it was the epoch of incredulity, it was the season of light, it was the season

14/15 Stone Serif Bold

It was the best of times, it was the worst of times, it was the age of wisdom, it was the age of foolishness, it was the epoch of belief, it was the epoch of incredulity, it was the season

14/16 Stone Serif Bold

It was the best of times, it was the worst of times, it was the age of wisdom, it was the age of foolishness, it was the epoch of belief, it was the epoch of incredulity, it was the season

ITC Tiffany Demi 72 point

ABCDEFGHIJK
LMNOPQRSTU
VWXYZ abcdefg
hijklmnopqrstu
vwxyz 12345678
90?&$%#@*""·,

ITC Tiffany Demi 10 point

ABCDEFGHIJKLMNOPQRSTUVWXYZ abcdefghij
klmnopqrstuvwxyz 1234567890 ?!/&$%#@*""":;.,

ITC Tiffany Demi 12 point

ABCDEFGHIJKLMNOPQRSTUVWXYZ abcdefghij
klmnopqrstuvwxyz 1234567890 ?!/&$%#@*""":;.,

ITC Tiffany Demi 13 point

ABCDEFGHIJKLMNOPQRSTUVWXYZ abcdefghij
klmnopqrstuvwxyz 1234567890 ?!/&$%#@*""":;.,

ITC Tiffany Demi 14 point

ABCDEFGHIJKLMNOPQRSTUVWXYZ abcdefghij
klmnopqrstuvwxyz 1234567890 ?!/&$%#@*""":;.,

ITC Tiffany Demi 16 point

ABCDEFGHIJKLMNOPQRSTUVWXYZ abcdefghij
klmnopqrstuvwxyz 1234567890 ?!/&$%#@*""":;.,

ITC Tiffany Demi 18 point

ABCDEFGHIJKLMNOPQRSTUVWXYZ abcdefghij
klmnopqrstuvwxyz 1234567890 ?!/&$%#@*""":;.,

ITC Tiffany Demi 20 point

ABCDEFGHIJKLMNOPQRSTUVWXYZ abcdefghij
klmnopqrstuvwxyz 1234567890 ?!/&$%#@*""":;.,

ITC Tiffany Demi 22 point

ABCDEFGHIJKLMNOPQRSTUVWXYZ abcdefghij
klmnopqrstuvwxyz 1234567890 ?!/&$%#@*""":;.,

ITC Tiffany Demi 24 point

ABCDEFGHIJKLMNOPQRSTUVWXYZ
abcdefghijklmnopqrstuvwxyz1234567890!?%&*

ITC Tiffany Demi 30 point

ABCDEFGHIJKLMNOPQRSTUVWXZ
abcdefghijklmnopqrstuv 1234567890

ITC Tiffany Demi 36 point

ABCDEFGHIJKLMNOPQRSTU
abcdefghijklmnopqrstu 123456

ITC Tiffany Demi 48 point

ABCDEFGHIJKLMNOP
abcdefghijklmnopq1234

ITC Tiffany Demi 60 point

ABCDEFGHIJKLM
abcdefghijklmno 123

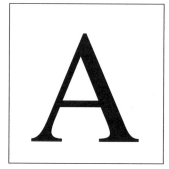

Times Roman 72 point

ABCDEFGHIJKL
MNOPQRSTUVW
XYZ abcdefghijkl
mnopqrstuvwxyz
1234567890
?!/&$%#@*""'':.,

Times Roman 10 point

ABCDEFGHIJKLMNOPQRSTUVWXYZ

abcdefghijklmnopqrstuvwxyz 1234567890 !?%&*

Times Roman 12 point

ABCDEFGHIJKLMNOPQRSTUVWXYZ

abcdefghijklmnopqrstuvwxyz 1234567890

Times Roman 13 point

ABCDEFGHIJKLMNOPQRSTUVWXYZ

abcdefghijklmnopqrstuvwxyz 1234567890

Times Roman 14 point

ABCDEFGHIJKLMNOPQRSTUVWXYZ

abcdefghijklmnopqrstuvwxyz 1234567890

Times Roman 16 point

ABCDEFGHIJKLMNOPQRSTUVWXYZ

abcdefghijklmnopqrstuvwxyz 1234567890

Times Roman 18 point

ABCDEFGHIJKLMNOPQRSTUVWXYZ

abcdefghijklmnopqrstuvwxyz 1234567890

Times Roman 20 point

ABCDEFGHIJKLMNOPQRSTUVWXYZ

abcdefghijklmnopqrstuvwxyz 1234567890

Times Roman 22 point

ABCDEFGHIJKLMNOPQRSTUVWXYZ

abcdefghijklmnopqrstuvwxyz 1234567890

Times Roman 24 point

ABCDEFGHIJKLMNOPQRSTUVWXYZ
abcdefghijklmnopqrstuvwxyz 1234567890

Times Roman 30 point

ABCDEFGHIJKLMNOPQRSTUVWXYZ
abcdefghijklmnopqrstuvwxyz 1234567890

Times Roman 36 point

ABCDEFGHIJKLMNOPQRSTUVW
abcdefghijklmnopqrstuvwxyz 123456

Times Roman 48 point

ABCDEFGHIJKLMNOPQR
abcdefghijklmnopqrstu 1234

Times Roman 60 point

ABCDEFGHIJKLMN
abcdefghijklmnopr 123

6/8 Times Roman

It was the best of times , it was the worst of times, it was the age of wisdom, it was the age of foolishness, it was the epoch of belief, it was the epoch of incredulity, it was the season of light, it was the season of darkness, it was the spring of hope, it was the winter of despair, we had everything before us, we had nothing before us, we were all going direct to Heaven, we were all going direct the other way-in short, the period was so far like the present period, that some of its noisiest authorities insisted on its being received, for good or for evil, in the superlative degree of comparison only.

8/10 Times Roman

It was the best of times, it was the worst of times, it was the age of wisdom, it was the age of foolishness, it was the epoch of belief, it was the epoch of incredulity, it was the season of light, it was the season of darkness, it was the spring of hope, it was the winter of despair, we had everything before us, we had nothing before us, we were all going direct to Heaven, we were all going direct the other way-in short, the period was so far like the present period,

9/10 Times Roman

It was the best of times, it was the worst of times, it was the age of wisdom, it was the age of foolishness, it was the epoch of belief, it was the epoch of incredulity, it was the season of light, it was the season of darkness, it was the spring of hope, it was the winter of despair, we had everything before us, we had nothing before us, we were all going direct to Heaven, we were all going

9/11 Times Roman

It was the best of times, it was the worst of times, it was the age of wisdom, it was the age of foolishness, it was the epoch of belief, it was the epoch of incredulity, it was the season of light, it was the season of darkness, it was the spring of hope, it was the winter of despair, we had everything before us, we had nothing before us, we were all going direct to Heaven, we were all going

10/11 Times Roman

It was the best of times, it was the worst of times, it was the age of wisdom, it was the age of foolishness, it was the epoch of belief, it was the epoch of incredulity, it was the season of light, it was the season of darkness, it was the spring of hope, it was the winter of despair, we had everything before us, we had nothing before us, we were all going direct

10/12 Times Roman

It was the best of times, it was the worst of times, it was the age of wisdom, it was the age of foolishness, it was the epoch of belief, it was the epoch of incredulity, it was the season of light, it was the season of darkness, it was the spring of hope, it was the winter of despair, we had everything before us, we had nothing before us, we were all going direct

11/13 Times Roman

It was the best of times, it was the worst of times, it was the age of wisdom, it was the age of foolishness, it was the epoch of belief, it was the epoch of incredulity, it was the season of light, it was the season of darkness, it was the spring of hope, it was the winter of despair, we had everything before us, we had nothing before us, we were all

11/14 Times Roman

It was the best of times, it was the worst of times, it was the age of wisdom, it was the age of foolishness, it was the epoch of belief, it was the epoch of incredulity, it was the season of light, it was the season of darkness, it was the spring of hope, it was the winter of despair, we had everything before us, we had nothing before us, we were all

12/13 Times Roman

It was the best of times, it was the worst of times, it was the age of wisdom, it was the age of foolishness, it was the epoch of belief, it was the epoch of incredulity, it was the season of light, it was the season of darkness, it was the spring of hope, it was the winter of despair, we had everything before us, we

12/14 Times Roman

It was the best of times, it was the worst of times, it was the age of wisdom, it was the age of foolishness, it was the epoch of belief, it was the epoch of incredulity, it was the season of light, it was the season of darkness, it was the spring of hope, it was the winter of despair, we had everything before us, we

13/15 Times Roman

It was the best of times, it was the worst of times, it was the age of wisdom, it was the age of foolishness, it was the epoch of belief, it was the epoch of incredulity, it was the season of light, it was the season of darkness, it was the spring of hope, it was the winter of despair, we

14/15 Times Roman

It was the best of times, it was the worst of times, it was the age of wisdom, it was the age of foolishness, it was the epoch of belief, it was the epoch of incredulity, it was the season of light, it was the season of darkness, it was the spring of hope, it was

14/16 Times Roman

It was the best of times, it was the worst of times, it was the age of wisdom, it was the age of foolishness, it was the epoch of belief, it was the epoch of incredulity, it was the season of light, it was the season of darkness, it was the spring of hope, it was

Times Italic 72 point

ABCDEFGHIJKL
MNOPQRSTUVW
XYZ abcdefghijkl
mnopqrstuvwxyz
1234567890
?!/&$%#@*""":;.,

Times Italic 10 point

ABCDEFGHIJKLMNOPQRSTUVWXYZ
*abcdefghijklmnopqrstuvwxyz 1234567890 !?%&**

Times Italic 12 point

ABCDEFGHIJKLMNOPQRSTUVWXYZ
abcdefghijklmnopqrstuvwxyz 1234567890

Times Italic13 point

ABCDEFGHIJKLMNOPQRSTUVWXYZ
abcdefghijklmnopqrstuvwxyz 1234567890

Times Italic 14 point

ABCDEFGHIJKLMNOPQRSTUVWXYZ
abcdefghijklmnopqrstuvwxyz 1234567890

Times Italic 16 point

ABCDEFGHIJKLMNOPQRSTUVWXYZ
abcdefghijklmnopqrstuvwxyz 1234567890

Times Italic 18 point

ABCDEFGHIJKLMNOPQRSTUVWXYZ
abcdefghijklmnopqrstuvwxyz 1234567890

Times Italic 20 point

ABCDEFGHIJKLMNOPQRSTUVWXYZ
abcdefghijklmnopqrstuvwxyz 1234567890

Times Italic 22 point

ABCDEFGHIJKLMNOPQRSTUVWXYZ
abcdefghijklmnopqrstuvwxyz 1234567890

Times Italic 24 point

ABCDEFGHIJKLMNOPQRSTUVWXYZ
abcdefghijklmnopqrstuvwxyz 1234567890 !?%&*

Times Italic 30 point

ABCDEFGHIJKLMNOPQRSTUVWXYZ
abcdefghijklmnopqrstuvwxyz 1234567890

Times Italic 36 point

ABCDEFGHIJKLMNOPQRSTUVWX
abcdefghijklmnopqrstuvwxyz 1234567

Times Italic 48 point

ABCDEFGHIJKLMNOPQR
abcdefghijklmnopqrstuv 123

Times Italic 60 point

ABCDEFGHIJKLMNO
abcdefghijklmnopq 123

Times Bold 72 point

ABCDEFGHIJKL
MNOPQRSTUV
WXYZ abcdefghij
klmnopqrstuvwx
yz 1234567890
?!/&$%#@*""".;.,

Times Bold 10 point

ABCDEFGHIJKLMNOPQRSTUVWXYZ
abcdefghijklmnopqrstuvwxyz 1234567890 !?%&*

Times Bold 12 point

ABCDEFGHIJKLMNOPQRSTUVWXYZ
abcdefghijklmnopqrstuvwxyz 1234567890

Times Bold 13 point

ABCDEFGHIJKLMNOPQRSTUVWXYZ
abcdefghijklmnopqrstuvwxyz 1234567890

Times Bold 14 point

ABCDEFGHIJKLMNOPQRSTUVWXYZ
abcdefghijklmnopqrstuvwxyz 1234567890

Times Bold 16 point

ABCDEFGHIJKLMNOPQRSTUVWXYZ
abcdefghijklmnopqrstuvwxyz 1234567890

Times Bold 18 point

ABCDEFGHIJKLMNOPQRSTUVWXYZ
abcdefghijklmnopqrstuvwxyz 1234567890

Times Bold 20 point

ABCDEFGHIJKLMNOPQRSTUVWXYZ
abcdefghijklmnopqrstuvwxyz 1234567890

Times Bold 22 point

ABCDEFGHIJKLMNOPQRSTUVWXYZ
abcdefghijklmnopqrstuvwxyz 1234567890

Times Bold 24 point

ABCDEFGHIJKLMNOPQRSTUVWXYZ
abcdefghijklmnopqrstuvwxyz 1234567890 !?%&*

Times Bold 30 point

ABCDEFGHIJKLMNOPQRSTUVWXYZ
abcdefghijklmnopqrstuvwxyz 1234567890

Times Bold 36 point

ABCDEFGHIJKLMNOPQRSTUV
abcdefghijklmnopqrstuvwxyz 12345

Times Bold 48 point

ABCDEFGHIJKLMNOPQ
abcdefghijklmnopqrstu 12

Times Bold 60 point

ABCDEFGHIJKLMN
abcdefghijklmnop 12

Times Bold Italic 72 point

ABCDEFGHIJKL

MNOPQRSTUV

WXYZ abcdefghij

klmnopqrstuvwx

yz 1234567890

?!/&$%#@""'';.,;.,*

Times Bold Italic 11 point

ABCDEFGHIJKLMNOPQRSTUVWXYZ
*abcdefghijklmnopqrstuvwxyz 1234567890 !?%&**

Times Bold Italic 12 point

ABCDEFGHIJKLMNOPQRSTUVWXYZ
abcdefghijklmnopqrstuvwxyz 1234567890

Times Bold Italic 13 point

ABCDEFGHIJKLMNOPQRSTUVWXYZ
abcdefghijklmnopqrstuvwxyz 1234567890

Times Bold Italic 14 point

ABCDEFGHIJKLMNOPQRSTUVWXYZ
abcdefghijklmnopqrstuvwxyz 1234567890

Times Bold Italic 16 point

ABCDEFGHIJKLMNOPQRSTUVWXYZ
abcdefghijklmnopqrstuvwxyz 1234567890

Times Bold Italic 18 point

ABCDEFGHIJKLMNOPQRSTUVWXYZ
abcdefghijklmnopqrstuvwxyz 1234567890

Times Bold Italic 20 point

ABCDEFGHIJKLMNOPQRSTUVWXYZ
abcdefghijklmnopqrstuvwxyz 1234567890

Times Bold Italic 22 point

ABCDEFGHIJKLMNOPQRSTUVWXYZ
abcdefghijklmnopqrstuvwxyz 1234567890

Times Bold Italic 24 point

ABCDEFGHIJKLMNOPQRSTUVWXYZ
*abcdefghijklmnopqrstuvwxyz 1234567890 !?%&***

Times Bold Italic 30 point

ABCDEFGHIJKLMNOPQRSTUVWXYZ
abcdefghijklmnopqrstuvwxyz 1234567890

Times Bold Italic 36 point

ABCDEFGHIJKLMNOPQRSTUVW
abcdefghijklmnopqrstuvwxyz 123456

Times Bold Italic 48 point

ABCDEFGHIJKLMNOPQ
abcdefghijklmnopqrstu 123

Times Bold Italic 60 point

ABCDEFGHIJKLMN
abcdefghijklmnopq 12

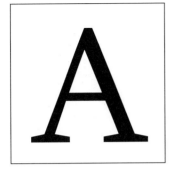

Trump Mediaeval 72 Point

ABCDEFGHIJKL
MNOPQRSTUV
WXYZ abcdefghij
klmnopqrstuvwx
yz 1234567890
?!/&$%#@★""·;·,

Trump Mediaeval 10 point

ABCDEFGHIJKLMNOPQRSTUVWXYZ abcdefghij
klmnopqrstuvwxyz 1234567890 ?!/&$%#@*"";.,

Trump Mediaeval 12 point

ABCDEFGHIJKLMNOPQRSTUVWXYZ abcdefghij
klmnopqrstuvwxyz 1234567890 ?!/&$%#@*"";.,

Trump Mediaeval 13 point

ABCDEFGHIJKLMNOPQRSTUVWXYZ abcdefghij
klmnopqrstuvwxyz 1234567890 ?!/&$%#@*"";.,

Trump Mediaeval 14 point

ABCDEFGHIJKLMNOPQRSTUVWXYZ abcdefghij
klmnopqrstuvwxyz 1234567890 ?!/&$%#@*"";.,

Trump Mediaeval 16 point

ABCDEFGHIJKLMNOPQRSTUVWXYZ abcdefghij
klmnopqrstuvwxyz 1234567890 ?!/&$%#@*"";.,

Trump Mediaeval 18 point

ABCDEFGHIJKLMNOPQRSTUVWXYZ abcdefghij
klmnopqrstuvwxyz 1234567890 ?!/&$%#@*"";.,

Trump Mediaeval 20 point

ABCDEFGHIJKLMNOPQRSTUVWXYZ abcdefghij
klmnopqrstuvwxyz 1234567890 ?!/&$%#@*"";.,

Trump Mediaeval 22 point

ABCDEFGHIJKLMNOPQRSTUVWXYZ abcdefghij
klmnopqrstuvwxyz 1234567890 ?!/&$%#@*"";.,

Trump Mediaeval 24 point

ABCDEFGHIJKLMNOPQRSTUVWXYZ
abcdefghijklmnopqrstuvwxyz 1234567890 !?%&*

Trump Mediaeval 30 point

ABCDEFGHIJKLMNOPQRSTUVWXYZ
abcdefghijklmnopqrstuvwxyz 1234567890

Trump Mediaeval 36 point

ABCDEFGHIJKLMNOPQRSTUV
abcdefghijklmnopqrstuvwx12345

Trump Mediaeval 48 point

ABCDEFGHIJKLMNOP
abcdefghijklmnopqrst123

Trump Mediaeval 60 point

ABCDEFGHIJKLM
abcdefghijklmno123

6/8 Trump Mediaeval

It was the best of times, it was the worst of times, it was the age of wisdom, it was the age of foolishness, it was the epoch of belief, it was the epoch of incredulity, it was the season of light, it was the season of darkness, it was the spring of hope, it was the winter of despair, we had everything before us, we had nothing before us, we were all going direct to Heaven, we were all going direct the other way-in short, the period was so far like the present period, that some of its noisiest authorities insisted on its being

8/10 Trump Mediaeval

It was the best of times, it was the worst of times, it was the age of wisdom, it was the age of foolishness, it was the epoch of belief, it was the epoch of incredulity, it was the season of light, it was the season of darkness, it was the spring of hope, it was the winter of despair, we had everything before us, we had nothing before us, we were all going direct to Heaven, we were all going direct

9/10 Trump Mediaeval

It was the best of times, it was the worst of times, it was the age of wisdom, it was the age of foolishness, it was the epoch of belief, it was the epoch of incredulity, it was the season of light, it was the season of darkness, it was the spring of hope, it was the winter of despair, we had everything before us, we had nothing before us, we were all going

9/11 Trump Mediaeval

It was the best of times, it was the worst of times, it was the age of wisdom, it was the age of foolishness, it was the epoch of belief, it was the epoch of incredulity, it was the season of light, it was the season of darkness, it was the spring of hope, it was the winter of despair, we had everything before us, we had nothing before us, we were all going

10/11 Trump Mediaeval

It was the best of times, it was the worst of times, it was the age of wisdom, it was the age of foolishness, it was the epoch of belief, it was the epoch of incredulity, it was the season of light, it was the season of darkness, it was the spring of hope, it was the winter of despair, we had everything before us, we had

10/12 Trump Mediaeval

It was the best of times, it was the worst of times, it was the age of wisdom, it was the age of foolishness, it was the epoch of belief, it was the epoch of incredulity, it was the season of light, it was the season of darkness, it was the spring of hope, it was the winter of despair, we had everything before us, we had

11/13 Trump Mediaeval

It was the best of times, it was the worst of times, it was the age of wisdom, it was the age of foolishness, it was the epoch of belief, it was the epoch of incredulity, it was the season of light, it was the season of darkness, it was the spring of hope, it was the winter of despair, we had everything before

11/14 Trump Mediaeval

It was the best of times, it was the worst of times, it was the age of wisdom, it was the age of foolishness, it was the epoch of belief, it was the epoch of incredulity, it was the season of light, it was the season of darkness, it was the spring of hope, it was the winter of despair, we had everything before

12/13 Trump Mediaeval

It was the best of times, it was the worst of times, it was the age of wisdom, it was the age of foolishness, it was the epoch of belief, it was the epoch of incredulity, it was the season of light, it was the season of darkness, it was the spring of hope, it was

12/14 Trump Mediaeval

It was the best of times, it was the worst of times, it was the age of wisdom, it was the age of foolishness, it was the epoch of belief, it was the epoch of incredulity, it was the season of light, it was the season of darkness, it was the spring of hope, it was

13/15 Trump Mediaeval

It was the best of times, it was the worst of times, it was the age of wisdom, it was the age of foolishness, it was the epoch of belief, it was the epoch of incredulity, it was the season of light, it was the season of darkness, it was the spring of

14/15 Trump Mediaeval

It was the best of times, it was the worst of times, it was the age of wisdom, it was the age of foolishness, it was the epoch of belief, it was the epoch of incredulity, it was the season of light, it was the season of darkness,

14/16 Trump Mediaeval

It was the best of times, it was the worst of times, it was the age of wisdom, it was the age of foolishness, it was the epoch of belief, it was the epoch of incredulity, it was the season of light, it was the season of darkness,

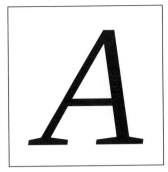

Trump Mediaeval Italic

ABCDEFGHIJKL
MNOPQRSTUV
WXYZabcdefghij
klmnopqrstuvwx
yz 1234567890
¿!&)$%#@""·;·,*

Trump Mediaeval Italic 10 point

ABCDEFGHIJKLMNOPQRSTUVWXYZ abcdefghij klmnopqrstuvwxyz 1234567890 ?!/&$%#@ "":;.,*

Trump Mediaeval Italic 12 point

ABCDEFGHIJKLMNOPQRSTUVWXYZ abcdefghij klmnopqrstuvwxyz 1234567890 ?!/&$%#@ "":;.,*

Trump Mediaeval Italic 13 point

ABCDEFGHIJKLMNOPQRSTUVWXYZ abcdefghij klmnopqrstuvwxyz 1234567890 ?!/&$%#@ "":;.,*

Trump Mediaeval Italic 14 point

ABCDEFGHIJKLMNOPQRSTUVWXYZ abcdefghij klmnopqrstuvwxyz 1234567890 ?!/&$%#@ "":;.,*

Trump Mediaeval Italic 16 point

ABCDEFGHIJKLMNOPQRSTUVWXYZ abcdefghij klmnopqrstuvwxyz 1234567890 ?!/&$%#@ "":;.,*

Trump Mediaeval Italic 18 point

ABCDEFGHIJKLMNOPQRSTUVWXYZ abcdefghij klmnopqrstuvwxyz 1234567890 ?!/&$%#@ "":;.,*

Trump Mediaeval Italic 20 point

ABCDEFGHIJKLMNOPQRSTUVWXYZ abcdefghij klmnopqrstuvwxyz 1234567890 ?!/&$%#@ "":;.,*

Trump Mediaeval Italic 22 point

ABCDEFGHIJKLMNOPQRSTUVWXYZ abcdefghij klmnopqrstuvwxyz 1234567890 ?!/&$%#@ "":;.,*

Trump Mediaeval Italic 24 point

ABCDEFGHIJKLMNOPQRSTUVWXYZ
*abcdefghijklmnopqrstuvwxyz 1234567890 !?%&**

Trump Mediaeval Italic 30 point

ABCDEFGHIJKLMNOPQRSTUVWXYZ
abcdefghijklmnopqrstuvwxy 1234567890

Trump Mediaeval Italic 36 point

ABCDEFGHIJKLMNOPQRSTUV
abcdefghijklmnopqrstuvw 12345

Trump Mediaeval Italic 48 point

ABCDEFGHIJKLMNOP
abcdefghijklmnopqrs123

Trump Mediaeval Italic 60 point

ABCDEFGHIJKLMN
acdefghijklmno123

6/8 Trump Mediaeval Italic

It was the best of times, it was the worst of times, it was the age of wisdom, it was the age of foolishness, it was the epoch of belief, it was the epoch of incredulity, it was the season of light, it was the season of darkness, it was the spring of hope, it was the winter of despair, we had everything before us, we had nothing before us, we were all going direct to Heaven, we were all going direct the other way-in short, the period was so far like the present period, that some of its noisiest authorities insisted on its being

8/10 Trump Mediaeval Italic

It was the best of times, it was the worst of times, it was the age of wisdom, it was the age of foolishness, it was the epoch of belief, it was the epoch of incredulity, it was the season of light, it was the season of darkness, it was the spring of hope, it was the winter of despair, we had everything before us, we had nothing before us, we were all going direct to Heaven, we were all going direct the other way-in short, the period was so far like the present period, that

9/10 Trump Mediaeval Italic

It was the best of times, it was the worst of times, it was the age of wisdom, it was the age of foolishness, it was the epoch of belief, it was the epoch of incredulity, it was the season of light, it was the season of darkness, it was the spring of hope, it was the winter of despair, we had everything before us, we had nothing before us, we were all going

9/11 Trump Mediaeval Italic

It was the best of times, it was the worst of times, it was the age of wisdom, it was the age of foolishness, it was the epoch of belief, it was the epoch of incredulity, it was the season of light, it was the season of darkness, it was the spring of hope, it was the winter of despair, we had everything before us, we had nothing before us, we were all going

10/11 Trump Mediaeval Italic

It was the best of times, it was the worst of times, it was the age of wisdom, it was the age of foolishness, it was the epoch of belief, it was the epoch of incredulity, it was the season of light, it was the season of darkness, it was the spring of hope, it was the winter of despair, we had everything before us, we

10/12 Trump Mediaeval Italic

It was the best of times, it was the worst of times, it was the age of wisdom, it was the age of foolishness, it was the epoch of belief, it was the epoch of incredulity, it was the season of light, it was the season of darkness, it was the spring of hope, it was the winter of despair, we had everything before us, we

11/13 Trump Mediaeval Italic

It was the best of times, it was the worst of times, it was the age of wisdom, it was the age of foolishness, it was the epoch of belief, it was the epoch of incredulity, it was the season of light, it was the season of darkness, it was the spring of hope, it was the winter of despair, we had everything before us, we had

11/14 Times Mediaeval Italic

It was the best of times, it was the worst of times, it was the age of wisdom, it was the age of foolishness, it was the epoch of belief, it was the epoch of incredulity, it was the season of light, it was the season of darkness, it was the spring of hope, it was the winter of despair, we had everything before us, we had

12/13 Times Mediaeval Italic

It was the best of times, it was the worst of times, it was the age of wisdom, it was the age of foolishness, it was the epoch of belief, it was the epoch of incredulity, it was the season of light, it was the season of darkness, it was the spring of hope, it was

12/14 Times Mediaeval Italic

It was the best of times, it was the worst of times, it was the age of wisdom, it was the age of foolishness, it was the epoch of belief, it was the epoch of incredulity, it was the season of light, it was the season of darkness, it was the spring of hope, it was

13/15 ITC Trump Mediaeval Italic

It was the best of times, it was the worst of times, it was the age of wisdom, it was the age of foolishness, it was the epoch of belief, it was the epoch of incredulity, it was the season of light, it was the season of darkness, it was the

14/15 Trump Mediaeval Italic

It was the best of times, it was the worst of times, it was the age of wisdom, it was the age of foolishness, it was the epoch of belief, it was the epoch of incredulity, it was the season of light, it was the season of darkness,

14/16 Trump Mediaeval Italic

It was the best of times, it was the worst of times, it was the age of wisdom, it was the age of foolishness, it was the epoch of belief, it was the epoch of incredulity, it was the season of light, it was the season of darkness,

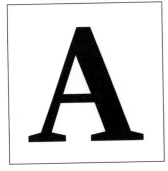

Trump Mediaeval 72 point

ABCDEFGHIJK
LMNOPQRSTU
VWXYZ abcdef
ghijklmnopqrstu
vwxyz 12345678
90?!&$%#★""·;·,

Trump Mediaeval Bold 10 point

ABCDEFGHIJKLMNOPQRSTUVWXYZ abcdefghij
klmnopqrstuvwxyz 1234567890 ?!/&$%#@*""::.,

Trump Mediaeval Bold 12 point

ABCDEFGHIJKLMNOPQRSTUVWXYZ abcdefghij
klmnopqrstuvwxyz 1234567890 ?!/&$%#@*"":;.,

Trump Mediaeval Bold 13 point

ABCDEFGHIJKLMNOPQRSTUVWXYZ abcdefghij
klmnopqrstuvwxyz 1234567890 ?!/&$%#@*"":;.,

Trump Mediaeval Bold 14 point

ABCDEFGHIJKLMNOPQRSTUVWXYZ abcdefghij
klmnopqrstuvwxyz 1234567890 ?!/&$%#@*"":;.,

Trump Mediaeval Bold 16 point

ABCDEFGHIJKLMNOPQRSTUVWXYZ abcdefghij
klmnopqrstuvwxyz 1234567890 ?!/&$%#@*"":;.,

Trump Mediaeval Bold 18 point

ABCDEFGHIJKLMNOPQRSTUVWXYZ abcdefghij
klmnopqrstuvwxyz 1234567890 ?!/&$%#@*"":;.,

Trump Mediaeval Bold 20 point

ABCDEFGHIJKLMNOPQRSTUVWXYZ abcdefghij
klmnopqrstuvwxyz 1234567890 ?!/&$%#@*"":;.,

Trump Mediaeval Bold 22 point

ABCDEFGHIJKLMNOPQRSTUVWXYZ abcdefghij
klmnopqrstuvwxyz 1234567890 ?!/&$%#@*"":;.,

Trump Mediaeval Bold 24 point

ABCDEFGHIJKLMNOPQRSTUVWXYZ
abcdefghijklmnopqrstuvwxyz 1234567890 !?%&

Trump Mediaeval Bold 30 point

ABCDEFGHIJKLMNOPQRSTUVWXYZ
abcdefghijklmnopqrstuvwxyz 12345678

Trump Mediaeval Bold 36 point

ABCDEFGHIJKLMNOPQRSTUV
abcdefghijklmnopqrstuvwx 1234

Trump Mediaeval Bold 48 point

ABCDEFGHIJKLMNOP
abcdefghijklmnopqrs 123

Trump Mediaeval Bold 60 point

ABCDEFGHIJKLM
abcdefghijklmn 123

6/8 Trump Mediaeval Bold

It was the best of times, it was the worst of times, it was the age of wisdom, it was the age of foolishness, it was the epoch of belief, it was the epoch of incredulity, it was the season of light, it was the season of darkness, it was the spring of hope, it was the winter of despair, we had everything before us, we had nothing before us, we were all going direct to Heaven, we were all going direct the other way-in short, the period was so far like the present period, that some of its noisiest authorities insisted on its being

8/10 Trump Mediaeval Bold

It was the best of times, it was the worst of times, it was the age of wisdom, it was the age of foolishness, it was the epoch of belief, it was the epoch of incredulity, it was the season of light, it was the season of darkness, it was the spring of hope, it was the winter of despair, we had everything before us, we had nothing before us, we were all going direct to Heaven, we were all going direct

9/10 Trump Mediaeval Bold

It was the best of times, it was the worst of times, it was the age of wisdom, it was the age of foolishness, it was the epoch of belief, it was the epoch of incredulity, it was the season of light, it was the season of darkness, it was the spring of hope, it was the winter of despair, we had everything before us, we had nothing before us, we were all going

9/11 Trump Mediaeval Bold

It was the best of times, it was the worst of times, it was the age of wisdom, it was the age of foolishness, it was the epoch of belief, it was the epoch of incredulity, it was the season of light, it was the season of darkness, it was the spring of hope, it was the winter of despair, we had everything before us, we had nothing before us, we were all going

10/11 Trump mediaeval Bold

It was the best of times, it was the worst of times, it was the age of wisdom, it was the age of foolishness, it was the epoch of belief, it was the epoch of incredulity, it was the season of light, it was the season of darkness, it was the spring of hope, it was the winter of despair, we had everything before us, we had

10/12 Trump Mediaeval Bold

It was the best of times, it was the worst of times, it was the age of wisdom, it was the age of foolishness, it was the epoch of belief, it was the epoch of incredulity, it was the season of light, it was the season of darkness, it was the spring of hope, it was the winter of despair, we had everything before us, we had

11/13 Trump Mediaeval Bold

It was the best of times, it was the worst of times, it was the age of wisdom, it was the age of foolishness, it was the epoch of belief, it was the epoch of incredulity, it was the season of light, it was the season of darkness, it was the spring of hope, it was the winter of despair, we had everything before

11/14 Trump Mediaeval Bold

It was the best of times, it was the worst of times, it was the age of wisdom, it was the age of foolishness, it was the epoch of belief, it was the epoch of incredulity, it was the season of light, it was the season of darkness, it was the spring of hope, it was the winter of despair, we had everything before

12/13 Trump Mediaeval Bold

It was the best of times, it was the worst of times, it was the age of wisdom, it was the age of foolishness, it was the epoch of belief, it was the epoch of incredulity, it was the season of light, it was the season of darkness, it was the spring of hope, it was

12/14 Trump Mediaeval Bold

It was the best of times, it was the worst of times, it was the age of wisdom, it was the age of foolishness, it was the epoch of belief, it was the epoch of incredulity, it was the season of light, it was the season of darkness, it was the spring of hope, it was

13/15 Trump Mediaeval Bold

It was the best of times, it was the worst of times, it was the age of wisdom, it was the age of foolishness, it was the epoch of belief, it was the epoch of incredulity, it was the season of light, it was the season of darkness, it was the spring of

14/15 Trump Mediaeval Bold

It was the best of times, it was the worst of times, it was the age of wisdom, it was the age of foolishness, it was the epoch of belief, it was the epoch of incredulity, it was the season of light, it was the season of darkness,

14/16 Trump Mediaeval Bold

It was the best of times, it was the worst of times, it was the age of wisdom, it was the age of foolishness, it was the epoch of belief, it was the epoch of incredulity, it was the season of light, it was the season of darkness,

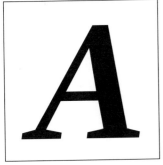

Trump Mediaeval Bold Italic 72Point

ABCDEFGHIJK
LMNOPQRSTU
VWXYZabcdefg
hijklmnopqrstu
vwxyz 12345678
90?!&) $%@"";.,*

Trump Mediaeval Bold Italic 10 point

ABCDEFGHIJKLMNOPQRSTUVWXYZ abcdefghij
klmnopqrstuvwxyz 1234567890 ?!/&$%#@*""":;.,

Trump Mediaeval Bold Italic 12 point

ABCDEFGHIJKLMNOPQRSTUVWXYZ abcdefghij
klmnopqrstuvwxyz 1234567890 ?!/&$%#@*""":;.,

Trump Mediaeval Bold Italic 13 point

ABCDEFGHIJKLMNOPQRSTUVWXYZ abcdefghij
klmnopqrstuvwxyz 1234567890 ?!/&$%#@*""":;.,

Trump Mediaeval Bold Italic 14 point

ABCDEFGHIJKLMNOPQRSTUVWXYZ abcdefghij
klmnopqrstuvwxyz 1234567890 ?!/&$%#@*""":;.,

Trump Mediaeval Bold Italic 16 point

ABCDEFGHIJKLMNOPQRSTUVWXYZ abcdefghij
klmnopqrstuvwxyz 1234567890 ?!/&$%#@*""":;.,

Trump Mediaeval Bold Italic 18 point

ABCDEFGHIJKLMNOPQRSTUVWXYZ abcdefghij
klmnopqrstuvwxyz 1234567890 ?!/&$%#@*""":;.,

Trump Mediaeval Bold Italic 20 point

ABCDEFGHIJKLMNOPQRSTUVWXYZ abcdefghij
klmnopqrstuvwxyz 1234567890 ?!/&$%#@*""":;.,

Trump Mediaeval Bold Italic 22 point

ABCDEFGHIJKLMNOPQRSTUVWXYZ abcdefghij
klmnopqrstuvwxyz 1234567890 ?!/&$%#@*""":;.,

Trump Mediaeval Bold Italic 24 point

ABCDEFGHIJKLMNOPQRSTUVWXYZ
abcdefghijklmnopqrstuvwxyzb1234567890 !?%&

Trump Mediaeval Bold Italic 30 point

ABCDEFGHIJKLMNOPQRSTUVWXYZ
abcdefghijklmnopqrstuvwxyz12345678

Trump Mediaeval Bold Italic 36 point

ABCDEFGHIJKLMNOPQRSTUV
abcdefghijklmnopqrstuvw 12345

Trump Mediaeval Bold Italic 48 point

ABCDEFGHIJKLMNOP
abcdefghijklmnopqr 123

Trump Mediaeval Bold Italic 60 point

ABCDEFGHIJKLMN
abcdefghijklmn123

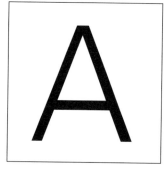

Univers Light 45 72 point

ABCDEFGHIJKL
MNOPQRSTUV
WXYZ abcdefghi
jklmnopqrstuvw
xyz 1234567890
?!&$%#@*""":;,

Univers Light 45 10 point

ABCDEFGHIJKLMNOPQRSTUVWXYZ abcdefghij
klmnopqrstuvwxyz 1234567890 ?!/&$%#@*" "":;.,

Univers Light 45 12 point

ABCDEFGHIJKLMNOPQRSTUVWXYZ abcdefghij
klmnopqrstuvwxyz 1234567890 ?!/&$%#@*" "":;.,

Univers Light 45 13 poins

ABCDEFGHIJKLMNOPQRSTUVWXYZ abcdefghij
klmnopqrstuvwxyz 1234567890 ?!/&$%#@*" "":;.,

Univers Light 45 14 point

ABCDEFGHIJKLMNOPQRSTUVWXYZ abcdefghij
klmnopqrstuvwxyz 1234567890 ?!/&$%#@*" "":;.,

Univers Light 45 16 point

ABCDEFGHIJKLMNOPQRSTUVWXYZ abcdefghij
klmnopqrstuvwxyz 1234567890 ?!/&$%#@*" "":;.,

Univers Light 45 18 point

ABCDEFGHIJKLMNOPQRSTUVWXYZ abcdefghij
klmnopqrstuvwxyz 1234567890 ?!/&$%#@*" "":;.,

Univers Light 45 20 point

ABCDEFGHIJKLMNOPQRSTUVWXYZ abcdefghij
klmnopqrstuvwxyz 1234567890 ?!/&$%#@*" "":;.,

Univers Light 45 22 point

ABCDEFGHIJKLMNOPQRSTUVWXYZ abcdefghij
klmnopqrstuvwxyz 1234567890 ?!/&$%#@*" "":;.,

Univers Light 45 24 point

ABCDEFGHIJKLMNOPQRSTUVWXYZ
abcdefghijklmnopqrstuvwxyz 1234567890 !?%&*

Univers Light 45 30 point

ABCDEFGHIJKLMNOPQRSTUVWXYZ
abcdefghijklmnopqrstuvwxyz 123456789

Univers Light 45 36 point

ABCDEFGHIJKLMNOPQRSTUVW
abcdefghijklmnopqrstuvwx 123456

Univers Light 45 48 point

ABCDEFGHIJKLMNOPQR
abcdefghijklmnopqrst1234

Univers Light 45 60 point

ABCDEFGHIJKLMNOP
abcdefghijklmnopq 123

6/8 Univers Light 45

It was the best of times, it was the worst of times, it was the age of wisdom, it was the age of foolishness, it was the epoch of belief, it was the epoch of incredulity, it was the season of light, it was the season of darkness, it was the spring of hope, it was the winter of despair, we had everything before us, we had nothing before us, we were all going direct to Heaven, we were all going direct the other way-in short, the period was so far like the present period, that some of its noisiest authorities insisted on its being received, for good or

8/10 Univers Light 45

It was the best of times, it was the worst of times, it was the age of wisdom, it was the age of foolishness, it was the epoch of belief, it was the epoch of incredulity, it was the season of light, it was the season of darkness, it was the spring of hope, it was the winter of despair, we had everything before us, we had nothing before us, we were all going direct to Heaven, we were all going direct

9/10 Univers Light 45

It was the best of times, it was the worst of times, it was the age of wisdom, it was the age of foolishness, it was the epoch of belief, it was the epoch of incredulity, it was the season of light, it was the season of darkness, it was the spring of hope, it was the winter of despair, we had everything before us, we had nothing before us, we were all going direct

9/11 Univers Light 45

It was the best of times, it was the worst of times, it was the age of wisdom, it was the age of foolishness, it was the epoch of belief, it was the epoch of incredulity, it was the season of light, it was the season of darkness, it was the spring of hope, it was the winter of despair, we had everything before us, we had nothing before us, we were all going direct

10/11 Univers Light 45

It was the best of times, it was the worst of times, it was the age of wisdom, it was the age of foolishness, it was the epoch of belief, it was the epoch of incredulity, it was the season of light, it was the season of darkness, it was the spring of hope, it was the winter of despair, we had everything before us, we had

10/12 Univers Light 45

It was the best of times, it was the worst of times, it was the age of wisdom, it was the age of foolishness, it was the epoch of belief, it was the epoch of incredulity, it was the season of light, it was the season of darkness, it was the spring of hope, it was the winter of despair, we had everything before us, we had

11/13 Univers Light 45

It was the best of times, it was the worst of times, it was the age of wisdom, it was the age of foolishness, it was the epoch of belief, it was the epoch of incredulity, it was the season of light, it was the season of darkness, it was the spring of hope, it was the winter of despair, we had everything before us, we

11/14 Univers Light 45

It was the best of times, it was the worst of times, it was the age of wisdom, it was the age of foolishness, it was the epoch of belief, it was the epoch of incredulity, it was the season of light, it was the season of darkness, it was the spring of hope, it was the winter of despair, we had everything before us, we

12/13 Univers Light 45

It was the best of times, it was the worst of times, it was the age of wisdom, it was the age of foolishness, it was the epoch of belief, it was the epoch of incredulity, it was the season of light, it was the season of darkness, it was the spring of hope, it was the winter

12/14 Univers Light 45

It was the best of times, it was the worst of times, it was the age of wisdom, it was the age of foolishness, it was the epoch of belief, it was the epoch of incredulity, it was the season of light, it was the season of darkness, it was the spring of hope, it was the winter

13/15 Univers Light 45

It was the best of times, it was the worst of times, it was the age of wisdom, it was the age of foolishness, it was the epoch of belief, it was the epoch of incredulity, it was the season of light, it was the season of darkness, it was the spring of

14/15 Univers Light 45

It was the best of times, it was the worst of times, it was the age of wisdom, it was the age of foolishness, it was the epoch of belief, it was the epoch of incredulity, it was the season of light, it was the season of darkness, it was the

14/16 Univers Light 45

It was the best of times, it was the worst of times, it was the age of wisdom, it was the age of foolishness, it was the epoch of belief, it was the epoch of incredulity, it was the season of light, it was the season of darkness, it was the

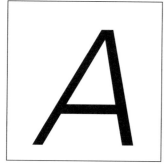

Univers Light Oblique 72 point

ABCDEFGHIJKL
MNOPQRSTUV
WXYZ abcdefghij
klmnopqrstuvw
xyz1234567890
?!&$$%#@*"";.,

Univers Light Oblique 10 point

ABCDEFGHIJKLMNOPQRSTUVWXYZ abcdefghij
klmnopqrstuvwxyz 1234567890 ?!/&$%#@""":;.,*

Univers Light Oblique 12 point

ABCDEFGHIJKLMNOPQRSTUVWXYZ abcdefghij
klmnopqrstuvwxyz 1234567890 ?!/&$%#@""":;.,*

Univers Light Oblique 13 point

ABCDEFGHIJKLMNOPQRSTUVWXYZ abcdefghij
klmnopqrstuvwxyz 1234567890 ?!/&$%#@""":;.,*

Univers Light Oblique 14 point

ABCDEFGHIJKLMNOPQRSTUVWXYZ abcdefghij
klmnopqrstuvwxyz 1234567890 ?!/&$%#@""":;.,*

Univers Light Oblique 16 point

ABCDEFGHIJKLMNOPQRSTUVWXYZ abcdefghij
klmnopqrstuvwxyz 1234567890 ?!/&$%#@""":;.,*

Univers Light Oblique 18 point

ABCDEFGHIJKLMNOPQRSTUVWXYZ abcdefghij
klmnopqrstuvwxyz 1234567890 ?!/&$%#@""":;.,*

Univers Light Oblique 20 point

ABCDEFGHIJKLMNOPQRSTUVWXYZ abcdefghij
klmnopqrstuvwxyz 1234567890 ?!/&$%#@""":;.,*

Univers Light Oblique 22 point

ABCDEFGHIJKLMNOPQRSTUVWXYZ abcdefghij
klmnopqrstuvwxyz 1234567890 ?!/&$%#@""":;.,*

Univers Light Oblique 24 point

ABCDEFGHIJKLMNOPQRSTUVWXYZ
*abcdefghijklmnopqrstuvwxyz 1234567890 !?%&**

Univers Light Oblique 30 point

ABCDEFGHIJKLMNOPQRSTUVWXYZ
abcdefghijklmnopqrstuvwxyz 1234567890

Univers Light Oblique 36 point

ABCDEFGHIJKLMNOPQRSTUVW
abcdefghijklmnopqrstuvwx 12345

Univers Light Oblique 48 point

ABCDEFGHIJKLMNOPQR
abcdefghijklmnopqrst 123

Univers Light Oblique 60 point

ABCDEFGHIJKLMN
abcdefghijklmno123

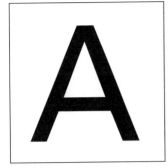

Univers 55 72 point

ABCDEFGHIJKL
MNOPQRSTUV
WXYZ abcdefghi
jklmnopqrstuvw
xyz 1234567890
?!/&$%#@*""":;,

Univers 55 10 point

ABCDEFGHIJKLMNOPQRSTUVWXYZ abcdefghij
klmnopqrstuvwxyz 1234567890 ?!/&$%#@*""";.,

Univers 55 12 point

ABCDEFGHIJKLMNOPQRSTUVWXYZ abcdefghij
klmnopqrstuvwxyz 1234567890 ?!/&$%#@*""";.,

Univers 55 13 point

ABCDEFGHIJKLMNOPQRSTUVWXYZ abcdefghij
klmnopqrstuvwxyz 1234567890 ?!/&$%#@*""";.,

Univers 55 14 point

ABCDEFGHIJKLMNOPQRSTUVWXYZ abcdefghij
klmnopqrstuvwxyz 1234567890 ?!/&$%#@*""";.,

Univers 55 16 point

ABCDEFGHIJKLMNOPQRSTUVWXYZ abcdefghij
klmnopqrstuvwxyz 1234567890 ?!/&$%#@*""";.,

Univers 55 18 point

ABCDEFGHIJKLMNOPQRSTUVWXYZ abcdefghij
klmnopqrstuvwxyz 1234567890 ?!/&$%#@*""";.,

Univers 55 20 point

ABCDEFGHIJKLMNOPQRSTUVWXYZ abcdefghij
klmnopqrstuvwxyz 1234567890 ?!/&$%#@*""";.,

Univers 55 22 point

ABCDEFGHIJKLMNOPQRSTUVWXYZ abcdefghij
klmnopqrstuvwxyz 1234567890 ?!/&$%#@*""";.,

Univers 55 24 point

ABCDEFGHIJKLMNOPQRSTUVWXYZ
abcdefghijklmnopqrstuvwxyz 1234567890 !?%&

Univers 55 30 point

ABCDEFGHIJKLMNOPQRSTUVWXYZ
abcdefghijklmnopqrstuvwxyz 12345678

Univers 55 36 point

ABCDEFGHIJKLMNOPQRSTUVW
abcdefghijklmnopqrstuvwx 1234

Univers 55 48 point

ABCDEFGHIJKLMNOPQR
abcdefghijklmnopqrs123

Univers 55 60 point

ABCDEFGHIJKLMN
abcdefghijklmno123

6/8 Univers 55

It was the best of times, it was the worst of times, it was the age of wisdom, it was the age of foolishness, it was the epoch of belief, it was the epoch of incredulity, it was the season of light, it was the season of darkness, it was the spring of hope, it was the winter of despair, we had everything before us, we had nothing before us, we were all going direct to Heaven, we were all going direct the other way-in short, the period was so far like the present period, that some of its noisiest authorities insisted on its

8/10 Univers 55

It was the best of times, it was the worst of times, it was the age of wisdom, it was the age of foolishness, it was the epoch of belief, it was the epoch of incredulity, it was the season of light, it was the season of darkness, it was the spring of hope, it was the winter of despair, we had everything before us, we had nothing before us, we were all going direct to Heaven, we were all

9/10 Univers 55

It was the best of times, it was the worst of times, it was the age of wisdom, it was the age of foolishness, it was the epoch of belief, it was the epoch of incredulity, it was the season of light, it was the season of darkness, it was the spring of hope, it was the winter of despair, we had everything before us, we had nothing before us, we

9/11 Univers 55

It was the best of times, it was the worst of times, it was the age of wisdom, it was the age of foolishness, it was the epoch of belief, it was the epoch of incredulity, it was the season of light, it was the season of darkness, it was the spring of hope, it was the winter of despair, we had everything before us, we had nothing before us, we

10/11 Univers 55

It was the best of times, it was the worst of times, it was the age of wisdom, it was the age of foolishness, it was the epoch of belief, it was the epoch of incredulity, it was the season of light, it was the season of darkness, it was the spring of hope, it was the winter of despair, we had everything before us, we

10/12 Univers 55

It was the best of times, it was the worst of times, it was the age of wisdom, it was the age of foolishness, it was the epoch of belief, it was the epoch of incredulity, it was the season of light, it was the season of darkness, it was the spring of hope, it was the winter of despair, we had everything before us, we

11/13 Univers 55

It was the best of times, it was the worst of times, it was the age of wisdom, it was the age of foolishness, it was the epoch of belief, it was the epoch of incredulity, it was the season of light, it was the season of darkness, it was the spring of hope, it was the winter of despair,

11/14 Univers 55

It was the best of times, it was the worst of times, it was the age of wisdom, it was the age of foolishness, it was the epoch of belief, it was the epoch of incredulity, it was the season of light, it was the season of darkness, it was the spring of hope, it was the winter of despair,

12/13 Univers 55

It was the best of times, it was the worst of times, it was the age of wisdom, it was the age of foolishness, it was the epoch of belief, it was the epoch of incredulity, it was the season of light, it was the season of darkness, it was the spring of hope, it was

12/14 Univers 55

It was the best of times, it was the worst of times, it was the age of wisdom, it was the age of foolishness, it was the epoch of belief, it was the epoch of incredulity, it was the season of light, it was the season of darkness, it was the spring of hope, it was

13/15 Univers 55

It was the best of times, it was the worst of times, it was the age of wisdom, it was the age of foolishness, it was the epoch of belief, it was the epoch of incredulity, it was the season of light, it was the season of darkness, it was the

14/15 Univers 55

It was the best of times, it was the worst of times, it was the age of wisdom, it was the age of foolishness, it was the epoch of belief, it was the epoch of incredulity, it was the season of light, it was the season of darkness,

14/16 Univers 55

It was the best of times, it was the worst of times, it was the age of wisdom, it was the age of foolishness, it was the epoch of belief, it was the epoch of incredulity, it was the season of light, it was the season of darkness,

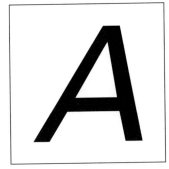

Univers Oblique 72 point

ABCDEFGHIJKL
MNOPQRSTUV
WXYZ abcdefghij
klmnopqrstuvwx
yz 1234567890
?!/&$%#@*""::.,

Univers Oblique 10 point

ABCDEFGHIJKLMNOPQRSTUVWXYZ abcdefghij
klmnopqrstuvwxyz 1234567890 ?!/&$%#@*""":;.,

Univers Oblique 12 point

ABCDEFGHIJKLMNOPQRSTUVWXYZ abcdefghij
klmnopqrstuvwxyz 1234567890 ?!/&$%#@*""":;.,

Univers Oblique 13 point

ABCDEFGHIJKLMNOPQRSTUVWXYZ abcdefghij
klmnopqrstuvwxyz 1234567890 ?!/&$%#@*""":;.,

Univers Oblique 14 point

ABCDEFGHIJKLMNOPQRSTUVWXYZ abcdefghij
klmnopqrstuvwxyz 1234567890 ?!/&$%#@*""":;.,

Univers Oblique 16 point

ABCDEFGHIJKLMNOPQRSTUVWXYZ abcdefghij
klmnopqrstuvwxyz 1234567890 ?!/&$%#@*""":;.,

Univers Oblique 18 point

ABCDEFGHIJKLMNOPQRSTUVWXYZ abcdefghij
klmnopqrstuvwxyz 1234567890 ?!/&$%#@*""":;.,

Univers Oblique 20 point

ABCDEFGHIJKLMNOPQRSTUVWXYZ abcdefghij
klmnopqrstuvwxyz 1234567890 ?!/&$%#@*""":;.,

Univers Oblique 22 point

ABCDEFGHIJKLMNOPQRSTUVWXYZ abcdefghij
klmnopqrstuvwxyz 1234567890 ?!/&$%#@*""":;.,

Univers Oblique 24 point

ABCDEFGHIJKLMNOPQRSTUVWXYZ
abcdefghijklmnopqrstuvwxyz 1234567890 !?%&

Univers Oblique 30 point

ABCDEFGHIJKLMNOPQRSTUVWXYZ
abcdefghijklmnopqrstuvwxyz 1234567

Univers Oblique 36 point

ABCDEFGHIJKLMNOPQRSTUV
abcdefghijklmnopqrstuvwx 1234

Univers Oblique 48 point

ABCDEFGHIJKLMNOPQ
abcdefghijklmnopqrs 123

Univers Oblique 60 point

ABCDEFGHIJKLMN
abcdefghijklmnop 123

Univers Bold 65 72 point

ABCDEFGHIJKL
MNOPQRSTUV
WXYZ abcdefghi
jklmnopqrstuvw
xyz 1234567890
?!/&$$%#@*""..

Univers Bold 65 10 point

ABCDEFGHIJKLMNOPQRSTUVWXYZ abcdefghij
klmnopqrstuvwxyz 1234567890 ?!/&$%#@*""":;.,

Univers Bold 65 12 point

ABCDEFGHIJKLMNOPQRSTUVWXYZ abcdefghij
klmnopqrstuvwxyz 1234567890 ?!/&$%#@*""":;.,

Univers Bold 65 13 point

ABCDEFGHIJKLMNOPQRSTUVWXYZ abcdefghij
klmnopqrstuvwxyz 1234567890 ?!/&$%#@*""":;.,

Univers Bold 65 14 point

ABCDEFGHIJKLMNOPQRSTUVWXYZ abcdefghij
klmnopqrstuvwxyz 1234567890 ?!/&$%#@*""":;.,

Univers Bold 65 16 point

ABCDEFGHIJKLMNOPQRSTUVWXYZ abcdefghij
klmnopqrstuvwxyz 1234567890 ?!/&$%#@*""":;.,

Univers Bold 65 18 point

ABCDEFGHIJKLMNOPQRSTUVWXYZ abcdefghij
klmnopqrstuvwxyz 1234567890 ?!/&$%#@*""":;.,

Univers Bold 65 20 point

ABCDEFGHIJKLMNOPQRSTUVWXYZ abcdefghij
klmnopqrstuvwxyz 1234567890 ?!/&$%#@*""":;.,

Univers Bold 65 22 point

ABCDEFGHIJKLMNOPQRSTUVWXYZ abcdefghij
klmnopqrstuvwxyz 1234567890 ?!/&$%#@*""":;.,

Univers Bold 65 24 point

ABCDEFGHIJKLMNOPQRSTUVWXYZ
abcdefghijklmnopqrstuvwxyz 1234567890 !?%

Univers Bold 65 30 point

ABCDEFGHIJKLMNOPQRSTUVWXYZ
abcdefghijklmnopqrstuvwxyz 1234567

Univers Bold 65 36 point

ABCDEFGHIJKLMNOPQRSTUVW
abcdefghijklmnopqrstuvw 12345

Univers Bold 65 48 point

ABCDEFGHIJKLMNOPQR
abcdefghijklmnopqrs123

Univers Bold 65 60 point

ABCDEFGHIJKLMN
abcdefghijklmno123

Univers Bold Oblique 72 point

*ABCDEFGHIJKL
MNOPQRSTUV
WXYZ abcdefghi
jklmnopqrstuvw
xyz 1234567890
?!/&$$%#@*""";;,*

Univers Bold Oblique 10 point

ABCDEFGHIJKLMNOPQRSTUVWXYZ *abcdefghij*
klmnopqrstuvwxyz 1234567890 ?!/&$%#@"":;.,*

Univers Bold Oblique 12 point

ABCDEFGHIJKLMNOPQRSTUVWXYZ *abcdefghij*
klmnopqrstuvwxyz 1234567890 ?!/&$%#@"":;.,*

Univers Bold Oblique 13 point

ABCDEFGHIJKLMNOPQRSTUVWXYZ *abcdefghij*
klmnopqrstuvwxyz 1234567890 ?!/&$%#@"":;.,*

Univers Bold Oblique 14 point

ABCDEFGHIJKLMNOPQRSTUVWXYZ *abcdefghij*
klmnopqrstuvwxyz 1234567890 ?!/&$%#@"":;.,*

Univers Bold Oblique 16 point

ABCDEFGHIJKLMNOPQRSTUVWXYZ *abcdefghij*
klmnopqrstuvwxyz 1234567890 ?!/&$%#@"":;.,*

Univers Bold Oblique 18 point

ABCDEFGHIJKLMNOPQRSTUVWXYZ *abcdefghij*
klmnopqrstuvwxyz 1234567890 ?!/&$%#@"":;.,*

Univers Bold Oblique 20 point

ABCDEFGHIJKLMNOPQRSTUVWXYZ *abcdefghij*
klmnopqrstuvwxyz 1234567890 ?!/&$%#@"":;.,*

Univers Bold Oblique 22 point

ABCDEFGHIJKLMNOPQRSTUVWXYZ *abcdefghij*
klmnopqrstuvwxyz 1234567890 ?!/&$%#@"":;.,*

Univers Bold Oblique 24 point

ABCDEFGHIJKLMNOPQRSTUVWXYZ
abcdefghijklmnopqrstuvwxyz 1234567890 !?%

Univers Bold Oblique 30 point

ABCDEFGHIJKLMNOPQRSTUVWXYZ
abcdefghijklmnopqrstuvwxyz 1234567

Univers Bold Oblique 36 point

ABCDEFGHIJKLMNOPQRSTUVWX
abcdefghijklmnopqrstuvwxyz 1234

Univers Bold Oblique 48 point

ABCDEFGHIJKLMNOPQRS
abcdefghijklmnopqrstu 123

Univers Bold Oblique 60 point

ABCDEFGHIJKLMNO
abcdefghijklmnop 123

Univers Black 75 72 point

ABCDEFGHIJKL
MNOPQRSTUV
WXYZ abcdefgh
ijklmnopqrstuv
wxyz 1234567
890?!/&$%#@*

Univers Black 75 10 point

ABCDEFGHIJKLMNOPQRSTUVWXYZ abcdefghij
klmnopqrstuvwxyz 1234567890 ?!/&$%#@*""":;.,

Univers Black 75 12 point

ABCDEFGHIJKLMNOPQRSTUVWXYZ abcdefghij
klmnopqrstuvwxyz 1234567890 ?!/&$%#@*""":;.,

Univers Black 75 13 point

ABCDEFGHIJKLMNOPQRSTUVWXYZ abcdefghij
klmnopqrstuvwxyz 1234567890 ?!/&$%#@*""":;.,

Univers Black 75 14 point

ABCDEFGHIJKLMNOPQRSTUVWXYZ abcdefghij
klmnopqrstuvwxyz 1234567890 ?!/&$%#@*""":;.,

Univers Black 75 16 point

ABCDEFGHIJKLMNOPQRSTUVWXYZ abcdefghij
klmnopqrstuvwxyz 1234567890 ?!/&$%#@*""":;.,

Univers Black 75 18 point

ABCDEFGHIJKLMNOPQRSTUVWXYZ abcdefghij
klmnopqrstuvwxyz 1234567890 ?!/&$%#@*""":;.,

Univers Black 75 20 point

ABCDEFGHIJKLMNOPQRSTUVWXYZ abcdefghij
klmnopqrstuvwxyz 1234567890 ?!/&$%#@*""":;.,

Univers Black 75 22 point

ABCDEFGHIJKLMNOPQRSTUVWXYZ abcdefghij
klmnopqrstuvwxyz 1234567890 ?!/&$%#@*""":;

Univers Black 75 24 point

ABCDEFGHIJKLMNOPQRSTUVWXYZ
abcdefghijklmnopqrstuvwxyz 1234567890

Univers Black 75 30 point

ABCDEFGHIJKLMNOPQRSTUVWXYZ
abcdefghijklmnopqrstuvwxyz 1234

Univers Black 75 36 point

ABCDEFGHIJKLMNOPQRSTUVW
abcdefghijklmnopqrstuvwy 123

Univers Black 75 48 point

ABCDEFGHIJKLMNOPQ
abcdefghijklmnopqr 123

Univers Black 75 60 point

ABCDEFGHIJKLMN
abcdefghijklmno12

Univers Black Oblique 72 point

ABCDEFGHIJKL MNOPQRSTUV WXYZ abcdefg hijklmnopqrstu vwxyz 123456 7890 ?!/&$%#@

Univers Black Oblique 10 point

ABCDEFGHIJKLMNOPQRSTUVWXYZ abcdefghij
klmnopqrstuvwxyz 1234567890 ?!/&$%#@*""::.,

Univers Black Oblique 12 point

ABCDEFGHIJKLMNOPQRSTUVWXYZ abcdefghij
klmnopqrstuvwxyz 1234567890 ?!/&$%#@*"":;.,

Univers Black Oblique 13 point

ABCDEFGHIJKLMNOPQRSTUVWXYZ abcdefghij
klmnopqrstuvwxyz 1234567890 ?!/&$%#@*"":;.,

Univers Black Oblique 14 point

ABCDEFGHIJKLMNOPQRSTUVWXYZ abcdefghij
klmnopqrstuvwxyz 1234567890 ?!/&$%#@*"":;.,

Univers Black Oblique 16 point

ABCDEFGHIJKLMNOPQRSTUVWXYZ abcdefghij
klmnopqrstuvwxyz 1234567890 ?!/&$%#@*"":;.,

Univers Black Oblique 18 point

ABCDEFGHIJKLMNOPQRSTUVWXYZ abcdefghij
klmnopqrstuvwxyz 1234567890 ?!/&$%#@*"":;.,

Univers Black Oblique 20 point

ABCDEFGHIJKLMNOPQRSTUVWXYZ abcdefghij
klmnopqrstuvwxyz 1234567890 ?!/&$%#@*"":;.,

Univers Black Oblique 22 point

ABCDEFGHIJKLMNOPQRSTUVWXYZ abcdefghij
klmnopqrstuvwxyz 1234567890 ?!/&$%#@*""

Univers Black Oblique 24 point

ABCDEFGHIJKLMNOPQRSTUVWXYZ
abcdefghijklmnopqrstuvwxyz 1234567890

Univers Black Oblique 30 point

ABCDEFGHIJKLMNOPQRSTUVWXYZ
abcdefghijklmnopqrstuvwxyz 123456

Univers Black Oblique 36 point

ABCDEFGHIJKLMNOPQRSTUVW
abcdefghijklmnopqrstuvwxyz 12

Univers Black Oblique 48 point

ABCDEFGHIJKLMNOPQ
abcdefghijklmnopqr 123

Univers Black Oblique 60 point

ABCDEFGHIJKLMN
abcdefghijklmno 12

University Roman 72 point

ABCDEFGHIJKLM
NOPQRSTUVW
XYZ abcdefghijkl
mnopqrstuvwxyz
1234567890
?!/&$%*""·:;·.,

University Roman 10 point

ABCDEFGHIJKLMNOPQRSTUVWXYZ abcdefghij
klmnopqrstuvwxyz 1234567890 ?!/&$%*"":.,

University Roman 12 point

ABCDEFGHIJKLMNOPQRSTUVWXYZ abcdefghij
klmnopqrstuvwxyz 1234567890 ?!/&$%*"":.,

University Roman 13 point

ABCDEFGHIJKLMNOPQRSTUVWXYZ abcdefghij
klmnopqrstuvwxyz 1234567890 ?!/&$%*"":.,

University Roman 14 point

ABCDEFGHIJKLMNOPQRSTUVWXYZ abcdefghij
klmnopqrstuvwxyz 1234567890 ?!/&$%*"":.,

University Roman 16 point

ABCDEFGHIJKLMNOPQRSTUVWXYZ abcdefghij
klmnopqrstuvwxyz 1234567890 ?!/&$%*"":.,

University Roman 18 point

ABCDEFGHIJKLMNOPQRSTUVWXYZ abcdefghij
klmnopqrstuvwxyz 1234567890 ?!/&$%*"":.,

University Roman 20 point

ABCDEFGHIJKLMNOPQRSTUVWXYZ abcdefghij
klmnopqrstuvwxyz 1234567890 ?!/&$%*"":.,

University Roman 22 point

ABCDEFGHIJKLMNOPQRSTUVWXYZ abcdefghij
klmnopqrstuvwxyz 1234567890 ?!/&$% *"":.,

University Roman 24 point

ABCDEFGHIJKLMNOPQRSTUVWXYZ
abcdefghijklmnopqrstuvwxyz 1234567890 !?%&*

University Roman 30 point

ABCDEFGHIJKLMNOPQRSTUVWXYZ
abcdefghijklmnopqrstuvwxyz 1234567890

University Roman 36 point

ABCDEFGHIJKLMNOPQRSTUVWXYZ
abcdefghijklmnopqrstuvwxyz 1234567

University Roman 48 point

ABCDEFGHIJKLMNOPQRSTUV
abcdefghijklmnopqrst12345678

University Roman 60 point

ABCDEFGHIJKLMNOPQR
abcdefghijklmnopqrst 123

ITC Zapf Chancery Medium Italic 72 point

ABCDEFGHIJKL
MNOPQRSTUV
WXYZ abcdefghijk
lmnopqrstuvwxyz
1234567890
?!/&$%#@*""":;.,

ITC Zapf Chancery Medium Italic 10 point

ABCDEFGHIJKLMNOPQRSTUVWXYZ abcdefghij
klmnopqrstuvwxyz 1234567890 ?!/&$%#@*"":;.,

ITC Zapf Chancery Medium Italic 12 point

ABCDEFGHIJKLMNOPQRSTUVWXYZ abcdefghij
klmnopqrstuvwxyz 1234567890 ?!/&$%#@*"":;.,

ITC Zapf Chancery Medium Italic 13 point

ABCDEFGHIJKLMNOPQRSTUVWXYZ abcdefghij
klmnopqrstuvwxyz 1234567890 ?!/&$%#@*"":;.,

ITC Zapf Chancery Medium Italic 14 point

ABCDEFGHIJKLMNOPQRSTUVWXYZ abcdefghij
klmnopqrstuvwxyz 1234567890 ?!/&$%#@*"":;.,

ITC Zapf Chancery Medium Italic 16 point

ABCDEFGHIJKLMNOPQRSTUVWXYZ abcdefghij
klmnopqrstuvwxyz 1234567890 ?!/&$%#@*"":;.,

ITC Zapf Chancery Medium Italic 18 point

ABCDEFGHIJKLMNOPQRSTUVWXYZ abcdefghij
klmnopqrstuvwxyz 1234567890 ?!/&$%#@*"":;.,

ITC Zapf Chancery Medium Italic 20 point

ABCDEFGHIJKLMNOPQRSTUVWXYZ abcdefghij
klmnopqrstuvwxyz 1234567890 ?!/&$%#@*"":;.,

ITC Zapf Chancery Medium Italic 22 point

ABCDEFGHIJKLMNOPQRSTUVWXYZ abcdefghij
klmnopqrstuvwxyz 1234567890 ?!/&$%#@*"":;.,